FOR OUR MOTHERS

Foreword: Representing the New Woman—Complexity and Contradiction

LINDA NOCHLIN

It is as hard to define what we mean by the "New Woman" as it is easy to find examples of her ubiquitous image not only in Western Europe but throughout the world in the era extending from the fin-de-siècle to the 1930s, and even to the decades beyond. Is the New Woman quint-essentially defined by the photography and film of Weimar Germany in such figures as Louise Brooks's Lulu in G. W. Pabst's film *Pandora's Box* (1929): seductive, self-aggrandizing, sexually ambiguous? Or is she more truly embodied in the courageous activism and professional expertise of the American aviator Amelia Earhart? Is the New Woman—envisioned as vamp or seductress—merely an updated avatar of a time-honored female topos: a streamlined version of Delilah; Salome; or, more recently, Becky Sharp or Mata Hari? Or is she a stalwart fighter for equal rights, the suffrage, and meaningful work for women, a battler for female independence and self-determination most poignantly embodied in photos and posters of Republican women engaged in the Spanish Civil War? Certainly, these two visions are not identical; indeed, they are contradictory, although there are many images, like Tamara de Lempicka's *Self Portrait in a Green Bugatti* of 1925, showing the elegant artist at the wheel of her high-powered car, that attempt to weld the sexy with the self-propelling. Yet what all New Images of the New Woman do have in common, flapper or vamp, political revolutionary or suffragette, is a heartfelt rejection of woman's traditional role as it was defined by every society in the world: rebellion against oppressive notions of the "womanly" understood to be a life devoted to subordinating one's own needs and desires to those of men, family, and children.

Certainly, it is hard to see the filmic Lulu as an embodiment of female agency in the best sense of the word. Yet at the time, and even today, she provided a powerful visual and psychological model for young women

trying to find their way in what might be called, to borrow from Bertolt Brecht, the jungle of the city, women on their own, seeking a viable identity in an alluring but dangerous modern setting.

This publication grew out of an exhibition, "Louise Brooks and the 'New Woman' in Weimar Cinema," and an accompanying symposium, "Exhibiting the 'New Woman': Louise Brooks, Amelia Earhart, and Marianne Brandt," which took place at the International Center of Photography in New York in 2007. The subjects of the individual talks—Louise Brooks, an American actress who made her reputation in a German film; Amelia Earhart, an American aviatrix whose deeds and image achieved international renown; and Marianne Brandt, a German artist who specialized in metalwork and collage—were placed in a larger context of representations of the New Woman, particularly those conflicting demands of reaction and progressivism in Weimar Germany in which Brooks and Brandt created their work.

However, one of the key contributions of *The New Woman International* is the way in which it broadens the scope of this gendered paradigm. Too often the discussion of this powerful "Woman" has been limited to *either* the flapper of Weimar *or* the hearty suffragist in the turn-of-the-century United States and Great Britain, with little or no crossover in those discussions and rare applications of them to regions beyond. In fact, not only did this image cross-pollinate across the Atlantic in the 1910s, 1920s, and 1930s, but it spread throughout all of Europe—including Eastern Europe—and into Asia, aided and abetted by globally proliferating mass media outlets. The image of Louise Brooks and other fashionable figures were popular in Japanese, Mexican, Euro-American, and other nationally based magazines around the globe. And Asian countries formulated their own responses to this alluring construct so popular with female consumers through such "cultural ambassadors" as Butterfly Wu (Hu Die), a stylish leading actress who traveled to film festivals in Moscow and Berlin in 1935, causing a reevaluation of stereotypes of Chinese women.[1] Moreover, as *The New Woman International* brings clearly into focus, distinctly non-Western forms of New Womanhood were developed in and contributed to this global phenomenon.

In general, the New Woman, wherever she might be, was a beacon to the adventurous and a threat to the upholders of traditional values. To female youth, the New Woman offered a paradigm of liberation and agency: liberation from corsets, long hair, and bulky skirts; bodily freedom through

participation in sports and dance; and, equally important, liberation in the even more encumbering realm of ideology. It was liberation from the ideal of true womanhood, the bondage of marriage and self-sacrifice, the denial of achievement through career and work outside the home, and, above all, sexual subordination and submission. It was even liberation from the notion that sexuality and gender were unambiguous givens.

The notion that any form of independence was masculinizing, that women were made to have purely domestic roles, and that efforts to achieve self-realization were selfish and unnatural had of course been successful weapons in the battle to keep women in line for many years. But these consciously articulated positions were supported by deeply embedded, often repressed, unconscious attitudes of misogyny on the part of traditional social institutions and the men—and some women—who supported them. Even some of those on the political Left subscribed to traditional notions where gender was concerned. Fear and hatred of women, characterized as either dangerous whores or harmless mothers, the threat of unfettered female sexuality and its dire temptations, the despising of feminine softness and shapelessness, a complex of often contradictory emotions vis-à-vis the female sex, haunted the German masculine imagination (and in varying forms those of many other nations as well). Klaus Theweleit's penetrating study of the German Freikorps after the First World War, *Male Fantasies,* is required reading for an understanding of this sinister phenomenon at its most intense, as is, of course, the work of Sigmund Freud.[2]

The recent exhibition at the Metropolitan Museum of Art, "Glitter and Doom: German Portraits of the 1920s" (2006), should be reviewed with the New Woman theme in mind.[3] For the New Woman was, for the most part, savagely and seductively pilloried in Weimar art, by male artists to be sure: the modern female embodied as voracious, grotesque, and sexually provocative, ambiguously feminine in her boyish haircut and loose but revealing vamp attire. To artists such as George Grosz and Otto Dix, woman in general but particularly the New Woman was the very embodiment of the degeneration and duplicity of the social order itself.

Behind the triumph of the New Woman and her representation, especially in Weimar Germany, in both high and popular culture—magazines, novels, films—lies the frightening imagery of the *Lustmord,* the sex murder, a popular theme at the same time. One might even think of the sex murder theme as a response of terrified males to the various manifestations of woman's liberation and the New Woman herself. Beth Irwin Lewis's pioneering work on the subject of the sex murder is essential to any discussion

of the New Woman theme, as is Maria Tatar's *Lustmord: Sexual Murder in Weimar Germany*.[4] The sex murder topic—a staple of mass journalism to this day—is amply illustrated by multiple horrific images by Grosz, Dix, Rudolf Schlichter, and Oskar Kokoschka (who wrote a vanguard play on the theme), and many others. On the dark side of the triumphant representation of the New Woman lie the misogynistic representations of outraged male fantasy: Hans Bellmer's eviscerated dolls, etchings of torn underwear and mutilated female flesh, blurry photos of crime scenes, and the paradigmatic figure of Jack the Ripper, who features as the dark figure of fate bringing the liberated heroine to her doom in *Pandora's Box*. Along with the hopeful representation of women's project of freedom and self-determination brought vividly to light during this period, one must consider the dark underbelly of the New Woman theme: that savage imagery of domination and sexual excess empowered by violent male fantasies. I believe it is impossible to consider the one without the other.

The New Woman could easily be envisaged as the sexually wanton, amoral temptress and femme fatale, like Louise Brooks—both the roles she played in film and in life—or, on the other hand, as the daring tomboy adventurer, outdoing men at their own game, like Amelia Earhart. More usually and generally it was the image of the independent young woman, her hair and skirts cut short, her bosom flattened, her face overtly bedizened with maquillage, her language racy and her sex life free and open, out in the world working at a profession or at least—and probably more often—earning a mere livelihood as a secretary or assistant of some sort, or as a dabbler in the arts or theater; a woman who controlled her own life, in short, in the quest of her own enjoyment, her own goals, which were not subordinate to those of a dominating male partner. This timely book reminds us that the desire for New Woman role models in this pursuit of liberation was a transnational one, not the realm of a particular nation or culture. A vibrant discourse is thus opened up by this volume, laying a rich foundation for exciting future studies on the varied dialogues taking place across borders—between the United Kingdom and India, between Germany and the United States, between all of Asia and all of Europe and so on—during the rise of the mass media age of the mid–nineteenth to the mid–twentieth century.

Notes

1. A paper on Butterfly Wu ("Crossing Boundaries: The New Chinese Woman and Chinese Cinema in 1935") was presented by Li-Lin Tseng in the panel "The New

Woman in Art and Visual Culture: An International Perspective," organized by Ruth Iskin and Susan Fillin-Yeh at the annual conference of the College Art Association, Los Angeles, February 2009.

2. Klaus Theweleit, *Male Fantasies*, trans. Erica Carter and Chris Turner, 2 vols. (Minneapolis: University of Minnesota Press, 1989).

3. Sabine Rewald, ed., *Glitter and Doom: German Portraits from the 1920s* (New York: Metropolitan Museum of Art, 2006).

4. Beth Irwin Lewis, "*Lustmord:* Inside the Windows of the Metropolis," in *Women in the Metropolis: Gender and Modernity in Weimar Culture,* ed. Katharina von Ankum (Berkeley: University of California Press, 1997), 202–31; Maria Tatar, *Lustmord: Sexual Murder in Weimar Germany* (Princeton: Princeton University Press, 1997).

Acknowledgments

A book with the global scope of *The New Woman International* could never have come together without its editors having incurred many debts, and it is our pleasure to extend our heartfelt thanks here. First, our deepest gratitude goes to this volume's contributors for sharing their collective insights and wisdom so freely and making this collaborative effort a real pleasure. *The New Woman International* has benefited from the support of several organizations. We are grateful for generous subventions from the Pratt Institute School of Art and Design and the Gender Institute and Julian Park Publication Fund of the University at Buffalo, the State University of New York (UB). A Faculty Fellowship from the Humanities Institute and the Dr. Nuala McGann Drescher Leave Program at UB each funded a semester's leave for Elizabeth Otto, which were used in part for work on this manuscript. Vanessa Rocco's award from the Pratt Institute Faculty Development Fund helped pay for indexing.

This project began as a result of the International Center of Photography's (ICP's) long-standing support of new perspectives on photography and gender. Otto's exhibition on Marianne Brandt in 2006 was followed soon after by Vanessa Rocco's on Louise Brooks. We were both thrilled when a pioneer of feminist scholarship, Linda Nochlin, agreed to chair a panel, "Exhibiting the New Woman" at ICP, which also included a talk by Kristen Lubben on Amelia Earhart. We were even more thrilled when that same pioneer agreed to write the foreword to this volume. We offer deepest thanks to her and ICP for getting us started. Our editor at the University of Michigan Press, Tom Dwyer, has had tremendous faith in this project from the beginning. He, along with Alexa Ducsay and Christina Milton, have been wonderful shepherds to the book through all stages of the process.

We also would each like to add some specific words of gratitude.

Otto: I have been fortunate to have several wonderful teachers who have now become colleagues and friends, each of whom has shaped my thinking about feminist art history. My first mentor, Patricia Matthews, as well as Mark Antliff, Patricia Leighten, Matthew Biro, and Kathleen Canning, have all been tremendously generous in sharing their knowledge and thoughts about historical constructions of gender and representation, and I thank them for this. A number of colleagues and friends have offered helpful advice and ideas along the way; these include (but are certainly not limited to) Tani Barlow, Kerstin Barndt, Martin Berger, Lizzie Finnegan, Randall Halle, Sabine Hartmann, Annemarie Jaeggi, Michelle Moyd, Anne Rubenstein, Brett Van Hoesen, and Gennifer Weisenfeld. I am very grateful to my fellow members of the Department of Visual Studies at the University at Buffalo for their collegiality and intellectual verve—Millie Chen, Adele Henderson, Jonathan Katz, Gary Nickard, and Jack Quinan in particular among them—and to numerous friends and colleagues in other departments, including Carrie Bramen, Tim Dean, and Margarita Vargas. Despina Stratigakos of the UB School of Architecture has been a great source of advice and inspiration throughout this project. Through their scholarly tenacity and deep thinking, my students have been invaluable in helping me to work through ideas about gender, technology, and the image. Finally, I cannot thank my coeditor, Vanessa Rocco, enough. Her vision and intelligence made this project possible, and her wry wit made our journey through New Womanhood a real delight.

My family, Tobias and Sascha Westermann, have been a wonderful source of support throughout this project, as have my parents, Mary and David Otto. This book is for my mother. A bit of a midwestern New Woman herself and often my first reader, I am deeply grateful for her support of my work and for her wonderful friendship.

Rocco: I would like first to thank the two women who in turn introduced me to the New Woman: Rose-Carol Washton Long, my dissertation adviser, who taught my first graduate seminar, "The New Woman of Weimar Germany"; and Joyce Rheuban, who "introduced" me to Louise Brooks in a Weimar Cinema seminar, both at the Graduate Center, City University of New York. Crucial intellectual support—considering the unusual topic of film stills—for my Louise Brooks exhibition at ICP in 2007 came from Buzz Hartshorn, Brian Wallis, and Christopher Phillips, as well as the staff at the George Eastman House and its Motion

Picture Collection, which holds Louise Brooks's personal archives. Also at ICP, thanks go to Phil Block and Suzanne Nicholas for their engagement with the "New Woman" panel and Leandro Villaro for some well-timed last minute help. Ira M. Resnick offered personal access to his astounding collection of film artifacts for both the show and this book, and for his time I am deeply grateful. Many thanks also to Jessica Rosner and Rodrigo Brandão at Kino International and to Matthew Witkovsky at the Art Institute of Chicago.

At Pratt Institute, I would like to thank Edward de Carbo and Frank Lind in the School of Art and Design who advocated for financial support for the volume, all of my colleagues in the Department of the History of Art and Design, especially Frima Fox Hofrichter, Marsha Morton, and Steven Zucker, and the students in my Women in Photography seminar who have enlightened me consistently. For long-term encouragement and cheerleading, I thank Norma Broude and Terry Lichtenstein. For their wise editorial comments and help, I thank Cynthia Fredette, Margaret Schwartz, and Cynthia Young. On a more personal note, I want to thank my parents, Dr. Thomas and Ellen Rocco, and Joseph McKnight, and my husband, Alan Chin, and our two gorgeous children, Nora and Zack, for supporting me during the stresses of putting a book together. Last, my gratitude goes to my intrepid coeditor, Elizabeth Otto, a distinguished scholar and a most adept and insightful editor and comrade.

I dedicate this book to the memory of my loving mother, Agnes Walsh McKnight.

Contents

Introduction: Imagining and Embodying New Womanhood

ELIZABETH OTTO AND VANESSA ROCCO

Was the New Woman flesh and blood, a metaphor, or both concurrently? During the later part of the nineteenth century and the early decades of the twentieth, a range of iconic female forms emerged to dominate the global pictorial landscape. Chorine stars, female athletes and adventurers, flappers, *garçonnes,* Modern Girls, *neue Frauen,* suffragettes,[1] and *trampky* were all facets of the dazzling and urbane New Woman who came to epitomize modern femininity. This construct existed as both a set of abstract ideas and ideals and a compilation of individual behaviors and experiences; varied as they were, these translated across national contexts and through a range of key historical moments, including First Wave feminism, colonialism, the First and Second World Wars, political revolutions, and the rise of modernism.

Yet consistent in all of her manifestations is the New Woman's radical challenge to the status quo. New Women embodied feminism in action or fashion statement extraordinaire. They entered men's educational institutions and professions; became catered-to consumers of goods, services, and media; and lived and loved in ways that defied convention. The New Woman was famously associated with the quest for female enfranchisement and political representation, but often, rather than asking for new rights, she simply claimed them—or else she was willing to take to the streets in order to achieve them (fig. Intro.1). While this incarnation of modern femininity set the trends for women worldwide, she often stood accused of dangerously subverting gender norms and encouraging lesbianism, mannishness, and criminal deviance. Indeed the New Woman seemed to be such a universally recognizable icon of change that she could instantly inspire and simultaneously incite strong reactions of fear or anger.

It was through visual images that the New Woman's presence was

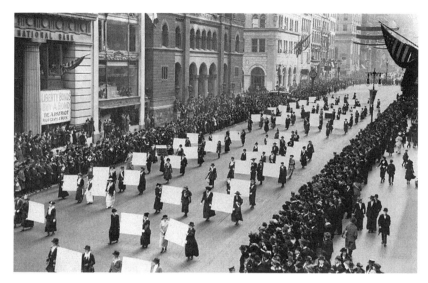

Fig. Intro.1. Suffragists "march in October 1917, displaying placards containing the signatures of over one million New York Women demanding the vote." (New York Times Archive.)

most overtly apparent. From the 1870s through the 1960s, artists, photographers, models, magazine editors, filmmakers, and actresses sought to define and contest the terms of modern femininity, and they created a pictorial archive of New Womanhood that still remains to be substantively and coherently interpreted. Over the past three decades, scholars of history, art history, and visual culture have often scrutinized the New Woman, but, with only a few significant exceptions, they have generally focused on specific contexts and neglected her transcendence of national and cultural borders.[2] Further, only limited attention has been paid to the ways in which New Womanhood was most deeply rooted in and debated through images and representations.[3] The New Woman as an inherently visual and global phenomenon has yet to be probed in a wider context.

Inaugurating a new chapter in the scholarship of this field, *The New Woman International: Representations in Photography and Film from the 1870s through the 1960s* confronts and examines the visual representation of this jubilant figure who could not be contained by national boundaries. This volume brings together generations of scholars who are experts in gender, photography, mass media, and film to analyze the New Woman from her inception in the later nineteenth century to her full development in the interwar period and to engage the variety of forms she took dur-

ing the 1930s and beyond. Contributors to *The New Woman International* address the ways in which these controversial female ideals figured in a range of parallel discourses, including those on gender norms, race, technology, sexuality, female agency, science, media representation, modernism, commercial culture, internationalism, colonialism, and transnational modernity. In exploring these topics, our authors investigate the terms of gendered representation as a process in which women were as much agents as allegories. These essays reveal the ways in which a feminine ideal circled the globe to be translated into numerous visual languages.

The New Woman was a creature not only of modernity but also of modern technology. Indeed, although she had her origins in Anglo-American literature, it was through her mass media representation in burgeoning urban cultures that she became a cultural lightning rod for those who were with her and against her. As Mary Louise Roberts has argued:

> Only a well-developed mass print culture could serve up such fantasies and nightmares of the self on a regular basis. Only an increasingly theatrical, spectacularized urban setting could blur the distinction between fantasy and reality, unloose imaginings, and facilitate a reader's translation of fictions into probable life plots.[4]

It was in tandem with such visual technologies of mass reproduction as lithography, offset printing, photographs, stereographs, and the cinema that—costumed in bloomers, drop-waisted skirts, or trousers—New Womanhood went global. In addition to mirroring an endless array of images of these women, the camera could function as an "instrument of self-determination," as Ute Eskildsen has observed.[5] Mass-produced representations also allowed for a critique of recent shifts in gender roles through cartoons and recontextualized photographs that could make New Womanhood appear somehow wrong—mannish, cheap, or superficial. The time-based medium of silent cinema animated images of modern femininity and created a new form of star with its attendant print culture.[6] While distinctly different from mass-produced representations, images that were seen by smaller audiences—one-off photomontages or hand-printed photographs—also played an important role, for it was in these that responses to the New Woman and representations of her expanded potential were often made.

During the ninety-year span examined by the contributors to *The New Woman International*, visual representation provided some of the most fertile ground for defining and expressing New Womanhood. Through

our focus on images captured through modern, film-based technologies—including photography, photojournalism, photomontage, and film—this volume zooms in on the primary loci through which New Woman figures were represented. For, while other kinds of pictures that were obviously the product of an artist's hand—painting above all—also helped define the New Woman, this trailblazing figure was most at home in quintessentially modern, mechanically based forms of imagery. As several scholars have shown, it was in such mass media as lithography and posters, as well as in precursors to film such as the panorama and diorama, that the mobile and fashionable *flâneuse* became a significant part of the urban visual landscape and a specifically feminine viewing subject that achieved broader recognition.[7] Ruth Iskin points out that late-nineteenth-century poster advertisements did not simply replace images of confinement with those of consumption but, significantly, these images appealed to their female audiences by prominently featuring spectacles of women's freedom and mobility.[8] By concentrating on photography and film, *The New Woman International* identifies essential links among gender, technology, and spectacle, and it explores the camera-made images that allowed for an increased circulation of representations of modern femininity. Film and photography are famously perceived to be fundamentally indexical media—in that viewers see these images as direct traces of the real world—and this fact gave these media a powerful cultural relevance for viewers. Tapping into this power, our book features women both in front of and behind the camera to reveal them as agents in constructing the New Woman as a creative avatar of change (fig. Intro.2). For example, in Germaine Krull's *Self-Portrait* from 1925, she represents herself as both object and maker; she is overtly modern and in control of the camera but also shows herself as hybrid and technologized. Photography and film were media at the border between modernism and mass culture, and this border space was also inhabited by the New Woman, who was on the leading edge of art, fashion, and culture but also had the market-driven appeal of the starlet, model, or salesgirl.

By contrast to histories of modernism that have tended to place the male viewer and creator at the center of culture, a focus on New Womanhood allows for another story to emerge, one that situates the development of a feminine modernism as parallel to the emergence of new visual technologies, democracy, and urban culture.[9] Already in the eighteenth century significant prototypes of New Womanhood had been brought to life through broader questions of public and private rights. Traces of these emergent New Women exist in early debates on political enfranchisement and revolution,

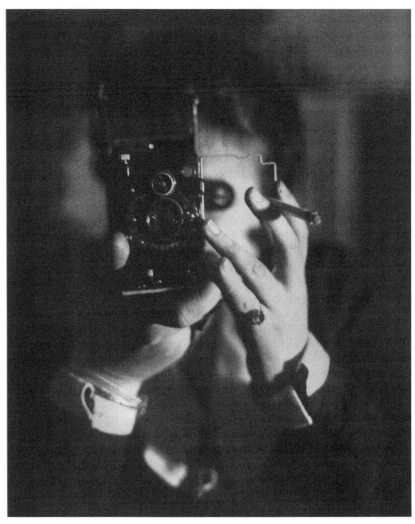

Fig. Intro.2. Germaine Krull, *Self-Portrait,* 1925. Gelatin silver print, 20.5 x 15.1 cm. (Pinakothek der Moderne, Munich, Foundation Ann and Jürgen Wilde © Museum Folkwang, Essen, Germany.)

including Olympe de Gouges's 1791 "Declaration of the Rights of Woman and Female Citizen" and Mary Wollstonecraft's *A Vindication of the Rights of Woman* of the following year.[10] In the nineteenth and early twentieth centuries—as various forms of photography emerged and quickly became all the rage—even such negative stereotypes as the frumpy bluestocking and the militant suffragette that visualized fears about female independence also

embodied some women's hopes.[11] It was in the 1880s and 1890s that the idea of New Womanhood truly began to germinate, particularly in England and America, where feminist activism, bohemian artistic circles, and the rise of women's colleges conveyed the perception that women were "in the process of no longer being the same."[12] This "new woman" came into sharp focus when she was named in print in British journalist Sarah Grand's 1894 essay "The New Aspect of the Woman Question" in the *North American Review*.[13] Within two months the term *New Woman* had become ubiquitous; two years later it had become a major export, making regular appearances in print, cartoons, and photographs in continental Europe as well.[14] The twentieth century saw a globalization of the New Woman under the terms *garçonne*, Modern Girl, flapper, and even *flapperista*.[15]

The members of the Modern Girl Around the World Research Group, whose groundbreaking book is the most significant and rigorous contribution to the study of interwar global New Womanhood to date, point out that such women were instantly recognizable anywhere on the planet. The Research Group characterizes these Modern Girls as "sometimes flashy, always fashionable" and asserts that they were identified by such traits as "bobbed hair, painted lips, provocative clothing, elongated body, and an open, easy smile."[16] Where interwar Modern Girls were unified by this specific look, earlier forms of New Womanhood did not necessarily adhere to a singular way of appearing but can be traced through ideas and practices. As Carolyn Christensen Nelson has pointed out, early New Women were identified by such traits as "educated," "bicycle rider," "smoker," "rational dress[er]," and "emancipated."[17] One such recognizable New Woman appeared in a Pictorialist photograph from the close of the nineteenth century by Robert Demachy (fig. Intro.3). While this New Woman's jaunty hat, voluminous locks, and heavy coat—not to mention her soft-focus appearance—would be shunned as outmoded by subsequent generations of flappers and starlets, her presence as a self-possessed smoker with an independent and contemplative gaze would endure as iconic traits of modern femininity. Indeed, as Barbara Sato has asserted in her work on the Japanese context, the Modern Girl, or *moga* for short, was initially not recognized as a singular image, and consolidation of her representation was in fact a political act on the part of intellectuals that rendered her a cultural force.[18] The New Woman's representation may have shifted from time and place, but what remained constant was that it was through *images* that she was almost always identified. Through photography and film, these images could most easily be transmitted, reprinted, or projected.

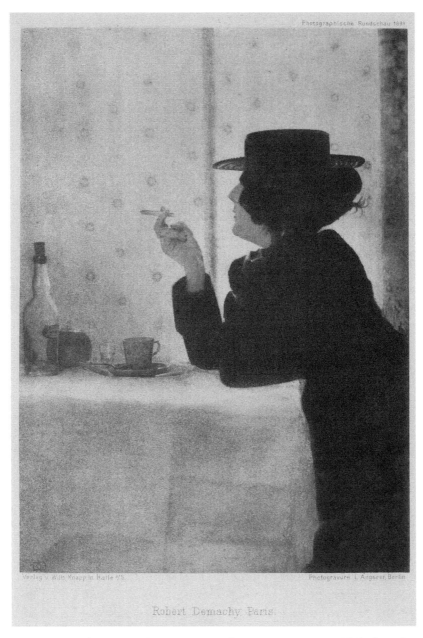

Fig. Intro.3. Robert Demachy, *Cigarette Girl—A Poster Design*. Published in *Pho-tographfische Rundschau* 13, no. 10 (October 1899), photogravure print. (Courtesy of the George Eastman House, International Museum of Photography and Film, Rochester, New York.)

From the start, the New Woman was a specter of controversy. She was a symbol of progress and modernity and at the same time seemed to embody decadence and decay. While the New Woman inspired fashion, film, photography, and art and was seen to epitomize positive changes in gender relations, she was also critiqued as intrinsically superficial and a passing fashion. As documents from the time and a number of scholars have shown, some commentators even saw her as presaging the downfall of conventional society.[19] Images of the New Woman played into long associations of femininity with artifice, but even superficial representations could function as a powerful tool for redefining gender norms. In the 1920s Joan Riviere theorized femininity as masquerade.[20] More recently Michel Foucault has asserted that sex as we know it is a relatively new idea that arose in the later nineteenth century and that this concept "made it possible to group together, in an artificial unity, anatomical elements, biological functions, conducts, sensations, and pleasures, and it enabled one to make use of this fictitious unity as a causal principle, an omnipresent meaning, a secret to be discovered everywhere: sex was thus able to function as a unique signifier and as a universal signified."[21] In crucial ways, New Women disrupted conventions of gender by refusing traditional performances of such feminine traits as passivity, aversion to public space, indifference to sexuality, and lack of creative genius. In these women's public and private lives, appearance could be strategic and even political, and for many it offered new experiences of the public sphere. A photograph from 1920 titled *Eleven Women and a Little Girl Lined Up for a Bathing Beauty Contest* is a playful and personalized self-display on the part of modern young women, but its status as a stock image of the National Photo Company also evokes the tradition of and trade in sexualized images of "fast" girls (fig. Intro.4).

The New Woman is nearly always cast as ambiguously gendered or a mixture of feminine and masculine attributes. Her gender-bending constituted a profound declaration of this figure's transgressive nature and inherent modernity, but it often stirred up fears that women would poach men's cultural and sexual authority and might even take their jobs. In the New Woman's nascent stages, femininity and heterosexuality were called into question as accusations of her "mannishness" and lesbianism held sway, leading to a perception of "the New Woman as Androgyne" as early as the 1870s, as Caroll Smith-Rosenberg's groundbreaking work has revealed.[22] Complemented by images of such prominent and "effeminate" men as Oscar Wilde, these types contributed to the conservative concept of a fin-

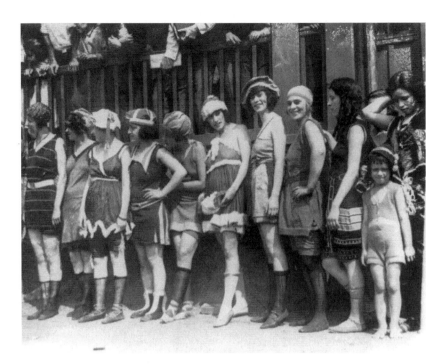

Fig. Intro.4. *Eleven Women and a Little Girl Lined Up for a Bathing Beauty Contest,* 1920. (National Photo Company. Black-and-white film copy negative, Library of Congress, Prints and Photographs Division, reproduction number LC-USZ62-58272.)

de-siècle society in decline on both sides of the Atlantic.[23] Beyond seeming to blur gender norms or threaten viewers' abilities to distinguish between men and women, representations of lesbians as a new type of women, a "third sex" that might be idealized or maligned, were powerfully captured in film and photography.

From her origins in declarations of rights and throughout the period investigated by our contributors, the New Woman is constantly associated with the word *freedom.* In addition to political enfranchisement, this term translated into women's more general independence in public and professional life, new possibilities of visibility and movement in public space, and the ability to travel even long distances on one's own. Habits of modern life formerly associated with men of all classes and women of the lower and working classes—smoking most obviously but also holding a job, drinking, going to clubs, and having sexual relationships outside of marriage—were experiences that now opened up to New Women of the middle and upper

classes. Sato points out that as Japanese intellectuals were hotly debating what class and practices defined the "true" Modern Girl, some of them looked favorably to a growing spectrum of urban women who were being changed by this phenomenon, particularly working women. "By seeking employment and securing some degree of economic independence, women, including the modern girl, would gain the know-how to voice their wants and satisfy them. Moreover, they would learn to define themselves beyond their relation to home and family."[24] Indeed, the New Woman's powerful signifiers were increasingly within the reach of lower and middle-class white-collar workers who might skimp on food to purchase the trappings of a higher-class appearance. And, by contrast to the general assumption of the New Woman as "white, educated, and middle class," Martha Patterson asserts that recent scholarship has demonstrated that "the New Woman's genesis had, in fact, more complicated underpinnings and more diverse expressions," which related to her historical, class, and national contexts, particularly in relation to colonialism and imperialism.[25] Thus fashion and appearance, far from being mere surface signifiers, confounded rigid class boundaries and undermined the presumption of a unidirectional transfer of knowledge across gendered, classed, and racial divides.

Taken collectively, the essays of *The New Woman International* chronicle modern women's challenges to convention, their mainstreaming as consumers, and their productive links to film and photography on a global scale. The contributions to this anthology evince the broad historical and geographic reach of the New Woman even as they treat her specific nuances in particular forms and representations. Individual sections and chapters move through key historical themes and phenomena to trace the interchange of ideas on style, politics, gender, and modernity that were at the heart of the spread of New Womanhood as it was deployed in film-based representations.

The essays in part 1, "The First New Women: Photography, Politics, and the Public Place of Women from the 1870s through the First World War," explore images produced in a diverse group of photo-based technologies and modes, including stereoviews, offset printing, mug shots, and portraiture. They address the New Women who flaunted convention by stepping into the male purviews of politics, society, and cultural production. Further, this section's authors examine links between imagery and feminism's first wave and reveal how representation preceded language in producing visions of New Womanhood. Starting in the late nineteenth century, such

mass-market photographic forms as the stereoview foregrounded challenges to gender conventions, as Melody Davis's essay demonstrates. She analyzes a series of "women's rights" themed stereoviews that circulated widely in the 1870s, well before the term *New Woman* came into play, presaging what the founders of New Woman literature in the United Kingdom would soon describe with words. Photography's role in documenting claims on public space, as well as the work, lives, and notorious antics of the Japanese Bluestockings, a radical literary group, is the subject of Jan Bardsley's essay. Despina Stratigakos identifies the phenomenon of illustrated newspapers' reporting of "Female Firsts," in which the European press reproduced photographs of women as pioneers and adventurers to define, in Stratigakos's words, "the extreme fringes of the new." And while photographed New Womanhood has often been seen as a strategic tool of identity construction for women in the West, Gianna Carotenuto explores how elite women in India created a range of New Woman identities in studio portraits, newspaper reproductions, and private albums that helped to define standards of femininity at home and in global news coverage. These representations conveyed new ideals of Indian womanhood that were intertwined with strains of nationalism, pro-Western sympathies, and the orientalizing imagery of the harem during colonialism's height in the early twentieth century.

The First World War inflicted devastation on a scale never before seen; it also caused a major dislocation in gender roles that reverberated throughout the following decades, as the two middle sections of this volume make clear. Germany was a center for the production of images of New Women in the 1920s; *The New Woman International* reflects on and complicates the extant scholarship on this period by broadening its geography and drawing connections to multiple global contexts. The essays in part 2, "Art and Identity: Gender Constructions in Photography and Photomontage of the 1920s," confront the rise of the New Woman as she was imaged and produced by individual artists; authors in this section examine the ways in which various photographic forms carved out radical identities that transgressed gender norms. While studies of European New Women have linked them to freedom and gender equality through their challenges to convention, Brett Van Hoesen's essay, the first in this section, continues with themes of colonialism by investigating New Women's participation in a "colonial imaginary" in which the spectacle of their freedom often depended on participation in the subjugation of racialized Others. Further, Van Hoesen explores how New Woman artists created works that partici-

pated in the spectacle of the colonies in an ambiguously critical manner. Mythic, modern, and fundamentally hybrid images of women were the primary focus of Hannah Höch's Dadaist photomontages; Matthew Biro's engagement of these representations as allegorical cyborgs sheds new light on Höch's works as radical critiques of the contemporary mass media and empowering interrogations of modern identity. Clare Rogan demonstrates how Germaine Krull, a German national who often worked in France, walked the line between art and pornography through her subversive images of lesbian sex in her "Les Amies" series and thus offered a powerful challenge to conventional viewing experiences. The expatriate experience also profoundly shaped the work of Bauhaus designer Marianne Brandt, who, like Krull, followed a long line of international women who traveled to experience the artistic freedom of Paris. Elizabeth Otto explores how Brandt embraced Bauhaus- and constructivist-influenced photography and photomontage to create remixed images of the French garçonne and other international New Woman figures. In Brandt's works, these modern females problematize their own perceived superficiality by emphasizing their status as powerful viewing subjects.

The later 1920s and the 1930s saw the height of the New Woman type and the ultimate transformation of representations of this Modern Girl. The essays of part 3, "Mass Media Icons: The New Woman as Embodiment of Transnational Modernity," explore the consolidation of the New Woman into a global image that was instantly recognizable in any context. Internationally resonant stars such as Brigitte Helm, the ubiquitous femme-bot from Fritz Lang's *Metropolis,* and Louise Brooks, a little Kansas girl who became the Weimar New Woman "It" girl in G. W. Pabst's films, are key examples of the contested nature of this media icon, as Maria Makela's and Vanessa Rocco's essays demonstrate. Makela explores how the mechanized New Woman of *Metropolis* tapped into broader fears about technology, doubling, and mistaken identity in the interwar period. By contrast, Rocco focuses on images that are instantly recognizable yet have rarely been discussed; the New Woman in film stills was a form of representation so powerful and pervasive that it was, as Rocco points out, "lodged in the cultural subconscious" since these images circulated in multiple mass media outlets. In the context of one particular mass media form, the newspaper, competing visions of New Womanhood could be placed side by side to enable reader participation in the formation and critique of this type. Martha Patterson examines the contested visions of stylish and sophisticated New Negro Womanhood presented in the serial nov-

els, advertisements, and photographs published in the *Pittsburgh Courier*, a thriving national newspaper that, now largely forgotten, was central to the Harlem Renaissance. In the context of Czechoslovakia, Karla Huebner analyzes how media representations of the Modern Girl provided a visual language for homegrown feminism and equality that was essential to the construction of the First Republic's democracy. The ambiguous fame and infinitely reproducible nature of interwar New Women was most famously embodied by the "Tiller Girls," which, as Lisa Jaye Young's investigation reveals, was an English chorus-girl enterprise that was widely perceived to be an American assembly-line product yet was wildly popular in Weimar Germany.

In the fourth section, "Girls and Crisis: The New Woman in the 1930s and Beyond," we borrow the title of a 1931 essay by Siegfried Kracauer in which, in the wake of the global financial collapse that had begun with the stock market crash of 1929, he describes the coordinated dances of chorus girls as an allegory of the empty, meaningless machinations of an economy gone bad. "One no longer believes them, the rosy Jackson Girls! They continue to attend just as meticulously to their abstract trade, but the happy dreams they are supposed to inspire have been revealed for years now as foolish illusions."[26] The essays in this section conclude the volume with a look at the transformations New Womanhood underwent during the tumultuous circumstances of economic depression, war, and revolution. In multiple contexts, icons of New Womanhood served as powerful inspirations that were deployed to a variety of political and cultural ends. Kathleen Vernon demonstrates how the imagery of the New Woman was co-opted by fascism through the equation of fashion with war in Franco's Spain. Concurrently this form of femininity also inspired a mass following through the hopeful figure of the aviatrix during the Great Depression, as Kristen Lubben shows in her essay on Amelia Earhart as a photographic icon. Finally, this section explores how the New Woman could be powerfully embodied in filmic representations of a gender-bending Chinese figure from the fourth century who was both timely and timeless. As Kristine Harris shows, modern films of the legend of Mulan, a cross-dressing warrior woman, created uncommonly bold female icons for the Chinese Nationalist revolution of the 1920s, the war with Japan of the 1930s and 1940s, and even through to the present day.

The representations caught on film that are analyzed by contributors to *The New Woman International*—mass-media images, art photography, self-portraiture, police mug shots, photomontage, and products of the

global film industry—served as spaces for contemplation of the fraught links between femininity and modernity, and they functioned as tools for women's participation in popular and avant-garde visual production. Through a rich array of interdisciplinary and groundbreaking scholarship on the visual manifestations of a worldwide form of modern femininity, the essays in this volume make a substantial contribution to the study of the dynamic phenomenon of the New Woman in photo-based media as she appeared across multiple decades and geographic contexts. Investigating both flesh-and-blood women and metaphorical constructions, *The New Woman International* draws on previous scholarship to initiate a new understanding of the profound interrelationship among imagery, technology, and internationalism in the representation of this figure who confronted, challenged, and forever changed norms of gender.

Notes

1. The terms *suffragist* and *suffragette* are sometimes confused with one another and are often seen as interchangeable. Because both terms are used by the authors in our volume and due to their extreme relevance for the development of ideas about the New Woman, we wish to clarify their meaning from the start. The former, *suffragist,* is the older and more general term for one who advocates for an extension of the vote, particularly to women; *Merriam-Webster's Dictionary* dates it to 1822. The second term, *suffragette,* originated in the early twentieth century as a slight to these advocates of women's political enfranchisement. Although it was reclaimed and became a name under which English women in particular worked collectively to achieve woman suffrage, a militant and even violent connotation still inheres in *suffragette* that is not implied by *suffragist.*

2. We applaud the most significant study on this count, which focuses on the 1920s and 1930s and deals to some extent with mass media imagery: The Modern Girl Around the World Research Group (Alys Eve Weinbaum, Lynn M. Thomas, Priti Ramamurthy, Uta G. Poiger, Madeleine Yue Dong, and Tani E. Barlow), eds., *The Modern Girl Around the World: Consumption, Modernity, and Globalization* (Durham: Duke University Press, 2008).

3. See Liz Conor's *The Spectacular Modern Woman: Feminine Visibility in the 1920s* (Bloomington: Indiana University Press, 2004), which is focused on the Australian context but has a wide-ranging theoretical structure that interprets New Womanhood broadly in relation to the visual sphere. Mila Ganeva's *Women in Weimar Fashion: Discourses and Displays in German Culture, 1918–1933* (Rochester: Camden House, 2008) is a highly interdisciplinary study of literature, film, and fashion as sites not only of women's representation but of female agency. See also Elizabeth Miller's discussion of *glamour* in relation to the New Woman criminal in film in *Framed: The New Woman Criminal in British Culture at the Fin-de-Siècle* (Ann Arbor: University of Michigan Press, 2008).

4. Mary Louise Roberts, *Disruptive Acts: The New Woman in Fin-de-Siècle France* (Chicago: University of Chicago Press, 2002), 7.

5. Ute Eskildsen, "Die Kamera als Instrument der Selbstbestimmung," in *Fotografieren hieß teilnehmen: Fotografinnen der Weimarer Republik,* ed. Ute Eskildsen (Dusseldorf: Richter Verlag, 1994), 13–25.

6. Jennifer Bean has pointed out that the recent availability of the video and television series *First Movie Ladies* and *Women Film Pioneers* has spawned a powerful wave of feminist film criticism. Jennifer Bean, "Introduction: Toward a Feminist Historiography of Early Cinema," in *A Feminist Reader in Early Cinema,* ed. Jennifer Bean and Diane Negra (Durham: Duke University Press, 2002), 1.

7. See Ruth Iskin, "The *Flâneuse* in French Fin-de-Siècle Posters: Advertising Images of Modern Women in Paris," in *The Invisible Flâneuse? Gender, Public Space, and Visual Culture in Nineteenth-Century Paris,* ed. Aruna D'Souza and Tom McDonough (Manchester: Manchester University Press, 2006), 113–28; and "Was There a New Woman in Impressionist Painting?" in *Women in Impressionism: From Mythical Feminine to Modern Woman,* ed. Sidsel Maria Søndergaard (Milan: Skira, 2006); as well as Iskin's book, *Modern Women and Parisian Consumer Culture in Impressionist Painting* (Cambridge: Cambridge University Press, 2007). For more on the panorama, diorama, and urban *flâneuse* in relation to early film, see Anne Friedberg, *Window Shopping: Cinema and the Postmodern* (Berkeley: University of California Press, 1993).

8. Iskin, "The *Flâneuse,*" 124.

9. For more on the assumed connections between modernism and masculinity, see Whitney Chadwick and Tirza True Latimer, eds., "Introduction," in *The Modern Woman Revisited: Paris between the Wars* (New Brunswick: Rutgers University Press, 203), xiv.

10. In the context of the French Revolution, Olympe de Gouges wrote this declaration as a small pamphlet. It asserted first and foremost that "woman is born free and remains equal to man in rights." Olympe de Gouges, *The Rights of Women* (1791), trans. Val Stevenson (London: Pythia Press, 1989), 6. For other significant early texts on women's rights and equality, see Adriana Craciun, ed., *Mary Wollstonecraft's* A Vindication of the Rights of Woman: *A Sourcebook* (New York: Routledge, 2002).

11. Judith Wechsler has analyzed images of the *bas bleus* in her "Daumier's Political Women" paper presented at the annual conference of the College Art Association, Los Angeles, February 2009. Martha Patterson has recently pointed out that, although the term *New Woman* was not coined until later, most of what would define her was already under discussion "throughout the nineteenth century and well beyond the transatlantic context." See Martha H. Patterson, "Beyond Empire: The New Woman at Home and Abroad" (review essay), *Journal of Women's History* 21, no. 1 (2009): 180. For one important study of the early craze for photographs, see Elizabeth Anne McCauley, *Industrial Madness: Commercial Photography in Paris, 1848–1871* (New Haven: Yale University Press, 1994).

12. Roberts, *Disruptive Acts,* 21.

13. Grand used this term in lowercase to describe a woman who has "proclaimed

for herself what was wrong with Home-is-the-Woman's-Sphere, and prescribed the remedy." See Sarah Grand, "The New Aspect of the Woman Question," *North American Review* 158 (March 1894): 270–76, reprinted in Carolyn Christiensen Nelson, ed., *A New Woman Reader: Fiction, Articles, and Drama of the 1890s* (Buffalo: Broadview Press, 2000), 142.

14. Writing on late-nineteenth-century France, Roberts usefully distinguishes between the "new woman" as sociological phenomenon and "New Woman" as cultural image. See Roberts, *Disruptive Acts*, 7.

15. Joanne Hershfield has discussed Mexico's New Woman, called among other names *la flapperista,* as enacting "the idea of a modern woman as well as a lifestyle made available to those who could afford to buy the trappings of that life: the clothes, the cosmetics, the middle-class household furnishings. She was neither a wife nor a mother; she was young and active and independent." Joanne Hershfield, *Imagining la Chica Moderna: Women, Nation, and Visual Culture in Mexico, 1917–1936* (Durham: Duke University Press, 2008), 58–59. See also Anne Rubenstein's work on "la pelona," the most often-used term for the New Woman in Mexico: "The War on *Las Pelonas*: Modern Women and Their Enemies, Mexico City, 1924," in *Sex in Revolution: Gender, Politics, and Power in Modern Mexico,* ed. Jocelyn Olcott, Mary Kay Vaughan, and Gabriela Cano (Durham: Duke University Press, 2006), 57–80.

16. Modern Girl Around the World Research Group, 1, 2.

17. Carolyn Christiensen Nelson, ed., "Introduction," in *A New Woman Reader,* ix. An amusing rendering of nearly all of these traits—educated, bicycle rider, smoker, rational dresser, and emancipated—was published as a cartoon in France's paper *Le Grelot* (April 19, 1896) under the heading "Revendications Féminines" (Demands of Women). See Roberts, *Disruptive Acts*, 24.

18. Barbara Sato, *The New Japanese Woman: Modernity, Media, and Women in Interwar Japan* (Durham: Duke University Press, 2003), 48–49.

19. See Mary Louise Roberts, "Sampson and Delilah Revisited: The Politics of Fashion in 1920s France," *American Historical Review* 98, no. 3 (June 1993): 657–83. For primary documents on the negative reaction to feminism, see the first two books in the series Antifeminism in America: A Collection of Readings from the Literature of the Opponents to U.S. Feminism, 1848 to the Present: Angela Howard and Sascha Ranaé Adams Tarrant, eds., *Opposition to the Women's Movement in the United States, 1848–1929* (New York: Routledge, 1997); and Angela Howard and Sascha Ranaé Adams Tarrant, eds., *Redefining the New Woman, 1920–1963* (New York: Garland, 1997).

20. Joan Riviere, "Womanliness as Masquerade" (1929), reprinted in Victor Burgin, James Donald, and Cora Kaplan, eds., *Formations of Fantasy* (London: Routledge, 1986), 35–44.

21. Michel Foucault, *The History of Sexuality*, vol. 1: *An Introduction*, trans. Robert Hurley (New York: Vintage, 1990), 117, 154.

22. Caroll Smith-Rosenberg, *Disorderly Conduct: Visions of Gender in Victorian America* (New York: Alfred A. Knopf, 1985), 245–96.

23. Nelson, "Introduction," x. See examples of similar sentiments from the Weimar era in Patrice Petro, *Joyless Streets: Women and Melodramatic Representation in Weimar Germany* (Princeton: Princeton University Press, 1989), 106–8.

24. Sato, 73–74.

25. Patterson, "Beyond Empire," 180. Also instructive is a 1910 didactic novel by the early feminist writer Charlotte Perkins Gilman entitled *The Crux.* In it, she sought to instruct middle- and upper-class young women on eugenics and citizenship, and she argued for the preservation of the "national stock." See Charlotte Perkins Gilman, *The Crux,* introduction by Dana Seitler (Durham: Duke University Press, 2003).

26. Siegfried Kracauer, "Girls und Krise" (Girls and Crisis), *Frankfurter Zeitung,* May 26, 1931, reprinted in Anton Kaes, Martin Jay, and Edward Dimendberg, eds., *The Weimar Republic Sourcebook* (Berkeley: University of California Press, 1994), 565–66.

The First New Women: Photography, Politics, and the Public Place of Women from the 1870s through the First World War

1

The New Woman in American Stereoviews, 1871–1905

MELODY DAVIS

If we could name a topic over which publishers, artists, and writers of the nineteenth century never seemed to tire, gender may well be it. Across diverse published and visual media, the question of the nature of men and women, as well as the polemics of separate spheres and "woman's rights," occupied the attention of the reading and picture-viewing public. What we call "gender," the typical nineteenth-century person called woman's or man's "nature." Meaning anything biological, *nature* also summed up, in one overfreighted word, human sexual difference. This difference was thus thought to be a biological matter, but, more significantly for society, it carried the consequence of dividing humanity against itself by gendered possessives ("woman's" or "man's"). To be human at that time necessarily carried an inherent opposition, as all qualities were given to one sex or the other. One was as much *not* a representative of the other sex's qualities as one was to embody those characteristics proper to one's own side of the biological divide. This division manifested itself in one of its most dramatic forms through a late-nineteenth-century comic character called the New Woman, who reinforced gendered difference by inverting its terms—all for a joke, of course.

"Woman's Rights" topics in comics and stereoviews first appeared in the 1870s with signs that would be adopted under a variety of "New Woman" stereoview titles that emerged in 1895. As the difference between them is scarcely more than titular, I have included "woman's rights" titles under the New Woman concept. Preceding her appearance by two decades was the popular reception of the stereoview in the 1850s, an object that was, like gender, split.[1] The viewer found that such divisions were united in the stereoscope in one binocularly unified field, three-dimensionally solid and photographically detailed. Also known as the stereograph, stereoscopic

photograph, or simply the "view," the stereoview was universally popular, evoking in its constructed homogeneity the divided human with naturalistic volume and obsessive regularity.

In the making of a stereoview, the subject is photographed on two negatives exposed 2.5 inches apart to mimic the distance between the eyes. The two prints from these negatives, when laterally transposed, mounted on cardstock, and viewed through a stereoscope or "free-viewed," replicate with photographic detail the subject in stereoscopic and binocular space. The pair of stereoscopic photographs and stereoscopes' lenses are highly effective at stimulating the natural neurological operations of "stereopsis," or stereoscopic vision.[2] It is not, therefore, illusory depth that we see in the stereoscope but depth that is *perceptually* real according to the brain's processing of retinal information. More accurately stated, stereoscopic photography is a replication of three-dimensional experience. Such replication in photographic detail was one of the most definitive visions of the nineteenth century, and it captivated the Victorians and spurred a vast industry with hundreds of millions of prints in circulation.

Stereoviews seemed to the nineteenth-century viewer magically reconstructive of reality. They offered a unified ocular field of visual adventure, volumetric and particularized, an environment whole and waiting for entry, and this was particularly seductive for a century positivistically focused on distinctions and divisions.[3] Topographical or constructed scene, it scarcely mattered—viewers couldn't say enough about feeling in medias res with the depicted actors or places. Stereoview addicts were readily supplied with scenes from every corner of the globe and site of interest, as well as *tableaux vivants*, or staged narrative scenes, which were the most popular.[4] By the late 1880s, the United States led the world in mass marketing stereoviews, and practically no American home in the late 1890s was without them.[5]

Among the *tableaux vivants*, the New Woman revealed the Victorian opposition between the sexes conjoined by the happy neurologic of stereopsis within one unified, three-dimensional view. I will focus on how from these divided states—two "natures" and two photographs—came an environment that, particularly in the New Woman stereoview, brought to consciousness the artifice of unitary constructions based foremost on division. By so accentuating its divided natures, the New Woman stereoview rendered the fiction of its construction unstable (instability, after all, being the operation of the comedy). By doubling that precariousness in an awareness of the workings of the medium itself, it laid bare the social landscape of the stereoview, founded on concepts of nature, division, and difference.

In order to understand gendered division and difference, let me discuss how stereoviewing occurred, first in the home and second on an individual basis. Since the advent of the Holmes-Bates stereoviewer in 1869, viewing took place as a person picked up a stereograph, glanced at the title printed beneath the photographs, and set them on a sliding rail that held the paired pictures. He or she then placed the head against a hood, which focused the eyes through lenses that crossed the vision and produced a fused, three-dimensional, and singular image from what were indisputably two separate, flat pictures. For the average Victorian this produced a deep sinking into space while looking at volumetric forms in a scene filled with photographic detail and the experience of a hovering "thereness"; these were magic and hypnotic effects. Now, on lowering the viewer, suddenly there was a deconstruction—one little card with two small, flat photographs. The viewer became acutely aware that the volumetric figures in space were nothing but constructions of his or her own brain, something akin to a novel yet photographically credible. No one could deny that the perception of the scene in three dimensions was just that—perceptual—and not a property of the respective, monocular photographs, but how exactly this happened seemed as much shrouded in mystery to the average viewer as the gestation of a child. Public, exterior volume and private, cranial space crossed the bridge of the stereoscope, and in the act of stereoviewing we witness a historically liminal space, a place where the romantic imagination in all its leisurely sensuality meets modern divisions, for example, character types, seriality, and text-image relation.

When it came to those modern divisions, the New Woman was born of them. The nature of the sexes had been pushed to the farthest extreme until the divide came together in comic inversion. Male and female roles were reversed in the New Woman stereoview, but, unlike her tropes in other media, the stereoview revealed that those roles, however spatially conceived and inviting, flattened out after viewing to what they at bottom were—flat. The message could not be ignored: space is a difference we mentally construct. The inverse message also begs attention: difference is a space we construct. The split, divided, and reconstructed stereoview and worldview eventually force on the viewer an awareness of the underpinnings of their logic. The stereograph fused the diametrical oppositions of its age, and otherness became a spatial entity only by means of mental gestation no matter how profoundly its objects seemed real and present.

From such a blurring of the interior and exterior, the stereoview allowed an intense proximity, a reminder of narrative's harbor within the

imagination, and it could, as a book, remain in the control of the hands. The narrative stereoview, sentimental, comic, and erotic, became the analog for Victorian relations, especially the convention of marriage. The triumphs and comic disasters of marriage were overwhelmingly favored in stereoviews, with the New Woman (definitely in the disaster category) permitted to volumetrically appear only to be flattened in one sequence of gestures. Three dimensional, she invited fantasy; two dimensional, she was just another marketing "title" (topical genres were called "titles" by stereo publishers). The gender divide that she so emphatically emphasized in her comedic inversion of the nature of the sexes became, thus, a matter of individual leisure and construction, appearing with less certainty than natural law and more closely related to fiction. Such fiction appeared when the ideology of dividing and reconstructing genders in the institutions of courtship and marriage seemed to reach a late-century crisis, signing with a nervous laugh the malleable artifice of the divide.

The New Woman literary character stood in stark contrast to misogynistic assumptions regarding women's limitations, dependence, and suitable roles, and thus she can be thought of as feminist, or protofeminist, for demanding a different set of circumstances than the constraints under which real women labored and to which these heroines often succumbed.[6] By the century's end, though, the words *New Woman* had mushroomed beyond literary characterizations, cropping up in popular culture as a catchall term for women who defied feminine convention: collegians, bicyclists, sports enthusiasts, professionals, divorcées, and any woman who didn't marry. It was also applied to feminists, who were at the time called "woman's righters" or suffragists. The New Woman was a harbinger of sweeping changes in gender conventions perceivable on the horizon for society but seldom realized in the lives of average women of the time.

Carroll Smith-Rosenberg has used the term *New Woman* to describe real women on the social vanguard such as members of the new, female collegiate and professional class.[7] Although I am indebted to her historical work, I am concerned with the appearance of a character who was usually a caricature in mass media. Actual women with serious intentions in the nineteenth century would have been unlikely to call themselves New Women, as one could find cartoons lampooning the audacity of such unconventional females on a regular basis in popular comic magazines such as the British *Punch* and the American *Puck*. What I am discussing, then, is no real woman nor any group of particular individuals; the New Woman in stereoviews is strictly a comic construction. A laughable curiosity, she

was capable of easing the pain of change by injecting it with levity. Thus, she became another incarnation of the theatricalized or extreme individual and a real boon to marketers on the lookout for modish styles to sell. And sell she did. There are over seventy different American stereoview titles related to or named "Women's Rights" or "The New Woman" from 1871 to 1907.[8] The late-nineteenth-century public was ripe for gender farce and the deflation of the overblown concept of "true womanhood."[9] As the century came to a close, it was in America especially that one found acceptance of topics with outlandish characters, a tendency this country developed with its tradition of the trickster character and the tall tale.

The first New Woman type of stereoview was issued by Littleton, New Hampshire, publisher F. G. Weller.[10] In *Woman's Rights—The Rehearsal,* 1872 (fig. 1.1), the husband is at the washtub, doing his wife's chores, while she, in fine street clothes, is practicing a lecture hall speech in front of the mirror. A second Littleton stereoview called *Woman's Rights,* copyrighted 1875, has the same pair: termagant wife, dressed to leave, issuing orders to the husband busily sewing and tending the baby.[11] He has been reduced to the demeaning chores of the wife, while her "rights" are clearly ironic—his subjugation. In the same decade, the Chicago-based Melander and Brother (formerly Lovejoy and Foster) published a New Woman stereoview—*Who's Running This House,* 1875—in which a top-hatted stranger

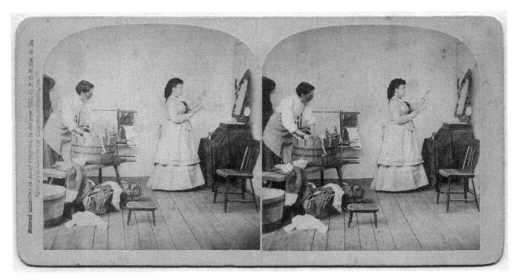

Fig. 1.1. F. G. Weller, *Woman's Rights—The Rehearsal,* 1872. (Collection of the author.)

appears at the homestead where the husband labors at the washtub, the son hangs the wash, and the seated mother, master of the house, is accompanied by her idle daughter, broom lying across her lap. The antifeminist message in these stereoviews is that the reversal of gender roles will unsex the man and give governance to the women, who will have no better sense than to make speeches or remain idle.

Since the end of the Civil War in 1865, women's study groups had been steadily appearing alongside organizations convening for "woman's rights" or socially progressive goals.[12] Charismatic personalities such as Elizabeth Cady Stanton, Victoria Woodhull, and Annie Besant earned their living on the professional speakers' circuit, drawing standing-room-only crowds. Stanton and Susan B. Anthony led the National Women's Suffrage Association, which was active in a prolific series of state campaigns for the enfranchisement of women, while "Notorious Victoria" Woodhull scandalized the public with speeches on free love, prostitution, marriage law, and workers' rights, also addressed in editorials in her newspaper, *Woodhull and Clafin's Weekly*.[13]

Temperance societies, too, behaved in an "unwomanly" fashion, filling lecture halls, advocating suffrage, and sometimes smashing saloons and disposing of liquor.[14] Such is the social context for the Weller and Melander stereoviews with wives who abandon their maternal duties for "masculine" politics or just plain laziness, as the censuring scenes imply.

The woman's rights and New Woman stereoviews were not necessarily responding directly to suffrage issues.[15] Rather, it is the much larger issue of power to which these stereoviews respond. Besides engaging in politics and activism, women sought education and work outside the home, as witnessed by steep rises in the number of women college students, graduates, and professions in the 1870s.[16] Benjamin Kilburn in 1871 photographed a cat as a "member of the sorosis," an organization of professional women journalists.[17] The bonneted, bespectacled cat with paws resting on an open book invites us to consider professional women as more "catty" than capable.

The "true woman," in contrast to the Sorosis member, appeared in countless early and midcentury texts, if perhaps less frequently among *real* women. She endeavored to limit her influence over men and public affairs to gentle suggestion and moral guidance. A literary invention mainly of the periodical press and the woman's novel, the idea of the true woman was a reaction to the impending sense of social breakdown between the male (public) and female (private) worlds. The hyperbole of the prose dedicated to her, however, created an emotive intensity equally threatening to those

vested in women's passivity. This prose, perhaps even containing a nascent feminism, derived power from the allegorical associations its proponents accrued to the home both as a site and as an ideological locus. While many have discussed the home as the place of women in the ideology of true womanhood, particularly with respect to its confinement, a new group of scholars argue that the rhetorical freight found liberally in the texts of its women proponents performed a different function than mere restriction. These scholars persuasively argue that such women writers looked to the separation of the domicile as a means of fostering solidarity and purpose and that they attempted to strengthen their readers' self-confidence and influence. By employing the home as a value and a protection, they astutely located the place not only where women found themselves but where power could be exercised and even increased without much social scrutiny. Some have termed this "domestic feminism," others "social sentimentalism." Whichever term is used, the concept of separate spheres, central to the role-playing of true womanhood, is best thusly understood.[18] Most important to the analysis of New Woman imagery is that separate sphere ideology fostered a heated prose with an intimidating influence through the aggrandizement of concepts of femininity.

It was in part in response to this fear that the New Woman stereoview arose. In the ideology of separate spheres, male and female realms were bifurcated into two halves, with the rule over each remaining proper to its gender: business, government, the military, and the public to men; and all home-associated persons and things, including the development of moral, religious, and affective values, to women. The question of the degree of the social reality of the separate spheres versus that of its fantasy in contemporaneous prose matters less than the positioning and extremity of the language surrounding it. Among the sentimental separatists (as I call them), none was so vociferous as the writers of what has been called "woman's literature," Catherine Beecher, Augusta Evans, Susan Warner, Sarah Hale of *Godey's Lady's Magazine,* and Harriet Beecher Stowe, among others.[19] These writers advocated the separate sphere precisely to validate women through a tactic of raising the sentimental and allegorical valuation of women's placement in the home and work there (a strategy similarly employed by 1970s feminist artists such as Mierle Laderman Ukeles). To the separatists, women were *superior* to men because their realm was the domicile and family and not the commercial and political world. Feminine modesty notwithstanding, the prose of these women encouraged anything but passivity or retiring attitudes. In their widely read literature, the nineteenth-

century woman at home held a largesse of power and an almost divinely moral status because she remained unsullied by traffic and commerce.

Domestic feminists such as Hale, Stowe, and Beecher strategically used pulpit-style emotionalism in a bid for covert power that was deployed through the populist, periodical press and its genres, topics considered at the time normative to feminine gender roles (housekeeping or home study). It has been a pitfall of some to judge these separatists as insufficient feminists or antifeminists. After all, women should stay at home, they repeatedly asserted. Yet, when one decloaks the purple prose, it becomes clear that for these women writers the home functions as an "operations central" for expansive influence and intensified status, an empire of mothers, as one writer has put it.[20] A Thomas Nast cartoon of 1869 even depicted the mother as an empress.[21] A foundation of sentiment antithetical to (but dependent on) capitalism, women's domestic power posed a threat of too great a feminine influence on the public realm. Club women were speaking, organizing, founding museums, and becoming public in the name of separate-sphere virtues extended to society.[22] Some temperance women and feminists became violent in the name of equality, home, and family, while women working for social progress employed a similarly unassailable rhetoric of sentiment-home-motherhood.[23] The sainted homemaker might ultimately control more than private quarters; the home radiated her influence, challenging the precepts of the public world of capital and masculine identity and its "natural" gender divisions.[24] Women's sentimental authority and home domination began to be interpreted as outright power, and those who generated cultural images freely indulged in imagery that expressed what we in the twenty-first century tend to call "castration anxiety."

An icon made to this order in the 1890s was the stereoview topic of the New Woman—pants wearing, bicycle riding, neglecting the laundry. The washtub became an especially revealing symbol, evolving away from the province of the lower classes that we see in French stereoviews and the art of Edgar Degas to become in America the very threshold of power. Water was the element of subordination, and the person wetted up to the sleeves, a trope that had previously signified the difference of the laboring class, now marked the difference of gender. In the fear over the flip-flop of the sexes and the contamination of mixing public and private, water became—on a man—the dirtiest trick of all. Piled-high sinks could also suffice in this signification.[25] Class, sex, and sexual exposure were conflated here, and the wash or dish tub was no more the place of laundering but a womblike basin for unmanning men.

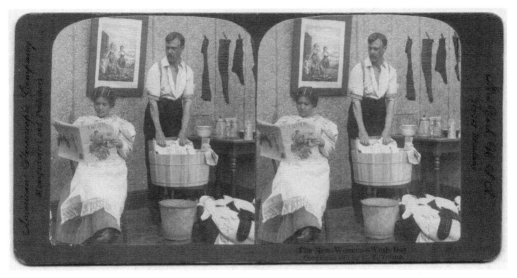

Fig. 1.2. R. Y. Young/American Stereoscopic Co., *Woman's Rights*, 1901. (Collection of the author.)

R. Y Young's *Woman's Rights* (American Stereoscopic Co., 1901) presents a leisurely lady reading a magazine called "TRUTH" while her laboring husband reads over her shoulder (fig. 1.2). The two bathing beauties on the wall picture with cruel irony a different order of wetness—sans clothes and sans laundry. Likewise, Benjamin Kilburn's stereoview of a laundering husband and comfortable, newspaper-reading wife has the protagonist whine with embarrassment: *And Me Old Chum's at the Door* (Kilburn Brothers, 1892). Another New Woman barks, *Don't Get the Clothes too Blue!* shaking her finger at her soaked and disgruntled man (Kilburn Brothers/James M. Davis, 1897), while the 1905 title *The Twentieth Century Washerwoman*, by C.H. Graves, makes clear who is the woman now, as the wife departs for the public sphere, leaving her damp husband behind.

In case male resistance is encountered, an 1897 Benjamin Kilburn/ James M. Davis sequential stereoview pair reveals the consequence. A foot-propped, reading New Woman in the first stereoview responds to her washerman's pleas in the second view of the series, *Don't Tell Me You Won't Wash!* (fig. 1.3), a beautifully stereoscopic scene of battery. Clothes on the floor and sheets spilling from the wringer add depth cues, and the straining muscles on the husband's neck and arm pop out, accentuated by shadow. An embroidered wall decoration, a frequent technique for introducing text

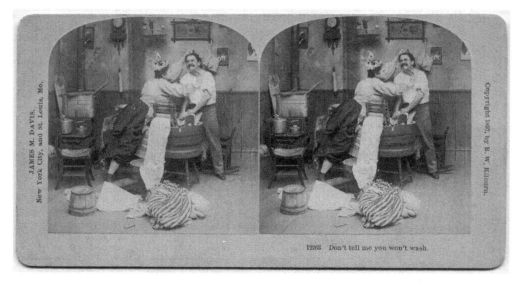

Fig. 1.3. Benjamin Kilburn/James M. Davis, *Don't Tell Me You Won't Wash!* 1897. (Collection of the author.)

in stereoviews, sarcastically reads, "What is Home without Mother," while the caged bird and hanging rolling pin remind us of sequestered home life and more traditional female weapons. The husband, here, is pinned, caged, battered, and feminized. His grimace, clenched fists, and tight muscles make the stereoview a (painful) success. Another pair by C. H. Graves/Universal Photo Art Company in 1900 also shows a husband's mutiny. *Maria, I Won't Wash Another Dud!* is the narrative title of a stereoview featuring a man who shakes his fist at his foot-propped wife, who is reading the comic magazine *Puck*. In the second title, *Don't Tell Me You Won't Wash!* Maria spanks him for his insubordination.

That there were feminist ideas twisted into perverse interpretations in these parodies is revealed in a six-view, cinema-inspired series by Strohmeyer and Wyman/Underwood and Underwood from 1900. The titles are the monologue of an irate bluestocking type—severely dressed, badly coiffed, bespectacled—in whom New Woman ideas have taken hold. The six sequential views show the New Woman accosting her husband, with the titles (1) *Yes, Mr. Caught-a-Tartar! The time is coming when* (2) *Woman will no longer be the mere slave.* She threatens him with (3) *Of brute Man, Sir!* (fig. 1.4), then proceeds to step on and beat him in (4) *No longer the poor, down-trodden:* (5) *Oppressed.* and (6) *Weak and helpless being she*

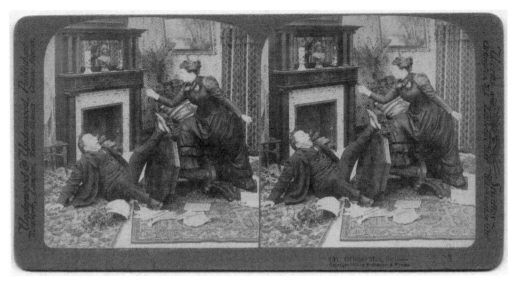

Fig. 1.4. Strohmeyer and Wyman/Underwood and Underwood, *Of brute Man, Sir!* 1900. (Collection of the author.)

is now is! In the last view, she hides her face in her hand and dissolves into tears. The New Woman, here, has turned the tables, made her ideas absurd, and exhausted herself in oppressing her oppressor, although he appears to be more bewildered than harmed. Even within its lampoon of feminism's argument, this view series manages to signal an ideological basis for bad behavior.

The New Woman idea was the first popular stereoview type in which feminist history appears, even if in reactionary form. Women's independent actions helped to shape her, and, although she was yet another female fiction born of "hysteria," she comes with a hardy breath in the lung, which of course she needed to ride her bike. Besides reforming clothing by dooming the corset and giving license to women to wear pants, the bicycle in the mid-1890s induced women to exercise and gave them personal freedom. The bicycle became a chief means for women to get to work and to pay calls, and the comic press found a subject to occupy the pens of its artists for years, with entire almanacs devoted to "wheelers" and "scorchers" (fast riders).[26] Stereoview publishers, however, tended to use the bicycle as one more satirical weapon with which to throw the New Woman "off balance."

One popular title repeated by several publishers is *Sew on Your Own*

Buttons, I'm Going for a Ride, as seen in a 1901 version by George W. Griffith (Griffith and Griffith). The bloomered wife in shirtwaist and tie authoritatively thrusts a shirt back to her husband, who is holding a broom and sitting defeatedly in his apron. She *will* ride—hang the buttons! The New Woman refusing to sew anymore in favor of the newfound freedom represented by her bicycle was delivering the message that feminists had been trying to impart—though to a far greater purpose—that men could no longer automatically expect women to be subservient to their needs.

Not only the bicycle but pants were the trouble here. An article of clothing exclusively reserved by general opinion for the male, pants were allied with power, sexuality, and privilege, while women who wore them were "castrating," out of control, licentious, silly, or any combination thereof. This prejudice had stood for several centuries, dating at least to the Reformation and a genre of woodcut prints known as "the battle of the breeches."[27] Through the nineteenth century, pants remained associated with the phallus and patriarchal privilege in spite of brief flirtations with bloomer outfits and "rational dress."[28] By 1895, however, these divisions were rapidly dissolving. It would be a tidy matter to give someone the credit for the liberation of legs. More than any one person, however, it was a machine—the bicycle—that steered pants into the realm of acceptability for women's dress, as bloomers greatly facilitated pedaling. It proved difficult, however, to overcome centuries of aversion to women in pants so that any object, such as a bicycle seat or a saddle, became subject to social suspicion if it separated a woman's legs. Inflamed by the thought of women's potential masturbation on bicycle seats, medical tracts of the 1890s attempted to dissuade the public from this sexual deviancy, especially censuring the "scorching," or bent over the handle bars, position.[29] Happily, these earnest doctors were not at all successful in discouraging women from riding fast, nor bloomers from separating the legs. As they became more common, pants, whether worn or scorned, continued to signify physical freedom and self-direction, including the sexual, and it was commonly believed that women who wore them were in some manner trying to usurp the privilege of men.

In stereoviews there were wonderfully clownish bloomers—striped, flowered, plaid, and huge—on women in the classic "leg up" position. The New Woman props one leg on a chair, bicycle, or piece of furniture, her bloomered crotch spread in an unabashedly lewd manner. In Underwood and Underwood's *New Woman—Wash Day*, 1901 (fig. 1.5), the trousered wife props a leg over the back of a chair in a sportsmanlike posture, which

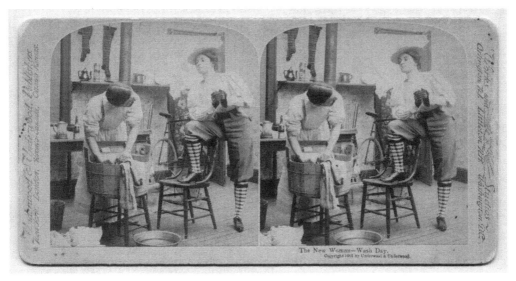

Fig. 1.5. Underwood and Underwood, *New Woman—Wash Day,* 1901. (Collection of the author.)

would have been considered positively vulgar. The trousers, boater hat, gloves, and men's style shoes suggest the immorality associated with cross-dressing, while the widely split legs and theatrical, plaid stockings would have signed the indecent by calling on stereoviews' common function of giving titillation with just a glimpse of a booted ankle. By contrast, the laboring husband is in the "castrated" position of wearing an apron and getting soaked. The husband bends to the washboard, a position that suggests penetration, while the wife stands erect, towering over him with a jaunty, arrogant expression. The rail that forms the back of the chair is positioned phallically between her legs, and the cigarette jutting from her lips carries its own symbolism of sexual license, which the bicycle in the doorway shares with the common sexual associative thread of "fast."

Dominating, bike-crazed wives—these images were meant to insult, but they soon lost their sting and settled into a wry domesticity. With baggy bloomers in bulging plaids, dangling cigarettes, and henpecked husbands, this new termagant and her crossed daughters must have provided quite a diversion for women buried in diapers and laundry, as well as sexual allure for men, with women in leg-up positions, displaying their well-turned calves. The New Woman was unnaturally bigendered, of "indeterminate sex."[30] In one variant with views entitled *New Woman Barber, The Fair,*

Young Barber, or *Hubby's Sunday Morning Shave,* women's desires were simultaneously threatening and alluring. These stereoviews received suggestion from British cartoons, which first appeared in the 1870s, depicting bloomer-clad feminists bearded or getting a shave.[31] The woman asserting her rights was not only copying men, these cartoons implied, but she would become a man, beard and all.

We see these tropes combined in the New Woman barber stereoview titles. William H. Rau/Griffith and Griffith's *New Woman Barber* stereoview of 1897 (fig. 1.6) presents a sexual object with her exposed petticoat and gartered knee indecently revealing. The razor blade in her hand is altogether a different matter, though, as it looms like a lethal bird in the foreground and flies out at the viewer in the stereoscope. Smiling, she leans over her husband, who protects his neck and grimaces. Notice how the rear mirror provides depth cues and visually advances the couple into the viewer's space. A version by Sterro-Photo, *The New Woman Barber,* 1898, repeats the same code, but the actor sadomasochistically offers up his stretched-backward neck. In spite of their comic vein, traditional femme fatale associations—Judith, Salome, and Delilah—enter these stereoviews.[32] The New Woman barber has taken the germ of a feminist idea and grafted it onto the old codes of the femme fatale via the newer tropes of bearded ladies and the "demon barber of Fleet Street."[33] Genders flip-flop dizzily with masculine, seductive women coded as erotic, amusing, and dangerous.

A great deal of social distance has been traveled from the "true woman" and the cult of the home to the New Woman and sex appeal. The New Woman mother, the true woman's evil twin, sped away from vaunted domesticity as fast as she could on her bicycle, leaving her husband upended in her wake. Pants wearing and leg flashing, the New Woman also became the matron of commodified sex appeal and thus helped to usher in the hypersexualized twentieth century. Of indeterminate gender, male and female, sexy and demonic, she was emblematic of the anxiety over women's new roles and renegotiated public and private spheres, and she played double with codes. For the misogynist, she was more confirmation that women were trying to become men and badly botching the business of the sexes, while for others she may have represented audacity, a fantasy of defiance, revenge on men, plural identification, or sadomasochistic desires.

A fictional character spun to release male frustration, the New Woman stereoview was certainly never intended to express support for feminism but stumbled and crashed in that direction by default. Consider that women

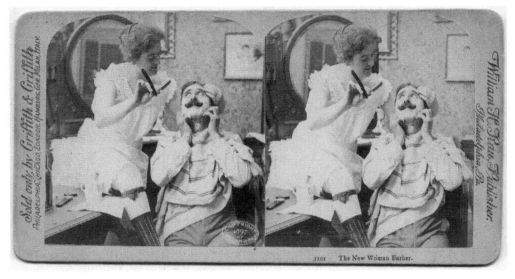

Fig. 1.6. William H. Rau/Griffith and Griffith, *New Woman Barber*, 1897. (Collection of the author.)

were "demeaned" by being in a domineering position, which means that the satire designed to keep them subordinate contradicted itself, for these were stereoviews that pictured women as victors, men as the vanquished. The implied dig was that husbands ought to reeducate their wives, but that, of course, suggests that gender is a process of education not nature. The New Woman stereoviews make clear the anxiety that no one could much rely on "nature" anymore to do its job with respect to the sexes. The viewer was continually reminded every time he or she lowered the stereoscope of the artifice it took to split the world into two parts only to reassemble it again into a lifelike environmental replication. So, too, the New Woman stereoview brought home the awareness that gender was a divide continually replicated in its simulations, and, through the stereoscope, viewers were reminded of this private, subjective, constructed nature, for the lenses of gender were crossed, and the artificial divides blended and converged, as do the eyes in a stereoscope, making this business of so many fine distinctions one amusing trip.

Notes

1. The popularization of the stereoview occurred at the 1851 Crystal Palace Exhibition in Hyde Park, London.

2. Theodore Brown, *Stereoscopic Phenomena of Light and Sight* (London: Gutenberg Press, 1903; facsimile ed., Culver City, CA: Reel 3-D Enterprises, 1994), 8; N. A. Valyus, *Stereoscopy* (London and New York: Focal Press, 1966), 51.

3. Mary Panzer, "Romantic Origins of American Realism: Photography, Arts, and Letters in Philadelphia, 1850–1875," PhD diss., Boston University, 1990.

4. George Hamilton, *Oliver Wendell Holmes: His Pioneer Stereoscope and the Later Industry* (New York, San Francisco, and Montreal: Newcomen Society in North America, 1949).

5. William C. Darrah, *The World of Stereographs* (Gettysburg, PA: William C. Darrah, 1977; reprint, Nashville: Land Yacht Press, 1997), 45. Linda McShane, *When I Wanted the Sun to Shine: Kilburn and Other Littleton, New Hampshire, Stereographers* (Littleton, NH: Sherwin Dodge, 1993), 52.

6. A. R. Cunningham, "The 'New Woman' Fiction of the 1890s," *Victorian Studies* 17, no. 2 (December 1973): 177–86; Linda Dowling, "The Decadent and the New Woman in the 1890s," *Nineteenth Century Fiction* 33 (1979): 434–52; Nina Baym, *Woman's Fiction: A Guide to Novels by and about Women in America, 1820–1870* (Urbana and Chicago: University of Illinois Press, [1978] 1993).

7. Caroll Smith-Rosenberg, "The New Woman as Androgyne: Social Disorder and Gender Crisis," in *Disorderly Conduct: Visions of Gender in America* (New York and Oxford: Oxford University Press, 1985), 245–96.

8. Melody D. Davis, "Doubling the Vision: Women in Narrative Stereography, the United States, 1870–1910," PhD diss., City University of New York, 2004, 89–90, appendix.

9. Barbara Welter, "The Cult of True Womanhood," *American Quarterly* 18, no. 2, pt. 1 (summer 1969): 151–74.

10. To view the images in 3-D from books, a stereo-lorgnette is helpful. See 3D stereo.com, Inc., www.3dstereo.com.

11. The dates, printed on the card mounts, refer to the copyright date, not the time the photographs were made, likely all at the same sitting.

12. Gale Collins, *American's Women: Four Hundred Years of Dolls, Drudges, Helpmates, and Heroines* (New York: William Morrow), 247–48.

13. William L. O'Neill, *Everyone Was Brave: A History of Feminism in America* (Chicago: Quadrangle Books, 1969), 74–76; Catherine Clinton, *The Other Civil War: American Women in the Nineteenth Century* (New York: Hill and Wang, 1984), 199; Miriam Schneir, "Introduction," in *Feminism: The Essential Historical Writings*, ed. Miriam Schneir (New York: Random House, 1972), 133. Also see O'Neill, 131; and Mary Gabriel, *Notorious Victoria: The Life of Victoria Woodhull, Uncensored* (Chapel Hill, NC: Algonquin Books, 1998), 219.

14. Clinton, 58–59.

15. O'Neill, 147.

16. "Senate Report: Women and Child Wage Earners in the United States, 1908–1911," reprinted in Miriam Schneir, ed., *Feminism: The Essential Historical Writings* (New York: Random House, 1972), 257.

17. Karen J. Blair, "Sorosis and the New England Woman's Club," in *The Clubwoman as Feminist: True Womanhood Redefined, 1868–1914* (New York: Holmes and Meier, 1980), 15–38.

18. Daniel Scott Smith, "Family Limitation, Sexual Control, and Domestic Feminism in Victorian America," in *Clio's Consciousness Raised: New Perspectives on the History of Women*, ed. Mary S. Hartman and Lois Banner (New York: Harper Colophon Books, 1974), 119–36; Carroll Smith-Rosenberg, "The Female World of Love and Ritual: Relations between Women in Nineteenth Century America," *Signs* 1 (autumn 1975): 1–29; Linda K. Kerber, "Separate Spheres, Female Worlds, Woman's Place: The Rhetoric of Women's History," *Journal of American History* 75, no. 1 (June 1988): 9–39; Jane Tompkins, *Sensational Designs: The Cultural Work of American Fiction, 1790–1860* (New York and Oxford: Oxford University Press, 1985), 124, 163; Gillian Brown, *Domestic Individualism: Imaging Self in Nineteenth Century America* (Berkeley: University of California Press, 1990), 59.

19. Hale was the editor in chief and the editorial writer for *Godey's Lady's Magazine,* the most popular American periodical of the nineteenth century. Augusta Evans, *St. Elmo* (1867; reprint, New York: Grosset and Dunlap, 1960); Susan Warner, *Wide, Wide World* (1851; reprint, New York: Feminist Press of the City University of New York, 1987); Catherine Beecher, *A Treatise on Domestic Economy* (1841; reprint, New York: Schocken Books, 1977); Christopher Crowfield, Harriet Beecher Stowe, *House and Home Papers* (Boston: Ticknor and Fields, 1865; reprint, University Press, Cambridge: Welch, Bigelow and Co., n.d.).

20. Mary Ryan, *The Empire of the Mother: American Writing about Domesticity, 1830–1860* (New York: Haworth Press, 1982).

21. Thomas Nast, "Woman's Kingdom Is at Home," *Harper's Weekly,* October 2, 1869, 640.

22. Blair, 15–38.

23. Aggressive revolt is a theme of Lisa Tickner's study, *The Spectacle of Women: Imagery of the Suffrage Campaign, 1907–1914* (Chicago: University of Chicago Press, 1988).

24. Amy Kaplan, "Manifest Domesticity," *American Literature* 70, no. 3 (September 1998): 581–606.

25. C. H. Graves/Universal Photo Art Co., *Mr. and Mrs. Henpeck Wash the Dishes,* 1908.

26. Robert A. Smith, *The Social History of the Bicycle: Its Early Life and Times in America* (New York: American Heritage Press, 1972), 35. See *Puck's Library,* 95 (May 1895), *Wheelers;* no. 106, *Scorchers* (May 1896); no. 122, *Punctures* (September 1897); and no. 130, *Pedal Pushers* (May 1898).

27. Christina Grössinger, *Picturing Women in Late Medieval and Renaissance Art* (Manchester: University of Manchester Press, 1997), 117.

28. Lois W. Banner, *American Beauty* (New York: Alfred A. Knopf, 1983), 86–87; John Woodforde, *The Story of the Bicycle* (New York: Universe Books, 1971), 132–33.

29. Ellen Gruber Garvey, *The Adman in the Parlor: Magazines and the Gendering of Consumer Culture, 1880s–1910s* (New York and Oxford: Oxford University Press, 1996), 105–34.

30. Smith-Rosenberg, 265.

31. Frank Bellew Sr., "Woman Asserts Her Rights," *Punchinello,* September 10, 1870, 380; C. J. Taylor, "Natural Advantages," *Puck's Library* 124 (November 1897).

32. John R. Reed, "Destructive Women," in *Victorian Convention* (Athens: Ohio University Press, 1975), 44–58.

33. Sweeney Todd, a character from an 1846 "penny dreadful," has reappeared in numerous stage plays and other media. See Robert L. Mack, *Sweeney Todd, the Demon Barber of Fleet Street* (Oxford: Oxford University Press, 2007).

2

The New Woman Exposed: Redefining Women in Modern Japanese Photography

JAN BARDSLEY

It was a photograph that got the New Woman fired. She had just started teaching at a girls' school in Northeast Japan in spring 1913 when someone spied a picture of the New Women's group known as the Bluestockings (Seitō-sha) and thought they recognized her in the shot (fig. 2.1). No matter that the accuser was wrong and she was not in the photo at all. Her principal saw no choice but to send the New Woman packing. But shouldn't she have expected something like this sooner or later? After all, she had joined the Bluestockings the summer before, even publishing a piece about a love affair in its literary journal.[1] What's more, hadn't Tsuda Umeko herself, president of the prestigious women's academy she had been attending, pushed her into this rural post as punishment for her association with the Bluestockings? Although the photograph was temporarily this New Woman's undoing, it did lead Kamichika Ichiko (1888–1981) back to the capital where she began pursuing what became a long career in writing and political engagement (fig. 2.2).[2]

Kamichika's scandal puzzled her contemporaries, but it prompts even more interesting questions now, ones that give us a new take on the photo that offended the principal as well as other, much reproduced images of the Bluestockings. Who were these notorious Bluestockings, how did they come to represent the New Woman (*atarashii onna*) of Japan in the 1910s, and, most important for this volume, what role did photography play in documenting their lives and inspiring fascination with them? This essay explores these issues by analyzing how the Bluestockings' notoriety intersected with other photographic representations of famous women in early-twentieth-century Japan. Clearly, photography functioned to frame the New Woman as a foreign import to Japan. Moreover, the Bluestockings' decision to self-publish photographs of themselves—including the one

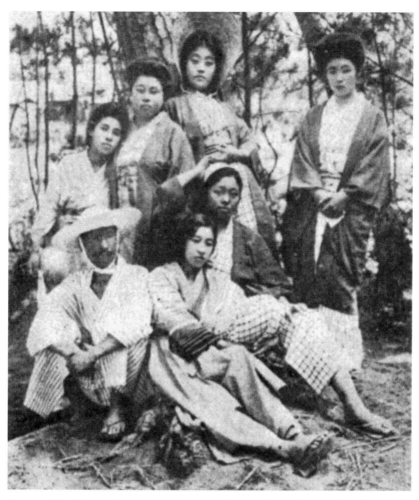

Fig. 2.1. "The Bluestockings' 1912 Vacation." Photographer unknown. This photograph of Bluestockings vacationing at the beach ran in the first anniversary issue of the New Woman journal *Seitō* 2, no. 9 (September 1912). *Seated, from left,* are Ikuta Chōkō, Hiratsuka Raichō, and Otake Kōkichi. *In the row behind, from left,* are Araki Ikuko, Yasumochi Yasuko, Kimura Masako, and Ikuta Chōkō's wife. (Courtesy of Fuji Shuppan.)

that got Kamichika fired—represented an important step in their efforts to direct how and by whom the New Women should be defined. Reading against the broader visual landscape of the day, however, one sees the Bluestockings' images as emerging in the increasingly blurred boundary dividing respectable—and ostensibly *private*—women (wives and daugh-

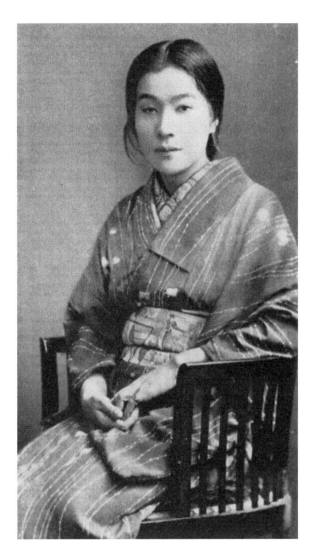

Fig. 2.2. "Kamichika Ichiko in Her Twenties." Photographer unknown. (Courtesy of Tokyo University Graduate School of Legal and Political Science Studies Archives.)

ters of privileged men) and women much less respected because of the sexualized and *public* nature of their work (geisha and prostitutes). It is the Bluestockings' emergence as New Women in this divide, I argue, that puts photography at the center of controversy; the Bluestockings' efforts to carve out more and freer space in the public sphere for women led to a reinvigoration of the borders of propriety, defending the lady.

To set the stage for this discussion, let us consider the culture of photography as the Bluestockings experienced it, reflecting on the changes taking place in representations of women during their girlhood, and then review

the group's history.[3] First of all, we observe that photography was an ordinary part of middle-class Japanese girls' lives by the early 1910s. Most of the Bluestockings, like other women of their class, grew up attending modern girls' schools, where having pictures taken at school sports events, at outings with their classmates, and in formal studio portraits with friends on graduation were routine events. They could even make their portraits public by sending them to magazines such as the new *Girls' Companion* (*Shōjo no tomo*), which regularly printed readers' photographs. When the time came for their families to arrange a marriage, these young women could also expect to sit for a studio portrait designed to appeal to prospective in-laws and husbands. As well, the Bluestockings would have seen ladies' magazines with nationalist overtones such as *Women's Pictorial* (*Fujin gahō*), first published in 1905, which displayed the portraits of royal and noble women, members of the Patriotic Women's Association, and group photographs of nurses' and teachers' associations as models of Japanese womanhood. In sum, the Bluestockings' world was replete with photographs: amateur photography, formal portraits, magazines, public photo exhibitions, family photos, and newspaper images of leaders and criminals alike.

Images of beauties (*bijin*) had a long history in Japan by this time, too, and albums of the loveliest geisha were marketed at home to Japanese and abroad to foreign consumers.[4] When buying picture postcards and sending them to men at the front became all the rage during the Russo-Japanese War (1904–5), geisha beauty starred once again. Yet geisha were aware of the allure newly associated with girl students such as the future Bluestockings, and some even replaced lavish kimono with the student's outfit.[5] Such blurring of the lines between geisha and young ladies provoked anxiety, as an incident related to one of Japan's first beauty contests exemplifies. In 1908, when P. T. Barnum tried to organize an international beauty contest of photographs through the *Chicago Tribune,* the newspaper *Jiji shinpō* agreed to deliver the Japanese winner through a nationwide campaign. Although the international contest dissolved before a winner could be selected, the Japanese chose sixteen-year-old Suehiro Hiroko, a "good girl from a fine family" and a student at Gakushūin, a prominent Tokyo school attended by royals. Unbeknownst to Suehiro, her brother-in-law had submitted her photo to the contest. Gakushūin's principal, the renowned General Nogi, expelled her from the school immediately, although he arranged a marriage for her later to ameliorate the damage.[6] Nogi took such drastic action because, like the principal at Kamichika's school, he knew that any hint of improper behavior on the part of a female student or teacher would

only fuel public suspicion that education corrupted girls. Despite Suehiro's problems, the *Jiji shinpō* published an album of 215 entries the next year with the caveat, "These are nice girls from good families so look on their pictures with respect."[7]

But the borders of respectability continued to blur. In 1909, University Face Powder (Daigaku oshiroi) combined images of twenty-five women—society women and geisha—in a full-page newspaper ad to show that its cosmetics appealed to all kinds of beauties. At about the same time, *Women's Pictorial* included photographs of actresses and geisha and ran ads featuring geisha models.[8] Thus, when the Bluestockings' New Woman photographs appeared in public, they functioned to obscure the borders of respectability even further. They topped the risqué attraction of the schoolgirl by offering a new representation of the Japanese woman, an intellectual, adult woman who was also a desiring one and had no qualms about publishing her photo for all to see.

The Bluestockings: New Women in Word and Image

The original members of the Bluestockings were five young Tokyo women, all graduates of the recently established Japan Women's College, who came together in 1911 to produce a literary journal that would be written, edited, and managed by women. The idea for the project originated with a literary man, Ikuta Chōkō, who believed that the group should nurture women of exceptional literary talent. Knowing that an all-women's intellectual effort would incite derision, Ikuta advised taking the name Bluestockings for the group and the journal (in Japanese, *Seitō*). By alluding to the famed eighteenth-century English women's salon, the young Japanese could have the first laugh and also claim common ground with those abroad who had also faced criticism for their public roles as thinking women.[9]

With fathers highly placed in academic and government circles, the Bluestockings enjoyed positions of privilege. They could expect to enter arranged marriages to promising men, bear and raise children, run homes and supervise servants, and participate in ladies' charitable and patriotic societies. In short, they could become "good wives, wise mothers" (*ryōsai kenbo*), fulfilling the modern role of the thrifty, loyal, and self-sacrificing manager of the home much promoted to women of their class. Expressed in visual terms, their lives would be documented by family portraits taken periodically at a local photography studio or in commemorative photos of their ladies' group. Elite institutions such as the Japan Women's College

and Tsuda Women's English Academy saw their mission as educating girls for these roles.

Visions of such a life would have filled most Japanese with envy, appearing luxurious compared to their own physically demanding labor on farms and in factories. But the Bluestockings had ambitions beyond domesticity. They showed more interest in gaining an education for their own ends rather than to further societal goals. Moreover, they wanted to participate in the creative trends of their day, activities that their male counterparts were making famous such as writing "personal fiction" (*watakushi shōsetsu*), translating Western works, and founding literary journals. Like these men, the Bluestockings sought to discover through artistic pursuit an authentic self that would transcend the rigid class- and gender-defined roles expected of them. The Bluestockings also hoped to achieve some measure of financial independence and, most likely, some recognition for their work. With these lofty goals in mind, the encouragement of Ikuta, and money donated by one member's mother, the Bluestockings got their project under way. They sought submissions from well-known women writers and unknowns alike, assembling an eclectic mix of poetry, short stories, literary essays, and translations and publishing a manifesto that called for women to recover the fire of their "hidden sun." The first issue of *Seitō* debuted in one thousand copies on September 1, 1911.

By the following month, the inaugural issue had sold out. Letters poured into the Bluestockings' office, requesting everything from subscriptions to personal advice. Expanding their membership beyond Tokyo and aided by new local members, the core Bluestockings took on the task of publishing a monthly journal. Editors' notes in every issue acquainted readers with plans for *Seitō*, news of the group's parties, the latest books they were reading, and what was happening in their personal lives. Newspaper reporters, eager for gossip, followed the Bluestockings closely. Government censors also kept an eye on them and gave them a warning in April 1912 when they published "The Letter" (Tegami), a story that depicted a wife arranging a clandestine rendezvous with her young male lover.[10]

Such attention prompted many to refer to the Bluestockings as New Women, the term used to describe the heroines of Henrik Ibsen's plays, which were stirring excitement in Japan at the time. The Bluestockings, however, had not yet adopted the label. They did produce a collection of critical essays on *A Doll's House* in the January 1912 issue of *Seitō*, including photographs of Japanese and foreign actresses in the role of Nora. Although the Bluestockings did not uniformly approve of Nora's impulsive

decision to leave her family, people soon began joking about the Bluestockings as a "training school for Japanese Noras." Perhaps the visibility of the Nora photographs in *Seitō,* coupled with the way the journal blended Japanese and Anglo actresses, sealed this association, especially for those who did not bother to read the essays.

As the first year of *Seitō*'s publication progressed, the Bluestockings became controversial. Two summer scandals—"The Five-Colored Liquor Incident" and "The Bluestockings' Visit to the Yoshiwara" pleasure quarters—bear recounting here. Much publicized, these 1912 incidents caused upheaval within the group, ultimately pushing the Bluestockings to adopt and define the title New Women. Although the Bluestockings' dubious fame caused some original members to leave the group this year, it inspired others to join. Kamichika Ichiko, for one, signed on that July. In hindsight, we can see that the controversial incidents of 1912 also alerted the public that long stable categories distinguishing types of women—foreign from domestic, ladies from geisha—and women from men were being threatened by these upstart Bluestockings.

Much of the summer controversy started when the June 1912 issue of *Seitō* included an anecdote implying that Hiratsuka Raichō, one of its best-known editors, had privately entertained a "beautiful young man" in her rooms at night. At the time of the visit, the young man was pleasantly inebriated, having come from a popular café where he had imbibed a Western-style cocktail mixed with five different kinds of alcohol. Unbeknownst to the public, the object of Hiratsuka's affection at the time and the writer of this anecdote was actually a young woman, Bluestocking Otake Kōkichi. Dubbed "The Five-Colored Liquor Incident" by a mischievous reporter, the midnight dalliance conjured an intoxicating image of the New Woman, implying that she was as exotic as a foreign potion and eager to prey on innocent young men. A tantalizing backstory enhanced the incident's shock value. The public already knew Hiratsuka because author Morita Sōhei's newspaper novel *Black Smoke (Baien)*, serialized in 1908, had made her the model for the lead character, Tomoko, an educated, European-literature-loving, tobacco-smoking, Zen-practicing woman with a mind of her own. The novel was based on a literary-inspired suicide fantasy nearly attempted by Hiratsuka and Morita that had made headlines. As Morita was a husband and father and Hiratsuka a college graduate, public disapproval of this apparently illicit sexual relationship was swift. The *Asahi* newspaper ran a photograph, a head shot purportedly of Hiratsuka, on its front page.[11] Although the picture resembles Hiratsuka, it is not her. As in Kamichika's

case, the issue of mistaken identity was immaterial; Hiratsuka made the news for behaving badly. Memories of this photograph, the newspaper story, and the novel and finally news of Hiratsuka's position as an editor of *Seitō* seemed more than enough evidence for the public to believe rumors of "The Five-Colored Liquor Incident."

"The Bluestockings' Visit to the Yoshiwara" incident in July 1912 only added to the public's suspicions about Hiratsuka and her companions. By arrangement of Otake's uncle, who believed the Bluestockings should know more about the lives of other women, Hiratsuka, Otake, and a third Bluestocking, Nakano Hatsuko, paid a visit to the Daimonjirō, a geisha house in the Yoshiwara, and spent the evening talking with the courtesan Eizan. Although ladies' reform societies had made visits to the pleasure quarters to study the problems of prostitution, Hiratsuka later spoke of the Bluestockings' excursion as a playful one, motivated largely by curiosity. When word of the visit got out, the newspapers had a field day, extending the Yoshiwara stay to three days and further painting the Bluestockings as hedonistic women. Passersby threw stones at Hiratsuka's family house for days. Even the Bluestockings were surprised at the virulence of the public reaction, not realizing the significance of their Yoshiwara visit as a remarkable instance of border crossing. As *Seitō* scholar Dina Lowy assesses the press reports, "The three women were depicted as frivolous, morally bankrupt, and out of line for crossing sexual, gender and class boundaries. Not only did they enter a world to which only men had free access, but they did so out of curiosity and not with the intent of social reform. . . . Their blithe association with loose sexuality and lower-class society allowed their demands for women's awakening and rights to be easily dismissed."[12]

Fast-forward to the end of that summer and we learn what is most important—the Bluestockings' response to their notoriety. It is also here that we encounter the photo that got Kamichika Ichiko fired (fig. 2.1). It is a photograph staged by the Bluestockings and published in the first anniversary issue of *Seitō,* and thus, it functions as a visual response to all the attention, much of it negative, swirling about these young women. The photograph is, in effect, a graphic volley in what would become the Bluestockings' fight to define the New Woman in positive ways and on their own terms. The image is a crucial one to keep in mind as we consider the public's growing perception of the New Women as a westernized Japanese bent on transgressing the borders of class, gender, and even nation.

The photograph was taken on an August day when five Bluestockings happened to be at the seashore, escaping Tokyo's oppressive heat. Although

Hiratsuka later wrote that they were working hard on *Seitō* during this trip, the women appear to be enjoying the luxury of free time and a degree of financial comfort as well. Two of the women, Yasumochi Yoshiko and Otake Kōkichi, were there to restore their health, and Hiratsuka Raichō, Kimura Masako, and Araki Ikuko were visiting them, along with Ikuta and his wife. Hiratsuka, Otake, and Ikuta sit comfortably on the ground, the three other Bluestockings stand closely together, and Otake reaches up to touch hands affectionately with Kimura. Ikuta's wife stands slightly apart from the group. The photo captures the women in a relaxed pose. Their cotton summer clothing reflects their easy life at the seashore. Would this image have surprised readers used to seeing the Bluestockings satirized as "ugly," "mannish," and "sprouting whiskers"?

The publication of this "backstage" view of the Bluestockings in *Seitō* welcomes the reader into their lives as if another friend to whom one talks of a summer vacation. As a photo reproduced in a controversial journal for public consumption, the image also communicates assurance. These Bluestockings are comfortable with themselves and each other and confident about continuing their literary project in the face of government scrutiny. There is not a hint of worry about the pressures facing them. They had printed a group photo before; the January 1912 issue of *Seitō* carries an image of nine Bluestockings, wearing serious expressions, clad in kimono, and gathered outside their office.[13] The formality of this photo, however, lacks the insouciance of the seaside image. One can imagine how many young readers, gazing at the summer photo, envied the Bluestockings their vacation, their friendships, and their fearless resistance to public pressure.

How did this photo come to the attention of Kamichika's principal? According to Kamichika's account, the principal found the photo reproduced in a 1913 book with the alluring title *The Inside Story of the New Women* (*Atarashii onna no rimen*).[14] It was another "potboiler" by the popular writer Higuchi Raiyō. The caption misidentified Kimura as Kamichika, an error that caused the principal such alarm that he bought all the store's copies of the books so no one else would make the same discovery.[15] Today, one finds this photograph reproduced in most histories of the Bluestockings. It looks so innocent now that it is almost hard to believe that it was once the racy evidence used to authenticate Higuchi's "inside story."

By 1913, the New Woman was drawing even more attention, turning *fujin mondai*, a term that may be translated as the "Woman Question," into one of the most controversial topics of the day. The New Woman's sexuality, her relationship to Western women's rights movements, her assertiveness

in public, and her freedom in private life all piqued curiosity. Here, too, the publication of further photographs played a role, as we shall see. Pushed to the center of the controversy and losing members because of this, the Bluestockings decided to devote a special section of the January 1913 issue of *Seitō* to the New Woman and to hold a public lecture in Tokyo on the topic in February. Although the Bluestockings accepted the New Woman title, they emphasized two points: first, the public was incorrect in defining the Bluestockings as flaunting propriety to satisfy base desires; and, second, the Bluestockings were on a mission of self-awakening that required rigorous interrogation of everything and everyone, including themselves. Whereas conventional wisdom sought concise definition, the Bluestockings argued that the New Woman should be understood as a pioneer of the unknown.

The photograph served both camps. For the Bluestockings, making group photographs public in *Seitō* and sponsoring a lecture showed that they would stand behind their status as New Women. For their detractors, publication of the Bluestockings' photos and their immodest appearance on the public stage proved that they cared little for their own or their families' reputations. Interestingly, it was also at this point that the Bluestockings required requests for membership in the group to be accompanied by the individual's photograph; they instituted this rule in 1913 as a way to keep men out after one published a story in *Seitō* under an assumed, feminine name.

There is one photograph extant of the Bluestockings' one and only public lecture, which took place in February 1913 (fig. 2.3). Although Hiratsuka remembers that nearly a thousand people attended the lecture, to her disappointment, two-thirds of the attendees were men (the Bluestockings aimed to speak to women). The photo captures a crowd of young women sitting in front listening attentively to the speaker. At the grand lectern stands Bluestocking Iwano Kiyo. Her speech, later published in *Seitō*, advocates that women will gain intellectual freedom only once they have achieved financial independence. A reporter for the *Yomiuri shinbun*, a national newspaper, gave Iwano's appearance and her speech rave reviews.

> Dressed in a silk crepe kimono and satin obi, her hair piled up in a towering marumage, [Mrs. Iwano Kiyoko] was greeted with enthusiastic applause as she mounted the stage. . . . Her ideas were clearly reasoned and delivered with great aplomb.[16]

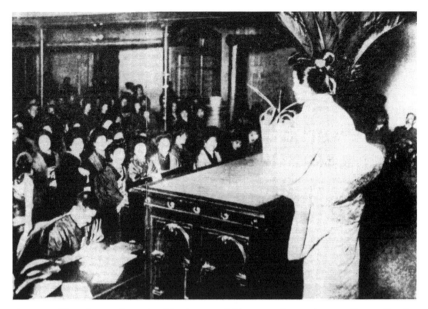

Fig. 2.3. "The Bluestockings' Public Lecture." Photographer unknown. Iwano Kiyoko speaking at the Bluestockings' public lecture event at Kanda Youth Hall in Tokyo on February 15, 1913. (Courtesy of Ōtsuki Shoten.)

Our appreciation of this photo is enhanced, however, if we pay less attention to Iwano's appearance and more to her politics. One of Iwano's lifelong passions and the focus of intense activist engagement for her between 1905 and 1909 was the fight for revision of what was known in shorthand as "Article Five," that is, the article in Japan's Police Security Regulations, enacted in 1890, that restricted women from participating in any political group or speaking in public on issues of a political nature. Her speech alludes to these earlier efforts "to dissolve the legal prohibitions that were unjustly restricting us."[17] The government did allow women in the Japan Women's Patriotic Association and other conservative organizations to make speeches. The Bluestockings, however, were skirting legal lines when they took to the stage to make remarks critical of the status quo and allowed themselves to be photographed doing so.

Intriguingly, this photograph points once again to Kamichika. Outraged by the Bluestocking event, Tsuda Umeko held a prayer meeting with all her students, warning them away from the Bluestockings as "an organization that spread subversive ideas." She called the group "the devil incarnate" and asked the students to pray for one among them that had been

led astray.[18] Although Kamichika bowed to pressure and withdrew her membership in the Bluestockings, it was too late to save her position at the academy. Before she knew it, Tsuda had engineered her quick removal from Tokyo. As if echoing Tsuda's sentiments two months later, the Ministry of Education issued a warning in April 1913, vowing that it would more scrupulously censor "the subversive ideas and salacious writings of the women who declare themselves New Women" for they were corrupting the "minds and morals of men and women students."[19] Rather than retreat, the Bluestockings explored ever more controversial territory in *Seitō*, debating laws regarding abortion and prostitution, and challenging mores that demanded chastity of women but not of men. They made explicit their desire to forge bonds with New Women abroad by translating the work of Emma Goldman, Ellen Key, and Olive Schreiner. As New Women, the Bluestockings continued to interrogate the borders that separated ladies from other women, pointing consistently to the ways in which such divisions benefited men. Their struggle to sustain *Seitō* lasted a few more years until the pressures of young motherhood, conflicts within the group, and the journal's financial woes led the Bluestockings to disband. The last issue of *Seitō* appeared in February 1916.

The Lady, the Geisha, and the New Woman: Blurred Borders

Understanding how the Bluestockings blurred the borders dividing women takes us again to the visual culture of early-twentieth-century Japan, beginning with a series of pictures published at the height of interest in the New Woman in 1913 and after the government had warned the Bluestockings to tone down their rhetoric. In June 1913, the major intellectual journal *Taiyō* (Sun) published a special issue on the Woman Question. The issue contained essays by over forty male intellectuals of the day and only one by a woman, the conservative educator Shimoda Utako, who contributed her thoughts on the "life of the single woman and its vices." *Taiyō* introduced a host of eminent women but did so only visually through a collage of photographs at the outset of the issue (fig. 2.4). (No pictures of the male writers accompanied their essays.) By placing diverse women together— foreign and Japanese, wives of famous men, and women famous for their own achievements—the editors framed the Woman Question as an open one. The notorious—English women's rights advocates, the Bluestockings, and Japan's first modern actresses—share space with the indisputably proper, the wives of powerful men and nobles. With titles in both English

現 代 婦 人 (三)
Famous women in Japan. (3)
現 代 婦 人 (二)
Famous women of Modern Japan. (2)

Fig. 2.4. "Famous Women in Japan." Photographer unknown. The *Taiyō* (Sun) issue of June 1913 contains collages of famous women of Japan.

and Japanese, the collages hint at the transnational, translingual quality of the New Woman. First, as if to point to British origins, come "The Militant Suffrazettes [*sic*] of London," a two-page collage of large, individual portraits of such famous activists as Emmelina Pankhurst and Constance Lytton, who had experienced imprisonment and hunger strikes, and led violent confrontations with authorities in their fight to gain the vote for women. Next, there is a half-page group photo of seven Bluestockings, Hiratsuka and Araki among them, gathered outside their office; the title, "The So-Called New Woman," is an indication of the questionable status of Japan's entrants, suggesting debate about whether or not they, too, are the genuine article. This is followed by three pages of collages of "Famous Women in Japan." The first features portraits of famous wives but includes the widowed educator Shimoda Utako. The second and third pages contain many more portraits; some depict women in Japanese dress, others in Western bonnets. Portraits of Yamakawa Sutematsu, wife of the minister of defense and a leader of women's charitable organizations, and the wife of a Tokugawa (the shogunal family that ruled Japan from 1600 to 1868), are combined with images of the first woman doctor in Japan, Yoshioka

Yayoi, and, surprisingly, the singer Hara Hideko, writer Okada Yachiyo, and actress Mori Ritsuko. The final collage, "Miss Sumako Matsui as 'Nola' [*sic*]," displays photos of a recent Tokyo production of *A Doll's House* and also includes an inset of a photograph of a European actress, Ms. Yavorsky, in the role of Nora. Such an unusual combination of women reflected the new reality in Japanese visual culture. As we have seen, one could find plenty of portraits of wives and noblewomen, as well as New Women, in public space. If we widen the lens further than these *Taiyō* collages, we may remember that numerous photographs of geisha appeared in advertisements decorating the Japanese visual field of 1913 and recall that University Face Powder ads employed images of both geisha and ladies. Was this the meaning of modernity? Had the technologies of reproduction and consumerism erased the boundaries dividing the lady from other women?

One incident of the day involving Bluestockings, geisha, and moral reform ladies points to the politically charged nature of such questions. As Japan was planning for the coronation of its new emperor in 1915, Tokyo's Shinbashi geisha offered to dance in the parade. The specter of "vulgar" geisha taking part in festivities honoring the throne and attended by foreign dignitaries horrified many women, inspiring members of the Japan Women's Christian Temperance Union and others to protest. Bluestocking Itō Noe countered with a vitriolic essay in *Seitō* in December 1915. "Arrogant, Narrow-Minded, Half-Baked Japanese Women's Public Service Activities" lambastes vain "aristocratic ladies" for the ways in which their characterization of prostitutes as "shameful women" magnifies their own position as virtuous ladies.[20] Although Itō advises paying attention to the ways in which poverty and the lack of education force women into prostitution, she fails to see how patriarchal values operated to divide women into opposing groups in the first place. In the end, the geisha were not included in the ceremonies, *Seitō* folded, and conservative women's groups continued to grow with the support of the government. The Bluestockings' efforts to question the borders of female propriety were trumped by the more powerful ladies' societies. At the sovereign's coronation, when Japan celebrated its mythic roots and modern power in national spectacle, ladyhood would also be upheld.

Kamichika's New Woman Mug Shot

One cannot leave a discussion of the Bluestockings and their photograph without mention of Kamichika's second photographic scandal. Back in

Tokyo after her failed attempt at teaching, Kamichika gained an excellent position as a newspaper reporter. Her problems began again, however, when she fell in love with Ōsugi Sakae, an anarchist writer, an advocate of free love, and a married man, who soon took up with Itō Noe. At one point, he was involved with three women: his wife Hori Yasuko, Itō, and Kamichika. Although Ōsugi believed that all four should live separately, only Kamichika was making a reasonable salary. The fact that she ended up supporting nearly all four in the relationship made her understandably angry. One night in November 1916, Kamichika's rage finally led her to stab Ōsugi in the throat at a teahouse. As Kamichika, Itō, and even Ōsugi's wife were linked by their association with *Seitō*, media attention turned once again to the Bluestockings as New Woman advocates of modern sexual mores. In the end, Ōsugi divorced his wife and moved in with Itō, and Kamichika had to serve two years in a women's jail for her crime. When Kamichika's picture appeared in the newspaper, fingering her as a New Woman criminal, the story was correct, and this time, unfortunately, so was the photograph (fig. 2.5).

Fig. 2.5. "Ōsugi Sakae Stabbed by Mistress." Photographer unknown. Photographs of Ōsugi Sakae and Kamichika Ichiko accompanied an article in Tokyo's *Asahi shinbun*, November 10, 1916, concerning what became known as the "Hikage Teahouse Incident." Ōsugi's simultaneous involvement with three women, all connected to the Bluestockings, became a much discussed scandal. (Courtesy of The Asahi Shimbum Corporation.)

The modern technology of the photograph exposed the New Woman of Japan to the nation. The photograph also proved a fitting symbol of the New Woman's ideals; she sought an authentic life in which practice and philosophy were one, and she wished to present herself to the public as such a unified person. The photograph, with its illusion of capturing the whole person, enhanced this dream and made it seem tangible to countless viewers. The New Woman underestimated the power of reproduction and new media to blur boundaries between women of different classes and nationalities, never imagining how this would intensify efforts to reinvigorate those borders. In Kamichika's case, she emerged from jail a wiser woman and went on to write several books. She was elected as one of the first female representatives to the Diet in the 1940s. In the 1950s, she successfully campaigned to make prostitution illegal in Japan, although she did so under the guise of protecting respectable Japanese housewives from "the spread of evil" caused by prostitutes, thus, invoking the borders of propriety she had once transgressed.[21] Biographies of Kamichika include pictures related to her youth, family, and illustrious career. They do not include the newspaper photo associated with her arrest, nor the photograph that got her fired.

Notes

1. Kamichika Ichiko, "Tegami no hitotsu" (One Letter), *Seitō* 2, no. 9 (September 1912): 100–120. Following East Asian practice, all Japanese names are given with family name first.

2. Kamichika Ichiko, *Kamichika Ichiko jiden* (Autobiography of Kamichika Ichiko) (Tokyo: Toshokan Sentā, 1997), 116–23. Kamichika resigned on the condition that she would receive a full month's pay and could recommend her successor.

3. This overview draws on Sakuma Rika, "Shashin to josei: Atarashii shikaku media no tōjō to 'miru/mirareru' jibun no shutsugen" (Photography and Women: The Advent of the New Visual Media and the Emergence of the Seeing/Seen Self), in *Onna to otoko no jikū: Nihon joseishi saikō* (Time-Space of Gender: Redefining Japanese Women's History), ed. N. Kono (Tokyo: Fujiwara Shoten, 1995), 187–237.

4. See Stanley M. Burns and Elizabeth A. Burns, *Geisha: A Photographic History, 1872–1912* (Brooklyn: Powerhouse Books, 2006).

5. Rebecca Copeland, "Fashioning the Feminine: Images of the Modern Girl Student in Meiji Japan," *U.S.-Japan Women's Journal*, nos. 30–31 (2006): 13–35.

6. Inoue Shoichi, *Bijin kontesuto hyakunen-shi: Geigi no jidai kara bishōjo made* (The Hundred-Year History of Beauty Contests: From the Era of the Geisha to Pretty Girls) (Tokyo: Shinchōsha, 1997), 8–30.

7. Sakuma, 219.

8. Ibid., 220.

9. For more on Japan's Bluestockings, translations of their works, and a guide to Japanese- and English-language scholarship on the group, see Jan Bardsley, *The Bluestockings of Japan: New Woman Essays and Fiction from "Seitō," 1911–16* (Ann Arbor: Center for Japanese Studies, University of Michigan, 2007). To easily distinguish the two, I refer to the group as the Bluestockings and the journal by its Japanese name, *Seitō*.

10. Araki Ikuko, "Tegami" (The Letter), *Seitō* 2, no. 4 (April 1912): 102–6; translated in Bardsley, 30–34.

11. "Koi no gisei" (Victims of Love), *Asahi shinbun,* March 26, 1908, 6.

12. Dina Lowy, *The Japanese "New Woman": Images of Gender and Modernity* (New Brunswick, NJ, and London: Rutgers University Press, 2007), 62–63. Lowy's book has an excellent analysis of the newspaper articles that followed the *Seitō* scandals, including reports of the Hiratsuka-Otake relationship.

13. This photograph is reproduced in Lowy, 18.

14. Hiratsuka Raichō and Teruko Craig, *In the Beginning, Woman Was the Sun* (New York: Columbia University Press, 2006), 191.

15. Kamichika, *Kamichika Ichiko jiden,* 122.

16. Hiratsuka and Craig, 212.

17. Iwano Kiyo, "Shisō no dokuritsu to keizai-jō no dokuritsu" (On Intellectual and Economic Independence), *Seitō* 3, no. 3 (March 1913), translated in Bardsley, 163–67. Iwano used Kiyo and Kiyoko interchangeably as her given name.

18. Hiratsuka and Craig, 191.

19. Ibid., 219.

20. Noe's essay is partially translated in Mikiso Hane, *Peasants, Rebels, Women, and Outcastes: The Underside of Modern Japan* (Lanham, MD: Rowman and Littlefield, 2003), 277–82. For original essay, see "Gōman kōryō ni shite futettei naru nihon fujin no kōkyō jigyō ni tsuite" (Arrogant, Narrow-minded, Half-Baked Japanese Women's Public Service Activities), *Seitō* 5, no. 11 (December 1915): 1–18.

21. Vera C. Mackie, *Feminism in Modern Japan: Citizenship, Embodiment, and Sexuality* (Cambridge: Cambridge University Press, 2003), 137.

3

Female Firsts: Media Representations of Pioneering and Adventurous Women in the Early Twentieth Century

DESPINA STRATIGAKOS

Like a creature from another planet, a beautiful young woman emerges from an enormous deep-sea diving suit, lavishing a broad smile on the surprised viewer (fig. 3.1). It is one of my favorite pictures from the early twentieth century depicting the so-called New Woman, a being who struck many of her contemporaries as profoundly alien. The weirdness of this image, even today, allows me to connect with the feeling many must have experienced when they encountered a woman who did not act like a woman, at least according to their personal and cultural expectations. Like them (I imagine), I find myself bewildered and amazed, wondering what this young woman is doing in an outfit that appears to belong in a Jules Verne novel. Who on earth (or underwater, apparently), is this woman?

The role of journalistic photography in shaping gender stereotypes during the Weimar Republic has been well documented by Patrice Petro and other scholars.[1] This radical era of German history, launched with the bloody overthrow of monarchical rule, embraced media images, and particularly those of the New Woman, as the signs of modernity. Considerably less attention has been paid to photographic representations of women in earlier Wilhelmine newspapers and magazines, which relied more heavily on text as their medium of communication.[2] Such images became increasingly common as printing technologies improved and photographic agencies appeared in the early years of the twentieth century, and the flourishing of a mass print culture ensured the images' wide distribution among German audiences.[3] In this essay, I address the documentary phenomenon of "female firsts," photographs appearing in the German press in the decade before the First World War that recorded female pioneers and adventurers in decidedly "unladylike" pursuits. While these images can be labeled

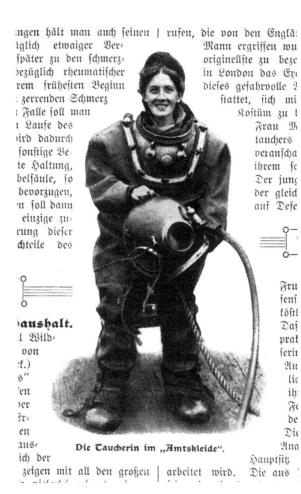

ngen hält man auch seinen | rufen, die von den Englä:
iglich etwaiger Ver= Mann ergriffen wu
später zu den schmerz= originellste zu beze
bezüglich rheumatischer in London das Er
rem frühesten Beginn dieses gefahrvolle 2
: zerrenden Schmerz stattet, sich mi
i Falle soll man Kostüm zu l
i Laufe des Frau M
iird dadurch tauchers
sonstige Be= veranscha
te Haltung, ihrem sc
belsäule, so Der junç
bevorzugen, der gleid
in soll dann auf Dese
einzige zu=
rung dieser
chteile des

aushalt.
l Wild=
von
f.)
s"
'en
ier
ir=
en
aus=
ich der
zeigen mit all den großen | arbeitet wird. Die aus

Fru
jenj
töstl
Das
prat
serii
Au
lic
iḥ
J
de
Die
Ana
Hauptsitz

Die Taucherin im „Amtskleide".

Fig. 3.1. Mrs. Mitch-ell, one of England's first female deep-sea divers, before begin-ning her workday inspecting ships' hulls at the Tilbury Docks. (From "Ein seltener Frauenberuf," *Die Welt der Frau,* no. 47 [1908]: 752.)

under the rubric of the New Woman, a type identified and constructed in part by the media, the nature of the photographs defies simple typologies by insisting on the singularity of the subject: the first female deep-sea diver, the first female architect, the first woman to ride a horse across America, and so forth. This tension between the singular and the type allows us to analyze how the press employed and manipulated such images and how the photographs themselves offered their own spaces of resistance.

The lady deep-sea diver surfaced in the pages of a 1908 issue of *Die Welt der Frau,* a magazine for women created in 1904 by August Scherl, whose nonpartisan, commercially oriented publications contributed to the growth of a mass readership among Germans.[4] *Die Welt der Frau,* a supplement to one of the publisher's popular family magazines, offered

a mixture of articles, illustrations, and advertising that targeted a largely domestic female audience.[5] On the page featuring the deep-sea diver, for example, the main articles addressed a new book about housekeeping and the manufacturing of cloth from pineapple fiber. The brief story about the deep-sea diver appeared in the Women's Work section under the title "An Uncommon Female Profession." Here we learned that "among the various professions that English women have snatched up in fierce competition with men, a diver is certainly to be described as the most novel." Only three women in London had qualified to undertake this "perilous field of work" and wear its "elegant, fifty-kilogram costume." Among them, the article featured "Mrs. Mitchell," the daughter-in-law of the Tilbury Docks' chief diver. Mrs. Mitchell is shown twice, before and after "her difficult descent to the sea bottom" to inspect ships' hulls. The first image shows the young diver on her own, holding her helmet and poised for work (fig. 3.1). Smiling at the camera, she radiates a sturdy confidence in the face of what we have been told is "perilous" and "difficult" work.[6] The second image depicts her after work, surrounded by men, who pull vigorously at her suit to remove it (fig. 3.2). The diver's smile has transformed into a grimace as her rubbery arms, pulled by two men, stretch out cartoonishly to either side of her. The physical struggle of the depicted scene is reinforced by the layout of the image and text: the man pulling to the right steps out of the picture frame, displacing the text. While the image of the deep-sea diver who cannot get out of her own clothes is comic, it is also mildly violent, as Mrs. Mitchell appears to be torn apart. As if visually responding to the text's reference to women ripping careers out of the hands of men, the men here snatch back. The diver's helplessness as she is stripped bare by men also tempers the self-reliance of the first image.

A more psychological tension characterizes the photograph of another female pioneer surrounded by men, in this case Jovanka Bontschits (fig. 3.3). The young Serbian was the first woman to earn an architecture degree from the Technical College of Darmstadt in 1913.[7] Bontschits, along with seven male members of her graduating class, was pictured on the cover of the *Berliner Illustrirte Zeitung*, a mass-circulation illustrated weekly published by Ullstein, another of the firms responsible for expanding German readership by depoliticizing and commercializing the news.[8] The lead caption identified her by her professional title, Fräulein Diplom-Ingenieur, and the reader's surprise at seeing the "Miss" instead of the accustomed "Mr." before the degree was no doubt heightened by the image itself, in which the Fräulein Diplom-Ingenieur appears as the odd (wo)man out.[9] It

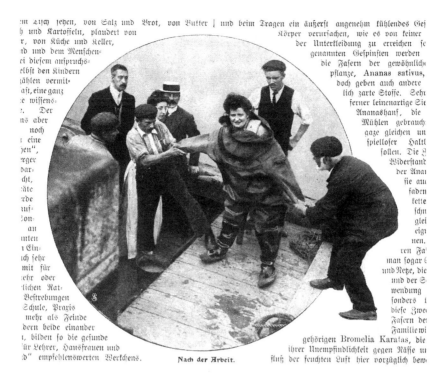

Fig. 3.2. Mrs. Mitchell being assisted out of her work clothes following her dive. (From "Ein seltener Frauenberuf," *Die Welt der Frau*, no. 47 [1908]: 752.)

is not so much the obvious differences—her clothes and hat (a lady did not go bareheaded in public) or the congratulatory bouquet of flowers—that stamp her as an outsider. Rather, the marks that I find most telling are written on the bodies of her male colleagues, particularly the man who stands at the far right of the photograph. Smiling at the camera, he jauntily holds a cigarette, the angle of which accents the deep dueling scar on his face (to the right of his chin). Such scars were the coveted badge of membership in the *Burschenschaften*, the elitist university student dueling and drinking fraternities, which banned undesirables, including Jews and women. A man comfortable in his privilege, he manages to convey the feeling that he occupies the center of a larger sphere even as he is marginalized in the photograph. His relaxed body posture, echoed by the other male students, contrasts with that of Bontschits, who sits in a constrained manner and looks unsmilingly into the camera lens. As much as she may be a member of this group, one senses that she has not yet been admitted to the club.

Fig. 3.3. Jovanka Bontschits surrounded by her fellow architecture graduates of the Technical College of Darmstadt. (From "Fräulein Dipl.-Ing.," *Berliner Illustrirte Zeitung* 22, no. 31 [1913].)

Bontschits's uneasy disposition on the *Berliner Illustrirte Zeitung* cover is made even more apparent by her lone appearance in the *Deutsche Frauen-Zeitung*, which featured the pioneer seated at her drafting table at home (fig. 3.4).[10] Leaning forward to work on a drawing, her pose relaxed and dynamic, she gazes at the viewer with a broad, winning smile. The contrast in tone between the two portraits, which are contemporary, is striking. The *Deutsche Frauen-Zeitung* brings us face-to-face with the energy and

Fig. 3.4. At ease:
Bontschits at the
drafting table.
(From "Fräulein
J. M. Bontschits,
der erste weibliche
Diplomingenieur
in Deutschland,"
*Deutsche Frauen-
Zeiung* 26, no. 102
[1913]: 1084.)

joy of the creator, while the *Berliner Illustrirte Zeitung* centers our atten-
tion on the oddity of her sex.

It is tempting to read these different approaches to documenting female
firsts as a reflection of their publishing venues. The *Berliner Illustrirte Zei-
tung* addressed a mass audience, including many Germans hostile to chang-
ing gender roles. By contrast, the *Deutsche Frauen-Zeitung,* a newspaper
produced by the publishing company Otto Beyer, targeted female readers,
an audience with presumed sympathies for women's professional advances.
But as the mixed messages contained in the *Welt der Frau*'s presentation
of a perhaps reckless and sometimes helpless Mrs. Mitchell suggest, the
coverage of female firsts in the women's press was not always entirely posi-
tive. Even the *Deutsche Frauen-Zeitung*'s representation of a happy and
productive Jovanka Bontschits shifted her from the public sphere of her
male colleagues to an isolated domestic setting, a move that recognized her
accomplishment while putting her in her place.

Incongruous framings of Katharina Pfeiffer, Germany's first female bricklayer, further reveal the complexity of the treatment of female firsts by the women's press. When Pfeiffer passed her guild examination in 1912 to become a journeyman bricklayer, her photograph appeared in at least three different women's magazines, each showing the same image (fig. 3.5). Unlike the tense group portrait with Bontschits featured in the *Berliner Illustrirte Zeitung,* the photograph of Pfeiffer shows her working alongside her male colleagues. The photographic staging of this female first thus conveyed a greater sense of integration by focusing on the work itself as the connecting glue rather than on the different nature of the participants.

Die Frau im Osten, an explicitly feminist publication, reproduced the photograph with only a simple, matter-of-fact caption, "A female journeyman bricklayer."[11] Allowing the image to stand alone implied that, while a female bricklayer was newsworthy, *Die Frau im Osten* readers understood her appearance as yet another piece in a broader narrative of progress that was increasingly familiar and mundane. The *Deutsche Frauen-Zeitung,* by contrast, included a brief article that struck a more congratulatory tone and assumed the need to explain to its readers what they were seeing in the photograph: after learning that Pfeiffer had recently passed the examination of the bricklayers' guild, readers were told that she "now works valiantly as a journeyman alongside her male colleagues."[12] Interestingly, the page layout paired Pfeiffer, on the right, with the image of an elderly male architect named Le Blanc on the left. Le Blanc, the oldest civil servant in Prussia's public works department, had just retired at the age of eighty-five, and this balancing of images and stories about old and new builders may have suggested to readers, if not a passing of the torch, at least the dawn of a new era. Finally, in its coverage of Pfeiffer *Die Deutsche Frau,* a commercial illustrated weekly, went beyond observation to interpret the implications of this shift in gender roles. In an article titled, "Extraordinary Female Professions," which surveyed the extreme reach of the grasping new career women, the magazine's editors commented on the manliness of apparitions such as Miss Pfeiffer and strongly cautioned against transgressing gender norms.[13] Thus, the same image carried different messages in these women's magazines, ranging from understated acceptance to outright rejection.

Such conflicting views in the women's press reflected broader divisions in contemporary German society about the nature and rightful place of the sexes. Beginning in the later nineteenth century, the women's movement had won substantial victories that made higher education and careers

Fig. 3.5. Katharina Pfeiffer, Germany's first female journeyman bricklayer. This photograph appeared in at least three journals in 1912. (From "Ein weiblicher Maurergeselle," *Die Frau im Osten* 6, no. 15 [1912]: 115.)

accessible to women.[14] These largely legal successes, however, failed to transform deep-set and persistent cultural attitudes that held transformations in gender roles to be a threat to the stability and health of the German family and nation. Predominantly male novelists, political leaders, sociologists, and doctors, among others, contributed to a burgeoning discourse at the turn of the century that treated women who transgressed conventional gender roles as freaks of nature and sexual deviants. In his 1908 treatise *Woman and Art,* for example, Karl Scheffler, a prominent art critic, viewed the growing numbers of female practitioners in the fine arts and architecture as an aberration in the natural order with disastrous consequences for art and society. Insisting on the inherent and powerful masculinity of artistic genius, Scheffler claimed that women who attempted to seize it "raped" their inner femininity, transforming themselves into hermaphroditic creatures with barren wombs and masculine sexual appetites.[15]

Gothic warnings such as these and the expectation that intellectual and sexual deviancy manifests itself physically on the body, a theory common in medical texts of the time, stoked public curiosity about the new breed of women. In a 1913 survey of female university students in Germany on

their inadequate housing situation, respondents complained of the discomfort of living alone in a pension, where, like an exotic species in a zoo, a young woman was constantly subject to the curiosity of other residents, who viewed her as the *Emanzipierte,* the liberated woman. The respondents urged the construction of residences for female university students where they could be among others like themselves and away from the prying eyes of curious strangers.[16] A voyeuristic desire to see what these New Women looked like undoubtedly stimulated the documentary phenomenon of "female firsts."

At first glance, it would seem that these photographs could only fail to disappoint in the quest for a freaky ladies show. Caricatures of mannish female artists and doctors sporting trousers and day-old beards, while the stock-in-trade of satirical magazines such as *Simplicissimus,* were hard to find in reality.[17] And yet documentary photographs of female pioneers such as Jovanka Bontschits and Katharina Pfeiffer, who appear to be physically healthy and "normal" young women, did not immediately dispel such expectations. In certain instances, the accompanying text insinuated corporeal imperfections or threats to the integrity of the subjects not visible to the naked eye.

In 1910, readers of the *Illustrierte Frauenzeitung,* a popular Berlin fashion magazine, encountered an extraordinary photograph of a female builder amid pages devoted to elegant hats and dresses. Balanced on a ladder high atop the city, she was shown making repairs to the roof of Berlin's City Hall (fig. 3.6). The accompanying text introduced her as the first woman to undertake the demanding practical training required for this profession and emphasized the "great deal of courage and self-confidence it takes to stand on a ladder at this height in female clothing and, at the same time, perform a difficult task; in any case, however, this activity should be recommended only to vertigo-free ladies."[18] While depicting the new horizons opening up to women, then, the magazine's editors conveyed a sense of danger pertaining to the female body and its clothing. If her skirt did not snag, the subtext seemed to say, plunging a woman to her death hundreds of feet below, her mental instability (the supposed female tendency to swoon) might lead to a similar ruin. This message, a warning to "lesser" women not to follow in the path of an exceptional (and perhaps aberrant) pioneer, was at variance with the calm assurance displayed by the builder herself.

Contradictions of this sort between image and word opened up a critical space for the reader. Confronted with a builder who did not appear fright-

Fig. 3.6. Scaling new heights: a woman makes repairs to the roof of Berlin's City Hall. (From "Frauen als Baumeister," *Illustrierte Frauenzeitung* 38, no. 2 [1910]: 17.)

ened by the suggested perils of her work (just as Mrs. Mitchell seemed eager to take the "perilous" plunge underwater), the reader was compelled to choose between competing truths. However, such a critical space might collapse, along with any apparent contradictions, if instead of identifying with the pioneer the female reader positioned her as Other. In the context of broader discourses about female hysteria, which treated swooning as a trait common to women (especially "ladies"), the builder's vertigo-free nature might be interpreted not as the healthy norm but rather as the freakish exception.[19] The warning about vertigo seems designed to encourage the reader to identify with the (supposedly) frail majority rather than the singularly strong pioneer. After all, who could be absolutely certain that she would not experience a momentary and deadly episode of vertigo? Doubt, once introduced, acts as a powerful restraint. The inclusion of warnings alongside such documentary photographs suggests that the greater danger inherent in such pioneering feats was not women tumbling off ladders or drowning at the bottom of the sea but rather their ability to inspire imitators.

Indeed, a 1912 article in *Die Deutsche Frau* on the rapidly swelling ranks of female pioneers and their courageous deeds, including the heroic rescues of Saint Petersburg's first female firefighter, leaves one with the impression that the presence of danger, rather than deterring young women from certain professions, may have increased their appeal. The richly illustrated article "Extraordinary Female Professions," mentioned earlier, acknowledged the pioneers' achievements, including Pfeiffer's graduation to the bricklayer's scaffold. It ended, however, with a call to order, expressing the hope that these "extraordinary female professions" would remain, on the whole, the exception rather than the rule. In emphatic terms, the editors made clear that these trailblazers were not to be followed: "A woman must not carry a man's tools, and a man must not don female clothing, for whoever does so is a horror before the Lord, your God."[20] *Die Deutsche Frau* had been created in 1911 by the Velhagen and Klasing publishing house, which was also responsible for the immensely popular illustrated weekly *Daheim*. While *Die Deutsche Frau* claimed it catered to educated (*gebildete*) women and featured advances made by women in diverse fields, its publisher clearly was not willing to offend its middle-class readership by suggesting a radical shift in gender roles.[21] Progress was one thing, perversion another.

The article's gathering of these exceptional pioneers into a group brings to the fore tensions inherent in the desire to forge the singular into a type. Five women in "very markedly masculine professions"—Katharina Pfeiffer (bricklayer), Marie Jermoloff (firefighter), Agnete von Bauditz (steamboat captain), Melly Beese (pilot), and Pauline Sonntag (blacksmith)—were described as "manly apparitions." The phrase leaves ambiguous whether the manliness belongs to the phenomenon of women choosing overtly masculine professions or to the appearance of the women themselves. Jermoloff appears in a long coat and scarf with a white dog at her feet, the latter a conventional symbol of fidelity in portraits of women. This dog, however, belongs to the fire station, and Jermoloff is posed in front of a fire truck. The blacksmith appears in a rural setting, wearing the apron and dress of a farm woman, as she shoes a horse. Pfeiffer is shown in a large hat and skirt laying bricks (fig. 3.5). None of these women displays the physical characteristics of manliness commonly associated with New Women in popular literature, and each portrait is distinct. What ostensibly unites these individual pioneers into a broader category of dangerous gender-benders is their "unusual" abilities. Like sword swallowers or flame eaters, these women seem normal until they display their "courage, cold-blooded-

ness, command skills, and, not least, physical strength and agility," qualities that the article states are rarely associated with women.[22] I would suggest, however, that the focus on the individual portrait (heightened through the use of photography) and the unique nature of the accomplishment works against such a merger, whether in this article or in the broader media phenomenon of female firsts. The identifying features of faces and names, such as the smiling Mrs. Mitchell, and the singularity of the achievement, such as the first woman to earn an architecture degree, make memorable these individuals as individuals, making the production of a type more difficult to achieve.

Not all female firsts involved professional achievements, and in media stories about female adventurers the novelty of the feat itself often added to the memorable qualities of the representation. In 1911, readers of *Die Welt,* a popular illustrated weekly, found themselves gazing at the image of a laughing young cowgirl astride a horse surrounded by an admiring crowd in downtown New York. The startling effect of the cowgirl's presence amid skyscrapers was matched by the short text, which informed readers that the "audacious" rider, Nan Aspinwall, had just arrived in the city after riding alone three thousand miles cross-country from San Francisco. The "young lady" had ably endured the "great stresses of the trip" despite often being compelled to sleep outdoors.[23]

Such unprecedented feats of athletic or physical stamina interested Wilhelmine readers, who lived in an era that embraced physical reform movements, including dress reform, nudism, and vegetarianism.[24] Dynamic images of athletic women in the mass media conveyed a message about the strengths of the female body that challenged deeply held cultural beliefs opposing femininity and physical robustness. The impact of this increased athleticism on the female body was a cause of concern at the time, and the reactionary viewpoint was expressed in a satiric newspaper story about the Venus de Milo, who came to Berlin, took up sports with a passion, and soon became "a skinny hermaphrodite with swelling biceps and a thin racing face."[25]

The media's documentation of female firsts, which depicted women in new roles and suggested the strength and dynamism of their female bodies, may have helped prepare the German public for the radical shift in gender roles that occurred during the First World War when women stepped en masse into the shoes of departing men. In this period, journalistic representations of women performing men's jobs shifted from portraying the singularity of the pioneer to suggesting a type. Thus, for example, the *Köl-*

ner Frauen-Zeitung, an illustrated women's weekly, published an image of a uniformed woman with the title "Woman as Streetcar Conductor." The caption explained that Berlin streetcars had recruited as conductors the wives of men drafted for military duty.[26] The female streetcar conductor is not named, and she looks down, deflecting our gaze to the tickets in her hand. Such images were less a record of exceptional individuals than a sign of the abnormality of the times, which forced transgression on German women. German men, already facing the horrors of trench warfare, wondered what others they would encounter on their return to the home front. Male authors of articles such as "The Manly Women" expressed gratitude to women for acting like men at a time of national crisis but insisted on a return to "natural" gender roles at war's end.[27] In an effort to keep things from going too far, in 1916 the German parliament attempted to pass legislation ensuring that wherever women and men worked together, women would be subordinate to men.[28] Even in times of war, certain rules remained inviolate.

The female pioneers and adventurers who, in the years preceding the war, stepped the farthest outside the "natural" order by exploring the Thames riverbed, Berlin rooftops, or other uncharted terrains, defined the extreme fringes of the new. The impetus to record them photographically suggests the German public's curiosity about the creatures that inhabited this outer sphere, while the representational framing of such firsts often seemed calculated to reinforce the desirability of remaining firmly within the safety of the old center of gender norms. And yet there is something vibrantly alluring about the cheerily clunky Mrs. Mitchell or the rough-and-tumble Nan Aspinwall. By virtue of its emphasis on the unique, the documentary phenomenon of female firsts reveals the singular within the type, and these images, like the women, remain fascinatingly hard to peg.

Notes

1. Patrice Petro, *Joyless Streets: Women and Melodramatic Representation in Weimar Germany* (Princeton: Princeton University Press, 1989); Lynne Frame, "Gretchen, Girl, Garçonne? Weimar Science and Popular Culture in Search of the Ideal New Woman," in *Women in the Metropolis: Gender and Modernity in Weimar Culture*, ed. Katharina Von Ankum (Berkeley and Los Angeles: University of California Press, 1997), 12–40; Katharina Sykora, Annette Dorgerloh, Doris Noell-Rumpeltes, and Ada Raev, eds., *Die Neue Frau: Herausforderung für Bildmedien der Zwanziger Jahre* (Marburg: Jonas, 1993).

2. For a broader discussion of images of women in the Wilhelmine press, see David

Ehrenpreis, *Beyond the Femme Fatale: Female Types in Wilhelmine Visual Culture* (Ann Arbor: UMI Press, 1998); Ingrid Otto, *Bürgerliche Töchtererziehung im Spiegel illustrierter Zeitschriften von 1865 bis 1915* (Hildesheim: August Lax, 1990); and Ulla Wischermann, *Frauenarbeit und Frauenbewegung in der illustrierten Presse des 19. Jahrhunderts* (Munich: K. G. Saur, 1983).

3. For a brief overview of the advent of photography in the Wilhelmine press, see *Fotografie in deutschen Zeitschriften, 1924–1933* (Stuttgart: Institut für Auslandsbeziehungen, 1982).

4. Peter Fritzsche, *Reading Berlin 1900* (Cambridge: Harvard University Press, 1996), 72–73.

5. *Die Welt der Frau* was a supplement to *Vom Fels zum Meer* from 1905 to 1917 and then to *Gartenlaube* from 1918 to 1920.

6. "Ein seltener Frauenberuf," *Die Welt der Frau*, no. 47 (1908): 752.

7. On women's integration of architecture schools in Germany, see Despina Stratigakos, "'I Myself Want to Build': Women, Architectural Education, and the Integration of Germany's Technical Colleges," *Paedagogica Historica* 43, no. 6 (2007): 727–56.

8. Linda J. King, *Best-Sellers by Design: Vicki Baum and the House of Ullstein* (Detroit: Wayne State University Press, 1988), 47.

9. "Fräulein Dipl.-Ing.," *Berliner Illustrirte Zeitung* 22, no. 31 (1913).

10. "Fräulein J. M. Bontschits, der erste weibliche Diplomingenieur in Deutschland," *Deutsche Frauen-Zeiung* 26, no. 102 (1913): 1084.

11. "Ein weiblicher Maurergeselle," *Die Frau im Osten* 6, no. 15 (1912): 115.

12. "Der erste weibliche Maurergeselle," *Deutsche Frauen-Zeitung* 25, no. 48 (1912): 504.

13. "Aussergewöhnliche Frauenberufe," *Die Deutsche Frau* 2, no. 26 (1912): 7.

14. James C. Albisetti, *Schooling German Girls and Women: Secondary and Higher Education in the Nineteenth Century* (Princeton: Princeton University Press, 1988).

15. Karl Scheffler, *Die Frau und die Kunst* (Berlin: Bard, 1908), 33, 41–42, 94. For a fuller discussion of Scheffler's views, see Despina Stratigakos, "The Uncanny Architect: Fears of Lesbian Builders and Deviant Homes in Modern Germany," in *Negotiating Domesticity: Spatial Productions of Gender in Modern Architecture*, ed. Hilde Heynen and Gulsum Baydar (London: Routledge, 2005), 145–61.

16. Ruth von Velsen, "Die Wohnungsverhältnisse der Studentinnen," *Die Studentin* 2, no. 11 (1913).

17. Renate Berger, *Malerinnen auf dem Weg ins 20. Jahrhundert: Kunstgeschichte als Sozialgeschichte* (Cologne: DuMont, 1982).

18. "Frauen als Baumeister," *Illustrierte Frauenzeitung* 38, no. 2 (1910): 17.

19. Deborah Lupton, *Medicine as Culture: Illness, Disease, and the Body in Western Societies,* 2nd ed. (London: Sage, 2003), 147–48.

20. "Aussergewöhnliche Frauenberufe," 9.

21. "Was wir wollen," *Die Deutsche Frau* 1, no. 1 (1911).

22. "Aussergewöhnliche Frauenberufe," 8.

23. "Die kühne amerikanische Reiterin Miss Nan J. Aspinwall . . . ," *Die Welt* 23,

no. 23 (1911): 446. On Aspinwall, see Tom Moates, "Two-Gun Nan . . . Genuine Cowgirl to the Core," *I.M. Cowgirl* 2, no. 1 (2008): 24–27.

24. Michael Hau, *The Cult of Health and Beauty in Germany: A Social History, 1890–1930* (Chicago: University of Chicago Press, 2003); Sabine Welsch, *Ein Ausstieg aus dem Korsett: Reformkleidung um 1900* (Darmstadt: Jürgen Häusser, 1996).

25. E. H. Stratz, "Die Vermännlichung der Frau," *Die Welt der Frau (Gartenlaube)*, no. 13 (1911): 193.

26. "Die Frau als Strassenbahnschaffnerin," *Kölner Frauen-Zeitung* 20, no. 38 (September 20, 1914): 5.

27. Ernst Boerschel, "Die Männlichen Frauen," *Daheim* 52, no. 36 (1916): 21–22.

28. Dr. M. M-z, "Frauen in der Kaserne: Der weibliche Hilfsdienst," *Vossische Zeitung*, January 6, 1917.

4

Domesticating the Harem: The New Woman in Colonial Indian Photography, 1895–1915

GIANNA CAROTENUTO

India's modern woman finds herself in transition as ignorance and superstition have given way to education. Veils are vanishing, the marriage age is edging up, and polygamy and enforced widowhood are becoming passé institutions. Cultured women are emerging now to lend a hand to their less fortunate sisters on the path of progress.[1]

So opens a biography on the Maharani of Baroda published in the British illustrated journal *Lady's Realm* in 1912 by the Indian writer Saint Nihal Singh. The Maharani, the wife of one of the British Crown's key native princes, would spotlight the political value of women in India's burgeoning future (fig. 4.1). The quote presents the reader with reference points with which to identify the status of Indian women. By the early twentieth century, the path of progress toward a modern India had taken the form of more education for women, new marriage laws, increased public presence, and the transformation of veiling and polygyny. The Maharani symbolized these advancements as one of India's New Women.

The liberated female, or New Woman, arose in the 1890s as a global phenomenon to challenge existing conditions of female power, freedom, and status. For India, the formation of an emancipated female identity sprang from the complex legacy of orientalism and its harem mythologies, the growing influence of modernism in the colony, the pressures of native political concerns, and the rising cosmopolitanism linking India to the European world. But what constituted a "typical" Indian woman in the early twentieth century and what is at stake in mapping her identity?

This essay reveals a series of major shifts in the visualization of female identity at the apex of colonialism in India (1895–1915). I propose that harem mythologies, the indigenous domestic sphere, and the emerging

Fig. 4.1. The Maharani of Baroda, Chimnabai, ca. 1912, photographer unknown, black-and-white photograph (5 3/4 in. x 4 1/4 in.). (From the *Lady's Realm*, 1912, Collection Laruelle, vol. 87, folio ne 63 D028506, Bibliothèque Nationale de France.)

HER HIGHNESS THE MAHARANI OF BARODA

rights of women converged to produce a new female role model for India, an image of a New Woman crafted and disseminated in the photographic image. A series of photographic portraits of elite Indian women from two archives, the Collection of the Nizam of Hyderabad, India, and the Laruelle Collection, Bibliothèque Nationale de France, illustrate the proposal. These pictures produced by European and Indian photographers for public and private, as well as domestic and foreign, audiences can be loosely categorized into four distinct types: the traditional Indian queen, the cosmopolitan maharani, the bourgeois *bhadramahila*,[2] and the sequestered *zenana* woman.[3] Each type identifies an aspect of New Womanhood shaped by imperial and national agendas. Rather than fixing female identity into neat categories, these four types form a kaleidoscopic record of shifting aesthetic and ideological patterns registering the evolving status of a modern Indian woman as she gradually parts ways with patriarchal

constraints and navigates the fluctuating terrain of tradition and modernity.[4]

Colonial India, functioning as Europe's cultural and spiritual opposite, was often conceived of as female. As nationalist interests pressed for emancipation from colonial rule, India's national identity was formulated in part through the female sphere, whereby women's bodies were grounds, not just subjects, for debate between colonizers and reformists.[5] In this struggle, the Indian woman was split between a harem and a *zenana* identity, often conflated by the British to represent the essentialized characteristics of the Orient symbolized by the harem, an institution they deemed deviant and morally repugnant, and presented as the consummate wife and mother by Indian nationalists her life in the *zenana* signified her virtue. Nonetheless, though the harem and the *zenana* functioned similarly as polygynous and segregated spaces to control and protect women from non-kinship men and as sites for colonial and nationalist discourse, in the colonial period they manifest female identity differently.[6] *Harem,* an Arabic term meaning both a forbidden and sacred space, produces an exotic, often erotic stereotype. The *zenana,* Indo-Persian for the women's section of the home, was a feminocentric space and a set of domestic practices not deliberately exotic or erotic.[7] Best understood in colonial visual culture, the harem connotes a realm of erotic fantasy, while the *zenana* signifies traditional family values and operates as the harem's "other."[8] The complex interrelationship between harem myths and *zenana* realities forms a foundational paradox for colonial Indian women. The emergence in the late nineteenth century of India's New Woman, who, once sequestered and veiled, entered the public sphere, challenges traditional constructs of the feminine.

The metaphorical power of the harem was a stereotype built on thousands of accounts in orientalist scholarship, literature, and art that exoticized the female sphere and lent credibility to such fantasies. The British colonialists regarded women as the measure of a civilization. Misunderstanding the traditional *zenana,* they concluded that its practices were degrading to women and passed legal and educational reforms, including laws against child marriage, suttee (widow burning), and prostitution. For the Indian nationalists, the new nation was articulated as a feminized space signified by the *zenana* and its customary practices.[9] Reclaiming the illicit, eroticized harem as a legitimate familial space, nationalists domesticated orientalist stereotypes for native ends and wrought new definitions of modern Indian womanhood derived from harem fantasies and *zenana* realities.

Women were also participants in the debate over identity politics. Elite

Indian females had far more agency in crafting the public image of women than has previously been acknowledged. Not only did "cultured women emerge to lend a hand to their less fortunate sisters on the path of progress," but they did so through their photographic image.[10] Fashionable and eye-catching, New Woman imagery affirmed burgeoning levels of female autonomy, worked in tandem with feminist advancements to expose harem stereotypes, and proved that male-dominated constructs were only partly responsible for influencing modern female identity. Using photography to rupture Western stereotypes, India's New Women would propel a cultural transformation by unifying the roles of good wife/good mother associated with the *zenana* and the fallen woman of the harem through deliberate acts of self-exoticization.

India's New Woman arose simultaneously in the late nineteenth century along with her counterparts in Europe and the United States to challenge conventional social, sexual, and spatial boundaries. For the West, the New Woman expressed autonomy, individuality, and overt female sexuality. In the Indian context, however, she is monogamous, educated, a companion and helpmate to her husband, and an ideal mother.[11] Different is the emphasis on enhancing domestic authority and education rather than gaining sexual power in public. The dawning sexual liberation of Western New Women came late to India encouraged by *sitaras* (starlets of early films) and Modern Girl muses for India's middle class.[12] Antecedent to these Modern Girls, India's New Woman is located in elite culture and characterized by her refined domesticity, modesty, and visibility. Increased mobility and individualism most accessible to the upper classes took her beyond the intimate, ritualized world of the *zenana* to the educational and professional opportunities of the public arena. Yet for all her explorations beyond the veil, India's New Woman remained connected to tradition and her *zenana* identity.

Claiming greater public exposure in the male world still meant playing to patriarchal standards that required controlled sexuality. India's New Woman harnessed harem stereotypes that suggested sexual freedom through Western modes of fashion and public display while maintaining references to indigenous femininity. To mix publicly with men, India's New Woman traversed deeply ingrained boundaries of *purdah* (meaning "seclusion" in the Indian context) to become part of a modernizing movement that sought to modify gender relations through greater equality.[13] To keep her honor and status intact, she employed domesticity and extreme femininity steeped in local cultural traditions to navigate this new field of experience.

New Woman imagery recorded changes in female visibility, tracking cosmopolitan elites to London and Paris and repackaging Indian womanhood for an increasingly global and modern culture. Portraits promoting India's New Woman circulated in the popular press, mainly in Europe, and registered these imperfect transitions. The representational opportunities of photography, a medium for a modern era, created and reinforced female status and beauty, which in the Indian context remained partially informed by orientalist harem imagery that exoticized women's condition through narratives of eroticism. New Woman imagery in India borrowed from both, creating a powerful amalgam of domestic and exotic components to bring forth a complex set of connotations that merges the wife-whore paradox particular to Western notions of female sexuality. By emphasizing the conjugal family ideal and education with exotic beauty, exceptional wealth, and "harem" lives, Indian versions of the New Woman, at first glance, may not evoke typical New Women by Western standards, but therein lies their victory.

As elite Indian women began traveling abroad, the harem myth began to crumble. Photographs of their global identities yield a new feminine image that was to be vital for the formation of modern India. Linked to the forces of feminism, in choosing this path the *zenana* woman claimed her freedom. The circulation of their images also served the interests of Indian men. Those aligned with the British Crown, such as the Maharaja of Baroda, placed their wives in the public eye, traveling to Europe and attending galas, to reinforce their political standing with the English. Photographs of itinerant royal Indian couples reflect certain Victorian affiliations and assert Indian traditions. In contrast, the seventh Nizam of Hyderabad, having the women of his legendary *zenana* photographed, played on the harem stereotype to flaunt his authority and symbolize his ties to traditional Indo-Islamic kingship against British corrective measures.

The title of Singh's article on the Maharani of Baroda, "A Typical Woman of New India," gives rise to a question: what exactly is considered typical for Indian women of this era? Most upper- and middle-class women in 1912, whether Hindu or Muslim, lived in some form of *purdah*, primarily to uphold religious and cultural traditions and secondarily as a means of exhibiting status. Their lives focused on raising and educating their children, negotiating the financial security of those children, and tending to the needs of their husbands, all of which took place within a community of women. For women of the working and poor classes, *purdah* was a luxury as labor required a public presence. For the elite women considered here,

purdah symbolized family honor, duty, and prestige brought by seclusion, but its limitations were negotiable.[14] New Woman portraits indicate an elite women's ability to move fluidly between public and private spheres and between cultures. Many elite Indian women traveled to Europe, like the Maharani of Baroda, and did not practice seclusion or veiling. This deviation from custom while abroad did not interfere with a woman's choice to maintain *purdah* at home, exemplifying its selective application and demonstrated in photographs circulating on both continents.

That *purdah* prohibited female representation is a long-standing theory that has influenced interpretations of female representation in the art history of India.[15] Life in the *zenana* may have limited female portraiture, but by no means did it eliminate it. New Woman imagery challenges this assumption to show that portraits of elite Indian women, many of whom lived in some form of *purdah,* were in fact extensive and had wide distribution in public and private domains. Pictures appearing in foreign and domestic magazines, in newsprint, on calling cards, and in family albums testify to the status and star power offered by photography, further dismantling taboos on public exposure for *zenana* women. That women were open to presenting themselves publicly through the photographic medium, and in many cases did so proudly, speaks to the changing landscape of female status and the New Woman's emerging authority and identity. India's elite women were driving a cultural shift that blended the good wife/good mother of the *zenana* with exotic harem myths by playing up not eliminating "harem" references.[16] Proven by subtle choices in dress, photographic composition and style, and levels of public exposure, New Woman imagery references an exoticized "oriental" glamour and allure popularized by harem stereotypes to gain elite Indian women access to European society while their exposure produced small steps toward greater emancipation at home.

Singh's narrative of "the typical woman of New India" portrays the Maharani of Baroda as both consummate traditional Indian woman and glamorous oriental queen. Within the context of the New Woman, Singh was not entirely wrong. A frequent world traveler, the Maharani carefully crafted a hybrid self-image to reflect her embrace of Western values and fashionable trends, signs of her cosmopolitanism, as well as to reinforce her traditional role as a good wife and mother.[17] She appears in public alongside her English-suited husband or alone with her children consistently dressed in classic Indian saris. Openly unveiled in public yet in *purdah* at home, she simultaneously advocated a traditional and modern identity,

emancipated yet restrained. Her book *The Position of Women in Indian Life* advanced the emerging freedom of other Indian women, though posited through Western models.[18] Her cross-cultural identity, a product of the colonial encounter, is disclosed by photography to reflects changes in Indian womanhood.

From the onset, photography functioned as propaganda and generated a series of ruptures between tradition and modernity that exposes the cultural hybridity of the New Woman. In Singh's article, the Maharani of Baroda is presented as typical to a European reader and promotes herself as a role model for Indian women. Dressed simply and traditionally in a plain sari with bare feet and an ordinary display of jewelry, she celebrates a common native femininity (fig. 4.1). However, the text gives a detailed accounting of her lifestyle and material wealth that belies her modest presentation and fulfills foreign expectations of exotic Indian royalty. Noting the value of her jewelry trousseau, item by item, the sophisticated decor of her living quarters, and the feudal operation of her well-staffed kitchen renders her far from conventional. This incongruity suggests a purposefully hybrid woman, one that appeals to expectations of European readers seeking the decadent oriental woman now carefully modernized while affirming an adherence to local customs (*dastur*) befitting her royal status.

Seated in a European-style chair, her modest attire emulates the conservatism characteristic of Victorian fashion popular among many of India's upper-class women.[19] Yet her traditional qualities are reinforced by the allusion made to an Indian goddess, a reference designed for local viewers. The Maharani holds a sitar against her body like the Hindu goddess Saraswati, directly citing ancient religious iconography and a contemporary image made popular in the paintings and oleographs of nineteenth-century painter Raja Ravi Varma. Secularizing the goddess in the Maharani sanctions her prescribed domestic role as keeper of the faith but also places her image within the popular vernacular, positioning her within traditional and modern domains. This photograph also documents the exchange of indigenous formats and Western pictorial conventions characteristic of colonial visuality and further complicates understandings of modern Indian female identity. Far from typical, such photography captures the elite colonial subject's movement toward "self-orientalization," which manifested in the embrace of Western stereotypes, a trope also played on by artists of the period in India and elsewhere.[20] This photo shows the layered meanings of colonial visuality and the incongruous blending of tradition and modernity of India's New Woman.

Fashion, as a form of self-expression, is as much about conformity as breaking boundaries of gender and identity. Different identities can be easily adopted and discarded through clothing. Although fashion can denote the oppression of women, positioning them as merely ornamental, it can also be used in liberating ways and may express ambiguities.[21] Some aristocratic elites emulated an international code of dress to mark their status. For the Indian women who traveled to Europe and appeared in Western crinoline and corsets, fashion was a vehicle of transformation, a realm of play and escape, used not only to integrate but to express their own interests.

Different from the native qualities conveyed by the picture of the Maharani of Baroda, cosmopolitan maharanis largely wore European dress to connote their sophistication. Such images, published in Europe, celebrated a new rite of cross-cultural femininity, situating these royal women firmly within the ranks of European nobility to complement their husbands' imperial associations and aspirations. A photograph by Europeans Bourne and Shepherd of the Maharani of Burdwan published in the English magazine the *Tatler* (March 31, 1909) foregrounds her wealth and power, and by extension that of her husband, while also legitimizing conjugal and economic parity with the British aristocracy (fig. 4.2).[22] This version of India's New Woman exemplifies transnational modernity unimpeded by traditional constraints.

The Maharani of Burdwan's heavily jeweled attire mimicked the opulence of a similar portrait of Queen Victoria also by Bourne and Shepherd. She sits unveiled, crowned and gloved, wearing a stiff, formal, lace-encrusted bodice and dressed in white, as dictated by English fashion. Swags of pearls and chokers of egg-sized emeralds and diamonds fulfill the fantasy of excessive wealth associated with Indian royalty while the rough cut of her jewelry reveals her native origins. An unveiled countenance accentuates her power to claim a modern identity. Yet her lavish presentation also recalls the excessive exoticism characteristic of orientalist harem images.

The development of the halftone photographic process revolutionized the European illustrated press of the late 1890s and contributed to the formation of India's New Woman. This method allowed for the reproduction of high-quality, full-page photographs, producing a new artistic genre of society portraiture and gossip journalism that flourished in newsprint magazines such as the *Tatler, Lady's Realm,* and *Femina* published in English and France. Pictures of elite Indian women were popular and were

Fig. 4.2. The Maharani of Burdwan, 1909, Bourne and Shepherd, black-and-white photograph (9 1/4 in. x 6 1/2 in.). (From the *Tatler*, March 31, 1909, Collection Laruelle, vol. 87, folio ne 63 D028506, Bibliothèque Nationale de France.)

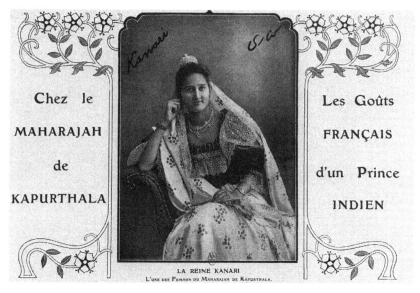

Chez le
MAHARAJAH
de
KAPURTHALA

Les Goûts
FRANÇAIS
d'un Prince
INDIEN

LA REINE KANARI
L'UNE DES FEMMES DU MAHARAJAH DE KAPURTHALA.

Fig. 4.3. The Maharani Kanari of Kapurthala, 1912, photographer unknown, black-and-white photograph (4 1/2 in. x 3 3/8 in.). (From the *Lady's Realm*, 1912, Collection Laruelle, vol. 87, folio ne 63 D028563, Bibliothèque Nationale de France.)

regularly featured, adding glamour and exoticism while also legitimizing the power of foreign women through New Woman narratives.[23]

The awareness of the viewer was inherent in India's New Woman imagery. Intended to appeal to European and Indian audiences, royal portraits circulated on multiple levels as family heirlooms, publicity shots, calling cards, and souvenirs available to the general public. Each type addressed a different constituency and extended the visibility of India's New Women and their entrée into the public sphere. A portrait from 1910 of Maharani Kanari of Kapurthala published in France reiterates the guise of the anglicized Indian queen (fig. 4.3). Kanari wears a loose bodice of Belgian lace and full mutton leg sleeves; she has white gloves clutched in hand with a tiny crown and veil atop her head, referencing the ubiquitous style of Queen Victoria, but the fabric and pattern of her veil and skirt are Indian. The Maharani's cross-cultural style reflects her native and European sensibilities celebrated in an accompanying article about her French taste and Indian charm. Her husband, Maharaja Jagatjit Singh, a world traveler and Francophile with a chateau in France, called Kanari his "travelling wife" (he had seven wives), identifying the mobility that existed for some *zenana* women.[24]

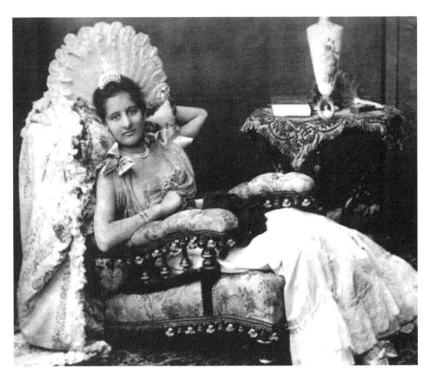

Fig. 4.4. The Maharani Kanari of Kapurthala, ca. 1910, photographer unknown, black-and-white photograph (original size unknown). (Reproduced in Rita Kumar, *Costumes and Textiles of Royal India* [London: Christie's Books, 1999], 71.)

A second photograph of Maharani Kanari reinforces the fusion of Western styles and harem stereotypes, both exotic identities taken up by India's New Woman (fig. 4.4). Posed provocatively on a chaise longue in a French gown with a loose bodice that radically exposes her bare arms, she is transformed into a glamorous odalisque. Her feet are covered in satin-bowed shoes, in contrast to the traditional bare feet of the Maharani of Baroda, and a seashell-like white headdress fans out behind her. This tantalizing look was also taken up in the same era by Mata Hari, the ultimate Western "harem" woman. When considered together, these provocative self-orientalized images indicate how certain elite Indian women unveiled and placed themselves on display, casting their sequestered status aside, while Western women indulged in the harem fantasy and took it to levels of erotic extreme.

These pictures of the cosmopolitan maharani suggest that a penchant for emulating Victorian standards and French haute couture was a mark

of distinction and sophistication for Indian queens and European women. In depicting themselves in this manner, Indian queens claimed parity with European New Women and achieved entry into European society on levels that remained inaccessible to Indian males. These fashionable photographs of Indian women can be read as a form of self-portraiture whereby the female subject in collaboration with the photographic process choreographs her identity, displays her power through fashion, inserts herself into foreign narratives and uses the photographic opportunity to disseminate her self-made image.

Another thematic trend in Indian New Woman portraiture is an emphasis on conjugal status and monogamy, contrary to the polygynous practices of most Indian elites and many of the women discussed here. Eliminating polygyny was an area of great political concern for the British, and reforming the deviant "harem" woman was part of their civilizing mission.[25] Articles written for the European public defined Indian women through their marital status and association with their husbands, reference points equated with good moral, that is, Christian, values. Despite advances in women's rights in India and Europe, a woman's economic power was dependent on her conjugal alliance. For the traditional Indian woman, an excessive display of jewelry directly referenced her husband's wealth and her status, a feature often emphasized in New Woman portraiture. The Indian New Woman as monogamous lent authenticity to her husband's claim to coequal status and membership in the network of European aristocracy. However, for the Indian woman exchanging polygyny for monogamy was simply a matter of trading one type of patriarchal control for another.

Patriarchal control is a factor in yet another New Woman type. Nationalist politics focused on improving the condition of women to craft a modern identity for the Indian nation. As a New Woman type, the *bhadramahila*, an educated upper-class woman primarily of Bengal, would offer a particular kind of Indian womanhood, one based in "certain culturally visible spiritual qualities that were clearly marked and intended to emphasize her essential femininity—in her dress, her eating habits, her social demeanor, her religiosity."[26] Yet she also embraced Westernized notions of freedom that allowed her to circulate beyond the confines of the home. Her role as a New Woman was crucial in resolving the contradictory problem of modernizing the Indian nation on Western terms and retaining a central national identity. India's New Woman in the form of the professional, English-educated *bhadramahila* came to exemplify this compromise through a fusion of imagery blending Western and Indian aesthetics that under-

scores her shifting cultural associations and accentuates her professional and domestic merit.

The *bhadramahila* became the designated icon for the Indian nationalist movement. Stemming from the Bhramo Samaj, a reform Hindu faction, the *bhadramahila* was a character invented by and for nationalist agendas, a type photographed extensively and distributed in the local and foreign press as an emblem of the New India. Defined as the ideal Indian woman, she was sister and citizen to the struggle for independence and dedicated companion to her husband.

Education was key to the *bhadramahila* identity. Reformist Indian men, committed to a progressive society that included educated women as partners, believed that if women were educated Indian society could no longer be characterized as decadent and backward.[27] The *bhadramahila* type was deemed virtuous due to her modesty and intelligence; she was employed, philanthropic, and influenced by Christian models of comportment. Such qualities shine through in a series of stripped-down photographs that feature *bhadramahila* women classically attired in plain cotton saris, hair pulled back in a tight knot emphasizing her unavailability, lacking embellishment but for a clear countenance. In contrast to cosmopolitan maharanis, this version of the New Woman was homegrown.

The restraint and simplicity of "the honorable representative for India, Miss Marie Bhor," is typical of *bhadramahila* portraits (fig. 4.5). Reproduced in *Lady's Pictorial* (1912) Miss Bhor's plain white cotton sari with a subtle patterned border is traditional, regional, and caste specific, recalling the understated tact of the Maharani of Baroda. Jewelry was the practical and symbolic indication of an Indian woman's wealth and standing regardless of her class and caste, yet we see Miss Bhor with little jewelry. In this distancing from customary displays of female power, she conveys self-made authority, her locus centered on intellectual and spiritual values. Her outward modesty is therefore an expression of her inner character, emphasizing the Indian woman as guardian of the nation's spiritual domain. Wrapping her sari close to her body, rather than overhead in the traditional manner, her head is bare, alluding to her post-*purdah* status.

Portraits of the mundane yet accomplished *bhadramahilas,* many of whom did not travel extensively, appeared in European ladies' journals alongside pages and pictures of the more glamorous maharanis, indicating the complex diversity of Indian female identity in the early twentieth century.[28] Similar to the New Woman of Europe, the *bhadramahila* engaged with political and social reform. She could flout conventions, become educated,

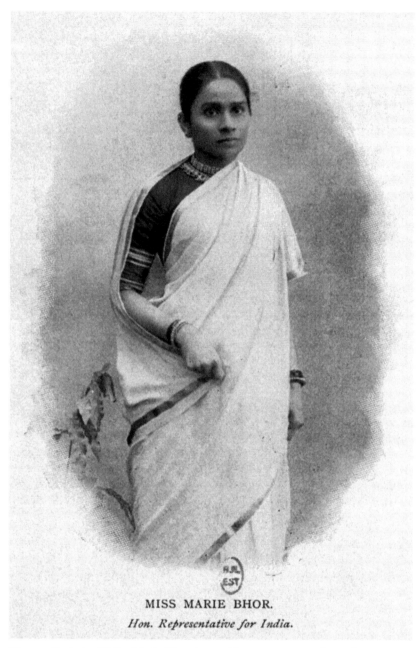

MISS MARIE BHOR.

Hon. Representative for India.

Fig. 4.5. Portrait of Miss Marie Bhor, honorable representative for India, ca. 1900, photographer unknown, black-and-white photograph (7 1/4 in. x 5 1/4 in.). (From *Lady's Pictorial,* ca. 1900–1910, Collection Laruelle, vol. 87, folio ne 63 D028482, Bibliothèque Nationale de France.)

take a job, and work outside the home. Yet such practices as living outside the familial home and social mingling between the sexes common to Western New Women did not come as readily for Indian New Women, who even as educated, politically engaged professionals, *bhadramahilas* were still bound to marriage and family, many still part of the *zenana* system. Because of their *purdah* status, autonomy and individuality were expressed differently, and much of their freedom was directed toward the good of the domestic sphere. Many entered medical and legal professions previously closed even to women in Europe and traveled to England for their education. Others participated in suffragist struggles such as the nationalist poet Sarojini Naidu and barrister Cornelia Sorabji, while others marched in the streets of London. Quintessential *bhadramahilas*, their efforts were aimed at female education and changing the structure of *purdah*, immediate concerns for colonial Indian women. Obtaining the vote, engaging in consumerism, or exploring open-ended female sexuality, interests of the Western New Woman, were changes that would arrive in the 1920s with the coming of the Modern Girl, bringing even more expansive forms of femininity, though the female vote in India was not achieved until 1950.

Simultaneously, amid modernity's growing appeal, the gathering force of Indian nationalism, and nascent female emancipation movements, a series of *zenana* photographs celebrate what in contrast seems archaic. A precursor to New Woman imagery, these portraits of the 44 wives, consorts, and companions of Osman Ali Khan, the seventh Nizam of Hyderabad (1911–48), taken circa 1915, portray the definitive elite *zenana* woman. This archive of 130 photographs produced by the prestigious native photographic studio of Raja Deen Dayal and Sons is the most comprehensive depiction of the Indian *zenana* to date.[29] In 2003 I discovered the photos in the Nizam's private apartment at King Kothi Palace in Hyderabad, rolled up at the bottom of a sealed cabinet, the decades of concealment indicative of their sentimental and intimate value. That the Nizam of Hyderabad exposed his women to the camera regardless of *purdah* and the strict orthodoxy of his Muslim court presents an intriguing set of concerns that incorporate issues of gender, power, and female autonomy as based within the domestic sphere. These pictures serve as reminders that, despite the cosmopolitan behaviors and progressive agendas of some Indian elite women in the early twentieth century, *purdah* and polygamy were still very much in practice.

These photographs digress from New Woman imagery by picturing traditional *zenana* women confined to *purdah* and loyal to age-old patri-

archal structures. Only in a portion of the 130 images in the archive are the 14 wives of the Nizam portrayed in complete compliance with their customary role in a series of 56 individual portraits that share similar composition and styling. The women of the Nizam's *zenana,* such as the wife Chunnu Begum pictured in figure 4.6, are exquisitely dressed in Hyderabadi *chaugoshia* with subtle variations in patterns, colors of costume, and jewelry that distinguish each woman's group and individual status within the ranks of the *zenana.*[30] Here the celebration of traditional Muslim practices and regional references is preferred, not the cosmopolitan gestures of India's New Woman, which openly embraced Victorian fashion or exposure in public. Unlike other types of New Woman imagery, which emphasize monogamy, mobility, and erudition, the Nizam's wives, though singled out for these portraits, remain part of the larger female collective as indicated in these pictures by the repetition of poses, the uniformity of dress, and the shared display of a pearl and diamond pendant (*choti taveez*) that signifies their membership in this *zenana* community. This membership, along with their roles as wives, mothers, and concubines, was a form of female authority, but one formulated through yet another perspective.[31]

The photographer emphasizes customary female power through compositional strategies. Like the portrait of the Maharani of Baroda, direct reference to Varma's revival of Indian goddesses and mythic heroines is made in Chunnu Begum's pose by the balustrade, a common setup in Varma's paintings. Therefore, the women of the Nizam's *zenana* are not the objectified bodies or fantasy figures found in orientalist renderings, and, though referencing Western-style studio portraiture, they are portrayed akin to traditional native heroines.

The anglicized portraits of maharanis and *bhadramahila* women were published in the foreign press to represent New Women circulating beyond *purdah.* The wives of the Nizam, however, have not traveled outside the *zenana.* Their portraits are situated in the confidentiality of the *zenana* garden enclosure where awkward painted backdrops of English country landscapes re-create a false reality. The intimacy of this inner world tied to a fantasy outer world connects these women to a broader artistic discourse and cosmopolitan desires that, unlike their New Woman sisters, these strictly sequestered women would rarely encounter. The private context reinforces the reality of customary constraints, which in this case is meant to underscore the Nizam's power and authority, rendering these *purdah* women much like the New Woman, who despite her aura of autonomy was still positioned in relation to her husband's status.

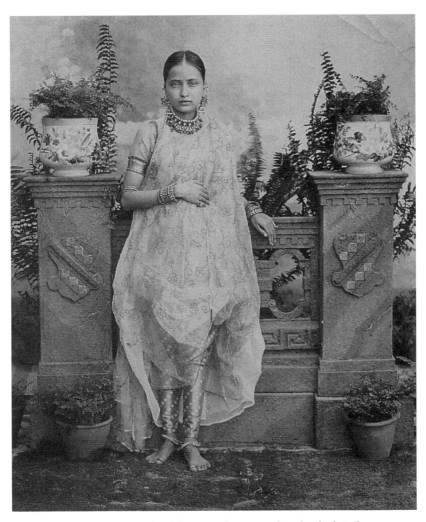

Fig. 4.6. Chunnu Begum, wife of the seventh Nizam of Hyderabad, India, ca. 1915, Raja Deen Dayal and Sons, silver gelatin print photograph (actual size of print 7 1/4 in. x 4 3/4 in.), unpublished. (Collection the Chowmahalla Palace Museum, Hyderabad, India.)

Considering these photographs in relation to New Woman imagery reveals similar stylistic references but different motives. The Nizam's court was defined by adherence to Indo-Islamic law and pride in the maintenance of Mughalai custom and ritual.[32] In keeping with Mughalai traditions, the *zenana* formed the core of courtly life and provided a stronghold of domesticity that produced heirs, alliances, and royal ritual.[33] In this

unprecedented archive, the Nizam flaunts his *zenana* of forty-four women. The sheer number of his wives, concubines, and consorts defies colonial pressure to end polygyny and indicates the Nizam's apparent lack of interest in the modern feminist reforms gaining ground in other courts. In this extensive photographic record of the lived *zenana*, the Nizam asserts his power and masculinity in keeping with traditional laws of Indian kingship, in which the *zenana* was a political asset and a necessary part of legitimizing his ability to rule. These photographs exhibit allegiance to a domestic practice under siege by both British imperialist agendas and Indian nationalist concerns. Contrary to other native princes, who were adopting monogamy and distancing themselves from this age-old institution, the Nizam celebrates it, reclaiming the orientalist harem stereotype for his own purposes. In numerous images in this archive, the Nizam is depicted as a stereotypical harem lord with his wives and concubines lounging in the manner of exotic odalisques.

Like his Mughal ancestors, the Nizam uses art to record his dynastic history for posterity. Well aware of the perceived "truth" factor of the photographic image, he unveils his "harem," displaying its size, abundance, and variety, as a matter of personal pride and proof of his observance of customary practices of Indo-Islamic kingship. Mughal portraits of the *zenana* accentuate the carefree and playful relationship between the monarch and his consorts, while the European orientalist versions depict the harem woman as a cunning seductress. Photos of the Nizam's *zenana* present poised women that are self-possessed, perhaps unveiled but not undressed. The depiction of the Nizam's *zenana* expresses the promise of traditional and patriarchal values as cohesive with modernity. Their status as New Women is ultimately absent, but as a transitional figure in the development of an emancipated Indian female, the women of the Nizam's *zenana* hold pride of place in a changing world. Their traditional attire and orientalized presentation establish their hybrid modernity, while resisting British hegemony.

The link between harem discourse and the development of "freedom movements" for women, as well as for the nation, and narratives that resisted nationalist and imperialist designs are presented in this essay as portending the vital role of women and the photographic image in shaping these agendas. Dipesh Chakrabarty's analysis of the modern Indian woman hinges on the idea of freedom. Unlike the ultrafree Western woman, characterized as "selfish and shameless in her public interactions with men, the modern Indian woman was educated enough to contribute to the larger

body politic but yet modest enough to be un-self-assertive and unselfish."[34] In all four types of the Indian New Woman, aspects of this modest proposal are evident, therefore indicating the variability of sometimes conflicting identities, identities that an individual woman might use at different times.

Harem tropes and modern notions are present in varying degrees in all of these portraits. When considering the orientalist opinion of the harem as a form of incarceration and the Indian belief in the *zenana* as the domestic ideal, New Woman imagery emerges from diametric tensions to form a cathartic release from harem types. The pictures from the Laruelle archive indicate a variety of Indian New Women and show them reaching beyond the limits of seclusion and veiling to explore emancipation, individuality, personal taste, and mobility. Each woman claims her autonomy by using the photograph to secure a modern identity. The Nizam of Hyderabad's wives, rather than antithetical to the New Woman, prefigure her unbridled expansiveness, and, although they are still in seclusion, in their own subtle manner they take steps toward greater freedom by standing in front of the camera. A woman of her time, midway between tradition and modernity, the elite Indian female continues to elevate male power while also achieving new degrees of emancipation. By the 1880s some New Women had liberated themselves from the *zenana* publicly through dress, travel, and lifestyle; others find their power privately by observing the fading forms of the *zenana* tradition. Common to both causes is the formative power of orientalist harem stereotypes repeatedly repositioned by the photographic image.

Notes

1. Saint Nihal Singh, "A Typical Woman of New India," *Lady's Realm* 33 (1912). (Copy viewed in the Collection Laruelle, Ne 63 Fol. Tome 87, D028484, Bibliothèque Nationale de France.)

2. *Bhadramahila:* female relative of bhadralok and member of the educated Bengali elite; participant in modern domestic reforms; applied to Muslim elite women in the early twentieth century. See Sonia Amin, *The World of Muslim Women in Colonial Bengal, 1876–1939* (Leiden: E. J. Brill, 1996). *Bhadralok:* a male member of a Western educated Bengali elite promoting modern domestic reforms favoring female education.

3. The circulation of these images is a subject of ongoing research. Five of the six images in this study were intended for foreign journals. The issue of authorship is also in question as some photographers signed the work while others did not.

4. See Angma Dey Jhala, *Courtly Indian Women in Late Imperial India* (London:

Pickering and Chatto, 2008), 15, regarding the elite *zenana* and its practices in the context of tradition and modernity.

5. Lata Mani, "Contentious Traditions," in *Recasting Women: Essays in Indian Colonial History,* ed. K. Sangari and S. Vaid (New Delhi: Kali for Women, 1989), 118.

6. Ruby Lal, *Domesticity and Power in the Early Mughal World* (Cambridge: Oxford University Press, 2005); Inderpal Grewal, *Home and Harem: Nation, Gender, Empire, and the Cultures of Travel* (Durham: Duke University Press, 1996).

7. Irene H. Barnes, *Behind the Pardah* (London: Marshall Brothers, 1897), 41.

8. Lal, 1–6.

9. Grewal, 7; Partha Chatterjee, "The Nationalist Resolution of the Women's Question," in *Recasting Women: Essays in Indian Colonial History,* ed. K. Sangari and S. Vaid (New Delhi: Kali for Women, 1989), 233–35.

10. For more on the history of female representation in colonial photography, see Sarah Graham-Brown, *Images of Women* (New York: Columbia University Press, 1988).

11. Geraldine Forbes, *Women in Modern India* (Cambridge: Cambridge University Press, 1996), 65.

12. Priti Ramamurthy, "All-Consuming Nationalism: The Indian Modern Girl in the 1920s and 1930s," in *The Modern Girl Around the World: Consumption, Modernity, and Globalization,* ed. The Modern Girl Around the World Research Group (Alys Eve Weinbaum, Lynn M. Thomas, Priti Ramamurthy, Uta G. Poiger, Madeline Yue Dong, and Tani E. Barlow) (Durham: Duke University Press, 2008), 150.

13. Forbes, 28.

14. Sylvia Vatuk, "Purdah Revisited," in *Separate Worlds: Studies of Purdah in South Asia,* ed. H. Papaneck and G. Minault (Delhi: Chanakya, 1982), 60.

15. Vidhya Dehejia and Pratapaditya Pal, *From Merchants to Emperors: British Artists and India, 1757–1930* (Ithaca: Cornell University Press, 1986), 131.

16. See Grewal, 42; Partha Chatterjee. *The Nation and Its Fragments: Colonial and Postcolonial Histories* (Princeton: Princeton University Press, 1993); and Dipesh Chakrabarty, *Provincializing Europe* (Princeton: Princeton University Press, 2000), 39.

17. Lucy Moore, *Maharanis* (London: Viking, 2004).

18. Maharani of Baroda and S. M. Mitra, *The Position of Women in Indian Life* (London: Longmans, Green, 1911).

19. Malevika Karlekar, *Re-Visioning the Past: Early Photography in Bengal, 1875–1915* (New Delhi: Oxford University Press, 2005), 113–32.

20. Ali Behdad, "The Powerful Art of Qajar Photography: Orientalism and (Self)-Orientalizing in Nineteenth-Century Iran," *Iranian Studies* 34, no. 1–3 (2001): 148.

21. Elizabeth Wilson, *Adorned in Dreams: Fashion and Modernity* (New Brunswick, NJ: Rutgers University Press, 2003), 246.

22. Mytheli Sreenivas, *Wives, Widows, and Concubines: The Conjugal Family Ideal in Colonial India* (Bloomington: Indiana University Press, 2008), 7.

23. Wilson, 158.

24. Moore, 99.

25. Sreenivas, 16; Antoinette Burton, *Dwelling in the Archive* (Oxford: Oxford University Press, 2003); see also Durba Ghosh, *Sex and the Family in Colonial India* (Cambridge: Cambridge University Press, 2006); Ann Stoler, "Making Empire Respectable: The Politics of Race and Sexual Morality in Twentieth Century Colonial Cultures," *American Ethnologist* 16 (1988): 634–60.

26. Chatterjee, *The Nation and Its Fragments*, 130–32.

27. Vatuk, "Purdah Revisited," 61.

28. For Bengali *bhadramahila* portraits, see Karlekar, 111–25.

29. Raja Deen Dayal (1844–1905) was court photographer to the sixth Nizam of Hyderabad from 1884 to 1905. These pictures, approximately dated to 1915, were taken posthumously, most likely by his son and successor Gyan Chand.

30. The *chaugoshia*, or traditional Muslim attire, is comprised of four parts: the *kurti* (long shirt), *choli* (blouse), *pyjamas* (tight drainpipe trousers), and *khada dupatta* (a length of fabric of about five meters worn over the shoulders and head).

31. For more on the full archive, see Gianna M. Carotenuto, "Domesticating the Harem: Re-considering the *Zenana* and Representations of Elite Women in Colonial Photography of India, 1830–1920," PhD diss., University of California, Los Angeles, 2009.

32. Benjamin B. Cohen, *Kingship and Colonialism in India's Deccan, 1850–1948* (New York: Palgrave Macmillan, 2007).

33. Lal, 1–23.

34. Chakrabarty, 17.

PART 2

*Art and Identity: Gender Constructions in
Photography and Photomontage of the 1920s*

5

Postcolonial Cosmopolitanism: Constructing the Weimar New Woman out of a Colonial Imaginary

BRETT M. VAN HOESEN

The New Woman of the Weimar Republic, a construct of both fact and fiction, dominated German visual culture of the 1920s and early 1930s. While there has been much discussion about the discourses of modernity embedded in the tropes of her image—the *Bubikopf* hairstyle, cigarette, lipstick-lined lips, and modern dress—her identity as a so-called New Woman (or *neue Frau*) was as much determined by her self-conscious positioning within the global world as by her look. The interwar popular press reinforced for its readers the spectacle of internationalism, particularly through the mechanism of documentary photography. The pages of the weekly and monthly *Illustrierte,* or illustrated newspapers, were packed with images of people, customs, architecture, as well as flora and fauna of distant lands far removed from German soil. Historians such as Hanno Hardt have rightly argued that this phenomenon, in conjunction with popular films, "helped reintegrate a defeated Germany visually into the world community."[1] This fascination with the outside world not only corresponded with Germany's recent defeat in the First World War but with the gradual loss of German colonies. These included Southwest Africa, Togo, Cameroon, German East Africa, territories in the Pacific, and Kiaochow on the Shantung Peninsula in China. While most of these colonies were lost over the course of the war, it was not until January of 1920, with the ratification of Paragraph 119 of the Treaty of Versailles, that Germany officially relinquished control over these sites. Although political sentiment regarding the colonies before and during the war was mixed, just months after ratifying the treaty the Reichstag voted to reobtain the former colonies as a means of reinserting Germany into the global economic sphere. Prior to the First World War, the Social Democratic Party had been skeptical of the colonial enterprise, but by March of 1920 the party, as well as a majority of the Independent Social Democrats, supported a neocolonialist

agenda. Historians have contended that, despite this political climate, the broader public during the Weimar era was not impacted by the loss of colonies.[2] This contention, however, discounts the role that the popular press and other mass-produced visual materials played in affecting majority culture. If the popular press was careful to avoid overt references to the war and its aftermath, it also evaded a direct discussion of the recent reduction of Germany's geographic borders. As a means of subtly coping with these territorial losses, through documentary photography and illustrated advertisements the press helped to foster nostalgia for Germany's prewar past by manufacturing what I will refer to as a *colonial imaginary,* restaging tropes of a bygone imperialist age.[3] Ethnographic photos and accompanying articles devoted to peoples from former colonial sites and images of explorers on safari, as well as "exotic" animals, botanicals, and vistas, created the myth that Germany sustained a foothold within a global community on a par with other European colonial powers.

The Weimar New Woman both as a reader and construct of the popular press played an integral role in fostering this colonial imaginary. In this essay, I examine two prevailing paradigms that characterized her function. The first involves the recurring comparison between the New Woman and variant renditions of the "Other" Woman. Mainstream journals such as *Berliner Illustrirte Zeitung (BIZ), Münchner Illustrierte Presse (MIP), Die Dame, Uhu,* and *Der Querschnitt* reinforced a visual taxonomy of female types, including mothers, workers, fashion models, and performers. This lexicon showcased a fascination for prototypical images of the New Woman, as well as for pictures of women from around the world, from Africa to the South Seas and from Asia to Latin America. In short, ideas concerning *Otherness* in relation to notions of the self served as a defining discourse of Weimar New Womanhood. The second paradigm involves the phenomenon of the New Woman as explorer. Seen in combination with her male counterpart, the female explorer typology contested the notion that expeditions and safaris were unsuitable for ladies. While such depictions played to the rhetoric of empowering the modern woman, the appeal of this particular persona also complied with a lingering taste for colonial adventure. Furthermore, the spectacle of the New Woman posed with exotic animals such as zebras, giraffes, and alligators catered to the prerequisite entertainment value of press photography. This pairing of women and animals ultimately referenced a host of discourses ranging from contemporary fashion aesthetics to more serious issues involving contemporary scientific studies and the racial politics of the Rhineland Controversy, beginning in 1919 and lasting through the 1920s.

If the popular press served as one of the main venues where Weimar postcolonial discourses were played out, other media, such as photomontage as practiced by members of the avant-garde, also contributed to this arena. The medium of photomontage has long been associated with the critique function of the avant-garde. While this designation is indeed appropriate, it has perpetuated the notion that photomontage is removed from its original photographic sources and defined as something wholly new.[4] Photomonteurs Marianne Brandt and Hannah Höch understood the culture of popular press photography during the 1920s—the dynamism, drama, entertainment value, and climactic moment—as well as the perceived truth-telling capabilities of the image. Through mimesis and satire of these traits, they created montages that were capable of critiquing the ideology of imperialism. At the same time, as loyal readers of *Illustrierte,* Brandt and Höch often assumed the less critical persona of armchair travelers. While neither had traveled to former colonies nor to locales far beyond Europe, press photographs simulated wider travel.[5] To varying extents, their montages presented tropes of Weimar postcolonialism, capturing the fascination for the "Other" Woman, the female explorer prototype, and the pairing of the *neue Frau* with exotic animals. In the case of both artists, their work embodies a dichotomy between critiquing the rhetoric of colonialism and celebrating the spectacle of internationalism. While this stance may seem contradictory, it reflects the slippage between the medium of photomontage and its indebtedness to its original documentary sources. More important, it illustrates the inherent contradictions intrinsic to Weimar postcolonialism.

(Post)Colonial Cosmopolitanism meets Weimar Postcolonialism

Using the term *postcolonial* in reference to the Weimar era warrants some explanation.[6] Gayatri Spivak's insightful suspicion of the artificial divide between colonial and postcolonial histories prompted my interest in the postcolonial condition of the Weimar Republic.[7] Despite the fact that German colonies were subsumed by other colonial powers during the First World War, the legacy of imperialism lingered in vestiges of political, popular, and, particularly, visual cultures. Nonetheless, mapping and defining the coordinates of Weimar postcolonialism is a challenging task due to its multidimensional character. Within the political realm, there was an impetus to protest the finality of the colonial settlement specified in the Treaty of Versailles.[8] This sentiment colored international relations between Germany and other European powers during the interwar period. It also became the agenda of

the Deutsche Kolonialgesellschaft (German Colonial Society, DKG), which by 1926 had 250 branches throughout Germany with a total of thirty thousand members.[9] Their procolonial stance manifested itself through published books, pamphlets, periodicals, calendars, novels, advertisements, theatrical events, school programs, and exhibitions. While it would be inaccurate to characterize this neocolonial climate of Weimar as pervasive, the reality is that the lingering legacy of German colonialism was discernible by the larger public through a variety of means. The historian Mary E. Townsend, writing in 1928, confirmed this by reporting on an active "contemporary colonial movement in Germany," which extended far beyond the framework of colonial associations by "telling the Germans more about their former colonies than they ever knew when those lands were German soil."[10] Townsend noted that such colonial-focused magazines as the *Koloniale Rundschau* and *Der Kolonial-Deutsche* had "a wide circulation although Germany owns no colonies."[11]

The Weimar popular press subscribed to a more subtle engagement with postcoloniality—reinforcing a number of visual tropes, including the aforementioned dichotomy between the New Woman and the "Other" Woman, the female explorer typology, and the pairing of the *neue Frau* with exotic animals. Collectively, these paradigms correspond to the conceptual framework of what Peter Van der Veer has called *colonial cosmopolitanism.* According to Van der Veer, cosmopolitanism is "not only a trope of modernity but also, and very specifically, of *colonial* modernity."[12] As such, colonial cosmopolitanism functions as a form of translation and conversion of the local into the universal.[13] In the case of the Weimar era, a plethora of visually oriented consumer commodities such as *Illustrierte,* films, novellas, collector's cards sponsored by cigarette companies, postcards, product packaging, displays at ethnographic museums, and *Völkerschauen* (human zoos) manufactured an aesthetic of *postcolonial cosmopolitanism.* As Germany's decreased access to the rest of the world necessitated this simulated cosmopolitanization of Weimar culture, the collective presence of this aesthetic reinforced a sense of sustained imperial might.

The Weimar New Woman and the "Other" Woman

> A pleasant feature was the girls, who in lines in front and behind the dancers, kept time by a body swing which caused their grass skirts to move in a pleasant rhythmic way. Many of these girls are extremely pretty, and of proportions that would exact the envy of many of our own women.[14]

Written and photographic accounts of the beauty and appeal of the "Other" Woman, as evinced by this quote from the Australian documentary photographer and filmmaker Frank Hurley, flooded the pages of Weimar *Illustrierte*. This so-called Other Woman functioned in contrast to the German New Woman. As a construct, the former represented a diverse geographic, cultural, and racial spectrum. Whether from New Guinea, Africa, Indonesia, Samoa, or a host of other locales, she was identified by her Otherness, a concept constituted by the color of her skin, ethnicity, dress, and the context in which she was photographed. The stark geographic divide between the German metropole and the former colonies meant that there was significantly less interaction between German citizens and former colonial subjects after the period of colonial rule. While there were some exceptions, most notably the touring groups for *Völkerschauen*, overall the geographic division between the *neue Frau* and the "Other" Woman meant that photographic comparisons were safe, part of a decisively postcolonial environment. In other words, admiration for the physical traits of women from other parts of the world could flourish given that these comparisons were theoretical and did not pose any real threat to European hegemony or racial purity. Uta G. Poiger has recently identified the "Asianization" of the Modern Girl, an aesthetic that served a range of advertising agendas in Weimar and Nazi Germany.[15] This mode of hybridity characteristic of the "international style" authored the Modern Girl as a byproduct of European and East Asian traits. It is important to note that other types of racial mixing were not *en vogue* during the 1920s and would not have functioned as a viable visual campaign for products such as cosmetics, tooth powder, and other toiletries. In short, modernist fantasies of the universal woman were committed to sustaining acceptable modifications of "whiteness."

The politics of hybridity did not preclude Weimar readers from curiosity about the "Other" Woman. The postwar years saw a dramatic increase in illustrated newspapers filled with advertisements and photographs catering to female consumers.[16] Illustrated and photographic renditions of the "Other" Woman were used to sell skin creams and soaps, products reliant on colonial imports such as dried coconut. Perpetuating the persuasive language of commodity culture, these images promoted markers of the "exotic" in order to sell products. A host of other types of pictures featuring women from around the world played to an interest in the global arena of New Womanhood, providing visual reportage about how women from across the world lived. The photographs of "Other" Women often featured the methods of what might be called "visual anthropology," an approach that was connected to the

research aims of ethnography and simultaneously rooted in pseudoscientific practices of spectatorship. Visual anthropology privileges the visual as a diagnostic tool in lieu of verbal communication.[17] Images of the "Other" Woman in the Weimar popular press often reinforced this conceptual framework; photographs published in journals such as *Der Querschnitt* and illustrated weeklies such as *BIZ* frequently allowed the photograph to "speak for itself." This meant that in many instances photos of the "Other" Woman were featured without accompanying articles or text, often juxtaposed with images of the New Woman. This comparative model played to the ideology of universalism by attempting to normalize or domesticate the "exotic" while at the same time "exoticizing" the domestic. According to Graham Huggan, this cultural construction engages two "opposite poles of strangeness and familiarity," which likely function together as a means of coping with newness.[18] Pages of *Der Querschnitt* often juxtaposed two seemingly unrelated photographs, reinforcing this type of reading. In a layout from the August 1925 issue, a fashion model from the London firm Reville is positioned next to a picture of two young women from New Guinea (fig. 5.1). The connection between these two images lies in the collective appearance of the women,

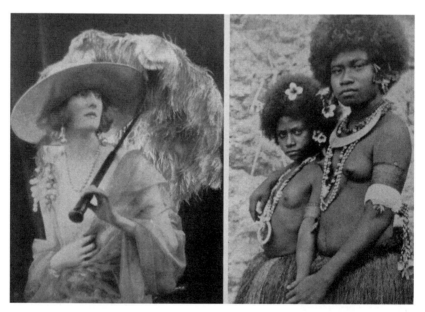

Fig. 5.1. A page from *Der Querschnitt*, August 1925. The captions read, from left to right, "Das schönste Modell der Firma Reville in London" and "Mädchen aus Neu-Guineu—Aus Captain Frank Hurleys Film, *Pearls and Savages*."

all of whom are elaborately adorned, showcasing a pageantry of femininity. The pairing simultaneously exploits the otherness of the New Woman and celebrates a curiosity about the "Other" Woman, a dynamic that would not have been lost on the readership.

Several of the photographs included in the Weimar press featured women from former German colonies such as Samoa, parts of Africa, and New Guinea. The latter locale was particularly popular, likely due to the prevalence of film stills and documentary photographs by the previously mentioned Australian filmmaker and photographer Frank Hurley. Hurley was a self-trained cameraman. He was renowned for accompanying expeditions to the Antarctic, serving as a war photographer, and producing films in conjunction with his own travels to the South Seas. The image from *Der Querschnitt* is a still from Hurley's 1921 film *Pearls and Savages.* Stills from this film, as well as a collection of related photographs published as a book a few years later, appeared in a number of issues of Ullstein Press publications, including *Der Querschnitt* and *BIZ.*[19] While not all of these images were of women, the two featured in figure 5.1 were widely reproduced. Their frontal pose, direct gaze, and partial nudity, as well as their adornment with jewelry, grass skirts, and flowers, served as identifiable markers for the "exotic." Additionally, their appearance reinforced a code of palatable beauty espoused by the "Other" Woman that was acceptable to Weimar readers.

Armchair Travelers and the New Woman Explorer Typology

When all geographic hideouts have been photographed, society will have been completely blinded.[20]

My wife holds the gun. Thank Heaven I have found the right sort of woman to take along with me into the desert and the jungle. If ever a man needed a partner in his chosen vocation it has been I. And if ever a wife were a partner to a man, it is Osa Johnson.[21]

The idea of the "Other" Woman is closely linked to the culture of exploration. The Weimar popular press featured photos, written accounts, and advertisements for a host of male explorers, hunters, filmmakers, and documentarians. It is significant to note that many of these individuals, like Frank Hurley, were not German. In light of Germany's postcolonial status, Australian, British, and American adventurers served as surrogates for a German tradition of exploration, which harkened back to the age of Alexander von

Humboldt. While curiosity certainly fueled the mass appeal of these features, the reality is that readers of Weimar *Illustrierte* relied heavily on these venues for information about sites beyond the boundaries of their cities, regions, or nation-state. As a result, armchair travelers willingly consumed stories and images concerning the politics, customs, and environmental wonders of Asia, the Americas, Africa, and the South Seas. Although they were often "newsworthy," these features also served as a calculated reprieve from postwar domestic politics. While the Weimar popular press skirted any overt reference to Germany's failed colonial past or renewed interest in reobtaining colonial properties, the coverage of explorers and the details of their expeditions reinforced a colonial imaginary. Simply put, the visually oriented realm of the press conveyed the message that the world was still collectable and consumable by a German readership.

In tandem with the male explorer persona, a New Woman explorer typology emerged in Weimar press and film culture. In contrast to her male counterpart, whose masculinity was conferred by his portrayal with a gun, felled animals, and subservient native guides or photo subjects, the New Woman explorer was firmly rooted in the field of high fashion. A signifier of the advertising industry, the New Woman was often used to promote products that relied on colonial imports. In conjunction with materials essential for manufacturing makeup and other beauty products, the skins and furs of exotic animals from well beyond the geographic boundaries of Europe were used to produce high-end shoes, garments, and accessories. In a full-page layout in *BIZ* in January of 1925, a series of photographs present the New Woman promoting alligator-skin shoes and leather ski jackets lined with leopard fur. One image from this page depicts a "huntress of high-taste" (fig. 5.2). A New Woman type donning the alligator-skin footwear she advertises mimics the victorious pose of a male hunter; with delicacy and grace, she steps on a dead, stuffed alligator. If courage was the desired signifier of the posturing by male explorers, the New Woman's equally staged triumph signals her fashion sense and lingering taste for colonial imports. It is worth noting that the text that accompanies this fashion spread reinforced the fact that products made from the skin and fur of exotic animals were not only in fashion but were "very modern," an additional indication that the colonial aesthetic was an essential ingredient of Weimar modernity.[22]

Though often relegated to being a huntress of high fashion, the New Woman explorer also encompassed a more active persona. Female travelers, adventurers, anthropologists, and photographers marked the liberation associated with the new age of womanhood. For the press, these types were

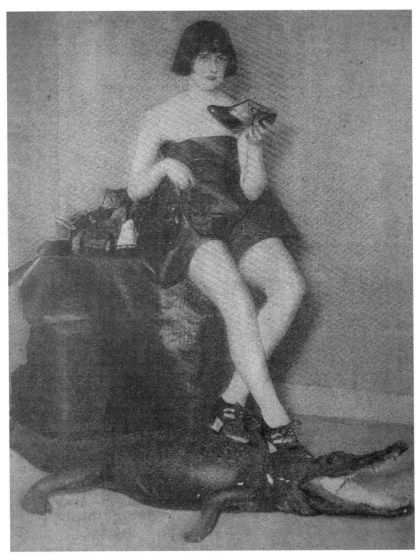

Fig. 5.2. Advertisement from *Berliner Illustrirte Zeitung*, January 1, 1925.

attractive; for some readers, they were a curiosity or inspiration; and for others they functioned as a spectacle, a means of selling papers and illustrated magazines through shock value. Like her male counterpart, this version of the New Woman explorer was often of a nationality other than German. If she served as a stand-in for wannabe German travelers, her identity as American, British, or Dutch connoted a safe zone where her freedom to explore foreign

terrain did not challenge codes of German domesticity. In other words, she fulfilled in look and concept the press's construct of the New Woman without establishing a precedent for German women. Furthermore, the varied nationality of these female explorers catered to the cosmopolitanization of Weimar visual culture by keeping tabs on the explorative activities of other Western powers.

One prime example of the New Woman explorer type was Osa Johnson (fig. 5.3). Originally from rural Kansas, she accompanied her husband Martin to Melanesia, Polynesia, Malekula, and Borneo, as well as on safari and hunting expeditions in Africa. Together they produced a range of feature films on-site, including, *Jungle Adventures* (1921), *Simba, the King of the Beasts* (1928), *Congorilla* (1932), and *Borneo* (1937). Between 1917 and 1937, they finished eight films and published nine books.[23] Through film stills and photographs, a number of these projects were showcased internationally, including in Germany. Osa Johnson, in particular, became a popular visual icon of the Weimar press. Images such as the one featured on the cover of *BIZ* in July of 1923 had great market appeal; the photo depicts her riding a domesticated Grevy zebra at the Hook Farm at the base of Mount Kenya (fig. 5.3). Johnson's appearance played to the persona of the New Woman with her cropped hair, powdered skin, lipstick-lined lips, and mannish safari wear. With savvy knowledge of the mass market, Johnson self-consciously authored her identity as a female adventurer and sought out the most sensational poses, including pictures with crocodiles, zebras, and lions.[24] Despite the fact that the Johnsons worked as a duo until Martin's death in 1937, Osa's image dominated their advertising campaign.

Postcolonial Cosmopolitans? The Photomontages of Marianne Brandt and Hannah Höch

The cosmopolitan dynamic of the popular press had a predictable impact on the vision of Weimar era photomonteurs. Artists such as Marianne Brandt and Hannah Höch consumed the postcolonial cosmopolitan aesthetic of the age, including the categories detailed earlier. Photomontage from the mid-1920s through the early 1930s functioned for both practitioners as primarily a private activity. In Brandt's case there is no clear evidence to suggest that she officially exhibited her roughly forty-five montages prior to the 1970s.[25] Similarly, Höch did not exhibit her 1920 photomontages publicly until 1929, when roughly eighteen of her works were shown at the "Film und Foto" exhibition in Stuttgart.[26] Despite the private character of these works, they

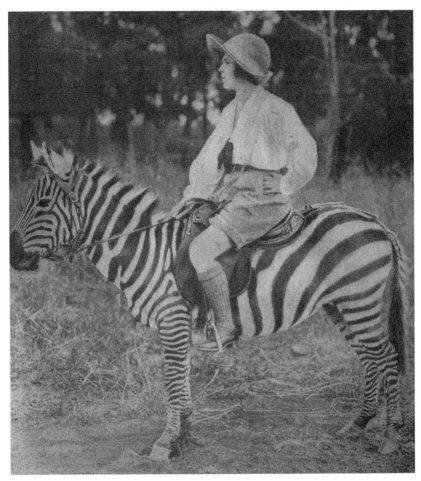

Fig. 5.3. Cover photo from *Berliner Illustrirte Zeitung,* July 22, 1923.

illustrate the ways in which Brandt and Höch actively engaged with pub-
lic discourses of New Womanhood originating in photojournalism and film.
While Höch and Brandt were not colleagues or in direct correspondence
with one another, they shared a number of common friends, including László
Moholy-Nagy and Kurt Schwitters.

Brandt's career and community during the 1920s centered on the Bau-
haus, where she was a student in Weimar beginning in 1924. Serving initially
as an apprentice in the Metal Workshop, she was eventually appointed its act-
ing director after the school moved to Dessau. As Elizabeth Otto has noted,
her photomontages illustrate a close affinity with the work of her mentor,

Moholy-Nagy, who likely introduced her to the practice. While the two draw on similar imagery clipped from the pages of the illustrated press and share an interest in universalism, Brandt's oeuvre takes on a decisively different character given her interest in showcasing the New Woman as a heroine of the age. Her travels to Norway and France and her imagined excursions to the United States, which were facilitated by films and the illustrated press, may have contributed to her fascination with the New Woman explorer prototype. Montages such as *Miss Lola* of 1926 (fig. 5.4) incorporate clippings of the German film producer Lola Kreutzberg. Pictured with a cheetah on the April 1926 cover of *BIZ*, this photo and others were taken while Kreutzberg was traveling in the Dutch colony of Indonesia in preparation for two films for which she served as the screenwriter, director, and camerawoman.[27] Like Osa Johnson, Kreutzberg's projects often involved the visually enticing world of exotic animals; posed photos with these indigenous creatures signaled the authenticity of her experience in foreign lands. Brandt's *Miss Lola* connects with the aesthetic and kaleidoscopic character of stills from films of the time such as Walter Ruttmann's *Berlin: Die Sinfonie der Grosstadt* (Berlin: Symphony of a Great City) of 1927, in which signs of the metropolis converge onto one plane, fusing fragments of architectural structures, modes of transport, portrayals of the masses, and individual city types. Brandt inserts the world of zoos, circus shows, and racetracks into her roster of urban imagery. Like the rows of houses, auto-packed streets, boat-lined rivers, and over-populated plazas, which are also featured in this work, these renditions of an animal habitat are chaotic, buzzing with urban energy, and ultimately artificial. In contrast to these collaged vignettes, Kreutzberg and the cheetah engage in a meaningful, slow-tempo embrace. While Kreutzberg appears here as a product of this urban frenzy, under the auspices of her travel outside of Europe the film producer genuinely and intimately connects with the animal kingdom. There is certainly an essentialist implication here, an overt association between "woman" and "nature." Nonetheless, Brandt empowers the New Woman as an inhabitant of both zones by showing her simultaneously as a trope of the metropolis and an interpreter of the natural world. Last, like the advertisements for alligator shoes, both Kreutzberg and the cheetah exemplify an ideal of "chic beauty" characteristic of the era. While the pairing of the New Woman with exotic animals was integral to the female explorer type, it also became a symbol of fashionability. In 1930, the African American performer Josephine Baker posed for promotional photographs with her pet leopard, Chiquita. The photos helped to advertise her new revue, "Paris qui Remue," performed at the Casino de Paris.[28] Baker's pair-

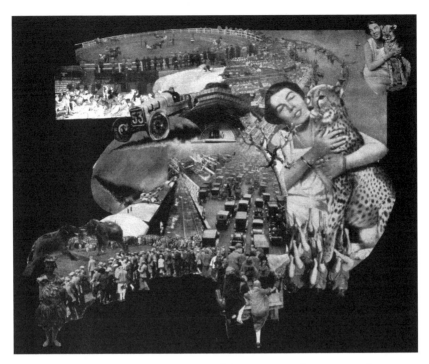

Fig. 5.4. Marianne Brandt, *Miss Lola,* 1926, photomontage with newspaper clippings on black cardboard, 48.0 x 63.2 cm. (Private Collection via Gallery Urich Fiedler, Cologne, Germany. © Artists Rights Society [ARS], New York, and VG Bild-Kunst, Bonn.)

ing with an exotic animal played to her cachet as a performer, as well as to the popularized aesthetic of "Negrophilia" in France during the Jazz Age.

As a number of her montages attest, Brandt was intrigued by pictures of people from other lands. The incorporation of this imagery into her montages conformed to a concept of interwar period universalism in that Brandt devoted a number of her photomontages to exploring equivalent modes of beauty espoused by women of different races, cultures, and nationalities. Brandt's work *o.T. (mit Anna May Wong)* (Untitled [with Anna May Wong]) from 1929 (fig. 5.5) showcases five female faces. The central image, a fragment of a pale-skinned, blond-haired model or film star, is flanked by two additional visages of the same scale. To the left is a profile image of the Chinese American actress Anna May Wong, whose depiction is echoed by a cleverly positioned silhouette. To the right is the face of a girl who resembles the fresh look of socialist propaganda posters: cropped hair, cloth head covering, and full smile. Atop this trio sits a more sensationalist duo, the bust of

a woman donning a vibrant black-and-white striped dress juxtaposed with the head of a zebra. The visual parity between these two creatures was no accident. The boldness of the zebra's black-and-white stripes was frequently co-opted by Weimar advertisement designers for a host of products. Neither the zebra nor the women depicted in this montage were anonymous to Weimar viewers. The same image of this particular zebra—clearly recognizable as such since no two zebras share the same striped pattern—was used in a popular 1928 poster advertisement for the Budapesti Ãllatkert (Budapest Zoo). The accompanying woman is the actress Katherine Hessling, the wife of Jean Renoir and renowned star of many of his films, including his 1926 rendition of Émile Zola's *Nana.* The image of Hessling was clipped from a 1929 issue of *Münchner Illustrierte Presse,* the source for a number of Brandt's images.[29] The lower section of the photomontage features a Mangbetu woman from the former Zaire, today the Democratic Republic of the Congo. The women of this region, renowned for their beauty, practiced the art of scull wrapping, which elongated the cranium. Next to the Mangbetu woman is a smaller reproduction of a giraffe, which serves as a counterpoint to the zebra. Typical of some of Brandt's collaged works, this montage incorporates the sleek and pure forms of Bauhaus elements: a rectangular cut of celluloid and a mounted oculus of glass. The last element in this composition is perhaps the most telling, a stylized figure eight, which resembles an upturned sign for infinity. This addition perhaps serves as a potent symbol for the link between all of these women, who exemplify desirable traits. Pictured in tandem with exotic animals, these subjects also "perform" a brand of femininity authored by the 1920s press and film culture.

Like Brandt, Hannah Höch celebrated the visual spectacle of Weimar popular culture. Her *Mass-Media Scrapbook* from circa 1933–34, a 114-page collection of roughly four hundred press photographs that she pasted into a copy of the journal *Die Dame,* is a prime example of the photomonteur's "eye" for visually arresting images. The scrapbook was most likely a private exercise, one that enabled Höch to collect and reminisce about the aesthetic of the Weimar age.[30] The album includes pictures of the New Woman, the "Other" Woman, domesticated animals, animals from far-off lands, botanical wonders, babies, and landscapes. This album and Höch's *From an Ethnographic Museum* series of photomontages, numbering roughly twenty and ranging in date from the mid-1920s to the early 1930s, often acritically romanticized the notion of the "Other" Woman as an emblem of an idealized, simplified world, one untainted by the powers of commerce and Western civilization. Still a number of her images from the Weimar era do engage

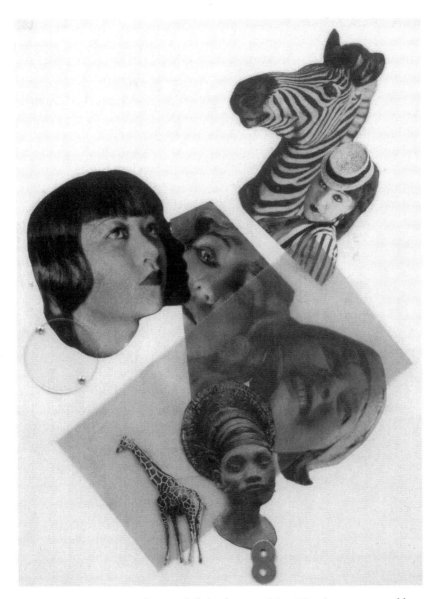

Fig. 5.5. Marianne Brandt, *Untitled (with Anna May Wong)*, 1929, assemblage of newspaper clippings, glass, celluloid, and metal, 67 x 50 cm. (Busch-Reisinger Museum, Harvard University Art Museums, Cambridge, Massachusetts. © Artists Rights Society [ARS], New York, and VG Bild-Kunst, Bonn.)

with a subtle critique of colonialism and contemporary neocolonialist discourses.

One such discursive arena included the overt racial politics of the Rhineland Controversy, which began in 1920. Propagandistically staged as an incident of international importance, the German press and government's response to France's stationing of North African soldiers along the Rhine permeated Weimar popular culture. As with Brandt, Höch's montages during the mid- to late 1920s remained a private activity yet one that actively engaged with public debates. On the surface, Höch's work *Die Kokette II* (The Coquette II) from circa 1925 (fig. 5.6) plays to the trope of the New Woman with exotic animals. Indeed, monkeys and pretty girls were gimmicks of Weimar cabaret and circus shows. This work, however, points to a

Fig. 5.6. Hannah Höch, *Die Kokette II* (The Coquette II), ca. 1925, photomontage, 13 x 13.4 cm. (Collection of Marianne Carlberg. © Artists Rights Society [ARS], New York, and VG Bild-Kunst, Bonn.)

more specific symbolism associated with the visual and linguistic tropes of the Rhineland conflict, the feared intermingling of white German women and black French colonial soldiers, the latter often pejoratively represented in the German press as grotesque, simian beasts. Satirical *Illustrierte,* such as the Munich-based *Simplicissimus,* exploited the inflammatory nature of the propaganda; Höch's montage masterfully diffuses the implied terror associated with gorillas absconding with white women. As the title of the photomontage implies, a flirtatious female figure, represented by a blond-haired *Mädchen,* engages playfully with her simian companion. The pair is unified by their attire; she wears the top from a white pantsuit while he has donned the bottoms. Far from an intimidating scene, the staged playfulness ruptures the hyperbole normally associated with such a pairing. Furthermore, Höch's critique of the role of the New Woman as a pawn of the Rhineland propaganda is implied here; rather than a sophisticated, independent female of the 1920s, she is just a child. While the relationship between Höch's montages and Weimar postcolonialism warrants an essay in its own right, the core point here is that photomontage, despite its indebtedness to its original documentary sources, provided the capability of critiquing the visual language of the press and the dangerous predilections of the larger culture.

Conclusion

What I have tried to present in this essay is a detailed, introductory account of the *neue Frau* during the Weimar Republic and her relationship to notions of the "Other" Woman and tropes of the exotic. In addition, I have shown that the varied nationality of female explorer types catered to a German interest in keeping tabs on the explorative activities of other Western powers. Indeed, Germany's decreased access to the rest of the world following the First World War necessitated a simulated cosmopolitanization of Weimar visual culture. The collective presence of this aesthetic ultimately reinforced a colonial imaginary, implying a vital future for German imperialism. My hope is that this essay will open the door for collaborative work that will extend beyond the Eurocentric focus of Weimar New Woman studies, allowing for a confluence of old and new approaches to this topic that embody a truly "global perspective." One potential model for this mode of inquiry involves Miriam Silverberg's call for the programmatic examination of the "Colonial Maiden" detailed in her essay "After the Grand Tour," included in the recent, invaluable volume *The Modern Girl Around the World.* According to Silverberg, the concept of the Colonial Maiden would comprise "girls

of the 'exterior' and the metropole," including "daughters of colonizers, the colonized, collaborators, and adventurers."[31] Like the Modern Girl or the New Woman, the Colonial Maiden would be considered as both an "icon and agent."[32] To my mind, this approach has great promise for opening up the concept of the *neue Frau* in Germany. Furthermore, a comprehensive study of the Colonial Maiden in relation to German colonial history would produce valuable cross-cultural comparisons and expose the imperialist discourses intrinsic to European concepts of modernity and universalism. Embracing and rigorously investigating concepts such as the Colonial Maiden in tandem with additional case studies involving Weimar postcolonial cosmopolitanism would go a long way toward expanding the field.

Notes

The research for this essay was completed with the generous support of a Junior Faculty Research Grant from the University of Nevada, Reno. I want to thank my colleagues in the Departments of Art and Women's Studies and those associated with the Gender, Race, and Identity Program at UNR for their comments on an earlier draft of this material.

1. Hanno Hardt, *In the Company of Media: Cultural Constructions of Communication, 1920s–1930s* (Boulder, CO: Westview Press, 2000), 61.

2. Wolfe W. Schmokel, *Dream of Empire: German Colonialism, 1919–1945* (New Haven: Yale University Press, 1964; Westport, CT: Greenwood Press, 1980), 2.

3. For additional reading on the role of popular press photography and the construct of a Weimar colonial imaginary, see my essay "Weimar Revisions of Germany's Colonial Past: The Photomontages of Hannah Höch and László Moholy-Nagy," in *German Colonialism, Visual Culture, and Modern Memory*, ed. Volker Langbehn (London and New York: Routledge, 2010).

4. For this position, see Peter's Bürger's discussion of montage in *Theory of the Avant-Garde*, trans. Michael Shaw (Minneapolis: University of Minnesota Press, 1984), 73–82.

5. In 1953, Brandt did embark on a six-month trip to China as the official curatorial accompaniment for the exhibition "German Applied Arts in the GDR." For further information, see Elizabeth Otto, *Tempo, Tempo! The Bauhaus Photomontages of Marianne Brandt* (Berlin: Jovis Verlag and Bauhaus-Archiv, 2005), 148.

6. For further discussion, see Marcia Klotz, "The Weimar Republic: A Postcolonial State in a Still-Colonial World" in *Germany's Colonial Pasts*, ed. Eric Ames, Marcia Klotz, and Lora Wildenthal (Lincoln and London: University of Nebraska Press, 2005), 135.

7. See Gayatri Chakravorty Spivak, *A Critique of Postcolonial Reason: Toward a History of the Vanishing Present* (Cambridge and London: Harvard University Press, 1999).

8. Schmokel, 77.

9. Ibid., 2.

10. Mary E. Townsend, "The Contemporary Colonial Movement in Germany," *Political Science Quarterly* 43, no. 1 (March 1928): 64–75 (65).

11. Ibid., 64–75.

12. Peter Van der Veer, "Colonial Cosmopolitanism," in *Conceiving Cosmopolitanism: Theory, Context, and Practice*, ed. Steven Vertovec and Robin Cohen (Oxford: Oxford University Press, 2002), 165–79 (169), emphasis added.

13. Ibid., 166.

14. Frank Hurley, from his Diary D, August 16, 1921, quoted in Jim Specht and John Fields, *Frank Hurley in Papua: Photographs of the 1920–1923 Expeditions* (Bathurst, Australia: Robert Brown in association with the Australian Museum Trust, 1984), 20.

15. Uta G. Poiger, "Fantasies of Universality? *Neue Frauen*, Race, and Nation in Weimar and Nazi Germany," in *The Modern Girl Around the World: Consumption, Modernity, and Globalization*, ed. The Modern Girl Around the World Research Group (Alys Eve Weinbaum, Lynn M. Thomas, Priti Ramamurthy, Uta G. Poiger, Madeleine Yue Dong, and Tani E. Barlow) (Durham: Duke University Press, 2008), 326–30.

16. Gideon Reuveni, *Reading Germany: Literature and Consumer Culture in Germany before 1933* (New York and Oxford: Berghahn Books, 2006), 115, 137.

17. For a variety of definitions and modes of visual anthropology, see Paul Hockings, ed., *Principles of Visual Anthropology* (Berlin and New York: Mouton de Gruyter, 1995).

18. Graham Huggan, *The Postcolonial Exotic: Marketing the Margins* (London and New York: Routledge, 2001), 13.

19. Frank Hurley, *Pearls and Savages: Adventures in the Air, on Land, and Sea in New Guinea* (New York and London: G. P. Putnam's Sons, 1924).

20. Siegfried Kracauer, "The Little Shopgirls Go to the Movies," in *The Mass Ornament: Weimar Essays*, trans. and ed. Thomas Y. Levin (Cambridge and London: Harvard University Press, 1995), 299.

21. Martin Johnson, *Safari: A Saga of the African Blue* (New York and London: G. P. Putnam's Sons, 1928), 208.

22. *Berliner Illustirte Zeitung*, January 1, 1925, 4.

23. Alexandra Lapierre and Christel Mouchard, *Woman Travelers: A Century of Trailblazing Adventures, 1850–1950* (Paris: Flammarion, 2007), 212.

24. Ibid., 208–9.

25. Otto, *Tempo, Tempo!* 10, 12.

26. Kristin Makholm, "Chronology," in *The Photomontages of Hannah Höch*, ed. Maria Makela and Peter Boswell (Minneapolis: Walker Art Center), 194.

27. For a full list of Kreutzberg's filmic achievements, see http://www.filmportal .de.

28. See the cover of Petrine Archer-Straw, *Negrophilia: Avant-Garde Paris and Black Culture in the 1920s* (London: Thames and Hudson, 2000).

29. See *Münchner Illustierte Presse*, December 1, 1929, 1664.

30. Melissa A. Johnson, "Souvenirs of Amerika: Hannah Höch's Weimar-Era Mass-Media Scrapbook," in *The Scrapbook in American Life,* ed. Susan Tucker, Katherine Ott, and Patricia Buckler (Philadelphia: Temple University Press, 2006), 135–52 (136).

31. Miriam Silverberg, "After the Grand Tour: The Modern Girl, the New Woman, and the Colonial Maiden," in *The Modern Girl Around the World: Consumption, Modernity, and Globalization,* ed. The Modern Girl Around the World Research Group (Alys Eve Weinbaum, Lynn M. Thomas, Priti Ramamurthy, Uta G. Poiger, Madeleine Yue Dong, and Tani E. Barlow) (Durham: Duke University Press, 2008), 354–61 (360).

32. Ibid., 357.

6

Hannah Höch's New Woman: Photomontage, Distraction, and Visual Literacy in the Weimar Republic

MATTHEW BIRO

The New Woman of Weimar society was a figure of both imagination and material reality.[1] The term referred to the new social roles that women increasingly adopted during the Weimar Republic as a result of changes in German work, politics, consumer culture, and entertainment. It also signified a set of stereotypical images or "types"—created by the burgeoning mass media—that affected male and female behavior alike. On a seemingly more basic level, the New Woman further suggested a changed mode of modern female identity that was to be distinguished from the traditional types characteristic of Wilhelmine society and was connected to the rationalization and "Americanization" of everyday life during the Weimar Republic. She thus quickly became a primary sign representing the radical transformation of Germany after the war, a symbol of how its politics, society, and everyday life had been irrevocably altered. As a result, she was constantly represented, lauded as an embodiment of new possibilities open to women of the time, and demonized as a primary force threatening the nation's social, moral, physical, and economic stability.

As I shall argue, the representation of the New Woman was central to the Weimar photomontages of the Berlin Dadaist Hannah Höch, because Höch's fundamental project was an interrogation of modern identity, and it was through photomontage that the New Woman's various forms, meanings, and actual states of being could be examined and reconfigured. Neither fully accepting nor fully rejecting the New Woman, Höch used her art to analyze the New Woman's myth and thereby to reveal both her ideological and her revolutionary potential. Central to Höch's analysis was an exploration of the New Woman's fundamentally cyborgian nature, which Höch suggested by representing the New Woman as an assemblage of

organic and mechanical parts. In this way, Höch revealed the New Woman to be both a consumer and a producer of representations in the mass media, a creative consciousness fundamentally concerned with the impact of technology on human bodies and minds and the ways in which technology's effects were influenced and channeled, strengthened or mitigated, through practices of montage.

Two of Höch's photomontages reveal the fundamentally hybrid nature of the New Woman as well as the influence she was beginning to have on her culture and society. Directly after the First World War, the compositional strategies of Höch's photomontages underwent a series of changes. She began to move away from the simultaneous "all over" montage structure of her earliest Dada works, completed in 1919 and early 1920, toward the simpler forms of composition that the other Berlin Dadaists were also beginning to favor.[2] Instead of multiple figures, Höch's later Dada photomontages, completed during 1920, began to focus on a much smaller set of main characters, generally between one and three in number. Like traditional forms of painterly and photographic representation, these photomontages articulated clear centers of interest or focus, and, by allowing for definite size differences between the various photomontage elements, the compositions also became more hierarchically organized. In addition, the indexical relationship between the photographic fragments and the photographic subjects was transformed. No longer choosing for the most part to appropriate specific historical individuals, Höch instead opted to construct common social or psychological types, often created out of a multiplicity of carefully cut fragments that left the spectator with little or no idea of the actual person from whom the components were originally drawn.

The Dadaist photomontage *Das schöne Mädchen* (The Beautiful Girl, 1919–20) (fig. 6.1), wherein Höch presents the New Woman as a seemingly brainless cyborg, is a good example of this new, more indexically distanced, anonymous, and general type of subject. Although the background is still extremely busy, the relative size and positioning of the figure make her the central element and thus the focus. Here a bathing beauty, dressed in a formfitting black bathing suit, sits on an I beam, her head—but not her bouffant hairdo—displaced by an electric lightbulb. She is surrounded by circular motifs, which seem to stand as symbols of her desire but also have connotations of danger or menace. The American boxer and heavyweight champion Jack Johnson, to whom the New York Dada artist Arthur Craven lost a boxing match in Barcelona in 1916,[3] moves in from the left, his body penetrating a thin motorcycle tire and his gloves touching the beautiful girl's

Fig. 6.1. Hannah Höch, *Das schöne Mädchen* (The Beautiful Girl), 1919–20, photomontage and collage, 35 x 29 cm (13 3/4 x 11 7/16 in). (Private collection. Photo: Bildarchiv Preussischer Kulturbesitz and Art Resource, New York. © 2010 Artists Rights Society [ARS], New York, and VG Bild-Kunst, Bonn.)

arm and parasol.[4] Perhaps a subterranean reference to Dada's international history, the Johnson figure also connotes sport, athleticism, and, because of his nakedness and proximity to the girl cyborg, cross-racial desire. To the right of the beautiful girl, a crankshaft juts aggressively outward toward the viewer, and around it appear BMW insignias of varying sizes. The crank-

shaft echoes the I beam, which also thrusts forcefully into the spectator's space. Partially balancing this suggestion of extended space in front of the main figure, the circular BMW logos, which are partly superimposed on one another, suggest a similar extension behind the beautiful girl as well. In addition, a young woman's face stares out at the spectator from the upper right corner. One eye has been replaced with a larger, cropped eye, and the lower portion of her visage is obscured by a woman's hand holding a pocket watch, which extends from the side of the beautiful girl's hairdo. In conjunction with the hand and watch constellation, the clusters of BMW logos perhaps suggest the hypnotic nature of commodity culture.

In many ways, Höch's girl cyborg follows the traditional forms of allegory in that it seems to present an embodied representation of an abstract concept or quality, in this case the new ideas about beauty created by the growth of commodity culture and spectacle during the early years of the Weimar Republic. Like traditional allegorical emblems, the cyborg's photomontage attributes—or in this case her signs of desire—can be read and enumerated. Here, because they are represented by means of idealized depictions appropriated from the mass media, these signs of desire—namely, of beauty, sport, sexuality, travel, and status—are all shown to exist as different types of manufactured products. And because they reveal the commodification of even the most intimate aspects of human existence, they also function as indicators of anxiety, a connotation that is reinforced by Höch's photomontage technique, which is characterized by disturbing physical and spatial disjunctions. At the same time, however, Höch's figure also interacts with its attributes and environment in strange and heterogeneous ways that seem odd in comparison to most traditional allegorical representations. In particular, it is unclear if the countenance in the top right corner belongs to the cyborg. On the one hand, it seems to be the correct size for her hairdo, and if the visage with the montaged eye did belong to the beautiful girl, then the power of commodity culture could perhaps be seen to emanate from the cyborg. On the other hand, the face of the woman with the montaged eye seems radically separate from the girl's body; and all the other photographic elements—hairdo, hand, and BMW insignias—seem to divide it from her lithe form. Following this reading, one could imagine the beautiful cyborg's consciousness being left behind as she explores physical pleasure and consumption in the modern world. No longer the figure in control, she is, instead, a passive and gullible consumer, a woman seduced by a field of attractive but ultimately two-dimensional images.

Although composed of different fragmentary photographic images, *The Beautiful Girl* represents a type not an individual. Unlike Höch's most famous photomontage, *Cut with the Kitchen Knife Dada through the Last Weimar Beer-Belly Cultural Epoch of Germany* (1919–20), and other early works, such as *Dada Panorama* (1919), for the most part *The Beautiful Girl* did not encourage its spectators to identify specific historical personages or imagine their particular histories and implied transformations as envisioned by the artist. (In the context of *The Beautiful Girl*, the historically specific figure of Jack Johnson seems like a remnant of Höch's earlier approach.) Thus, because it drew attention to a common type, *The Beautiful Girl* could have prompted its spectators to focus on the mass media and commodity culture as institutions and how they functioned to create, channel, and repress both female and male desire. Expressing both pleasure and anxiety about the identity roles offered to German women through manufactured goods and the culture industry, it suggested that its viewers examine their relationship to the modern myths circulating in the early years of the Weimar Republic.

As Maria Makela notes, *The Beautiful Girl* is very similar to another work of approximately the same size and format, *Hochfinanz* (High Finance), a photomontage with collage from 1923, which is understood to belong to Höch's post-Dada moment (fig. 6.2). Although it is dated two years later than *The Beautiful Girl*, *High Finance* seems closer in imagery and composition to the works that Höch created around 1920 than it does to those created after 1922, which were even simpler and more abstract.[5] This suggests that the photomontage has been misdated or the similarity can stand as evidence of Höch's continuing Dadaism during the Weimar Republic, the fact that she continued to use photomontage to investigate changes in the mind and body under the conditions of mass reproduction. Most important for understanding Höch's representations of New Women, however, is the fact that *High Finance* presents cyborgian New Men, figures with which Höch's New Women were dialectically interrelated.

High Finance presents two full-length male figures striding across a landscape that consists of a bird's-eye view of a fairground with ceremonial buildings and a stadium. They are surrounded by other objects, including an aerial view of a factory complex hovering at the level of their shoulders, a large tire with a truck positioned at its apex, a shiny chrome nut or ball bearing that appears to prevent the tire from rolling, and two fragmentary double-barreled shotguns, each showing a stock, a trigger, and a breech broken open to receive shells. Both men clutch machine parts in their right

Fig. 6.2. Hannah Höch, *Hochfinanz* (High Finance), 1923, photomontage and collage on paper, 36 x 31 cm (14 3/16 x 12 3/16 in). (Galerie Berinson, Berlin and UBU Gallery, New York. © 2010 Artists Rights Society [ARS], New York and VG Bild-Kunst, Bonn.)

hands as if they were clubs or canes, and to the left of the leftmost figure, two or three small fragments of what is possibly a striped flag appear. Both men, moreover, have had their heads replaced with new ones, which seem too large for their bodies. The carefully cropped profile of the man on the left has not been identified, while the man on the right sports the countenance of Sir John Herschel, the nineteenth-century British chemist. Originally shot by Julia Margaret Cameron in 1867, this portrait was

appropriated from an article on Cameron published in the ladies' fashion magazine *Die Dame* in May 1920.

Höch's photomontage is inscribed on the bottom left margin with a dedication to László Moholy-Nagy, who published it in 1925 in his book *Painting Photography Film* where the photomontage was given an alternative title, *The Multi-Millionaire*, and a caption, "The dual countenance of the ruler."[6] As implied by its two titles and caption, Höch has constructed a rather threatening image of two bourgeois men that suggests connections between capitalism, militarism, and nationalism during the Weimar Republic and, depending on how the spectator reads the "flag" in the background, perhaps monarchism and Americanism as well. (Because its colors are faded, the flag could stand for a number of different nations, including the German Imperial Empire or the United States of America.) The men hold machine parts in their hands like tools, their heads and bodies have been augmented with oversized shotguns, and they are pressed together shoulder to shoulder almost as if they were parts of the same organism. Höch thus depicts these traditional figures of the capitalist ruling order as having been transformed through technology and having adapted themselves to their modern postwar world. The violence and power of these two members of the economic ruling class are suggested by the threatening way in which they hold their tools, the shotguns that have become parts of their bodies and heads, the fragmented and mismatched character of their figures, and the fact that their size relative to the other elements suggests that they dominate their environment. In addition, the ground on which they walk, the Fair Grounds and Centennial Hall in Breslau, evokes their nationalism. Built by the architects Hans Poelzig and Max Berg in 1913 to commemorate Germany's defeat of Napoleon in 1813, this complex was regarded by many Germans in the early 1920s as a symbol of hope and renewal for a nation that had once again been defeated and occupied by the French.

Like the beautiful girl, the capitalists of *High Finance* are portrayed as types not individuals. Although the figure on the right can be easily identified as Herschel, his identity seems to have more to do with self-reflexive concerns than it does with Herschel's role in German society or culture. One of the reasons that Höch might have chosen to appropriate Herschel's visage may have been to establish a lineage for her work. Just as she possibly cited the expressionist artist Käthe Kollwitz in *Cut with the Kitchen Knife* to refer to an important woman artist who preceded her historically and whose achievements had perhaps helped to make Höch's own career

easier, the Herschel reference in *High Finance* may have been a way to acknowledge Cameron as another important precursor or role model for Höch. In addition, Herschel himself was an early photographer, and he made several key contributions to the history of photography.[7] Höch might thus have included his portrait as a subtle way of indicating part of the history out of which her practice of photomontage emerged.

For these reasons, it seems that *High Finance*, like *The Beautiful Girl*, used its photomontage fragments not for political satire but rather to explore broader currents in German society, specifically, the manifold and reactionary connections between capital, the military, nationalism, and counterrevolution that characterized the Weimar Republic's early years. To emphasize the newness of this dangerous amalgam of concepts, forces, and institutions, Höch made her financiers cyborgs. The old Wilhelmine order had been changed by war and revolution, but, as Höch's photomontage suggests, this did not mean that it had renounced its conservative and authoritarian values. Instead, as the photomontage implies, German capitalists were using all possible means of technological enhancement to maximize their profits irrespective of the human costs. And by representing its cyborgian capitalists as giants violently ruling an industrialized world, the photomontage suggests that divisions in wealth and power would only become greater over time.

In addition, when compared to *The Beautiful Girl*, *High Finance* implies something perhaps unexpected about gender difference in the modern world, namely, that the growth of technology did not seem to radically alter traditional differences between men and women but, rather, to intensify them. The beautiful girl is identified with the mass media, commodity culture, spectacle, and perhaps (because of her montaged eye) spectatorship, attributes that can all be read as rendering her passive. The financiers, on the other hand, are associated with the means of production and, furthermore, with movement, activity, and violence. Although technology, the photomontages suggest, has changed both genders in the modern world, these transformations can still be understood in terms of an active-male, passive-female dichotomy. Pairing these two montages raises the question of whether technology—often seen as a force that overcame distinctions and linked opposites—could also increase and reify gender differences in a manner similar to the way it augmented and solidified social and economic stratification. For this reason, despite their greater simplicity, these more traditionally composed works are just as ambiguous as the early Dada works characterized by the compositional strategy of simultaneous montage. The

critique characteristic of Höch's earliest photomontages has here become more general, but, like the earliest works, *The Beautiful Girl* and *High Finance* do not appear to have been made to provide answers. Instead they provoke disturbing questions about the relationship between gender and industry, commodification, capital, spectacle, and the broader technological system that subtends them.

In recent years, Höch's photomontages have provoked debate around how to properly interpret them. As Peter Nisbet has argued, identifying Höch's photographic source material can serve a number of different purposes. It can help refine and correct the dating of the works; it can "shed some light on the artist's choices, by showing what was omitted, excised, transfigured; and it can, perhaps, contribute to the interpretation of the work in question."[8] By raising the question of interpretation, Nisbet draws our attention to the problem of "allegory" in Weimar culture. In the discourse on avant-garde art of which writings on Dadaism form a part, "allegory" is an important but problematic concept. On the one hand, it defines avant-garde art's primary mode of signification or meaning making. On the other, it has over time bound together radically contradictory meanings. One of the thorniest aspects of allegory has to do with the relationship between appropriation and meaning. When an artwork appropriates a fragment from the culture around it—be it a literary theme, a visual style, a material object, or a visual source cut from another form of representation—does that work thereby convey to its various spectators significations drawn from the original work and its context? Or does it, on the contrary, substitute new meanings for the fragment's original ones?

Walter Benjamin argued the latter even if his actual practices of interpretation sometimes contradicted this contention. Discussing the things that the allegorist appropriates, Benjamin argued that the appropriated object

> is now quite incapable of emanating any meaning or significance of its own; such significance as it has, it acquires from the allegorist. He places it within it, and stands behind it; not in a psychological but in an ontological sense. In his hands the object becomes something different; through it he speaks of something different and for him it becomes a key to the realm of hidden knowledge; and he reveres it as the emblem of this.[9]

Numerous theorists of modern and contemporary art have agreed with this understanding of allegorical appropriation. Peter Bürger, for example,

argued that avant-garde art continues aestheticism's emancipation of art from subject matter. Directly citing Benjamin's theory of allegory, Bürger insisted that avant-garde art negates the original contextual meanings of its various appropriated parts.[10] Instead of drawing the viewer's or the reader's attention to what is actually represented, the parts of the avant-garde artwork put the focus on the conceptual principles behind the work's construction.[11] As a result, there is no room for subject matter in Bürger's account of the historical avant-garde.

Höch's photomontages, on the other hand, support both forms of reference; at times they seem to refer to specific historical individuals and contexts, while at other times they seem to use the photographic fragment as a representative of a type and thus in a manner that does not seem historically specific. But can we really assume that Höch intended to trigger knowledge of real people and particular historical situations through her photomontages? As suggested by the growing interest in visual literacy as promoted by the mass media during the Weimar Republic, the answer is yes. Moreover, as suggested by her photomontages, she also saw the New Woman as one of the central figures promoting this development, an insight that was shared by other cultural producers working in the mass media.

As scholars have noted, the Weimar Republic represents a moment in which the modern language of photojournalism was first developed, where newspaper and magazine layout became a significant form of creative endeavor, where the photograph became a primary mode of communication, and where much thought was devoted to analyzing these transformations.[12] Magazines and illustrated newspapers, it was argued, promoted a new form of reading that was impatient, distracted, and tailored to an active life.[13] This was a mode of apprehension in which, for better or for worse, bits of reading time were snatched amid other activities. As a result, reading materials became more visual, fragmented, and emphatic, thereby beginning a development in which changes in reading habits and changes in material culture mutually reinforced one another and contributed to lasting transformations in the ways in which ordinary Germans received and processed information. Periodical covers, for example, were changed in order to address the new, supposedly less-attentive reader. Whereas before the war they had featured illustrations, single posterlike photographs began to be used more and more during the Weimar Republic, with a prominent series title above the image to lodge the periodical brand in the reader's consciousness and a caption below it to explain its significance. Articles, moreover, became shorter and were increasingly broken up by

photographs, illustrations, and captions. In addition, images became less closely connected to the texts. Now, instead of directly illustrating the text all the time, pictures could also function as amplifications of the article and represent aspects of the subject to which the text only alluded. Pictures, furthermore, became the primary means of communicating meaning—although few believed that they could function easily without some text—and many argued that a largely visual mode of understanding the world was becoming dominant.

As suggested by *The Beautiful Girl*, Höch associated the cyborgian New Woman with this new, more "distracted" consumption of montages of images and texts that characterized the experience of reading illustrated magazines and newspapers, a mode of perception that was strongly debated. In 1927, for example, Siegfried Kracauer argued that the illustrated newspapers—whose aim, he quipped, was "the complete reproduction of the world accessible to the photographic apparatus"—promoted a profound loss of historical understanding.[14] Because they merely represented topical subjects wrenched out of their original contexts and juxtaposed without being given a new, historically informed significance or structure, "the flood of photos sweeps away the dams of memory. . . . Never before has a period known so little about itself. In the hands of the ruling society, the invention of illustrated magazines is one of the most powerful means of organizing a strike against understanding."[15] Benjamin, on the other hand, argued in 1936 that the distracted mode of perception that characterized the experience of film, illustrated magazines, and architecture was potentially revolutionary.[16] It was a mode of perception that was tactile (as opposed to optical), habitual, and collective, and as such it was much more suited to the new tasks that confronted human awareness at turning points of history. Although Benjamin never explained how this not-fully-conscious form of perception allowed human beings to achieve revolutionary consciousness, he clearly defined how distracted perception helped to mobilize the masses and condition people to the increased threats to life and limb characteristic of modern life, a conditioning that it achieved by exposing people to the shock effects of montage. For Höch, as we have seen, the distracted perceptual experience promoted by the modern media was a mixed bag, a way of apprehending things that could be used for both revolutionary and reactionary ends.

The *Berliner Illustrirte Zeitung*, or *BIZ*, provides a good example of the new modes of distracted viewing and reading to which Höch was responding through her photomontages—and not simply because it was

the illustrated newspaper from which Höch appropriated a number of her photomontage fragments. Founded in 1892 and taken over in 1894 by the Ullstein Verlag, the publishing company for which Höch worked between 1916 and 1926, the *BIZ* was the most popular illustrated newspaper in Germany during the Weimar Republic. The weekly paper regularly published photographs encompassing a wide variety of different subjects, including contemporary political and social events, the lives of politicians and celebrities, war and other forms of social and political unrest, natural catastrophes, foreign lands and people, scenes from popular films and theatrical productions, new technologies, and, significantly, all forms of modern life. Its articles were generally short and interspersed with photographs, illustrations, and captions that broke up and amplified the blocks of printed text. It also published poetry and serialized novels, and it had regular advertising and humor sections. Although it is commonly thought to have been a newsmagazine, it did not present an overall or balanced account of the news of each week; rather, its coverage was determined by the interest and appeal of its visual materials. As Kurt Korff, the editor in chief from 1905 to 1933, explained, "The *BIZ* adopted the editorial principle that all events should be presented in pictures with an eye to the visually dramatic and excluding everything that is visually uninteresting. It was not the importance of the material that determined the selection and acceptance of pictures, but solely the allure of the photo itself."[17] The *BIZ* was thus in many ways a central medium through which the German public was exposed to the new and developing practices of photomontage, here understood in a broad sense as juxtaposing photographs with texts and other forms of illustrative materials. Despite its emphasis on visual communication, juxtaposing words with images, and breaking up and shortening blocks of text, however, the *BIZ*'s layout was for the most part designed so as to smooth over the dislocations produced by its strategies of montage. The experience of simultaneously (and distractedly) viewing and reading was intended to be new and exciting, but, like the *BIZ*'s advertisements, it was also expected to be easily intelligible and not thus radically transformative of the status quo.

Significantly, as suggested by the following brief inventory of articles and photomontages that appeared in 1919, the *BIZ* also published features that were self-reflexive, promoted visual literacy, and taught its growing audience about the new forms of optical communication being introduced by the mass press. The cover of the February 16 issue, for example, stressed the new speed of information delivery. It depicted newspapers being unloaded from a two-cockpit biplane with a caption that noted that

the *BZ am Mittag*, another Ullstein publication, was the first newspaper to be delivered regularly in this way.[18] An article from August 17, on the other hand, instructed readers on "the art of instantaneous photography," detailing all the considerations that went into creating successful candid images of modern life.[19] Underwater lights and observation tools were featured in a November 9 article on new technological developments; the profession and technical tricks of newspaper photographers and their contributions to "a change in our way of thinking" were discussed on December 14; and a brief history of newspapers' roles in fostering crime prevention, world exploration, technological advance, economic growth, political engagement, democracy, bureaucratic reform, and public works was printed on December 28.[20]

Contests for cash prizes were also used to promote visual literacy, their puzzles designed to encourage readers to engage with and comprehend the new ways of combining photographs and texts. A Christmas contest announced on December 28, 1919, for example, awarded cash prizes to viewers who could identify six people or objects photographed from above (fig. 6.3).[21] In terms of images, the layout of the contest page is evenly balanced from side to side and weighted slightly toward the bottom, the main element of dynamism coming from the central circle with its strong diagonal orientation. The text is presented in three small pieces on the top, left, and right, all of which are surrounded on three sides by larger images. The written material reinforces the idea that we generally perceive things from a normal or usual vantage point, telling us that the world appears differently from "above" and that from the perspective of a zeppelin or airplane things reveal "a completely different form." Readers were encouraged to identify with the nontraditional viewpoint implied by the photographs by describing what was depicted and submitting their answers. If they identified the images correctly, the *BIZ* promised, they might be rewarded; out of all the correct answers, up to eleven lucky entries would be chosen to receive cash prizes ranging from fifty to three hundred marks. The answers, moreover, which were published a month later, were all cyborgian or technological in subject matter: a photographer hunched over his camera, a soldier wearing an assault helmet, a fireman in a smoke helmet, a coffee mill, a lantern, and an arc lamp. Not only did the editors encourage their readers to identify with a technologically enhanced viewpoint associated with planes, zeppelins, and tall modern buildings, but, through their choice of photographs, they also suggested the ubiquity of machines and technologically augmented human beings in modern life.

Fig. 6.3. "Christmas Prize Puzzle: The World as Seen from Above," *Berliner Illustrirte Zeitung* (Berlin Illustrated Newspaper) 28, no. 52 (December 28, 1919): 544.

Cyborgian images, as mentioned earlier, are images that are reflexively concerned with the impact of technology on the human body and mind. During the late 1920s and early 1930s, however, Ernst Jünger was already pursuing a very disturbing line of thought about the transformation of perception by the mass media. Citing aerial photographs like the ones used by the *BIZ* editors, Jünger argued that film and photography were altering human physiology and ethics, producing people with a "second, colder consciousness."

> The photograph stands outside the realm of sensibility. It has something of a telescopic quality: one can tell that the object photographed was seen by an insensitive and invulnerable eye. That eye registers just as well a bullet in midair or the moment in which a man is torn apart by an explosion. This is our characteristic way of seeing, and photography is nothing other than an instrument of this new propensity in human nature.[22]

By developing a second consciousness, human beings would learn to see themselves as objects, stand "outside the sphere of pain," and, finally, evolve an objectified—that is, more pragmatic and less feeling—worldview.[23] Although the *BIZ* editors probably did not share Jünger's authoritarian understanding of the specific changes that new photographic angles and perspectives would foster in human consciousness, it is clear that they found the novel, nontraditional viewpoints exciting and expected that their readers would derive pleasure from them.

A later contest in visual literacy, announced by the *BIZ* on July 5, 1925, also attempted to foster an identification with new forms of distracted perception—in this case, the recognition and naming of image fragments. In addition, it simultaneously brought in a new focus on gender. It promised its viewers potential cash prizes if they could successfully identify photographic fragments depicting partial faces and body parts of the famous, including Charlie Chaplin, Dr. Hugo Eckener, Gerhard Hauptmann, Jack Dempsey, and Benito Mussolini (fig. 6.4).[24] This contest is particularly significant as it also implies that—as photomontage developed during the Weimar Republic—an expectation arose in the popular press that certain readers could be expected to recall the identity of a represented person or object from a fragmentary image presented in a photomontage. It thus suggests that during the 1920s Höch might also have assumed that at least some of the viewers of her works would remember the original subjects, meanings, and contexts depicted in the cut-up printed photographs they

Fig. 6.4. "Oh, These Children!" *Berliner Illustrirte Zeitung* 34, no. 27 (July 5, 1925): 846.

contained and, furthermore, that they would call on these memories when interpreting them.[25]

The contest page's layout and strategies of communication are noteworthy. Not only do they reveal a debt to both Dada and constructivist montage, but they are also fairly radical for a mainstream newspaper of the time. The photographic images are ambiguous, sharp-edged, and strangely shaped; two of the largest are pasted in at an angle, and the meaning of the page must be created by connecting elements across three different media: a handwritten title and drawn top image of a little girl holding scissors and a male portrait, the oddly shaped photographic fragments depicting pieces of important male figures, and columns of text anchoring the bottom of the page. In addition, the contest reveals and obscures a central tension subtending the rise of both photomontage and the mass media during the Weimar Republic, namely, the role of the New Woman in mass society.

Although the photomontage contest page depicts a little girl and not a New Woman, the girl could easily be interpreted as a stand-in for the latter figure. This is the case because of the girl's clothing and chin-length haircut with bangs, which evoke the New Woman's frequently girlish appearance, short skirt, and bobbed or pageboy hairstyle. In addition, like the New Woman, the little girl is represented as both the subject and the object of the mass media, and, like the New Woman, she is shown as active, powerful, and even threatening vis-à-vis the New Men whose images she transforms. Read in this way, the contest page communicates contradictory messages. On the one hand, the New Woman is empowered through the images; she is represented as the creator of photomontages, and powerful men are shown to be subject to her ability to cut and splice. On the other hand, she is trivialized through the written text, which characterizes her as "Little Katherine, the daughter of one of our editors," who, while unattended, has "destroyed" the masculine portraits on her father's table and who now requires the *BIZ's* readership to restore meaning to an assemblage of fragments. Although they have a clear and powerful effect, her actions are suggested to be without thought or purpose. As was also the case with Höch's *The Beautiful Girl*, a female figure is simultaneously represented as both a producer and a depicted subject of the new mass media, potentially powerful but brainless at the same time.

The *BIZ's* representation of the female photomontagist suggests that with the rise of the mass media women come to define not only themselves but also men in ever more powerful ways. As was suggested by the conjunction of the two photomontages by Höch analyzed earlier, technology

made men and women more interrelated as well as more able to affect one another. The contest seems to acknowledge this new more powerful interrelationship while at the same time partially obscuring the insight through the implied narrative, which blurs the lines between the powerful New Woman whose existence radically destabilizes the traditional patriarchal order and a silly little girl who can still be controlled by masculine discourses and institutions. In addition, the contest further obscures this insight through aspects of its heterogeneous printed form, which identifies the little girl and the expression of paternal condescension with historically earlier forms of representation—namely, drawing and handwriting—as opposed the modern photography and type, which characterize the masculine sections of the page. Indeed, in the contest's narrative, the New Woman appears to have lost her ability to splice, another sign of patriarchal fears of the New Woman's power to define both herself and others in the age of technological reproducibility.

As indicated by the specific montage strategies and self-reflexive tendencies of her photomontages, Höch responded to the new modes of simultaneous seeing and reading promoted by the illustrated magazines and newspapers, and to some extent she incorporated forms and strategies derived from these new types of print journalism into her art. Contrary to even the most radical examples in the establishment press (such as the *BIZ's* contests promoting visual literacy), however, Höch used photomontage to encourage her spectators to employ their distracted modes of perception to dismantle the status quo and reveal the hidden political agendas, social ideologies, and "ideal" psychological types that the mass media promulgated. Thus, although Höch was in many ways inspired by the German culture industry, she also remained fundamentally opposed to it, seeking, as she did, to turn the strategies of mass communication and advertising against the mass media itself. As Höch demonstrated through her art, the mass media and new practices of photomontage potentially empowered the New Woman by allowing her to redefine herself and criticize the patriarchal figures that still attempted to dismiss and control her.

Notes

Some of the ideas that inform this essay are treated at greater length in chapter 5 of my book, *The Dada Cyborg: Visions of the New Human in Weimar Berlin* (Minneapolis: University of Minnesota Press, 2009).

1. Atina Grossmann, "*Girlkultur,* or Thoroughly Rationalized Female: A New Woman in Germany?" in *Women in Culture and Politics: A Century of Change,* ed.

Judith Friedlander, Blanche Wiesen Cook, Alice Kessler-Harris, and Carroll Smith-Rosenberg (Bloomington: Indiana University Press, 1986), 62–80.

2. Hanne Bergius, *"Dada Triumphs!" Dada Berlin, 1917–1923, Artistry of Polarities* (New Haven: G. K. Hall, 2003), 113–88.

3. Francis M. Naumann, *New York Dada, 1915–1923* (New York: Harry N. Abrams, 1994), 162–63.

4. Maria Makela, "Notes to Plate 9," in Peter Boswell, Maria Makela, Carolyn Lanchner, and Kristin Makholm, *The Photomontages of Hannah Höch* (Minneapolis: Walker Art Center, 1996), 34.

5. Ibid., 35.

6. See László Moholy-Nagy, *Painting Photography Film* (Cambridge: MIT Press, 1969), 106.

7. On Herschel, see Naomi Rosenblum, *A World History of Photography,* 3rd ed. (New York: Abbeville Press, 1997), 27–29, 32, 46–47, 197.

8. Peter Nisbet, "A Cut-Up at the Dada Fair," *Boston Book Review* 4, no. 3 (April 1997), 8–9.

9. Walter Benjamin, *The Origin of German Tragic Drama* (1925, 1928) (New York: Verso, 1990), 184.

10. Peter Bürger, *Theory of the Avant-Garde* (1974) (Minneapolis: University of Minnesota Press, 1984), 69.

11. Ibid., 79–80.

12. See, for example, Tim N. Gidal, *Modern Photojournalism: Origin and Evolution, 1910–1933* (New York: Macmillan, 1973), 5–30; Fred Richin, "Close Witnesses: The Involvement of the Photojournalist," in *A New History of Photography,* ed. Michel Frizot (Cologne: Könemann, 1998), 591–611 and in particular 599–600; and Torsten Palmér, *The Weimar Republic Through the Lens of the Press,* ed. Hendrik Neubauer (Cologne: Könemann, 2000), 4–37.

13. See Edlef Köppen, "The Magazine as a Sign of the Times" (1925), Kurt Korff, "The Illustrated Magazine" (1927), and Johannes Molzahn, "Stop Reading! Look!" (1928), all in *The Weimar Republic Sourcebook,* ed. Anton Kaes, Martin Jay, and Edward Dimendberg (Berkeley: University of California Press, 1994), 644–45, 646–47, 648–49.

14. Siegfried Kracauer, "Photography" (1927), in Siegfried Kracauer, *The Mass Ornament: Weimar Essays* (Cambridge: Harvard University Press, 1995), 57–58.

15. Ibid., 58.

16. Walter Benjamin, "The Work of Art in the Age of Mechanical Reproduction" (1936), in Walter Benjamin, *Illuminations* (New York: Schocken, 1969), 238–41, 250.

17. Kurt Korff, "The Illustrated Magazine," in *The Weimar Republic Sourcebook,* ed. Anton Kaes, Martin Jay, and Edward Dimendberg (Berkeley: University of California Press, 1994), 646–47.

18. "Zeitungs-Flugdienst Berlin-Weimar," *Berliner Illustrirte Zeitung* 28, no. 7 (February 16, 1919): 49.

19. "Die Kunst der Moment-Photografie," *Berliner Illustrirte Zeitung* 28, no. 33 (August 17, 1919): 318–19.

20. "Interessantes aus dem Reich der Technik," *Berliner Illustrirte Zeitung* 28, no. 45 (November 9, 1919): 462–63; "Der Photograf als Journalist," *Berliner Illustrirte Zeitung* 28, no. 50 (December 14, 1919): 522–23; "Die Zeitung als Pionier," *Berliner Illustrirte Zeitung* 28, no. 52 (December 28, 1919): 546–47.

21. "Die Welt von Oben Gesehen," *Berliner Illustrirte Zeitung* 28, no. 52 (December 28, 1919): 544; "Auflösung unseres Preisrätzels aus Nr. 52," *Berliner Illustrirte Zeitung* 29, no. 5 (February 1, 1920): 55.

22. Ernst Jünger, "Photography and the 'Second Consciousness,'" excerpt from "On Pain" (1934), in *Photography in the Modern Era: European Documents and Critical Writings, 1913–1940*, ed. Christopher Phillips (New York: Metropolitan Museum of Art and Aperture, 1989), 208.

23. Ibid., 207–8.

24. "O, diese Kinder!" *Berliner Illustrirte Zeitung* 34, no. 27 (July 5, 1925): 846; "Ergebnis unserer Preisaufgabe aus Nr. 27," *Berliner Illustrirte Zeitung* 34, no. 31 (July 31, 1925): 991.

25. After the First International Dada Fair in Berlin in 1920, Höch did not exhibit her photomontages again until the landmark Film and Photo exhibition in Stuttgart in 1929. Although she continued to make photomontages throughout the Weimar Republic (and, indeed, until her death in 1978), she appears to have regarded photomontage as a more private pursuit during most of the Weimar years. Thus the only audience for her photomontages during most of the 1920s was a private one.

7

Acting the Lesbian: *Les Amies* by Germaine Krull

CLARE I. ROGAN

Sometime between 1922 and 1924, Germaine Krull (1897–1985), a young female photographer, decided to create two portfolios of double female nudes in interiors, titled *Akte* (Nudes) and *Les Amies* (Girlfriends). While *Akte* presented the women in flirtatious poses, *Les Amies* reveals overtly sexual lesbian scenes. Produced in Berlin, a center for experimental sexual politics and advocacy for homosexual rights in the interwar years, these photographs reveal one private response to the possibilities of the city. Seizing a role previously allowed only to men, Krull photographed explicit sexual material yet posed her models in ways that curiously frustrate the expectations of the male gaze and of the genre of erotic or pornographic material. The compositions and costumes suggest playful enactments or temporary diversions rather than statements of identity,[1] yet once circulated and viewed by others they risked charges of pornography. Indeed, reproductions of three photographs were ultimately included in the extensive study *Die Erotik in der Photographie* (The Erotic in Photography) (1931–32), where they were reinserted into the dominant discourses on erotic images.

 Throughout her life, Krull avidly seized the new professional and personal opportunities available to women, as Kim Sichel has detailed. From 1915 to 1917 or 1918, Krull studied photography at the Munich Lehr- und Versuchsanstalt für Photographie, and by 1918 she had established a studio in Munich. Following the Bavarian socialist revolution of 1918, Krull was expelled from Bavaria in February 1920 for her attempt to smuggle two communists across the border to Austria. From January 1921 to January 1922, she traveled with her husband, Samuel Levit, to the Soviet Union, where she attended the Third World Congress of the Communist International in Moscow. During this time she was jailed twice as an antirevolu-

tionary and ultimately expelled by the Soviets. After separating from Levit and recuperating from typhus, Krull moved to Berlin, where with funds from her new lover, Hans Basler, she established a photography studio jointly with Kurt Hübschmann.[2]

In Berlin, Krull turned her attention from politics back to photography, specifically to dance and nude photographs, including the homoerotic subjects of this essay. In 1918, she had contributed seven pictorialist female nudes to a portfolio copublished by Krull, Josef Pécsi, and Wanda von Debschitz-Kunowski.[3] In Berlin, Krull created a group of nude studies of her sister Berthe and another group of photographs of a woman known as Freia together with a second woman, using the visual conventions of *Freikörperkultur* or nudist movement photographs.[4]

In *Akte* and *Les Amies* the subject and poses threaten the position of the photographs as art. The existing copies of the portfolios are not dated, and the exact dates of the photography sessions are unknown. In her autobiography, Krull discussed the production of some commemorative Lenin albums, then mentioned her interest in creating "galant" photographs.[5] This suggests that the portfolios were executed in 1924 sometime after Lenin's death on January 21. Krull first discussed her concept with Gretel Hübschmann, the wife of her studio partner, Kurt Hübschmann.

> In that period, I wanted to make something new; I thought of taking some blatant photographs, perhaps galant. Gretel Hubschmann found it a good idea, so we took a series of photographs of semi-nude figures, but I wasn't happy with them. We also tried to take some fashion photos for which I felt no inclination. Gretel, however, liked them a lot.[6]

Seeking to "make something new," Krull turned to "galant" photographs, a euphemism that could refer to a range of depictions of illicit sexual activity and recalled French erotic art and literature.[7]

With the founding of the Weimar Republic, censorship had ended, but the earlier laws on obscenity remained in effect. The constitution of the Weimar Republic, signed on August 11, 1919, clearly stated in article 118, paragraph 2, "Censorship does not take place."[8] Yet the paragraph continued, permitting laws regulating film and advocating the protection of youth from "*Schund- und Schmutzliteratur*" (trash and dirt), that is, violent and erotic literature.[9] Moreover, the existing legal code from 1872 remained in effect, including paragraph 184, which criminalized the sale and distribution of obscene material, including visual material.[10]

Nevertheless, if Krull wished to imitate "galant" photographs, they were widely available in Berlin before the First World War and the supply continued after the war ended. Gary Stark detailed the extent of pornographic material circulating in Germany during the Wilhelmine Empire.[11] The diversity of material continued into the 1920s; the prevalent types of pornography were summarized in 1921 in two reports on the German Central Police Department for the Prosecution of Indecent Texts, Images and Advertisements, known as Polunbi. The Polunbi collection included about seven thousand examples of photographs depicting "sexual activities in all imaginable modes."[12] Loose photographs were stored in albums organized thematically, including a section for "homosexual and autoerotic pictures."[13] The Polunbi albums may also have placed female homoerotic images within the category of female nudes. The report estimated that at least several hundred thousand pornographic photographs were in circulation. They were usually postcard size and cost three marks or more.[14]

One version of the portfolio, *Akte*, currently in a private collection in Munich, contains twelve photographs within a gray-brown cardboard portfolio hand lettered with the title. The prints are all the same dimensions, some vertical, some horizontal, 16.5 x 22.2 cm, and mounted on a heavyweight cream canvas-finish paper. By choosing this size print, Krull distinguished her works from the usual postcard dimensions of pornographic photographs, subtly reinforcing the position of her prints as works of fine art.[15] The individual prints are not numbered; whether Krull intended the photographs to follow in a specific sequence is unknown. With standard *Bubikopf* bobbed hairstyles and simple white slips, the two young models could represent any New Woman. Standing in Krull's studio against a simple white wall or seated on a divan draped in a paisley shawl, they pose in various casual positions, naked or partly draped by a slip or a shawl (fig. 7.1). Despite their partial undress, only one plate suggests an embrace, and even this does not imply a sexual act. Sichel argues that such images "could have been seen in an academic art setting, despite their playfulness."[16]

In contrast, *Les Amies*, shot around the same time and with at least one if not both of the same models, clearly enacts a lesbian sexual encounter. The cover of *Les Amies* is a similar gray cardboard portfolio, hand lettered in black ink with the title. The choice of the French term, *Amies*, instead of the German, *Freundinnen*, suggests a conscious reference to French "galant" photographs. Again the images are not numbered, leaving the sequence unknown. A portfolio of *Les Amies* in a private collection in

Fig. 7.1. Germaine Krull, *Untitled,* from *Akte* (Nudes), gelatin silver print, ca. 1922–24. (Dietmar Siegert Collection.) (Copyright Estate Germaine Krull, Fotografische Sammlung, Museum Folkwang, Essen.)

California contains eleven photographs in addition to the portfolio case. It is possible that some versions of the portfolio included twelve photographs as a gelatin silver print with the same two models, clad in the same clothes, was listed at auction in 2005.[17]

Within *Les Amies,* although the sequence is not certain, the different costumes and props suggest different moments in a sexual encounter. If we add the image listed at auction in 2005, then the sequence starts with both women fully dressed in coats and cloche hats, seated on the divan, and smoking. The next image might be that in which both women are fully dressed though lying in a tight embrace on the divan, as the skirt of one woman falls to reveal her thigh, on which her companion rests her hand. As the models gradually undress, their clothing suggests masculine and feminine role-playing. One of the women wears knee-length breeches, a white tailored shirt, and a tie suggesting a masculine role in the scenario (fig. 7.2). Nevertheless, her high-heeled suede shoes make her fashionable and feminine, not actually cross-dressing. The second woman in this image wears a dark, gauzy, lace-trimmed negligée, much more sophisticated than the

Fig. 7.2. Germaine Krull, *Untitled*, from *Les Amies*, gelatin silver print, ca. 1922–24. (Private collection.) (Copyright Estate Germaine Krull, Fotografische Sammlung, Museum Folkwang, Essen.)

simple white slips in *Akte*. The contrast between masculine and feminine styles continues in another print, in which the femininely clothed woman swoons horizontally on the divan, as the woman in breeches holds her in a commanding embrace.

Krull's choice of clothing for her models, especially the selection of knee-length breeches for the model playing a masculine role, evokes contemporary fashions yet exceeds general usage. Wearing menswear tailored

jackets, ties, and short hair and smoking cigarettes had been signs of "deviant" women since the 1880s, yet the signification shifted dramatically in the 1920s with the expansion of the New Woman beyond a restricted group of female students and professionals. In the 1887 edition of his *Psychopathia sexualis*, Richard von Krafft-Ebing stated that female homosexuals wear masculine haircuts and tailored clothing.[18] By the 1920s, masculine clothing styles such as white shirts, ties, and tailored jackets were no longer clear indicators of transgressive masculinity or same-sex orientation in women but could also be merely signs of the latest fashions. As Laura Doan has stated, in 1920s Britain, "boyish or mannish garb for women did *not* register any one stable spectatorial effect."[19] Doan argues that in the mid-1920s, masculine dress for women signified merely the height of fashion and bohemianism rather than any coherent sexual identity.[20] Patrice Petro analyzed the changing representations of masculine styles for women in the pages of the leading German fashion magazine, *Die Dame,* and noted that from 1924 to the end of the decade articles debated the "masculinization" of the New Woman, portrayed with cropped hair and menswear jackets. However by 1931 the masculine fashions had disappeared from *Die Dame* in favor of extremely feminine styles.[21]

Yet Krull's choice to depict a model in breeches rather than a tailored skirt departs from representations of the New Woman, and suggests a more playful reference to theatrical cross-dressing or fancy dress.[22] In 1924, New Women and lesbian or Third Sex women were still typically depicted wearing a skirt rather than trousers, which would indicate transvestism rather than same-sex identity.[23] Representations of lesbian bars such as Rudolf Schlichter's watercolor *Damenkneipe* (Women's Bar), circa 1923–25, depict even the most masculine of women wearing skirts.[24] In October 1924, an issue of the journal for lesbian readers, *Die Freundin,* included an image of two women dancing together, both with short *Bubikopf* hairstyles and wearing skirts with their tailored jackets and ties.[25] As late as 1924, even within the pages of this journal for lesbians, masculine lesbians did not wear trousers.

In the remaining eight photographs in *Les Amies*, the models are naked except for their dark stockings and sometimes their shoes. The overt sexuality of the models is emphasized by the stockings, unlike the bare legs of the models in *Akte*. The depiction of stockings had long been considered a sign distancing a figure from the conventions of the ideal, asexual nude based on classical models.[26] The choice of the dark stockings also emphasizes the contemporaneity of the models. In contrast, photographs of nude

Fig. 7.3. Germaine Krull, *Untitled*, from *Les Amies*, gelatin silver print, ca. 1922–24. (Private collection.) (Copyright Estate Germaine Krull, Fotografische Sammlung, Museum Folkwang, Essen.)

figures specifically described as models for artists, and therefore intended as ideal citations of classical models, are absent any clothing that would imply a contemporary existence.[27]

In contrast to the conversational poses of the models in *Akte,* most of the poses for *Les Amies* are tangles of intricately interlocking limbs in which sexual acts are posed but not entirely convincing. Some positions appear more sculptural than sexual (figs. 7.2–7.4). One image suggests cunnilingus, yet the head is placed slightly too far away.[28] Another image enacts a "69" pose of double cunnilingus, yet again the heads are ever so slightly out of position and the composition becomes a protosurrealist study of a nude torso from behind, with dark stockings at right and left (fig. 7.4). One more image presents a clear view of one woman's crotch, as one leg flails above her.[29] The pose would seem to prevent sexual satisfaction, although it provides the viewer with a brief glimpse of vaginal lips.

Throughout *Les Amies,* Krull repeatedly obscures the models' anatomy, oscillating between inviting the spectator's desiring gaze and frustrating the clarity such a gaze requires. As Abigail Solomon-Godeau observed

Fig. 7.4. Germaine Krull, *Untitled,* from *Les Amies,* gelatin silver print, ca. 1922–24. (Private collection.) (Copyright Estate Germaine Krull, Fotografische Sammlung, Museum Folkwang, Essen.)

about the "lesbian" scenes staged for nineteenth-century daguerreotypes, "[W]omen together . . . are typically posed in ways that provide the viewer with maximum visual access to their bodies."[30] These conventions continue into the twentieth century, yet Krull's models fold their arms across their faces, tilt their heads so their pageboy hairstyles hide their eyes,[31] and press their bodies so close together that their breasts are partly hidden. Even more surprising, in not a single image does a model directly gaze out at the camera. The standard acknowledgment of the viewer of erotic material, the address to the third party outside the image, never takes place. These models remain hermetically sealed in the studio, failing to address the frustrated desiring gaze, to symbolically invite the third party to join the sexual adventures taking place. Despite the direct view of the crotch in one image and the depictions of cunnilingus, the eroticism is contained between the two women, with no imaginary space for a third, presumably male, viewer to enter.

Psychoanalytic theories of the gaze have defined spectator positions in gendered terms, with the male position or gaze described as active and

aligned with the desire to possess the female object, in contrast to the female, passive position that would allow only the desire to become the object. As research into queer viewing positions has argued, these viewing positions are not exclusively aligned with the sex of the viewer: a man can take on the desire to become the object when viewing a homoerotic scene.[32]

The compositional structure of Krull's *Les Amies* invites a desiring gaze that is narcissistic, a gaze that desires to be one of the women while rejecting the possibility of possessing them both. This argument extends Sichel's observation that Krull dismissed "the male gaze of Weimar culture in favor of a female gaze" and her emphasis on the gazes within the images as the female models view each other.[33] In *Les Amies*, there is no space for a third party: the only possibility is to become one of the women. Moreover the specific acts depicted suggest a woman's knowledge of how women have sex with women rather than a man's imagined projection. The repeated emphasis on how the hands are placed in each image and sexual position stresses the crucial importance of the hands as instruments in female-female sex. In contrast, the absence of a dildo suggests that there is no need for a penis or indeed for the symbolic phallus. In comparison, Christian Schad's satirical drawing of two woman engaged in oral sex, *Sisters*, circa 1929, includes an enormous dildo, which has been discarded in the corner, simultaneously emphasizing the desire for the phallus while comically bemoaning its dismissal.[34]

By photographing erotic scenes, Krull not only constructed the desiring gaze but also placed herself in the position of that gaze, taking on privileges previously permitted only to male photographers. The trope of the male artist desiring his female model, of the creative act as intimately connected to the sexual act, goes back as far as the classical tale of Pygmalion and echoes throughout Western art since the Renaissance. Similarly, for photographers, Solomon-Godeau notes that "photographic activity was itself intuitively perceived as sexually charged."[35] Although there is evidence of women's involvement in manufacturing and distributing pornographic photographs before and during the First World War,[36] these women remained on the margins of commercial photography. For an ambitious, professionally trained woman photographer such as Krull to create erotic and even pornographic material required her to transgress the definitions of middle-class respectability.

Krull's motivation for creating *Akte* and *Les Amies* remains unclear: her later account of wanting to make "galant" photographs remains the most

viable explanation. Yet that decision was made within the context of her unorthodox—and temporarily bisexual—personal life and the artistic possibilities in Berlin in the 1920s.

In her later biography, Krull mentioned various male lovers across the years, as well as one female lover, Elsa, with whom she had an affair during her time in Berlin and into 1925 after she left Berlin for Amsterdam and then Paris: "At that time, I also had a friend, Elsa, who came to help me when I had too much to do. Elsa was the only woman in my life for whom I had feelings that were more than friendly; she was married and had a lover, and for that reason didn't have much time for me."[37] During an account of a visit to Paris with Elsa, most likely in 1925, Krull elaborated further.[38]

> I never loved a woman, but with Elsa the joy of feeling together was great; she too never left my side. We would have laughed if someone had described us as lesbians; Elsa was so profoundly mine that the physical issue did not count, it had very little importance. She had never experienced an orgasm, not with her husband nor with her lover, and thus it had to be me to give her pleasure. Everything was very simple and we were happy to share a secret.[39]

Krull's dismissal of the term *lesbian* reflects the fluidity of female sexual identity in the 1920s, especially for adventurous New Women. According to an interview conducted by Ilse Kokula, one woman reported that it was "chic" to pretend to be lesbian in the 1920s.[40] There is no evidence that Krull had more than one same-sex affair.[41] At the same time as her affair with Elsa, she was having an affair with Joris Ivens, whom she later married.[42] Similarly, as Krull relates, Elsa also had not only a husband but also a male lover in addition to her relationship with Krull.

At the same time that Krull was making photographs with explicit same-sex female imagery, the visibility of women who loved women was reaching a new point of public depiction, public concern, and individual practice. The lesbian or Third Sex woman was a subject for popular caricatures, novels, and fine art editions in addition to erotic or pornographic photographs.

In 1923, comic representations of both male and female homosexuality were published in the popular illustrated journal *Simplicissimus* by Karl Arnold as examples of the decadent nightlife of Berlin. Arnold's "Berlin Pictures XXI" was subtitled "Schwuhl," a term already in use to describe homosexuals.[43] Part of an ongoing series of comic Berlin scenes, "Schwuhl" represents a crowded nightclub, with three same-sex couples dancing

in the crowd. Another *Simplicissimus* caricature by Arnold in the same year included male and female homosexuals (an effete young man and a masculine woman wearing a monocle) among the types observed "At the Bar."[44] These caricatures indicate that by 1923 gay and lesbian bars were considered a routine sign of the decadence of Berlin, a status codified in 1931 when the humorous guidebook *Führer durch das "lasterhafte" Berlin* (Guide to "Depraved" Berlin) included sections on homosexual, lesbian and transvestite locales.[45]

Popular German and international literature also included new accounts of lesbian subjects. In 1924, Alfred Döblin published *Die beiden Freundinnen und ihr Giftmord* (The Two Girlfriends and Their Murder by Poison), based on the criminal case of two working-class married women who had an affair and poisoned the husband of one of them. Victor Margueritte's novel *La Garçonne* was published in Paris in 1922 and already translated into German by 1923.[46] *La Garçonne* recounts the misadventures of a wealthy bourgeois young woman who has an affair with a woman, then several affairs with men. A review of the German translation emphasized the similarity of experience between French and German women, describing the novel as a "depiction of the post-war young woman from the better classes, as she 'eroticizes' in the same way in Paris, London and Berlin."[47]

Female same-sex subjects were also depicted in the fine arts. In 1919, the limited-edition journal *Arkadien* published Paul Verlaine's poem "Pensionnaires" together with an etching by Michel Fingesten depicting two young schoolgirls engaged in the cunnilingus metaphorically described in the text.[48] Lene Schneider-Kainer included several homoerotic double nudes in her illustrations of the ancient Greek dialogs of Lucian, *Hetärengespräche* (Courtesan Conversations), published in 1920.[49] For the second volume in the limited-edition luxury series, *Der Venuswagen*, the Fritz Gurlitt Verlag published *Sappho oder die Lesbierinnen* (Sappho or the Lesbians) with a voyeuristic text from the eighteenth century by Etienne de Jouy and seven contemporary etchings by Otto Schoff. In 1921, in a highly publicized trial, Wolfgang Gurlitt, publisher of the *Venuswagen* series, was charged with obscenity; although six of the nine volumes in the series were ruled to be obscene, *Sappho or the Lesbians* was dismissed as risqué but not obscene.[50]

If indeed Krull photographed her two portfolios in 1924, the timing roughly coincides with the founding of a new journal, *Die Freundin* (The Girlfriend), established in August 1924 by Der Bund für Menschenrechte

(League for Human Rights). The League for Human Rights was a political and social group advocating for homosexual rights. It published *Die Freundin* for its women members, as well as distributing the journal via newsstands throughout Germany.[51] Whether Krull socialized in lesbian groups such as the League for Human Rights is unknown; Sichel cites possible social overlaps among the lesbian actress Maximiliane Ackers, Krull, and Krull's model Freia.[52]

It is unclear how or if Germaine Krull planned to distribute the photographs in *Akte* and *Les Amies* and how many prints she made of each image, but a search of auction records over the last twenty years suggests that relatively few prints were created. The handmade quality and hand lettering of the portfolio covers for both *Akte* and *Les Amies* suggest that Krull never editioned the work or produced formal portfolios for widespread sale. A search of auction records located nine images from *Les Amies* that came up for sale between 1987 and 2008. For eight of these nine images, between one and three prints were listed. For the ninth image, there were five listings, but this may incorporate multiple listings for the same print after it failed to sell at earlier auctions.[53] It is likely that some prints were destroyed between 1933 and 1945 either in raids on pornographic material by the National Socialists or by the bombs of the Second World War. Nevertheless, it seems reasonable to conclude that Krull may have printed at most five or so prints of each photograph, whether distributed in portfolios or as single images.

Nevertheless, the reproduction of three photographs from *Akte* and *Les Amies* in *Die Erotik in der Photographie* (1931–32) demonstrates that the portfolios did circulate at least within a small group of collectors, and through this publication to a much larger audience. Published in three volumes, this extensive study records a range of erotic and pornographic photographs. The first volume of *Die Erotik in der Photographie* includes detailed scholarly articles on the history of erotic photography, market distribution techniques, censorship, and other topics. The subtitle of the study, *The Historical Development of Nude Photography and Erotic Photographs and the Relationship to Psychopathia Sexualis,* stresses the scholarly, scientific, and regulatory apparatus called on to justify the volumes. Nevertheless, the second and third volumes are heavily illustrated, suggesting that the eventual audience was less interested in scholarship than in viewing the pictures, which overwhelmingly depict single women, whether nude or in various stages of undress.[54] Both the second and third volumes include sections with "lesbian" themes, but the almost total absence of male homo-

Fig. 7.5. Germaine Krull, *Boarding-School Friends,* gelatin silver print, ca. 1922–24, published in *Die Erotik in der Photographie,* ed. Erich Wulffen et al. (Vienna: Verlag für Kulturforschung, 1931–32). (Agfa Photo-Historama Collection.) (Copyright Estate Germaine Krull, Fotografische Sammlung, Museum Folkwang, Essen.)

erotic imagery is striking; only one double male nude image is included, and it is categorized as a flagellation scene rather than an image of male homosexual activity.[55]

Three photographs by Germaine Krull were reproduced in *Die Erotik in der Photographie,* two from *Akte* and one from *Les Amies,* with titles reinserting these images into standard definitions of female-female sexuality. The third volume reproduces an image from *Akte* under the title "Boarding-School Friends" and lists the source as the Archive of the Institute of Sexual Studies in Vienna (fig. 7.5).[56] This title frames the image by locating it at a boarding school, a site often used as a fantasy locale, where lesbian attractions were seen as transitional moments of temporary homosexuality between young women inevitably destined for heterosexual adulthood after graduation. Simultaneously, the credit line placing the actual photograph in the collection of the Archive of the Institute of Sexual Studies in Vienna implies that this subject is indeed suitable for scientific study

as an example of deviant sexuality. Another image from *Akte* was reproduced in the third volume under the title "The Girlfriend's Confession: Photo Study by a Berlin Photographer."[57] In the image, the two women are partly draped, and their heads come together as one speaks to the other, but their faces are obscured, leaving any indication of the emotional content unclear. Reframing the conversation as a confession places the image within the putative drama of female relationships. It is possible that the publishers did not know the name of the photographer and attributed it to an unidentified male "Berlin Photographer." Strangely, for none of these images is Krull credited, although many contemporary photographers are credited by name in these volumes.

The editors of *Die Erotik in der Photographie* reproduced one image from *Les Amies,* selecting one of the least explicit, though overtly lesbian, scenes, the scene reproduced in this essay as figure 7.2, with one woman fully dressed, wearing breeches. Within *Die Erotik in der Photographie,* the plate is titled "Absentminded: Snapshot of a female homosexual character from a portfolio."[58] By choosing this print from the portfolio, the editors selected an image that emphasized masculine and feminine roles among homosexuals yet is unusually passive in the poses of both women. It is also an image that would fit in the preliminary stage of the sequence of events, unlike several of the explicitly sexual poses.

As discussed earlier, Krull's photographs strikingly ignore the expectations of the desiring viewer, leaving faces and breasts obscured; this frustration of the gaze becomes even more apparent in comparison with the other female homoerotic images in *Die Erotik in der Photographie.* The image from *Akte* published under the title "Boarding-School Friends" is on a double-spread layout with three other double-female images, two credited to F. Bassler and one to Heinz von Perckhammer. In the other images the women are entirely nude and display breasts and faces in full either frontally or in profile. In contrast, in Krull's image the foreground figure turns away from the viewer, her face hidden, and only one breast partly visible, while the background figure leans forward, her face partly hidden and again only one breast on partial display.

Despite the scholarly apparatus, the text of *Die Erotik in der Photographie* rarely comments on the double-female nudes or lesbian scenes. The introduction to the second volume briefly mentions lesbian scenes in order to dismiss the argument that the number of certain types of images corresponds to the frequency of such activity.

The frequent appearance of photos representing lesbian scenes surely cannot be explained by asserting that the circle of lesbian-inclined individuals is as excessively large as the number of photographs of this subject would lead one to surmise. The frequency of this motif can be explained more readily, in that two girls from the circles of such models can be more easily persuaded to allow themselves to be photographed in "harmless embraces," than with a male partner in an obscene position. And the buyer of pornographic photographs, even without being interested in the lesbian representation as such, finds in such a photograph the pleasure that two female nudes offer him.[59]

According to this assessment, lesbian scenes appealed to (male) purchasers of pornographic photographs merely because they depicted two women. Production of the images was also easier because female models were more willing to enact lesbian scenes, which were considered "harmless," than to pose with a male model in an explicitly sexual scene.

Germaine Krull's creation of "galant" photographs in *Akte* and *Les Amies* depicted double-female nudes in titillating and even explicitly sexual poses. By placing herself in the role of the creator of such images, Krull transgressed the expectations of middle-class respectability, yet that transgression was consistent with the sexual fluidity of certain independent New Women in the 1920s. Choosing to photograph female-female scenes instead of female-male scenes, Krull relied on the putative "harmlessness" of such poses and the willingness of her models to undertake these poses in a sense of play. Nevertheless, Krull structured the compositions and poses in ways that frustrate a male gaze, denying the ability to enter the scene and allowing only the narcissistic ability to become one of the women, to take on the female role. These photographs reframe the conventions of pornographic images for men, permitting the possibility of a desiring gaze that is specifically female, desiring women. Yet, as demonstrated by the reproduction of these images in *Die Erotik in der Photographie*, such images could still be reincorporated into the dominant and predominantly male discourse of erotic images.

Notes

1. On the interpretation of these photographs as playful, see Kim Sichel, *Germaine Krull: Photographer of Modernity* (Cambridge: MIT Press, 1999), 33–35.

2. I am indebted to Kim Sichel's exemplary exhibition catalog for all biographical details and some key concepts such as Krull's playful approach to lesbian imagery. Ibid., 5–35.

3. Ibid., 14.

4. Ibid., 32–34, pls. 3.1–3.4.

5. Germaine Krull, *La vita conduce la danza,* trans. G. Chiti (Florence: Giunti Gruppo Editoriale, 1992), 125.

6. Ibid. I am grateful to Nadja Aksamija for this and the subsequent translations from the Italian. This and subsequent quotes from Krull's *La vita conduce la danza* appear in slightly different translations in Sichel, 32–34.

7. I was unable to consult Krull's manuscript, which is written in French. However, French and Italian usages for the term *galant* are similar. Compare *Trésor de la langue française* (Paris: Centre national de la Recherche Scientifique, 1971–94), s.v. "Galant"; and *Grande Dizionario della Lingua Italiana* (Turin: Unione Tipografico-Editrice Torinese, 1961–2002), s.v. "Galante."

8. Kurt Richter, *Der Kampf gegen Schund- und Schmutzschriften in Preußen auf Grund des Gesetzes zur Bewahrung der Jugend vor Schund- und Schmutzschriften vom 18. Dezember 1926,* 2nd rev. ed. (Berlin: R. von Decker's Verlag, 1931), 5.

9. Ibid.

10. Ibid. For more on paragraph 184 see Gary Stark, "Pornography, Society, and the Law in Imperial Germany," *Central European History* 14, no. 3 (1981): 213–29.

11. Stark, 200–229.

12. [Kurt] Richter, *Über Pornographien und ihre Bekämpfung* (Berlin: Ministerium des Innerns, 1921), 17, Geheimes Staatsarchiv Dahlem, Berlin. GStA-PK I. HA Rep. 77 Tit. 2772, nr. 1, vol. 1. This and all subsequent German translations are mine.

13. Von Glasenapp, unpublished report regarding "Besonderen Haushaltungsplan für die Deutsche Zentralpolizeistelle zur Bekämpfung unzüchtiger Bilder, Schriften, und Inserate in Berlin," July 12, 1921, Geheimes Staatsarchiv, Dahlem, Berlin, GstA PK, I. HA Rep. 77 Tit. 2772, nr. 2, vol. 1, 65.

14. Richter, *Über Pornographien,* 18–19.

15. Compare with similar comments on the format of *Les Amies.* Sichel, 35.

16. Sichel, 34.

17. Philips de Pury and Company, New York, *Photographs,* April 28, 2005, lot no. 89, http://www.artnet.com. Accessed February 4, 2009.

18. Richard von Krafft-Ebing, *Psychopathia sexualis mit besonderer Berücksichtigung der conträren Sexualempfindung,* 2nd ed. (Stuttgart: Verlag von Ferdinand Enke, 1887), 66.

19. Laura Doan, *Fashioning Sapphism: The Origins of a Modern English Lesbian Culture* (New York: Columbia University Press, 2001), 96.

20. Ibid.

21. Patrice Petro, *Joyless Streets: Women and Melodramatic Representation in Weimar Germany* (Princeton: Princeton University Press, 1989), 103–27.

22. I am indebted to Madelyn Shaw for this interpretation.

23. This essay uses the word *lesbian,* but in the 1920s phrases such as "ideal female friendship" and "Third Sex" were more popular. See Alice Kuzniar, *The Queer German Cinema* (Stanford: Stanford University Press, 2000), 22–27.

24. Götz Adriani, ed., *Rudolf Schlichter: Gemälde, Aquarelle, Zeichnungen* (Munich

and Berlin: Klinkhardt and Biermann, 1997), 150–51, no. 71; Peter Nisbet, ed., *German Realist Drawings of the 1920s* (Cambridge: Harvard University Art Museums, 1986), 233, no. 97.

25. "Jazz," *Die Freundin*, 1, no. 4 (October 1, 1924): 3.

26. Compare depictions of stocking-clad prostitutes in works by Edgar Degas, discussed in Hollis Clayson, *Painted Love: Prostitution in French Art of the Impressionist Era* (New Haven: Yale University Press, 1991), 27–55.

27. Compare Arthur Schulz, ed., *Italienische Acte [sic]* (Leipzig: Verlag Carl Scholtze, 1905). See also Susan Waller, "Censors and Photographers in the Third Republic of France," *History of Photography* 27, no. 3 (autumn 2003): 222–35.

28. Illustrated in Sichel, pl. 3.10.

29. Ibid., 35, pl. 3.7.

30. Abigail Solomon-Godeau, "Reconsidering Erotic Photography: Notes for a Project of Historical Salvage," in *Photography at the Dock: Essays on Photographic History, Institutions, and Practices* (Minneapolis: University of Minnesota Press, 1991), 235.

31. See Uwe Scheid, *Freundinnen: Bilder der Zärtlichkeit, Der Doppelakt in frühen Photographien* (Dortmund: Harenberg, 1987). Sichel also notes that the faces are hidden. Sichel, 35.

32. See Caroline Evans and Lorraine Gamman, "The Gaze Revisited, or Reviewing Queer Viewing," in *A Queer Romance: Lesbians, Gay Men, and Popular Culture*, ed. Paul Burston and Colin Richardson (London and New York: Routledge, 1995), 13–56.

33. Sichel, 35.

34. The drawing is reproduced in Jill Lloyd and Michael Peppiatt, eds., *Christian Schad and the Neue Sachlichkeit* (New York and Munich: Neue Galerie and Schirmer/Mosel Verlag, 2003), 194.

35. Solomon-Godeau, 235.

36. See Waller, 231. During the First World War, women represented almost one-quarter of German prosecutions for pornography. Stark, "Pornography," 221.

37. Krull, 132.

38. On the timing of the visit to Paris, see Sichel, 69.

39. Krull, 136.

40. Ilse Kokula, "Die 'goldenen Zwanziger' in Berlin—von unten gesehen," *LesbenStich* 4, no. 2 (1983): 24–28, quoted in Nancy P. Nenno, "*Bildung* and Desire: Anna Elisabet Weirauch's *Der Skorpion*," in *Queering the Canon: Defying Sights in German Literature and Culture*, ed. Christoph Lorey and John L. Plews (Columbia, SC: Camden House, 1998), 215.

41. Sichel, 33.

42. Krull, 132–34.

43. Karl Arnold, "Berliner Bilder XXI: Schwuhl," *Simplicissimus*, July 30, 1923, 224. The additional *h* in the word *Schwuhl* imitates the Berlin accent. Compare Keith Spalding, *An Historical Dictionary of German Figurative Usage* (Oxford: Blackwell, 1952–ca. 2000) s.v. "schwul."

44. Karl Arnold, "Aus der Diele" (At the Bar), *Simplicissimus,* September 3, 1923, 283.

45. Curt Morek, *Führer durch das "lasterhafte" Berlin,* facsimile of 1931 ed. (Berlin: Nicolaische Verlagsbuchhandlung, 1996).

46. Victor Margueritte, *La Garçonne: Sittenroman aus dem heutigen Paris,* trans. Edmund Edel (Berlin: Ehrlich, 1923). See also Mary Louise Roberts, "'This Civilization No Longer Has Sexes': *La Garçonne* and Cultural Crisis in France after World War I," *Gender and History* 4, no. 1 (spring 1992): 55–56.

47. "Marginalien," *Der Querschnitt,* 3 (1923): 88.

48. The poem appeared in *Arkadien* 1, no. 1 (1919): 44. See also Clare Rogan, "Desiring Women: Constructing the Lesbian and Female Homoeroticism in German Art and Visual Culture, 1900–1933," PhD diss., Brown University, 2005, 155–57.

49. Rogan, "Desiring Women," 158–61; Sabine Dahmen, *Leben und Werk der jüdischen Künstlerin Lene Schneider-Kainer im Berlin der zwanziger Jahre* (Dortmund: Edition Ebersbach, 1999), 101–11.

50. Rogan, "Desiring Women," 167–69.

51. See Katharina Vogel, "Zum Selbstverständnis lesbischer Frauen in der Weimarer Republik. Eine Analyse der Zeitschrift, 'Die Freundin,'" in *Eldorado: Homosexuelle Frauen und Männer in Berlin, 1850–1950* (Berlin: Edition Hentrich, 1984), 162–68. For an analysis of the images in *Die Freundin,* see Clare Rogan, "'Good Nude Photographs': Images for Desire in Weimar Germany's Lesbian Journals," in *Tribades, Tommies, and Transgressives,* vol. 1, *Histories of Sexualities,* ed. Mary McAuliffe and Sonja Tiernan (Newcastle: Cambridge Scholars Press, 2008), 145–61.

52. Sichel, 311, n. 24. Sichel's information came from Ulrike Boehmer.

53. http://www.artnet.com. Accessed February 4, 2009.

54. The Ergänzungsband, or second volume, includes 111 images of single women (clothed or nude) out of 171 photographs, while the Nachtragsband, or third volume, includes 135 images of single women out of 173 pictures. *Die Erotik in der Photographie,* ed. Erich Wulffen, Erich Stenger, Otto Goldmann, Paul Englisch, Rudolf Brettschneider, Gustav Bingen, and Heinrich Ludwig (Vienna: Verlag für Kulturforschung, 1931–32), Ergänzungsband and Nachtragsband.

55. *Die Erotik in der Photographie,* Ergänzungsband, 77.

56. *Die Erotik in der Photographie,* Nachtragsband, 121, pl. 165.

57. *Die Erotik in der Photographie,* Nachtragsband, 45, pl. 54.

58. *Die Erotik in der Photographie,* Ergänzungsband, 70.

59. "Vorbemerkung," in *Die Erotik in der Photographie,* Ergänzungsband, 7–8.

8

Paris—Dessau: Marianne Brandt and the New Woman in Photomontage and Photography, from *Garçonne* to Bauhaus Constructivist

ELIZABETH OTTO

She wanted to die, but she also wanted to live in Paris.[1]

The draw of Paris on women of the world has long been recognized. For them, as for Emma Bovary, the fictitious heroine of Gustav Flaubert's novel, France's capital represented infinite possibilities and specific opportunities. From the early nineteenth century and well into the twentieth, female artists and art students from Europe and North America journeyed to the city to enjoy artistic freedoms largely denied them in their home countries, most significantly life-drawing classes with the nude, requisite training for any serious artist.[2] As early as 1803, Paris's Free Drawing School for Young Ladies, which was modeled on a similar local school for men, became one of the first publicly funded art schools for women, including foreigners.[3] Later in the century one expatriate artist, American-born impressionist Mary Cassatt, wrote of these opportunities, "[A]fter all give me France. Women do not have to fight for recognition here if they do serious work."[4] In the nineteenth and early twentieth centuries, Paris offered women artists the chance to participate in some of the most lively and avant-garde artistic and popular visual cultures in the world.

In this essay I focus on one of the many women who went to Paris to absorb its ambiance and opportunities for artistic immersion: the Bauhaus designer, photographer, and photomonteur Marianne Brandt. In many ways a quintessential New Woman, Brandt is best known for her sleek designs for household objects, which have come to epitomize Bauhaus aesthetics.[5] She started training at a private drawing school in 1911 in the German town of Weimar and in 1912 began studies at Weimar's Grand Ducal College of Art, a rare exception in Germany in that it accepted female

students. In 1916–17 Brandt studied art in Munich; then she returned to Weimar and received her degree in 1918. During at least four subsequent extended trips to Paris, Brandt's work underwent a series of changes that reflected her radical modernization as both a woman and an artist. Whereas during her initial yearlong stay in 1920–21 she was still an expressionist painter, on later trips her choice of media and her work shifted dramatically through both her exposure to the visual delights of France's metropolis and, starting in 1924, her studies at the Bauhaus.[6] In her life and her work, Brandt audaciously traversed borders, not only into foreign territory but into media and aesthetics that had previously been reserved for men. Translating ideas and experiences of the international New Woman into the latest visual technologies, Brandt's photomontages and photographs touch on issues of private emotions, public space, and national and personal identity as they were impacted by shifting gender relationships of the time.

In a highly influential essay on gender, modernism, mass culture, and representation, Andreas Huyssen critiques one of the main theses of the nineteenth and twentieth centuries, namely, that mass culture such as Emma Bovary's consumption of novels and other cheap goods "is somehow associated with woman while real, authentic culture"—such as Flaubert's *Madame Bovary*—"remains the prerogative of men."[7] Through her constructivist figurative work, Brandt broke down this gendered divide. She consumed the mass media of the interwar illustrated press and then used its images to create avant-garde photomontages; she stepped both behind and in front of the camera and harnessed visual technologies to explore her contexts and her own embodiments of modernist femininity. Brandt was a key participant in the rational modernism of the constructivist Bauhaus. But it was in Paris, the traditional city of women's artistic innovation, that she tasted the cosmopolitan life of France's New Woman, an experience that profoundly influenced her own figurative work and her life.

After first exploring the draws that both Paris and the Bauhaus held for women and looking briefly at Brandt's early work, I will focus on her turn to photomontage while in Paris during her 1926 stay in relation to her changing self-constructions as a woman and Bauhaus designer. As I will show, ideas from Brandt's Parisian photomontages carried over to her photographic work at the Bauhaus.

Among the global struggles for suffrage, France's was among the longest fought, with women receiving the vote only in 1964; this was a situation

very different from that in Germany where women were granted suffrage in 1918. Yet, already in the later nineteenth century, a particular type of French feminism developed that emphasized feminine beauty even as it attempted to win women's political and societal freedom.[8] In this form, as Marie Louise Roberts explains, New Womanhood coalesced under the uniquely French title of *éclaireuse*, a term that, like *avant-garde,* originally referred to those in the forefront of a military operation. Given the centrality of notions of beauty and grace to French femininity and in light of the growing presence and reputation of female artists in Paris, it should be no surprise that the world of representation became a primary site of the fight for emancipation. As Tamar Garb has shown, nineteenth-century debates on sexual difference rested on such beliefs as an inherent connection between femininity and the world of appearances, and the idea that women's strengths lay "in their highly developed powers of observation and perception," even if some male scientists saw women as lacking the intellectual capacity to comprehend their observations.[9] In the early twentieth century, women's legal, political, sexual, and economic rights continued to be actively debated in France by such feminists as the medical doctor Madeleine Pelletier, who pushed for changes in women's education, suffrage, and access to abortion.[10]

By the period after the First World War, visuality and the New Woman in France and elsewhere were indelibly linked. Racy images of *garçonnes*—the French term for a boyish New Woman—were deployed in the arguments about how French women would become modern. In interwar photojournalism, visual debates about women's changing appearances and roles in society were played out and a broader fascination with female mobility was brought to the fore. Glossy and literary magazines of the 1920s often depicted women swimming, riding bicycles, flying airplanes, and driving cars. These perceived connections between New Womanhood and freedom of movement fundamentally changed what it was to be a woman of the time, particularly a woman artist. Various aspects of Paris's visual culture were a strong pull to the often freethinking female artists who continued to flock there for education, to participate in the city's avant-garde movements, or to become part of its bohemian and expatriate literary groups.[11] As I now turn specifically to Brandt's work in Germany and France, I want to pick up on the link between travel and representation in order to examine her photomontages as both media interventions and a form of female *flânerie* in which vision is connected to gendered experiences of the interwar metropolis.

Brandt first moved to Paris in 1920 after she and her husband, the Norwegian painter Erik Brandt, married in 1919 and lived in his homeland. She was drawn to Paris not for her art education, since she had already completed a full course of study, but for the culture and life offered by the city. Because many of her personal papers were destroyed in the Second World War, it is difficult to reconstruct the exact nature of Brandt's time in Paris, but two letters to her family focus particularly on her love of the city's beauty and the life it offered, despite its being expensive; her and Erik Brandt's international (largely Norwegian) context; and the fact that they hired a female model to pose in their combined apartment and atelier.[12] "That is more for Erik, I just work along with him," she wrote of the model, suggesting that her painting of this period was generally not done from life.[13] Her expressionist paintings of these years show some resemblance to those of her teacher, Fritz Mackensen, and to the work of Oskar Kokashka, which she would have seen in Munich. Still, in important ways Brandt's paintings were already pushing the boundaries of this traditional medium by embracing a combination of feminine and technological elements. In an untitled self-portrait of circa 1920, Brandt shows her own head in a minimalist, industrialized landscape that is further abstracted by a wash line and sheets blowing in the wind (fig. 8.1). Brandt's features are severe, and she appears almost to be in mourning as she closes her eyes to her surroundings, a gesture that suggests an ambiguous relationship with vision.

After her first stay in Paris and additional travels in the south of France, Brandt returned to Weimar to study sculpture. In 1923 she saw the first major exhibition of the Weimar Bauhaus, which would have included radically new designs for household objects, constructivist sculptures, and purely abstract paintings. Shortly thereafter she piled up her own paintings and burned them. Then she joined the Bauhaus and began her studies again.

One of the most influential art institutions of the interwar period, the Bauhaus offered a completely new approach to art and design, and, by integrating men and women into the school, it shifted gender relationships.[14] Brandt's Bauhaus metal designs are now some of the most iconic images associated with the school. The year she began her Bauhaus studies, 1924, was also the year she opted to apprentice herself to the Metal Workshop at the encouragement of her mentor, the Hungarian constructivist László Moholy-Nagy. According to her own account, the other members of the workshop—all men—initially assigned her the most repetitive and

Fig. 8.1. Marianne Brandt, *Untitled (Self Portrait)*, ca. 1920, vintage silver gelatin print of painting, oil on canvas, destroyed. (Photograph collection of the Bauhaus-Archiv, Berlin. © Artists Rights Society [ARS], New York, and VG Bild-Kunst, Bonn.)

mundane tasks in the hopes of scaring her off, presumably to the weaving workshop, into which most of the female students were streamed.[15] Brandt survived the hazing and went on to become arguably the most successful member of the Metal Workshop, securing numerous contracts with industry for production of her metal lamps and eventually taking over as acting director of the workshop when Moholy-Nagy left the Bauhaus.[16] The dramatic change in Brandt's artistic identity that occurred through her time at the Bauhaus reflects a broader shift in artistic production away from expressionism. At the same time many women artists were no longer restricted to what were considered "feminine" aesthetics, and they participated, for example, in the international constructivist movement, which—in its coldness and rejection of beauty as a criterion—was often seen as more masculine. Likewise Brandt left painting behind to work in metal, a material that was seen strictly as masculine at the Bauhaus.[17]

In the summer of 1926, Brandt took a sabbatical from the Bauhaus to

return to Paris for a nine-month stay with her husband.[18] She made this return as an artist who had renounced painting in a dramatic manner; this rejection of figurative easel painting would have been reinforced by her two years at the Bauhaus, where Walter Gropius had referred to it derisively as "salon art" in the Bauhaus's founding manifesto.[19] Yet Brandt's new craft, metalwork, was not something that she could take with her. Instead, while in Paris for this second, longer stay, she turned to photomontage, a medium with which she had brief experience during her 1924 class with Moholy-Nagy, in which she made two montages of photograms.[20] Photomontage was perfect for Paris since it was portable and markedly different from oil painting, and it also allowed Brandt a renewed chance to explore the human figure. In these new works, Brandt mixes photographic reproductions collected in Germany as early as 1925 with those scavenged in France. These photomontages tap into the interwar pictorial field to intervene in her contemporaries' representations of metropolitan life, consumer culture, and, above all, the New Woman, the most frequently occurring and potentially self-referential figure in Brandt's photomontages.

Remembered as a "bobbed-hair, pencil-thin sexpot who smoked cigarettes, drank cocktails, and danced to the rhythms of jazz bands," our historical conception of France's *garçonne* of the 1920s seems particularly linked to her fashions and vices.[21] In one of Brandt's most glorious photomontages from her 1926–27 stay, *Pariser Impressionen* (Parisian Impressions), Brandt put modern cosmopolitan femininity on display and, through this new medium, suggested that New Womanhood was as much about agency as it was about appearance (fig. 8.2). As Brandt seems to celebrate the superficial beauty of Paris's Modern Girls, she also challenges and parodies this view of them. True to its title, *Parisian Impressions* presents a jumble of glittering women—and a few men—costumed and dressed to the nines. This photomontage can be interpreted as a tour through Paris by a *flâneuse*, a leisured, strolling female viewer.[22]

Parisian Impressions represents the city's women in multiple ways. First, the city is specifically evoked by the presence of such particular markers as the Eiffel Tower, and feminine spectacle is most obviously represented by the showgirls dominating this work, including the smiling face of one of Paris's most famous dancers at the lower right, the young American Josephine Baker.[23] The colorful forms of two other showgirls who evoke femininity as performance (blue, on the left) and sexuality (pink, on the right) frame Baker's head like pendant wings of a triptych. The pink dancer wears more accessories than clothes as she appears simply in underpants,

Fig. 8.2. Marianne Brandt, *Pariser Impressionen* (Parisian Impressions), 1926, photomontage of newspaper clippings on gray paper. (Collection of the Stiftung Bauhaus Dessau. © Artists Rights Society [ARS], New York, and VG Bild-Kunst, Bonn.)

shoes, opera-length gloves, and a hat. She embraces the oversized head of American actor Adolphe Menjou, who adds a further element of French femininity to this montage, for he was the star of the hit film *A Woman of Paris* (1923, dir. Charles Chaplin). This title phrase would have been evoked by Menjou's face, thus giving an audio component to this montage of Paris's women.

While women are on display, Brandt's work makes it clear that visual

pleasure is not a simple matter. Baker looks sharply to her right, and her gaze directs our vision to the montage's center, where the realistically colored legs of another dancer are stroked by a portly and refined man whose eyes are half closed in pleasure. Grotesquely, the legs are missing a torso but sprout an ancient Egyptian relief head that is twisted backward; the leg fetishist does not appear to notice that the body he so desires is an awkward amalgam. Here, as elsewhere in this montage, women's legs function as shorthand for the female body as sexualized spectacle. At the same time, legs also allegorize the freedom and mobility enjoyed by the women of Paris. Just above these large, luscious, and disembodied lower limbs, a group of tiny legs appears, each one of them smaller than a matchstick and laboriously cut out. They belong to the mostly female members of a crowd that stands to wait for a double-decker bus at the montage's center. Rather than offering feminine spectacle, these legs appear as supports for ordinary women as they board public transport to take off again through the city.

Female mobility is also the focus of the lower-right portion of *Parisian Impressions*, where another woman sits behind the wheel of a luxurious car. She appears to have stopped here after her own carefree journey through the city. A closer look reveals an aggressive yet incomplete removal in this montage element, for the headless remains of two men in tuxedos are visible in the back seat. Thus, in the location of an artist's signature is an adamantly independent woman amid the sights of Paris. The city is laid out as an open secret in *Parisian Impressions* and as a locus of feminine spectacle that also invited female pleasure—and humor—through vision.

In addition to exploring modern women's freedoms, Brandt also addressed the international nature of New Womanhood in works such as *Nos soeurs d'Amerique* (Our American Sisters), also of 1926 (fig. 8.3). This work unites images of three very different modern women on a ground of blank paper. The busy patterns of the work's halftone prints create visual resonances so that the figures in the crowd form a field of dots, which is echoed in the leopard that is being washed by his strong and capable mistress at the right, the skintight checkered dress and matching hat of a model to the left, and the homespun plaid of a pistol-packing woman of the American Wild West.[24] All three of the women's faces are partially or wholly hidden, which allows them to function as types rather than individuals. The work includes a single male figure at the upper right who appears to swoon as he takes in the overwhelming sight of these imports from across the Atlantic.

During the first decades of the twentieth century, "American" influence

Fig. 8.3. Marianne Brandt, *Nos soeurs d'Amerique* (Our American Sisters), 1926, photomontage of newspaper clippings, ink. (Collection of Merrill C. Berman. © Artists Rights Society [ARS], New York, and VG Bild-Kunst, Bonn.)

was felt increasingly in much of the world through exports of fashions, Hollywood films, and even in the new sciences of work efficiency known as Taylorism or Fordism.[25] In the interwar period, when the migrating nature of New Womanhood was seen as thrilling by some and as a cause for concern by others, this type was linked to admiration for and fear of global Americanization. In 1925 one French commentator wrote that "the innocent young thing (*l'oie blanche*) of yesterday has given way to la garçonne of today. In this way as well, the war, like a devastating wind, has had an influence. Add to this sports, movies, dancing, cars, the unhealthy need to be always on the move—this entire Americanization of old Europe, and you will have the secret to the complete upheaval of people and things."[26] The same year that Brandt made *Our American Sisters,* the German journalist Friedrich Sieburg criticized his contemporaries' adoption of such standardizing American practices as beauty pageants, which he saw as corrupting youthful innocence with commercialism and greed.[27] Still, many of Brandt's contemporaries looked on all things American as new, exciting, and progressive.

The textual framing of *Our American Sisters* situates these women's nationality first and foremost by presenting them as American female types: can-do handler of exotic animals, fashion-forward model, and gun-toting female deputy. In referring to these women as "sisters" in French, the text strikes a note of irony to suggest that, although they are biologically the same as French women, in actuality they are radically different in their American approach to life. Brandt highlights their status as types and presents them as a subject for visual investigation, something she spotlights in two specific ways. First, the three larger figures of *Our American Sisters* appear as if they were projections in a futuristic cinema; they are on display for and positioned among members of a crowd gathered at the center of the montage. Second, at the bottom of *Our American Sisters* are the words *Féminin Illustré,* or "Women's Illustrated," which makes this photomontage into a design for the cover of a women's magazine. Several of Brandt's photomontages from this period appear to have been proposals for commercial design work, but there is no evidence that she was successful in these attempts.[28] As either an actual or mock magazine cover proposal, *Our American Sisters* suggests that it is just a first look at these foreign women who are close enough to be siblings but far enough to merit a thorough visual investigation. For Brandt, herself a foreign transplant to Paris, these larger-than-life images of stylish and foreign female types may have reflected her own sense of belonging to a global sisterhood.

Another of Brandt's Paris photomontages, *Bull—Donkey—Monkey*

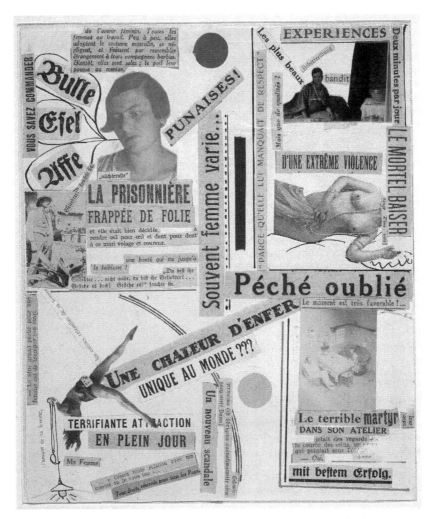

Fig. 8.4. Marianne Brandt, *Bulle—Esel—Affe* (Bull—Donkey—Monkey), 1926, one side of a double-sided photomontage of newspaper clippings and gelatin silver prints; red, yellow, and blue paper; red, green, yellow, and black ink. (Collection of the Bauhaus-Archiv, Berlin. © Artists Rights Society [ARS], New York, and VG Bild-Kunst, Bonn.)

(Bulle—Esel—Affe) of 1926, one side of a double-sided composition, relies even more heavily on French text to thematize the New Woman's mobility and the female body as spectacle, even as it probes more deeply into tense and even painful gender relations (fig. 8.4). Unlike the majority of her other photomontages, most of the images in *Bull—Donkey—Mon-*

key are not halftone prints from magazines but original photographs. This work is highly personal, for these photographs reflect ambiguously on a love triangle among Brandt, her husband, and her sister Susanna Liebe, who came to visit during the 1926–27 Paris sojourn.

In addition to these personal photographs, *Bull—Donkey—Monkey* is an elaborate collection of newspaper and magazine text, ink drawing, and a few plain squares of colored paper. Different from Brandt's other montages in style, it is closer to works by Dadaists such as Brandt's friend Kurt Schwitters or Hannah Höch.[29] Höch occasionally used images of her friends and lovers in her montages—*Cut with the Kitchen Knife* of 1919–20 is the most famous example—and she, too, focused on the changing roles of women. Brandt's extensive use of text here is unique, and it gives *Bull—Donkey—Monkey* the feel of a scrapbook as much as of a montage.

Bull—Donkey—Monkey is a materialization of tensions between Brandt's romantic life and her status as a member of the avant-garde. Read clockwise it offers meditations on the New Woman, expresses profound anger and hurt in her marriage, and concludes with suggestions of her own agency as an artist and a woman. In the upper left Brandt appears with a New Woman's signature bob and shouts "Bull," "Donkey," and "Monkey" at her husband, three terms foraged from the press that suggest Erik Brandt's brutishness, stubbornness, and ridiculousness. In the context of their earlier letters, however, "Monkey" (*Affe*) seems to have been their mutual nickname; here it is twisted into an insult. Below the animal names, Erik Brandt gads about in a garden, oblivious to her name-calling. "'Lover!' She hissed" stretches between them; other bits of text accuse him of infidelity and suggest Brandt's feelings of imprisonment and search for revenge. Directly above her head is a completely different textual extract, which makes *Bull—Donkey—Monkey* about much more than an interpersonal drama: ". . . on the feminine future. All women to work. Little by little they begin to adopt masculine dress, neglect themselves, and in the end strangely resemble their bearded companions. Soon they are dirty; hairs sprout from their chins." At stake is Brandt's seemingly conflicting status as a wife and artist who, through her work at the Bauhaus, was enjoying much more success than her husband; thus she stands accused of becoming manly herself.

Bull—Donkey—Monkey still includes suggestions of marital harmony, as at the upper right, where Brandt appears in a more traditionally feminine costume and poses along with the phrase "the most beautiful / experiences." But these are interrupted by suggestions of their fleeting nature ("two minutes a day"), by more name-calling ("bandit" for her), and the

phrase "the deadly kiss" next to a headless reclining female nude whose body is punctuated by red dots for nipples. The phrase "forgotten sin" in large lettering leads down to a photograph at the lower right that was taken by Marianne Brandt and shows Erik Brandt and Susanna Liebe sitting in the Brandt apartment in Paris.[30] Text beneath this photograph—"the moment is very favorable!" "with great success," and "the terrifying martyr in his atelier"—positions Erik Brandt as opportunistic, lecherous, and self-pitying. The reference to the atelier may also make light of his status as an old-fashioned painter now that Brandt herself has moved on to the Bauhaus system of workshops. While it is playful at times, these first three quarters of *Bull—Donkey—Monkey* blast her husband with a bilingual barrage of insults.

What seems to be Brandt's salvation in this work is her own agency and transformation. These come to the fore in the lower left quadrant. While there are still a few biting phrases directed at Erik Brandt, this quarter is dominated by a beautiful, dynamic, and muscular female acrobat, a kind of stand-in for the artist herself. She flies through the air, completely free, her movement traced in space by three arching lines. Like a modernist allegorical figure—and a sort of *éclaireuse*—she holds a light in her hand, not a traditional torch but an adjustable overhead lamp very much like Brandt's Bauhaus designs of the time.[31] Labeled "my wife's lover," this lamp suggests that Brandt's heart really lay with the Bauhaus. Not only is the acrobat a creative dynamo, but she powerfully experiences her own desires. "A hellish heat" roars out from between her thighs, and her body arcs around the phrases "a terrifying attraction" and "in broad daylight." The whole of this lower left quarter appears illuminated by the yellow constructivist sun at the right, which suggests a new day after this muddle of dramatic emotions.

Brandt and her husband divorced in 1935 after years of living apart.[32] In a letter from that year, she suggests that the relationship had long been over, writing that "for me it was already divorce in the moment I understood that he actually wanted her."[33] The 1926–27 stay in Paris changed much for Brandt. She lived in an international and metropolitan context—likely speaking three different languages on any given day—and mastered the mass media through montage. She also seems to have ceased seeing herself as married and, like the female driver at the lower right of *Parisian Impressions,* began to cut out one of the most important men in her life.[34] These Parisian photomontages were an outpouring of creativity that focused on a specifically female experience of modernity as an awkward and sometimes painful joining of old and new.

When she returned to the Dessau Bauhaus in 1927, Brandt took up the position of *Mitarbeiter* (chief assistant) of the Metal Workshop; the following year she would become the workshop's acting director. As she continued to receive recognition for her metal designs, she also worked in parallel on her pictorial representations in photomontage. And she turned more seriously to photography in 1928.[35] In a series of untitled self-portraits, including one from 1928–29 in which her camera is clearly visible, Brandt envisioned herself as a Bauhaus New Woman and a sort of artist constructor (fig. 8.5). Throughout this series of photographs, Brandt always appears reflected in polished metal surfaces, her visage and body combined with the medium of her revolutionary designs. In the particular photograph that I include with this essay, Brandt appears in her Bauhaus atelier; we can see her framed by elements of Walter Gropius's building. Behind her a snowy landscape suggests an open future, as Brandt appears bright-eyed with her camera, the technological means for creating this new imagery. Approximately eight years after her untitled painted self-portrait (fig. 8.1), in which she shows her face amid feminine laundry and an industrialized landscape, Brandt has moved boldly through a series of abstract and representational strategies, working in metal, photomontage, and photography, to an integrated means of self-presentation as a technologized and avant-garde New Woman.

Part of what made *Madame Bovary* so radically modern in mid-nineteenth-century France was Flaubert's use of appropriation and citation. Through Emma Bovary's reading of novels, Flaubert created a form of literary montage by evoking "the wealth of fictional forms being practiced as the novel rose to a major cultural genre."[36] He also created an assemblage of images in words as Emma peruses the pictures in her books and gazes at etchings of women involved in romance, fashion, travel, and sentimental emotion.[37] While Flaubert once famously and controversially declared his own identification with this character—"Madame Bovary, c'est moi"—critics and historians generally agree with Huyssen that she is tragicomically aligned with cheap, transitory, and feminine culture while the authorial Flaubert embodies masculine "authentic culture."[38] Writing about the prevalence of representations of female readers among late-nineteenth-century painters, Griselda Pollock recently observed that these were "paradoxically one of the paradigmatic images of a *negative*, feminine relation to modernity. From Fragonard to Van Gogh, women appear as readers of novels in paintings of modern life. The advanced novels of the time, like Flaubert's

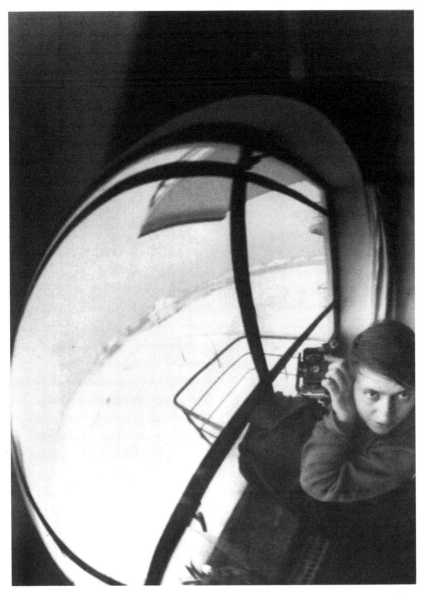

Fig. 8.5. Marianne Brandt, *Untitled (Self Portrait with Camera)*, 1928/29. Silver gelatin photograph; modern print (no vintage prints extant). (Collection of the Bauhaus-Archiv, Berlin. © Artists Rights Society [ARS], New York, and VG Bild-Kunst, Bonn.)

Madame Bovary (1857), exposed the woman reader as silly and susceptible to sentimental fiction in an implied contrast to the disciplined rationalism of the modernist male author."[39]

Almost seventy years after the publication of *Madame Bovary*, Marianne Brandt, a woman who, like Emma, was almost magically drawn to Paris, made her own practice of multilingual reading and viewing into the basis of an art form, one that foregrounded the tension between modern women's perceived superficiality and depth.[40] In creating these images, crossing national and linguistic borders, and working in multiple media, Brandt provided a retort to Flaubert as she reinvented herself as a media-savvy and ultimately ardently independent Bauhaus New Woman.

Notes

1. Gustave Flaubert, *Madame Bovary* (1857), Norton critical edition, ed. Margaret Cohen (New York: W. W. Norton, 2005), 52.

2. Diane Radycki, "The Life of Lady Art Students: Changing Art Education at the Turn of the Century," *Art Journal* 42, no. 1 (spring 1982): 9.

3. Tamar Garb, "'Men of Genius, Women of Taste': The Gendering of Art Education in Late Nineteenth-Century Paris," in *Overcoming All Obstacles: The Women of the Academie Julian*, ed. Jane Becker and Gabriel Weisberg (New Brunswick, NJ: Rutgers University Press, 1999), 121.

4. Mary Cassatt, letter to Sara Tyson Hallowell, 1893, quoted in Griselda Pollock, *Mary Cassatt: Painter of Modern Women* (London: Thames and Hudson, 1998), 56. Women artists in France were still often seen as lesser than their male counterparts; see Tamar Garb, *Sisters of the Brush: Women's Artistic Culture in Late Nineteenth-Century Paris* (New Haven and London: Yale University Press, 1994), 153.

5. Images of Brandt's metal designs have been reproduced extensively, as have the objects themselves. See Barry Bergdoll and Leah Dickerman, eds., *Bauhaus: Workshops for Modernity*, exhibition catalog (New York: Museum of Modern Art, 2009), 109, 143, 145, 232–33, 284–85.

6. Marianne Brandt, "Lebenslauf um Antrag auf Wiedererlangung der Deutschen Staatsangehörigkeit," n.d., collection of Bernd Freese, Frankfurt am Main. For more on Marianne Brandt's various trips to Paris, see Anne-Kathrin Weise "Pariser Impressionen, Marianne Brandt und Frankreich," in *Das Bauhaus und Frankreich*, ed. Isabelle Ewig, Thomas W. Gaehtgens, and Matthias Noell (Berlin: Akademie Verlag, 2002), 231–41.

7. Andreas Huyssen, "Mass Culture as Woman: Modernism's Other," in *After the Great Divide: Modernism, Mass Culture, Postmodernism* (Bloomington: Indiana University Press, 1986), 47.

8. Mary Louise Roberts, "Making the Modern Girl French: From New Woman to *Éclaireuse*," in *The Modern Girl Around the World: Consumption, Modernity, and Globalization*, ed. The Modern Girl Around the World Research Group (Alys

Eve Weinbaum, Lynn M. Thomas, Priti Ramamurthy, Uta G. Poiger, Madeleine Yue Dong, and Tani E. Barlow) (Durham: Duke University Press, 2008), 77–95.

9. Tamar Garb, "Berthe Morisot and the Feminizing of Impressionism," in *Perspectives on Morisot,* ed. T. J. Edelstein (New York: Hudson Hills, 1990), 63.

10. See Madeleine Pelletier, "A Feminist Education for Girls" (Paris, 1914), in *Feminisms of the Belle Epoque: A Historical and Literary Anthology,* ed. Jennifer Waelti-Walters and Steven C. Hause (Lincoln and London: University of Nebraska Press, 1994), 101–16; and Madeleine Pelletier, *L'Émancipation Sexuelle de la Femme* (Paris: M. Giard and E. Brière, Libraires-Éditeurs, 1911).

11. Gill Perry, *Women Artists and the Parisian Avant-Garde: Modernism and "Feminine" Art, 1900 to the Late 1920s* (Manchester: Manchester University Press, 1995).

12. Marianne Brandt, letter to sister Johanne Liebe, October 17, 1920, and Marianne Brandt, letter to parents and sister Johanne, n.d. (likely end of December 1920 or January 1921), both in the collection of the Bauhaus-Archiv, Museum for Design, Berlin.

13. Brandt, letter to parents and sister.

14. Anja Baumhoff, "What's the Difference? Sexual Politics of the Bauhaus," chapter 3 of *Gender at the Bauhaus: The Politics of Power at the Weimar Republic's Premier Art Institute, 1919–1932* (Frankfurt am Main: Peter Lang, 2001), 53–75; Elizabeth Otto, "On the 'Beautiful' and 'Strong' Sexes at the Bauhaus: Marianne Brandt, Gender, and Photomontage," in *Bauhaus: A Conceptual Model,* ed. Bauhaus-Archiv Berlin, Klassik Stiftung Weimar, and Stiftung Bauhaus Dessau (Ostfildern: Hatje Cantz Verlag, 2009), 291–94.

15. Marianne Brandt, "Letter to the Younger Generation," in *Bauhaus and Bauhaus People,* ed. Eckhard Neuman, trans. Eva Richter and Alba Lorman (New York: Van Nostrand Reinhold, [1970] 1992), 106.

16. It was Moholy-Nagy who first used hyperbole in relation to Brandt's designs, referring to her as "my best and most ingenious student (90% of all Bauhaus Designs are by her)." Moholy-Nagy, letter to Ernst Bruckmann, June 26, 1929, collection of the Bauhaus Dessau Foundation.

17. Anja Baumhoff, "Masculine Material in Women's Hands: The Metal Workshop," chapter 7 of *Gender at the Bauhaus,* 131–46. Eleven women started in the Metal Workshop, but other than Brandt none of them completed their degrees there (143).

18. Marianne Brandt, Bauhaus-Diploma, September 10, 1929, collection of the Bauhaus-Archiv, Berlin. In addition to her 1920–21 trip, Brandt had also gone to Paris two more times (in 1924 and 1925) for shorter stays with her husband (Brandt, "Lebenslauf").

19. Walter Gropius, "Program of the Staatliches Bauhaus in Weimar" (April 1919), in *The Weimar Republic Sourcebook,* ed. Anton Kaes, Martin Jay, and Edward Dimendberg (Berkeley: University of California Press, 1994), 435.

20. Elizabeth Otto, *Tempo, Tempo! The Bauhaus Photomontages of Marianne Brandt* (Berlin: Jovis, 2005), 14–17.

21. Roberts, 77.

22. For more on female *flânerie*, see Anne Friedberg, *Window Shopping: Cinema and the Postmodern* (Berkeley: University of California Press, 1993).

23. Petrine Archer-Straw, *Negrophilia: Avant-Garde Paris and Black Culture in the 1920s* (London: Thames and Hudson, 2000), 94–97.

24. The gun on the right has been lost since *Our American Sisters* was reproduced in the 1970s. See Hans and Gisela Schulz, *Bauhaus 2* (Leipzig: Galerie am Sachsenplatz, 1977), 20.

25. Frederick Taylor's *The Principles of Scientific Management* had already been published in 1911. For a discussion of both positive and negative perceptions of American influence in the 1920s, see the "American Modernity" section of Anton Kaes, "*Metropolis* (1927): City, Cinema, Modernity," in *Weimar Cinema: An Essential Guide to Classic Films of the Era,* ed. Noah Isenberg (New York: Columbia University Press, 2009), 182–85.

26. "Une Controverse: L'emancipation de la jeune fille moderne est-elle un progress reel?" *Le Progrès civique*, June 13, 1925, 840, quoted in Roberts, 77.

27. Friedrich Sieburg, "Anbetung von Fahrstühlen" (Worshiping Elevators), *Die literarische Welt* 2, no. 30 (July 23, 1926): 8, trans. Don Reneau and reprinted in *The Weimar Republic Sourcebook*, ed. Kaes, Jay, and Dimendberg, 402–3.

28. See, for example, two works from 1927: *Cirque d'hiver* (Winter Circus), reproduced in Otto, *Tempo, Tempo!* 66–66; and *Tempo-Tempo, Progress, Culture*, reproduced in Elizabeth Otto, "A 'Schooling of the Senses': Post-Dada Visual Experiments in the Bauhaus Photomontages of László Moholy-Nagy and Marianne Brandt," *New German Critique* 36, no. 2 107 (summer 2009): 101–4.

29. It is unclear if Brandt and Höch ever met, but they did have friends in common (e.g., Schwitters and Moholy-Nagy). Brandt would have known Höch's photomontage work through Moholy-Nagy, who owned one and reproduced it in his *Painting Photography Film,* trans. Janet Seligman (London: Lund Humphries, [1925, 1927] 1969), 94.

30. While scholars had assumed this to be a photo of Marianne Brandt, Manja Weinert identified it as Susanna Liebe. See Manja Weinert, "Marianne Brandt: Fotomontagen und Foto-Text-Collagen," MA thesis, Humboldt Universität zu Berlin, 2003, 30–39 (available through Grin Verlag).

31. See, for example, *ME 105a* (1926), designed with Hans Przyrembel, in Bergdoll and Dickerman, 233.

32. In 1933 Brandt traveled to Norway to search for work after the National Socialist takeover in Germany but was called home by her family. She may have seen Erik Brandt at that time.

33. Marianne Brandt, letter to Marthe and Bernhard Berensen, April 5, 1935, collection of the Bauhaus-Archiv, Berlin.

34. Brandt's mentor, Moholy-Nagy, was another significant man in her life. For more on that relationship, see Otto, "A Schooling of the Senses."

35. Elisabeth Wynhoff, ed., *Marianne Brandt: Fotografieren am Bauhaus* (Ostfildern-Ruit: Hatje Cantz Verlag, 2003), 102.

36. Margaret Cohen, "Introduction to the Second Edition," in Gustave Flaubert, *Madame Bovary* (1857), Norton critical edition, ed. Margaret Cohen (New York: W. W. Norton, 2005), ix.

37. See, for example, Flaubert, 33–34.

38. Huyssen, 45–47.

39. Pollock, 134.

40. In 1935, poor and out of work under the Nazi regime, Brandt would write to old friends in Paris that she longed for "the most beautiful city." Brandt, letter to Marthe and Bernhard Berensen.

PART 3

Mass Media Icons: The New Woman as
Embodiment of Transnational Modernity

9

Mistaken Identity in Fritz Lang's *Metropolis*

MARIA MAKELA

> Only one profound allegory was discernible [in *Metropolis*]—although it is not
> to the author's liking, let alone intended by her: a certain depth to the motif of
> the female *Doppelgänger*, who embodies at once the unleashed inferno of the
> senses and the most tender virtue of the virgin.[1]

It was with these words that Willy Haas, the film critic for *Die literarische
Welt*, ended his withering review of *Metropolis*. Like others who saw the
movie when it premiered, Haas liked its technical brilliance but hated the
plot, which he found unconvincing in virtually every respect save that of
the female *Doppelgänger*. Her simultaneous embodiment of "both the
unleashed inferno of the senses and the most tender virtue of the virgin"
was, for him, the only aspect of the film that rang true. At once chaste
and highly sexual, Maria was also good and bad, loving and hateful, con-
structive and destructive—a potent symbol of "everywoman" whose char-
acter is essentially dichotomous and thus undecipherable and ultimately
unknowable. Unlike the men of the *Freikorps* (Free Corps) studied by
Klaus Theweleit, Haas was preoccupied not so much with "messy" female
sexuality as with woman's supposed inscrutability.[2] It is this that he takes as
a given and singles out as the one valid message in the entire film.

I want to suggest that Haas's words bespeak more than just an inability
to comprehend the opposite sex. My essay will argue that they and the
film they describe articulate deep-seated anxieties in Weimar-era Ger-
many about the supposed opacity of identity, especially, though not only,
the identity of women. Developing in tandem with a number of highly
publicized medical and technological developments that were pioneered
in German-speaking Europe and were believed to disguise class, ethnic-
ity, age, and sexual orientation, these anxieties were exacerbated by the

rise of the emancipated New Woman, who blurred gender boundaries in the aftermath of the First World War. Although neither of the *Metropolis* Marias corresponds exactly to the stereotype of the New Woman, together they speak to the slippages of identity that she embodied. Indeed, a central if underemphasized theme of the film is the inability of men in particular to *distinguish* between the two Marias. I will maintain here that the chaos that results in the fictional city of Metropolis from this misidentification expressed pervasive fears about what might happen in a real world where traditional markers of class, ethnicity, age, and gender are effaced.

The Film

On the tenth of January 1927, *Metropolis* premiered at Berlin's Ufa Palast am Zoo. Originally about two hours in length, the story as presented by director Fritz Lang and scriptwriter Thea von Harbou is set in the future in the city of Metropolis. As has often been noted, the plot is convoluted and confusing, and I will not recount it here in its entirety.[3] Certain key moments in it are nevertheless central to my argument, among them the process by which the likeness of Maria (fig. 9.1) is transferred by the scientist Rotwang to the female robot that he had earlier made. Maria is captured, then encased in an apparatus that is attached by wires to the seated robot, her head enclosed by a metal cap with diodes (fig. 9.2). The duplication process initiated by Rotwang is then made visible to viewers by rings of light that move up, down, and around the robot's body in a caress analogous to Pygmalion's embrace of his statue come to life. The procedure complete, the real Maria is released from captivity, and her twin, identical to her except that she is not chaste and virtuous but sexual and illicit (fig. 9.3), leaves Rotwang's house and begins to wreak havoc. Her first stop is the office of Joh Fredersen, master of the city's massive industrial complex. It is here that Fredersen's son Freder, who is in love with Maria, sees them together, believes himself to have been betrayed, and falls psychically ill for much of the rest of the film. In the next scenes, Rotwang introduces the robot to the elite of Metropolis at a nightclub, where she captivates the men, who riot as they vie for her affection. The ersatz Maria then makes her way underground, and there, too, she unleashes chaos. Telling the workers who are meeting there that there is no more time for patience, she incites them to revolt, and they destroy the machines that control the city, putting their children in grave danger. Ultimately the film ends happily, with Maria and Freder united,

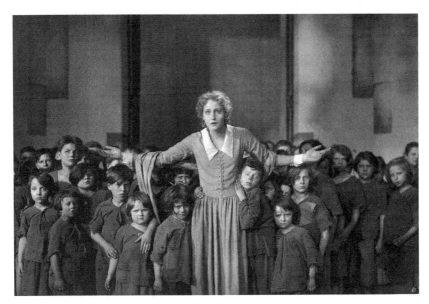

Fig. 9.1. The real Maria with the children from Fritz Lang's *Metropolis*, 1927. (Courtesy of Deutsche Kinemathek, Museum für Film und Fernsehen, Berlin.)

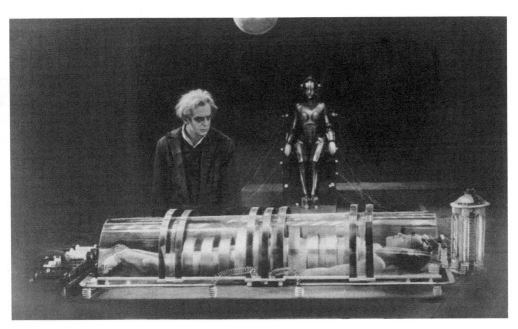

Fig. 9.2. The transformation scene from *Metropolis*, 1927. (Courtesy of Deutsche Kinemathek, Museum für Film und Fernsehen, Berlin.)

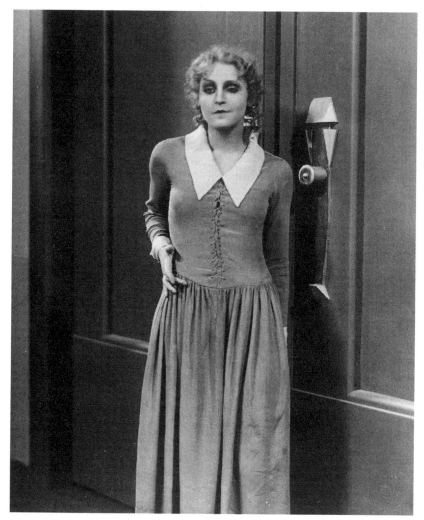

Fig. 9.3. The ersatz Maria from *Metropolis*, 1927. (Courtesy Deutsche Kinemathek, Museum für Film und Fernsehen, Berlin.)

the children saved, the robot burned at the stake, and labor and capital optimistically if improbably reconciled.

Metropolis was not a critical success. To be sure, almost everyone praised its stunning special effects, but Germany's major film critics pilloried its sentimental ending. Off-putting, too, was the murky mixture of Christianity, socialism, and Nietzscheanism, resulting in what Herbert Ihering termed "an ideological film without an ideology."[4] From the United

States, H. G. Wells contributed his own damning review, spoofing the idea of a slave population servicing machines that produce nothing and of a master so inattentive to industrial efficiency that he drove his workers to the point of exhaustion. For him the "crowning imbecility of the film" was the conversion of the robot into the likeness of Mary. He did not understand, he wrote, why "Mary has to be trapped, put into a machine like a translucent cocktail shaker and undergo all sorts of pyrotechnic treatment in order that her likeness may be transferred to the Robot. The possibility of Rotwang just simply making a Robot like her evidently never entered the gifted producer's head."[5]

Notably, nobody in Germany seemed to find this procedure unusual, however much they disliked other aspects of *Metropolis*. It is this that I want to use as my point of departure for an interpretation of the film that roots it in contemporary debates about technology and the body. This issue has been at the center of many investigations of *Metropolis*, but I want to focus here on one aspect of the film that is seldom noted, which is the chaos that results at key points in the story from the *misidentification* of the robot as Maria.[6] As described earlier, disaster occurs in the film because a complicated technical/medical procedure that had transformed one body into another made it impossible for the inhabitants of Metropolis, especially the men, to identify the real Maria. Notably, beginning in the early 1920s, when Lang and Harbou were first conceiving this narrative of mistaken identity, and continuing throughout the decade, Germans were in fact inundated with information about several new medical procedures that likewise were thought to mask identity.[7] It is this discourse to which I now turn.[8]

Noses, Testicles, and Ovaries

"Mundus vult decipi—the world will be deceived." So began the surgeon Ludwig Levy-Lenz's 1933 introduction to and apologia for cosmetic surgery, "Beauty Operation," published in the widely read Berlin journal *Die Ehe* (Marriage).[9] Levy-Lenz was, of course, but one in a long line of plastic surgeons that extends back to 800 BCE in India, when physicians utilized skin grafts in their surgical work.[10] Yet both he and his Berlin colleague Jacques Joseph—who pioneered the scarless procedure of removing bone and cartilage from within rather than from without the nose—were among the first to argue that psychic pain was as real as physical pain and that those individuals whose facial or bodily features set them clearly apart from oth-

ers suffered intense emotional trauma that deserved amelioration.[11] This they could find, among other places, in the department of "social cosmetics" at the Institute for Dermatology at the University of Berlin, whose task it was to deal not with the mutilated former soldier but with the uninjured set apart by their appearance. In particular, increasing numbers of Jews began to patronize cosmetic surgeons to have their noses "fixed" so they could better blend in. Even those who could not afford the cost of cosmetic surgery had alternatives in the form of widely advertised and inexpensive gadgets that allegedly would tame untoward body parts.[12]

It was in this beauty-conscious environment of the 1920s that age first became an issue in mass culture. Cosmetic surgeons also played a role here because it was they who could return old, "unerotic" bodies to some semblance of youthfulness through surgical procedures such as face-lifts. But the more sensational method of overcoming decrepitude, and one that received considerable attention in Weimar-era Germany, was rejuvenation, that is, the complete transformation of the aged body into a youthful one. Here it was scientists in the field of endocrinology who made the most important contributions.

The study of the endocrine glands had its beginnings in the 1880s, but it was in the first two decades of the twentieth century that much of the pioneering research occurred.[13] The so-called sex glands—the testicles and ovaries—attracted the particular attention of endocrinologists, of whom Eugen Steinach was doubtless the most famous. As director of the Physiological Section of the Institute of Experimental Biology in Vienna, Steinach conducted experiments in which, among other things, he transplanted ovaries into male rats and guinea pigs and observed the development of female physical characteristics and behavior and testicles into females and noted the opposite. Based on these observations, Steinach argued that the characteristics of sex—body build, breasts, internal and external genitals, sexual orientation, mating rituals—were all generated by testicular and ovarian hormones, described at the time not as testosterone or estrogen but as glandular "juices" or "secretions." Since the physical characteristics of masculinity or femininity diminished in old age, he reasoned that the aging suffered from a deficiency of such hormones. If their gonads could be encouraged to produce more, then the sexual characteristics would be reinvigorated and the individuals might also regain some of the general vitality of youth. How to do this? Steinach claimed that for males vasectomies were the answer, having subjected senile rats to this minor operation and found that the once lethargic, underweight, and almost lifeless ani-

mals became active, gained weight, developed glossy new fur, and regained sexual interest. Emboldened by these findings, he then went on to vasectomize men, cutting their spermatic cords to promote the rejuvenation of the testicles and foster production of the hormones that would then go on to reinvigorate the entire body. His patients purportedly gained weight, improved muscle and skin tone, and became more physically and sexually energized.

Steinach was not alone in his experiments with rejuvenation. Equally sensational was the research of Serges Voronoff, chief surgeon at the Russian Hospital in Paris. Voronoff also believed that bodily decrepitude in men was due to the exhaustion of the testicles and hit upon the idea of supplementing the aging glands with young ones, experimenting first by transplanting the testicles of young bucks into old rams. Given the "paucity of young men willing to donate testicles," as Sander Gilman has noted with tongue-in-cheek understatement, as well as the French prohibition of the removal of any part of the body even in death, Voronoff then experimented with grafting testicular tissue from young chimpanzees or baboons onto aging men.[14] Forty-three patients initially received the testicular grafts, which were, at least according to Voronoff, wildly successful. He then set up his own monkey farm to keep him supplied with goods, employing a former circus animal keeper to run it.

Attempts to rejuvenate women with tubal ligations and ovarian transplants were more invasive and ultimately less successful, but organotherapy was said to provide an alternative for them. This involved placentas and the sex glands of animals as the source of extracts that were prepared by squeezing out the organic secretions much as one would the juice of an orange (fig. 9.4). These extracts were administered as infusions that allegedly had a rapid and pronounced effect on the body; according to one doctor whose clinic in Charlottenburg specialized in glandular extracts and ovarian radiation treatments, which were also said to be extremely effective, women could be rejuvenated by as much as ten years with such procedures.[15]

Yet it was not just decrepitude that was now thought to be correctable through manipulation of the gonads or use of their secretions. As described earlier, Steinach's experiments with rejuvenation actually began with his research into sexuality, which convinced him that the hormones of men and women who had the physical and/or psychic characteristics of the opposite sex were simply out of whack and that homosexuality could be "cured" if the imbalance caused by these maladept hormones could be put right. His

Fig. 9.4. Sterile preparation of the "pressed juice." (From Heinz Zikel, *Mein Verjüngungs-Verfahren* [My Rejuvenation Technique] [Neubabelsberg bei Potsdam: Verlagsbuch-Handlung M. Hahn, 1926].)

solution to the problem was to implant a testicle of a heterosexual donor into the groin of a homosexual man, the secretions of which were said to be sufficient to effect the desired shift in both behavior and appearance. Ultimately these results proved hard to duplicate by other surgeons, but that did not diminish the vogue for such operations in the early 1920s.[16]

Be it nose jobs, face-lifts, vasectomies, testicular grafts, or organotherapy, such medical practices—all presented at the time as safe and effective—were widely discussed in Germany's mass media of the 1920s. Prominent medical journals regularly featured essays on or by Steinach and other endocrinologists.[17] Books geared to the scientific community proliferated on the subjects,[18] and illustrated periodicals popularized procedures thought to mask identity.[19] Most spectacular was a film eponymously titled after Eugen Steinach himself, who both produced and starred in it. Premiering in January 1923 in Berlin at the Ufa Palast am Zoo, *Der Steinachfilm* (The Steinach Film) was Ufa's first feature-length documentary, playing seventy minutes in length to audiences that packed the movie house several times a day for weeks.[20] In graphic sequences, the film illustrated to the public exactly how vasectomies and testicular transplants were performed on rats

and guinea pigs as well as on men. It also presented convincing before and after images of feminine or decrepit men made masculine or youthful by the operations.

The publicity worked. By the mid-1920s, Voronoff had performed about a thousand monkey-gland transplants and Steinach so many vasectomies that his very name became a verb; men were not rejuvenated but "Steinached" (*versteinacht*). Likewise, women flocked to organotherapy clinics for infusions or irradiation and purchased salves, creams, or foodstuffs made from placentas, hormonal extracts, or other ingredients widely advertised in the mass media as cures for decrepitude.[21]

Whether these procedures were really effective is beside the point. Weimar-era Germans now *believed* it was possible to hide one's ethnicity with plastic surgery or mask one's age or "true" sexual proclivities with vasectomies, transplants, or hormone therapy. It is thus hardly surprising that no one in Germany wondered about the procedure used by Rotwang to give the robot Maria's likeness, as did H. G. Wells from his more distanced perspective in America. For Germans—inundated as they were with images of and stories about plastic surgery, gender realignment, and rejuvenation—successful bodily makeovers that could *fool* others occurred only via complicated chemical, medical, and technical procedures. Indeed, at least one critic, Eugen Gürster of *Der Kunstwart,* specifically related the plot of *Metropolis* to the medical practices popularized by the early endocrinologists, noting that Thea von Harbou had tried to appeal to as many people as possible in the film by mixing willy-nilly half-baked ideas about socialism, industry, and Steinach together in one pot.[22] However critical, Gürster's comments demonstrate the extent to which a mass public now thought that science could in fact effectively and even essentially transform the human body and its functioning, masking traditional markers of sexual, ethnic, and age identity.

In this regard it is of interest that much of the contemporary criticism of *Metropolis* refers to Maria not as a *Maschinenmensch* (machine-human or robot) but as a *künstlicher Mensch* (artificial human), just as it identifies the creation of the "artificial" creature as perhaps *the* central theme of the film.[23] Although this is little noted in literature that emphasizes the film's fascination with machines, it is relevant not just to my discussion but also to one other strand of contemporary discourse. *Kunstseide,* otherwise known as artificial silk or rayon, was much in the news when *Metropolis* premiered. Notably, like the medicine practiced by the endocrinologists and plastic surgeons, *Kunstseide* was also thought to hide identity, though

not as it relates to sexual orientation, ethnicity, or age. Rather, it effaced markers of class, especially for women, and as such it is of special significance here.

Rayon

When, in 1916, Thea von Harbou published a book on the topic of the German woman and the world war, she was well aware of the material shortages that were wreaking havoc on the lives of her fellow citizens.[24] All combatant countries suffered privation, of course, but the British blockade of 1915 made it especially difficult for Germans. Luxury import items such as coffee, tea, and tobacco could be done without, but other goods, such as rubber and leather, also obtained from abroad, were more essential. So, too, was cloth, the production of which was now difficult since Germany imported almost all of its cotton, linen, wool, and silk.[25] Initially existing stockpiles sufficed to keep the country's civilian and military population clothed, but these were soon used up, even with the rationing systems that were put in place to stretch the supplies. Women were admonished by Harbou and others to reduce the width and shorten the length of their dresses in order to conserve fabric, while paper cloth and other ersatz fibers were developed and marketed as viable alternatives to traditional fibers. Rayon was one such product.

The world's first synthetic fiber, made by forcing the viscous form of cellulose through tiny holes in spinnerettes and then treating the extruded filaments with a chemical bath, rayon was invented in the 1880s in France and England and used initially only as an effect fiber in notions. But with the British blockade, German chemists turned their attention to developing rayon fibers that could be used to make yard goods, since cellulose, the chief component of plants and trees, was plentiful and available. Already by 1917—that is, much earlier than elsewhere—women's clothing in Germany was being made out of artificial silk. Notably, rayon was considerably less expensive than real silk, even as it mimicked many of silk's characteristics.[26] When *Metropolis* premiered in 1927, the cheapest grades of rayon cost about three-quarters the price of real silk, while medium-grade yard goods and products that women could buy off the rack at department stores cost about half the price of comparable silk wares. Even Bemberg—the finest and most expensive grade of rayon featured in Irmgard Keun's *Das kunstseidene Mädchen* (The Artificial Silk Girl)—cost about one-quarter

of silk's price. For the first time, women of modest means who previously could only have worn wool or cotton because they could not afford silk could purchase stockings and clothing that *simulated* silk in look and feel. As one writer put it in 1928:

> It's now difficult for the well-off lady to call attention to her status [through outward appearances]. To be sure, the higher quality of her clothing might distinguish her, but such quality will be obvious only to the cultivated, trained eye. Superficially the clothes are exactly the same. . . . If the judge's wife wears a real fur with a pure silk lining, the unmarried factory worker . . . will wear a fake fur with artificial silk lining and both will look equally elegant. If the [wealthy] cosmopolitan clads her legs in the finest silk stockings, the calves of her less financially fortunate sister will also shimmer, but in artificial silk, and *no one will be able to tell the difference.*"[27]

Notably, even the terminology used by the major rayon producers masked differences. None of them referred to their products as *Kunstseide* but either came up with terms like *Glanzstoff* (radiant cloth), which avoided the pejorative associations of the artificial and inauthentic, or simply appropriated the term *Seide* (silk) altogether, as with the brands Bemberg Seide, Travisé Seide, and Breda Seide, all of which were rayon products. In 1928, a consortium of silk-producing companies sued Bemberg over this very issue, claiming that Bemberg marketed its wares as silk when they were in fact artificial silk and that this was false advertising. They lost, not just once but in appeal after appeal. The courts ruled that everyone knew that Bemberg Seide was *Kunstseide* and not genuine *Seide,* and besides, the term *Seide* itself really had no meaning anymore, as it was used to refer to a wide variety of products, some of which were pure, some artificial, and some a mixture.[28] That the silk companies fought back by mounting their own extensive ad campaign to convince consumers that there really *was* a difference between artificial silk and genuine silk is indicative of the extent to which differences between the fake and the real had in fact been effaced by the end of the 1920s when *Metropolis* premiered.[29] It is also indicative of the anxiety, both economic and psychic, that this effacement caused in some quarters. This is powerfully articulated in *Metropolis* as well, which gives plaintive voice to the fears of upper-class men that they would be unable to assess the "true" character of women based on their appearance.

The Filmic Body Disembodied

"No one will be able to tell the difference," be it the difference between Jew and Christian, young and old, homosexual or heterosexual, or upper and lower class. To be sure, ultimately everywhere women wore rayon, men had the Steinach operation, and Jews got their noses fixed. But because many of these procedures and innovations were first pioneered and then widely publicized in German-speaking Europe via Weimar's famed mass media, the perception was stronger here than elsewhere that boundaries were permeable and identity opaque. The sharp increase in the early 1920s in the number of periodicals and articles devoted to typology, graphology, palmistry, and astrology speaks to this point. Believing themselves incapable of gauging character, class, gender, ethnicity, or age on the basis of physical appearance or clothing, Germans turned to other means, including handwriting, body posture, palms, and the stars (fig. 9.5).[30]

In closing, I would like to return to *Metropolis* and propose that its *filmic* body, like so many other bodies of the Weimar era, does not disclose its identity in any clear-cut way, either to contemporary viewers or to us. As mentioned, Lang and Harbou appear to have conceived of the story in the latter half of 1923, just when the *Steinachfilm* was being screened throughout Germany. Harbou then went on to write *four* versions of the story: a serialized novel that was published in at least one illustrated newspaper at the end of 1926; the novel in book form that was published in 1926; a shorter version of the novel that was released when the film premiered in January 1927; and then, of course, the screenplay of the film itself.[31] All of these versions are different, and it is still not entirely clear which was written first, in other words, which was the "original."[32] As regards the film itself, very few people actually saw the version that premiered in January 1927, which had a running time of about 153 minutes. For its American release, the film was cut to 107 minutes, in part to excise the portions of the narrative that referred to Freder's mother, Hel, because of concerns about the similarity in the spelling of her name to the English word *hell*. Although this muddied the plot rather significantly, Ufa nevertheless adopted the American version when it became clear that the long version was not doing well in Germany. This is the one that Germans in the provinces saw beginning in April 1927 until a second German version, just slightly longer than the American, was released in August. Running 117 minutes in length, it was the only version of the film that could be seen until 2001, when a reconstructed version of the original was released. But

Fig. 9.5. Advertisement for the Ullstein pamphlet *Charakter und Wesen aus der Handschrift zu lesen* (Reading Character and Essence in Handwriting) in *Die Koralle* 3, no. 11 (1928), inside back cover. The pamphlet promises to teach the science of graphology, once considered superstition but now a "science whose practical value is debated by no one."

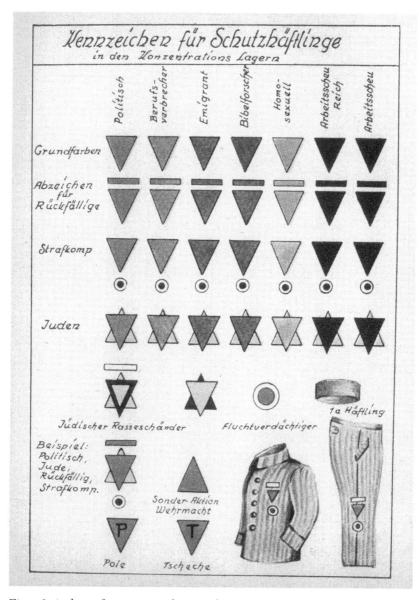

Fig. 9.6. A chart of prisoner markers used in German concentration camps, circa 1938–42, United States Holocaust Museum and Memorial. (Courtesy of KZ Gedenkstätte Dachau.)

even that was missing about 30 of the original 153 minutes. These were found in the summer of 2008, some eighty years after the film's premier, in the single known extant copy of the original in an archive in Buenos Aires.

Ironically, then, a film that is in large part *about* confusion of identity is itself confused *in* identity insofar as there is no one definitive version of it. As such, it is perhaps the quintessential exemplar of Weimar Germany's engagement with this vexing issue. Perhaps it was this as much as anything that intrigued Hitler, who, on seeing *Metropolis* with Joseph Goebbels years before he came to power, purportedly said that he wanted Lang to make Nazi films.[33] The reasons for Hitler's interest have been variously construed, but I want to suggest that his own anxieties about identity may have played a role. Doubtless he did not know about the multiple versions of the film when he saw it, nor would that have especially interested him if he had. Yet surely the film's conclusion appealed to Hitler, not just because labor and capital are reconciled in a way that he imagined for Nazi Germany but because the chaos that had resulted from misidentification was brought under control. Some ten years after the premier of *Metropolis*, the Nazis would institute their system of colored triangles and yellow stars to identify political dissidents, criminals, Jehovah's Witnesses, Gypsies, homosexuals and Jews (fig. 9.6) in an effort akin to that of Weimar-era typologists to pin down perceived slippages of identity and make transparent that which was thought to have become opaque. In Nazi-era Germany, as in *Metropolis*, "good" vanquished the "bad," the "genuine" won out over the "fake," and "authenticity" trumped "inauthenticity." Small wonder that Hitler liked the film.

Notes

I would like to thank Vanessa Rocco and Elizabeth Otto for the invitation to participate in this anthology and for their thoughtful and critical reading of this essay. Thanks, too, to Grace Linden and Daniel Castro for research and technical assistance.

1. W[illy] H[aas], "Zwei große Filmpremieren," *Die literarische Welt* 3 (January 21, 1927): 7. Unless otherwise noted, all translations are mine.

2. Klaus Theweleit, *Male Fantasies,* trans. Erica Carter and Chris Turner (Minneapolis: University of Minnesota Press, 1989).

3. On the defective coherence of the plot strands, see Michael Minden, "Introduction: The Critical Reception of *Metropolis*," in *Fritz Lang's Metropolis: Cinematic Visions of Technology and Fear,* ed. Michael Minden and Holger Bachmann (2000; reprint, Rochester, NY: Camden House, 2002), 53.

4. Herbert Ihering, "Der Metropolis-Film," *Berliner Börsen-Courier,* January 11,

1927, trans. Holger Bachmann and Meg Tait, in *Fritz Lang's Metropolis: Cinematic Visions of Technology and Fear,* ed. Michael Minden and Holger Bachmann (2000; reprint, Rochester, NY: Camden House, 2002), 87.

5. H. G. Wells, "Mr. Wells Reviews a Current Film," *New York Times Magazine,* April 17, 1927, reprinted in *Fritz Lang's Metropolis: Cinematic Visions of Technology and Fear,* ed. Michael Minden and Holger Bachmann (2000; reprint, Rochester, NY: Camden House, 2002), 98.

6. Among the most compelling studies of *Metropolis* are Tony Kaes, "Metropolis: City, Cinema, Modernity," in *Expressionist Utopias: Paradise, Metropolis, Architectural Fantasy,* ed. Timothy O. Benson (Los Angeles: Los Angeles County Museum of Art, 1994), 154–55; Siegfried Kracauer, *From Caligari to Hitler: A Psychological History of German Film* (Princeton: Princeton University Press, 1947), 149–50; Andreas Huyssen, "The Vamp and the Machine: Fritz Lang's *Metropolis,*" in *After the Great Divide: Modernism, Mass Culture, Postmodernism* (Bloomington and Indianapolis: Indiana University Press, 1986), 65–81; Roger Dadoun, "Metropolis Mother-City—'Mittler'—Hitler," trans. Arthur Goldhammer, *Camera Obscura* 15 (autumn 1986): 137–63; and Thomas Elsaesser, "Innocence Restored? Reading and Rereading a 'Classic,'" in *Fritz Lang's Metropolis: Cinematic Visions of Technology and Fear,* ed. Michael Minden and Holger Bachmann (2000; reprint, Rochester, NY: Camden House, 2002), 123–38.

7. The architect responsible for the sets of *Metropolis,* Eric Kettelhut, stated that he read a first sketch for the film in April 1924, just after the Berlin premier of Lang's film *Nibelungen.* See Patrick McGilligan, *Fritz Lang: The Nature of the Beast* (London: Faber and Faber, 1997), 108–9.

8. A more in-depth elaboration of the surgical practices discussed here and their resonance in visual and literary culture can be found in Maria Makela, "Grotesque Bodies: Weimar-Era Medicine and the Photomontages of Hannah Höch," in *Modern Art and the Grotesque,* ed. Francis Connelly (Cambridge: Cambridge University Press, 2003), 193–219.

9. Ludwig Levy-Lenz, "Schönheits-Operation," *Die Ehe,* August 1933, 20–21.

10. My discussion of the history of plastic surgery draws especially on Sander L. Gilman, *Making the Body Beautiful: A Cultural History of Aesthetic Surgery* (Princeton: Princeton University Press, 1999).

11. On Joseph, see especially Sander Gilman, "Das Gesicht wahren: Zur ästhetischen Chirurgie," in *Gesichter der Weimarer Republik: Eine physiognomische Kulturgeschichte,* ed. Claudia Schmölders and Sander L. Gilman (Cologne: Dumont, 2000), 96–112.

12. See, for example, a gadget said to fix "nasal flaws" that was regularly advertised in the *Berliner Illustrirte Zeitung* in 1919 and 1920. See also the suction cup designed to create "full bosoms," which was advertised, among other places, in *Die Pille* 11, no. 17 (1921): 50.

13. The literature on this topic is voluminous. Particularly succinct is Laura Davidow Hirshbein, "The Glandular Solution: Sex, Masculinity, and Aging in the 1920s,"

Journal of the History of Sexuality 9, no. 3 (July 2000): 277–304; and Chandak Sengoopta, "Glandular Politics: Experimental Biology, Clinical Medicine, and Homosexual Emancipation in Early-Twentieth-Century Central Europe," *Isis* 89, no. 3 (September 1998): 445–73. Briefer, more popular essays on the issue would include Chandak Sengoopta, "'Dr. Steinach Coming to Make Old Young': Sex Glands, Vasectomy, and the Quest for Rejuvenation in the Roaring Twenties," *Endeavour* 27, no. 3 (September 2003): 122–26; and Chandak Sengoopta, "Secrets of Eternal Youth," *History Today* 56, no. 8 (August 2006): 50–56.

14. Gilman, *Making the Body Beautiful*, 297.

15. Heinz Zikel, *Mein Verjüngungs-Verfahren* (Neubabelsberg bei Potsdam: Verlagsbuch-Handlung M. Hahn, 1926).

16. On this, see Sengoopta, "Glandular Politics," 467–68.

17. A small sampling of articles in scientific journals from the late 1910s and early 1920s would include Magnus Hirschfeld, "Ist die Homosexualität körperlich oder seelisch bedingt? Eine Erwiderung," *Münchener Medizinische Wochenschrift* 65, no. 11 (1918): 298–99; Augustin Krämer, "Der Dimorphismus bei Mann und Frau," *Zeitschrift für Sexualwissenschaft* 7, no. 1 (April 1920): 1–9; and Kurt Blum, "Homosexualität und Pubertätsdrüse," *Zentralblatt für die Gesamte Neurologie und Psychiatrie* 31 (1923): 161–68.

18. See, for example, E. Steinach, *Verjüngung durch experimentelle Neubelebung der alternden Pubertätsdrüse* (Berlin: Verlag von Julius Springer, 1920); and Sergius Voronoff, *Verhütung des Alterns durch künstliche Verjüngung: Transplantation der Gelschechtsdrüse vom Affen auf den Menschen*, trans. Zoltán von Nemes Nagy (Berlin: Eigenbrödler Verlag, 1926).

19. As but one example, see Curt Thomalla, "Das Drüsenrätsel: Die geheimnisvolle Wirkung der inneren Sekretion," *Uhu* 1, no. 2 (November 1924): 82–91, 142–44.

20. Two versions of the film, a "popular" and a "scientific," together with the Zensurkarten (Prüf-Nr. 6673) and copious reviews of it from both the specialized and daily press, are preserved in the Filmarchiv of the Bundesarchiv. Publicity material about the film is also extant in the Deutsche Kinemathek, Schriftgutarchiv. Some indication of the extent to which the ideas of Steinach and other endocrinologists captured the popular imagination are the spoofs of them by avant-garde writers living in Germany at the time. See, for example, Anti, "Deutschlands Verjüngung," *Die Pille* 2, no. 25 (1921): 17–19; and Til Brugman, "Warenhaus der Liebe" and "Revision im Himmel" in *Til Brugmann: Das Vertippte Zebra, Lyrik und Prosa*, ed. Marion Brandt (Berlin: Hoho, 1995), 72–81, 111–22. For a description and analysis of these, see Makela, "Grotesque Bodies," 206–12.

21. See, for example, the ad for Lukutate, an Indian berry available as jellied fruit, marmalade, and bouillon cubes that purportedly worked rejuvenation miracles, in *Die Koralle* 3, no. 3 (1927): 165, or for Satyrin, a hormone preparation that rejuvenated sexual function, in *Die Pille* 2, no. 25 (1921), last page. Again, some indication of the popularity of such remedies can be gleaned from avant-garde spoofs of them. Til Brugman's "Tempora leren mores" is a satirical short story that describes the case of a

woman who wants to be as young as the girls who excite her husband. After deciding against a transplantation of ape testicles, she tries her luck with a macrobiotic wonder salve but in her greediness uses the entire tube at once and turns herself into a fetus. The story was published only in Dutch, and considerably after it was written, in *De Nieuwe Stern* 4 (1949): 669–88.

22. Eugen Gürster, "'Metropolis' oder der Weltanschauungsfilm," *Der Kunstwart* 41, no. 1 (1927–28): 43–46.

23. See the selection of clippings in the Deutsche Kinemathek, Schriftgutarchiv, Mappe 992, *Metropolis* 1926 G, R: Fritz Lang, 1/9, 2/9, and 3/9, including, for example, "Die Uraufführung des 'Metropolis-Films,'" *Bochumer Anzeiger,* January 12, 1927; and "Metropolis. Uraufführung im Ufa-Palast am Zoo," *Berliner Morgenzeitung,* January 12, 1927.

24. Thea von Harbou, *Die deutsche Frau im Weltkrieg: Einblicke und Ausblicke* (Leipzig: Hesse und Becker Verlag, 1916).

25. The literature on the problems in the textile industry created by the British blockade and the development of "ersatz" fibers is plentiful. I found particularly helpful Carl Königsberger, *Die deutsche Kunstseide- und Kunstseidenfaserindustrie in den Kriegs- und Nachkriegsjahren und ihre Bedeutung für unsere Textilwirtschaft* (Berlin and Leipzig: Walter de Gruyter, 1925).

26. I base this claim on advertisements for yard goods and off-the-rack clothing in issues of *Gustav Cords Frauenmode, Die praktische Berlinerin,* and *Der Konfektionär* throughout the 1920s.

27. Vogtland, "Wer verbraucht die meiste Kunstseide?" *Die Kunstseide* 10 (1928): 133, emphasis added.

28. "'Bembergseide' keine Irreführung des Publikums! Ein wichtiger Entscheid des Kammergerichts," *Mitteilungen der J. P. Bemberg Aktien-Gesellschaft* 1, no. 1 (1928): 6.

29. See, for example, the advertisement in *Die Dame* 56, no. 12 (1929): 51.

30. The number of articles devoted to systems that would help discern character published in the popular Berlin periodical *Uhu* in the mid-1920s is indicative of the extent to which this topic preoccupied Germans. As but one example, see Margret Naval, "Hand und Charakter," *Uhu* 1, no. 1 (October 1924): 85–87, 126–30. The *Deutsche Bücherverzeichnis* from 1926 to 1930 lists six periodicals entirely devoted to *Menschenerkenntnis* (character analysis), and books such as Gerhard Venzmer's *Sieh dir die Menschen an: Ein Überblick über die biologische Verwandtschaft zwischen Körperform und Wesenskern des Menschen* (Stuttgart: Franckh'sche Verlagshandlung, 1931) were published in large and multiple editions. For a summary of literature that analyzes various aspects of this phenomenon, see Makela, "Grotesque Bodies"; and Maria Makela, "Politicizing Painting: The Case of New Objectivity," in *Legacies of Modernism: Art and Politics in Northern Europe, 1890–1950,* ed. Patrizia C. McBride, Richard W. McCormick, and Monika Zagar (New York: Palgrave Macmillan, 2007), 133–48.

31. Curiously, the serialized novel was published not in a Berlin newspaper but

in Frankfurt's *Das illustrirte Blatt* 14, nos. 35–50 (August 28–December 11, 1926). My thanks to Robin Schuldenfrei for her help in obtaining a copy of this. The novel that appeared in 1926 in book form was 273 pages in length, while the one of 1927 was only 193 pages in length and was referred to in the press as a *Volksausgabe* (folk edition). See Aros, "Metropolis," *Berliner Lokalanzeiger: Film-Echo,* January 17, 1927, Deutsche Kinemathek, Schriftgutarchiv, Mappe 992, *Metropolis* 1926 G, R: Fritz Lang, 1/9. The only extant copy of the original screenplay is preserved in the estate of the composer who wrote the score for *Metropolis*, Gottfried Huppertz, in the Deutsche Kinemathek, Schriftgutarchiv, 4.4-79/05 Huppertz 2, and is included as a PDF file in *Metropolis: DVD-Studienfassung* (Berlin: Filminstitut, Universität der Künste, 2005).

32. Leonardo Quaresima, in "Ninon, la hermana de María: *Metropolis* y sus variantes," *Archivos de la Filmoteca de Valencia* 17 (June 1994): 5–37, makes an attempt to determine the chronology of the serialized novel, the book form of the novel, and the screenplay, although he does not consider that there were *two* editions of the book form of the novel. I am most grateful to Charles Haxthausen for alerting me to and sharing his notes on Quaresima's article, as well as for the productive conversations we have had about the film.

33. Kracauer, 164.

10

"Chocolate Baby, a Story of Ambition, Deception, and Success": Refiguring the New Negro Woman in the *Pittsburgh Courier*

MARTHA H. PATTERSON

Given the thriving black newspaper culture in the Harlem Renaissance, it is surprising that few scholars have analyzed the important role they played in shaping the New Negro Movement. Instead, most work on the Renaissance has focused on the generally middlebrow subscription periodicals such as the *Messenger, Crisis,* and *Opportunity,* mined for their rich visual and literary arts and particularly important for their constructions of the New Negro and New Negro Woman. And, indeed, scholarship on these periodicals has been invaluable as I seek to better understand the heteroglossic nature of New Negro Woman literary and visual representations in black newspapers of the period.

Most recently, in *Word, Image, and the New Negro,* Anne Elizabeth Carroll looks at the tension between protest and affirmative visual and textual content in periodicals such as *The Crisis,* published by the National Association for the Advancement of Colored People (NAACP). "The cognitive dissonance created by such juxtapositions is crucial to the impact of the magazine: combining these texts allows *The Crisis* to launch a vicious critique of the treatment of African Americans in America but also to assert African Americans' ability to overcome such treatment, and it motivates readers to act."[1] Meanwhile, the creative arts in these periodicals played a significant role in "revealing points of shared humanity" with white readers while offering more complex images of African Americans.[2] In *Enter the New Negroes: Images of Race in American Culture,* Martha Jane Nadell adopts W. J. T. Mitchell's term *interartistic* to describe "the complexity and variability of word/image relations within works that mix the two media on the material level."[3] Mitchell emphasizes the danger of assuming an

ideologically unified periodical, writing, "'Difference is just as important as similarity, antagonism as crucial as collaboration, dissonance and division of labor as interesting as harmony and blending of function."[4]

But a Harlem Renaissance newspaper such as the increasingly popular *Pittsburgh Courier*, a weekly published by Robert L. Vann, may well propel Mitchell's dissonance into cacophony. Publishing simultaneously the acerbic wit of thorn-to-the-Negro-elite, George Schuyler, a campaign against *Amos 'n' Andy*, skin-lightening advertisements, black history cartoons, church news and racy blues advertisements, while extolling female race leaders with front-page photographs and decrying fallen women with salacious detail, the *Courier* confounds efforts to find ideological consistency within its pages. The newspaper's mélange of genres, ideologies, and visual media, both paradoxical and profane, with a representational crisis of the New Negro Woman—as beauty queen, chorus girl, college girl, fallen girl, club woman, businesswoman, novelist, blues singer, or dutiful mother at the center—would increasingly come to define the Harlem Renaissance as an openly heterogeneous performative space where, to use Judith Butler's phrase, "the 'reality' of gender is constituted by the performance itself [rather than] an essential and unrealized 'sex' or gender which gender performances ostensibly express."[5]

Compounding the complexity of the *Courier*'s cultural work, the female images in its pages evoked a host of debates central to African Americans living under Jim Crow, including eugenics, the commodification of black women, light-skin privilege, civil rights, and interracial relationships. The paper raised eugenic fears by chastising career girls who seemed to be denying their responsibility to the race by "evad[ing] motherhood" and thereby "refus[ing] to lay aside . . . their selfishness and false pleasures for the sake of the Race."[6] Yet the iconography of a chorus girl's beauty and independence rather than a mother's selfless devotion or a race leader's uplifting ideal dominated the *Courier*'s pages. By 1928, at the urging of *Courier*'s business manager Ira Lewis, the front page featured photographs of beauty queens, "some of whom were in school or in the black 'social set,' like the girls of the Delta Gamma Theta Sorority of Chicago or the May Queen from the Clark Memorial Baptist Church of Homestead" and some of whom danced proudly on Broadway.[7] Even before the *Courier* launched an "Illustrated Feature Section," photographs of scantily clad, light-skinned chorus girls increasingly appeared on its pages after 1925, and the paper tended to emphasize the legitimacy of the chorus girl as a credit to the race by foregrounding her college education, work ethic, or color-line break-

through performance. Yet in at least one novella by arguably the *Courier's* most prolific writer, George Schuyler, and in the images that frequently accompanied it, the chorus girl signifies the sexual appropriation of black women within a commodity-driven mass culture. Schuyler would ultimately invoke the Mann Act, also known as the White-Slave Traffic Act of 1910, which banned the interstate transport of women for immoral purposes, to signal not only the exploitation of black women by black men caught in the whirlpool of urban vice but also and paradoxically the criminalization of black men who pursue relationships with white women. As such, the iconography of the New Negro Woman became a most powerful tool through which black journalists could explore the contradictions of Jim Crow and still sell newspapers.

At a time when the leading subscription black civil rights periodicals battled declining circulation figures, the *Pittsburgh Courier's* more sensational formula seemed to be working. In the late 1920s it published a national edition that circulated throughout the United States, parts of Europe, Cuba, the Philippines, the Virgin Islands, and the British West Indies. It not only thrived but managed to garner most of the major Harlem Renaissance literary talent.[8] More than the *Defender,* the *Amsterdam News,* the *New York Age,* or Marcus Garvey's *Negro World,* the other major black newspapers circulating in Harlem at the time, the *Courier* presented major Harlem Renaissance writers, including Alice Dunbar Nelson, Countee Cullen, Langston Hughes, and Zora Neale Hurston, as well as sensational fiction by well-known white writers such as DuBose Heyward, to a predominantly black working- and middle-class audience. At the end of 1928, the journalist and Boston *Post* feature writer Eugene Gordon declared that the *Courier* was America's best black weekly.[9] The 1920s' reigning sardonic wit, H. L. Mencken, agreed, and both he and the flamboyant white art critic and promoter of the Harlem Renaissance Carl Van Vechten subscribed.

By 1926, the *Courier's* circulation was nearly thirty-five thousand; by 1930 it had grown to over fifty thousand. It was second to the Chicago *Defender* but by the late 1930s would surpass it.[10] Even though in 1927 the *Courier* had to close its branch office in New York City, it retained agents in New York, and after joining the Associated Negro Press in November of 1925, it increasingly shifted away from local news in favor of national coverage. In 1920 Vann contracted with the white-owned Chicago advertising agency the William B. Ziff Company to acquire national advertising and in 1928 to produce the "Illustrated Feature Section," which included fiction, true crime stories, cartoons, photographs, and celebrity gossip focused on

African Americans. Ziff offered the feature section to all of his black newspaper clients, and it achieved a combined circulation of more than a quarter million.[11]

In 1928, Vann convinced Ziff to give the editorial position for the feature section to George Schuyler, whom Vann had hired in 1925 to write editorials for the *Courier* and whose bitingly satiric columns would soon be credited for much of the paper's success. Special features editor Floyd Calvin declared in October of 1928 that the *Courier* now had "It," a term Elinor Glyn had coined in 1923 as shorthand for sex appeal and what Clara Bow later personified in the 1927 film of the same name.[12] Although Schuyler held the editorial position of the "Illustrated Feature Section" only a short time, he contributed to it long after he left Chicago in 1929. Using a variety of different pseudonyms, presumably to disguise the extent of his contributions, Schuyler became an ever more important voice in Vann's *Courier* and the "Illustrated Feature Section."[13] Although most scholars today know his work chiefly through his lampoon of racial identity obsessions in *Black No More* (1931), his newspaper writing and the intertextuality of its context promise to complicate our understanding of some of the Harlem Renaissance's most enduring icons. And, although it is almost impossible to determine whether Schuyler juxtaposed certain items intentionally given the often last minute page-design changes the *Courier* underwent to accommodate advertisers, the pastiche of content tells alternating narratives essential to understanding how stories and images of the New Negro Woman may have resonated with readers.

Vann's *Courier,* especially when conjoined with the "Illustrated Feature Section," presented readers with more obviously contradictory content to create a kind of postmodern Harlem Renaissance text in which communally-conscious civil rights or uplift rhetoric and a consumption-oriented individualist ethos vied for the reader's attention. Accordingly, the "Illustrated Feature Section" pronounced itself "Clean, Wholesome and Refreshing" even as it offered titillating images of scantily clad women and lurid details of "true crime."[14] The dissonance of hair straightener, blues record advertisements, photographs of black female race leaders, exposés of the private lives of chorus girls, and sensational fiction about numbers runners and speakeasies points to a consumer-driven modernity, potentially liberating for black women but also objectifying and stereotyping black men and women within Jim Crow. Sparked in part by the spectacularly feminine chorus girl, the compulsive desires of the modern age potentially overtook men and women alike. As Rita Felski notes in *The Gender of Modernity,*

"The subject is decentered, no longer in control of his or her desires, but prey to the beguiling forces of publicity and the image industry."[15] Driven by these desires, black characters in Schuyler's fiction risk becoming the very primitivist stereotypes of blackness that white patrons of Harlem longed to consume. At the same time, Schuyler links modern consumption practices to Jim Crow racism, which exploited both the fear of and desire for black sexuality.

Within this context, the New Negro Woman is especially difficult to characterize, especially through the lens of George Schuyler. Even though in later years he became a fiercely conservative journalist (and member of the radically anticommunist John Birch Society) and in the 1920s regularly lambasted such race leaders as Howard University professor Kelly Miller and Universal Negro Improvement Association founder Marcus Garvey, he often maintained what would have been viewed as radical positions on issues, including interracial marriage and women's rights. While Schuyler's 1928 novella "Chocolate Baby: A Story of Ambition, Deception, and Success," serialized in the "Illustrated Feature Section," conforms to the sensational serial conventions of the damsel in distress—the virtuous heroine is continually on the verge of being sexually assaulted before the "to be continued"—he defies these conventions by crafting her as a sexually assertive version of the New Negro Woman modeled after increasingly popular light-skinned female entertainers. The tragic mulatta in "Chocolate Baby" becomes both victim and active agent in her seduction. The social and religious mores that protect the heroine also appear outmoded—quaint, southern, and ultimately inimical to the modern age. By offering readers in words and images the thrill of female arousal coupled with the moral outrage of male sexual predation, Schuyler constructs and refigures a dominant rendering of the modern female seduction narrative. As Felski notes, in much modern fiction the modern woman's insatiable desires appear as both "a natural manifestation of an all-consuming primordial female desire . . . [and] simultaneously . . . the unnatural condition of the modern woman whose perverse cravings are stimulated by capitalist decadence."[16] Schuyler, however, legitimates the sexually assertive version of the New Negro Woman by transferring the onus of "capitalist decadence" onto a black male rogue.

As such, the New Negro Woman who appears in the "Illustrated Feature Section" in many ways reflects the appeal of the increasingly popular mulatta New Negro Woman protagonist in Harlem Renaissance fiction, a figure Cherene Sherrard-Johnson defines in *Portraits of the New Negro*

Woman as encouraging both black and white readers to "participate in a voyeuristic fantasy of interracial interaction" whereby "white readers vicariously experience black American culture, while black readers identify with the mulatta's trespasses in mainstream society." For Sherrard-Johnson, the tragic mulatta in fiction, film, and painting becomes an "Afro-modernist icon," as "her tragic potential, phenotypical ambiguity, trangressive sexuality, and idealized femininity" are commodified.[17] Caught up in the "whirlpool," or what Nella Larsen would call the "Quicksand" of Harlem in her 1929 novel of the same name, Schuyler, however, uses that fluid turmoil to challenge prevailing gendered and racial expectations.

In part, Schuyler does this by creating a complex "cultural dialogics" within his serial fiction, which harnesses 1920s era celebrity fever to present trenchant social commentary.[18] As Patrick Collier notes, modern journalism has been frequently criticized for extolling the celebrity at the expense of the civic, writing, "Newspapers hosted this devalued culture of celebrity, which press critics read as evidence of degraded news values—a shift away from matters of civic import towards trivia and ephemera."[19] Schuyler, however, would incorporate the new emphasis on the famous and notorious to comment on matters of tremendous import to black readers of the time, reminding them that under Jim Crow "the public/private divide" has always been "troubled" because blackness carried with it the deepest fears of whites.[20]

In a weekly series that ran in six installments from November 3 to December 8, 1928, Schuyler, writing as Samuel I. Brooks, serialized "Chocolate Baby." The opening drawing by Helen W. Smith, in which a woman succumbs to the seductive embrace of her dance partner amid jazz, martini glasses, gin bottles, and silhouettes of other cabaret dancers combined with the interwoven title, foregrounds the mulatta chorus girls who were ever more popular on the Broadway stage (fig. 10.1).[21] The title, in fact, may be a reference to a Gilda Gray number in the Florenz Ziegfeld Follies of 1922 entitled "It's Getting Dark on Old Broadway." The lyrics read "Pretty choc'ate babies / Shake and shimmie ev'rywhere / Real dark-town entertainers hold the stage. / You must black up to be the latest rage."[22]

The title and the opening image are, however, a tease. The story contains no "chocolate babies" or black chorine stars, which by the late 1920s had become a ubiquitous feature of the *Courier* and other black newspapers. But the text and illustrations of "Chocolate Baby" promise the threat that the female protagonist will become one. As such, word and image both evoked a heated debate in the black press about the role of the chorus girl

Fig. 10.1. "Chocolate Baby," drawing by Helen W. Smith, in George Schuyler's "Chocolate Baby, a Story of Ambition, Deception, and Success," *Pittsburgh Courier*, November 3, 1928.

Fig. 10.2 ."What of Nudity on the Stage? Are Producers Confusing Art and Vulgarity?" *Pittsburgh Courier,* November 6, 1926.

in the image-making mid- to late 1920s terrain of the New Negro Woman. In a 1926 *Pittsburgh Courier* article, Floyd Calvin questioned "What of Nudity on the Stage? Are Producers Confusing Art and Vulgarity?" and chastised "Chorines, You Can't Be Naughty and Still Be Nice—and Artistic." The article features four photographs of scantily clad stars, twenty snippet interviews with leading journalists and community leaders, and Langston Hughes's celebratory cabaret poem "To Midnight Nan at Leroy's" (fig. 10.2).[23] In the upper-right photograph appear Broadway chorines Florence McClain and Lillian Carroll, "two of hundreds coming under the lash of criticism of too scanty costumes on the stage." On the left stands Sadye Tapper of the "Brownskin Models." And in the upper center with her arms akimbo appears Baby Evelyn Wiggins, one of Amanda Kemp's Dancing Dolls, "whose stage dress represents what many think should be the standard to safeguard our morals." In the lower photograph, Winifred Anderson of the "7-11" company kneels in a supplicant pose. She is one "whose dance would be frowned upon by those who condemn 'nudity on the stage.'" Although Calvin quotes both detractors and endorsers of stage

nudity, he seems to be winking at the new trend, especially given his inclusion of Schuyler's tacit endorsement.

> [W]hy should anyone object to the display of that which is beautiful, attractive and stimulating, especially when our modern world is so humdrum and drab? And why should we conceal and affect to ignore that of which we ALL know? If we can stand to see a chorus girl's hand, why not her hip? If we can view her back, why not her breast?

Other features in the paper insisted that the scantily clad chorine was "Glorifying The Brownskin Girl" (fig. 10.3). In the accompanying photograph, three stars of Irvin C. Miller's new production "Brownskin Models" appear draped, barelegged, and in heels in what seems less like a splashy Broadway promotion than an artist's studio portrait.[24] The two flanking chorus girls smile; the middle one sits, her head and torso encircled, her bare thigh bent, her gaze cast seductively downward. On the right side of the photograph, George Schuyler in his "Aframerica" series indicts the Jim Crow abuses in an "Inert and Indifferent" Wheeling, West Virginia. Under the photograph and to the left of it, two articles appear about the sensational Rhinelander case, in which Leonard Kip Rhinelander sought a divorce over his wife's supposed concealment of her African American heritage. During the course of the lawsuit, Alice Rhinelander was compelled to undress before the jury. "French Can't Understand Rhinelander Suit Because Wife Isn't 'Pale Enough'" reads the brief article immediately below the "Brownskin Models" photograph. The context for this photograph transforms the "Brownskin Models'" sensual display into an act of defiance in the face of Jim Crow degradation and gives added resonance to the photograph's accompanying text: "Mr. Miller, with that singular originality which is a foundation of success has struck a responsive chord. He is truly glorifying the brownskin beauty and draws a fine line between nudity and art."

In "Chorus Girl Has Helped Glorify Modern Woman," Eva Jessye wrote in August of 1928 that the chorus girl had become the public face of an increasingly spectatorial consumer culture and had the potential to sell a New Negro Woman beauty icon to a middlebrow white audience: "The chorus girl has forced recognition of the beauty and charm of the colored woman, not only from the outside, but has awakened the Negro woman herself to her own possibilities, which feat may be considered the greater accomplishment."[25] But even if it meant tacitly acceding to the increasing

Fig. 10.3. "Glorifying the Brownskin Girl," *Pittsburgh Courier*, December 12, 1925.

commodification of black female sexuality, the mulatta chorine Broadway star's success takes yet another twist as it signifies a spectacular triumph over the color line. Crucial to the mulatta chorine star as modern icon is the fact that she wasn't passing but she had still achieved a measure of white mainstream success, and in that narrative, reiterated in the photographs peppering the newspaper's front page and feature sections, she turned the

uplift ideal of the previous generation's New Negro club woman, a decorous model of selfless devotion to the race, on its head.[26]

And yet the *Pittsburgh Courier*'s editorial page noted with alarm the extent to which the modern girl, or the "girl of today," was being equated with sexual exposure.

> We agree that men will become educated to seeing almost anything. They can not help themselves. We become educated to lynchings, hangings and riots; but can we say that we ever admire them? . . . We are educated to the V-neck, but do we admire a chest made bare from the neck to the suggestive prints of the bust? We are educated to the habit of exposing the knees, but we are forced to observe the garter as well. Can it be said we admire this gradual undressing right in public view?[27]

Indeed, even though the mulatta chorine's success depended on and perpetuated a commodified jezebel stereotype, she became a racial representative who must not commit the "sin" of adopting white people's prohibition era licentiousness even as she gains white mainstream success.

Schuyler's "Chocolate Baby" narrative reiterates a common plot in the *Courier*'s Harlem Renaissance newspaper fiction, a beautiful southern country girl seduced by an urban masher, a plot that reflected the anxiety that black migration brought with it the exploitation of a modern culture dominated by the "anonymous, competitive social relations of mass consumption."[28] S. Gordon Johnson, a thirty-five-year-old traveling insurance salesman with a "widespread reputation as an invincible lover," arrives in southern Hainesville and immediately determines to seduce the beautiful, fifteen-year-old "chocolate baby," Martha. For her part, Martha, whose name evokes propriety as the dutiful welcomer of Jesus, has ambitions to become a racially representative New Negro Woman by going to "one of the big colleges in the north." Although the other men in Hainesville are too intimidated by the family's respectability to make overtures to Martha, to Johnson she "looks like a million dollars" and as if she would be "just another female to fool and throw by the wayside, as he had many others." Determined to approach marriage "thoughtfully and carefully," Martha also adopts a commodifying gaze when she looks at Johnson, for "he was the best dressed colored man she had ever seen. When she glanced at him it reminded her immediately of the clothing advertisements she had so often seen in the magazines from the big cities."[29]

On the one hand, Schuyler appeals to popular conservative sentiments

by highlighting the deleterious effect of gin and jazz and the vulnerability of country women unable to outmaneuver slick urban operatives. To lower her guard, Johnson plays jazz music and spikes her lemonade, which awakens her passions in a "wave of ecstasy and abandon. . . . With eyes bloodshot and wild, and lips moving ravenously like some jungle beast, Johnson whirled Martha off her feet and carried her, protesting very feebly, toward his room."[30] When, at the beginning of the next installment, Johnson trips over the rug, striking his head on the door, his fall prevents hers: "To think that Johnson should have attempted to assault her!"

On the other hand, later in the second installment, Johnson, albeit under the false promise of marriage, awakens Martha's passions again so that she "leaned toward Johnson with a sigh of sensual and spiritual satisfaction. . . . She closed her eyes and enjoyed the heavenly blissfulness of his kiss and the passionate movements over her lithe and supple body."[31] The title of the novel, "Chocolate Baby," would seem to confirm Schuyler's highlighting of the performative nature of gender. Presumably coming from Johnson's perspective, the title suggests that whatever her protestations and whatever her traditional uplift ambitions, Martha may be easily transformed into a good-time girl. At the same time, the title, in conjunction with Martha's quite ready sexual awakening, encourages readers to see her as a newer and fiercely contested version of the New Negro Woman.

Johnson faces unwanted competition for Martha's affections in the third installment when the "immaculately dressed" Ralph Armstrong takes over the local insurance office in which Martha works and determines to become her protector by thwarting Johnson's seduction. In a voice of feminist protest, Martha adamantly rebuffs what she sees as Armstrong's officious interference. Defending less her virtue than her autonomy, she declares, "[Y]ou need not think that because I work here you own me," and in the caption to the stylized drawing that illustrates the text, a bobbed-haired Martha in a flapper dress retorts, "I think it would be an excellent idea for you to mind your own business" (fig. 10.4).[32] The illustration appears next to an advertisement for "Organ Grinder Blues," sung by Ethel Waters, in which a women leans back on her porch wicker armchair, one arm behind her head, smiling, her head turned to hear the music. Just below appears an ad for "Tuskegee Belle Beauty Aids," which features a photograph of a black woman in a graduation cap and gown. Competing iconographies of the New Negro Woman appear throughout the run of "Chocolate Baby" as if to highlight the performative nature of her creation. Whether sassy to the virtuous New Negro Man, languidly listening to the

Fig. 10.4. "I think it would be an excellent idea for you to mind your own business," *Pittsburgh Courier*, November 17, 1928.

latest blues number, or posing as the proud girl graduate, she may at least choose the persona she will adopt.

In the fourth installment, Johnson cooks up an even more nefarious plot to bed Martha, who, having succumbed to his pleas to meet him in Chicago, is now in Johnson's urban apartment and even more vulnerable. Contracting with a Mrs. Jones, the madam of a seedy brothel, Johnson assures Jones that Martha will soon be hers to train in the business: "After I have a little fun I'll turn her over to you and you can train her to bring in the jack." It is within the city that Johnson's plans descend from date rape to premeditated white slavery, and Martha's commodification would seem to be complete. But even before Johnson plies her with drinks, his caresses arouse her: "[S]he only wanted this man's body to be touching hers and for him to hold her in his vice-like arms." And in an editorial aside, Schuyler offers a knowing wink to an audience outraged and titillated by Martha's sexual awakening and assault: "What happens to Martha now? No tellin', folks, no tellin'. But it looks like it won't be long now. Be sure and read what happens next week. That fifth installment will be just too bad."[33]

The speed of Martha's seduction and apparent ruin propels the narrative. With an excitement bordering on manic recklessness, the characters career toward Jazz Age self-destruction. In articles such as "Where, Oh, Where Are the Nice, Nice Girls?" a reporter for the *Courier* would note that "The modern girl makes love any time—when the speedometer registers 70 per, the thrill is greater" (fig. 10.5). With the pace of life "in transportation, cooking, eating, dressing and even sleeping— . . . faster, the frills between courtship, engagement and matrimony have eliminated themselves." According to "a prominent minister," "We are going too fast. The Negro is breathless in pursuit of the things he cannot afford." But in another photograph on the same page, the editors seem to celebrate the new freedom. Below a smiling "modern girl," the caption reads "This pretty girl is typically modern. Her smiling countenance and wind-blown bob express gay abandon."[34]

Even as Schuyler's novella begins by negotiating competing notions of changing black female roles, it turns to one of policing the color line by controlling black male sexuality. When Johnson lures Martha to Chicago, a city that, according to historian Kevin Mumford, by the 1920s was notorious in the black press for racial mixing, Ralph Armstrong invokes the Mann Act to get Johnson arrested.[35] Ostensibly passed to prevent the trafficking of women across state lines into prostitution, the Mann Act was frequently criticized in the black press as unfairly targeting black men while

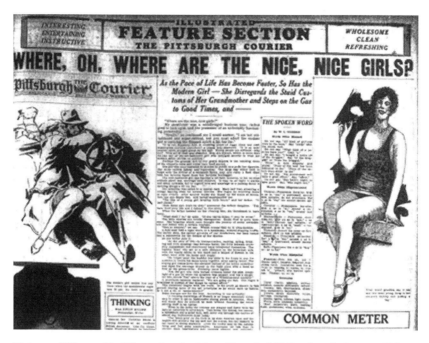

Fig. 10.5. "Where, Oh, Where Are the Nice, Nice Girls?" *Pittsburgh Courier,* February 8, 1930.

not protecting black women. By shifting readers' attention to the Mann Act, Schuyler implicitly reminds them of the discriminatory nature of legislation that was used almost exclusively to "protect" white women who were held within *white* slavery. But the Mann Act also became a means by which state officials could police sexual relationships between black men and white women. In perhaps the most notorious case of its deployment, black heavyweight champion Jack Johnson had been convicted in 1913 of violating the Mann Act when he brought his white girlfriend, a former prostitute, to another state to marry her. Johnson left the country for some years but was arrested on his return in 1920 and served a one-year sentence.[36]

In alluding to Jack Johnson, Schuyler evoked what Mumford sees as the "paradox of black male sexuality" even as he pricked the cult of celebrity that so dominated sensational journalism. According to Mumford, Johnson's power to defeat white opponents within the ring and his sexual appeal, regardless of race, outside of it created a "sexual predicament . . . in which the black figure is both feared and desired."[37] By capitalizing on this paradox, Schuyler seemed to perpetuate racist stereotypes of black male

sexuality even as he spoke to the need to protect black women and hold all men, regardless of wealth or celebrity status, to the law. By November and December of 1928, such an apparent criticism of Johnson might have been easier to make. Jack Johnson's fame had lost some of its luster when the *Courier* reported in November of 1928, in the midst of the Schuyler's "Chocolate Baby" serial, that Johnson had been subpoenaed for fraud for allegedly donating 150 dollars to Democratic Party officials in exchange for a position on the Chicago police force.[38]

At the end of the novel, however, when Martha drops her charges and marries Armstrong, leaving Johnson frustrated but not incarcerated, Schuyler appeals to critics of the Mann Act. In previous columns, Schuyler had, in fact, satirized it as a Prohibition-like failure, inevitable in an era of Jazz Age carousing and perilous as an assault to civil liberties: "Nobody is free to do anything that the sacred majority doesn't want done. . . . If some poor workingman hits the numbers and wants to take his girl to some resort in the next state where they can have a wonderful week-end with no questions asked as long as he pays off, the Mann Act looms up in front of him with threats of long incarceration."[39] Schuyler became, in fact, an ardent defender of interracial relationships after his marriage to the well-to-do white Texan Josephine E. Cogdell in 1928 and their consequent removal to Chicago, Jack Johnson's hometown. The following year Schuyler would write *Racial Intermarriage in the United States: One of the Most Interesting Phenomena of Our National Life.* And even though the *Courier* rarely published photographs or drawings of explicit interracial relationships in this period, it did report what seemed to be an increasing trend. Floyd Calvin had declared in April of 1928 in the *Courier* that the "Intermixing of Races in Harlem" was an "Everyday Occurrence."[40]

Schuyler's sleight of hand in weaving the politics of interracial relationships the debate over New Negro Woman icons reveals a sophisticated negotiation of market-driven formulas and civil rights protest. Schuyler, on the one hand, seems to represent modernity as a threat to women if one reads Johnson as representing a menacing, individualistic, urban modern sensibility, and Martha as signifying an early model of racial uplift and propriety. In that reading, the story urges black readers to save those potential race leaders who are most vulnerable to the seductions of a consumer-driven culture. But such a reading is complicated by the fact that both visually and textually modernity is represented, as it often was in the white imagination, by a threatening black man. The Mann Act, then, would seem to serve a protective function for the black community in the story; it

prevents a backward historical trajectory in which Martha is sold into (sexual) slavery. On the other hand, Schuyler's novella also presents modernity as a greater threat to urban black men, who, far from the watchful eye of traditional family and social structures, seem particularly susceptible to predatory northern vice. Given the general mistrust many black Americans felt toward the Mann Act, invoking it may have signaled the decline of both community policing and a stoic, independent black manhood just when they seemed to be most needed.

Refined and transgressive, familiar and exotic, icon of uplift and degradation, the chorine star meanwhile becomes transformed in Schuyler's narrative from a figure signifying the appropriation of black women—commodified as a sexual plaything explicitly by a black male protagonist but also implicitly by a white, male, Broadway audience—into a covert critique of the Mann Act in its criminalization of black male relationships with white women. If, as Jayna Brown notes, the dancing chorine star brought "to life the titillating 'problem' of miscegenation, [and] showed that the color line was sexually drawn through the nation's social geography," her performances also offered the promise that the breaks in that line were in full view.[41] Schuyler uses the popularity of the "chocolate baby" to move from one more accepted set of transgressions—black and white men's appropriation of black women—to the transgression, the perceived social threat that dare not speak its name, black men with white women. In a rather stunning reversal, Schuyler evokes the spectacle of the New Negro Woman to remind his audience of the civil liberties denied the New Negro Man.

Notes

1. Anne Elizabeth Carroll, *Word, Image, and the New Negro: Representation and Identity in the Harlem Renaissance* (Bloomington: Indiana University Press, 2005), 15.

2. Ibid., 105.

3. Martha Jane Nadell, *Enter the New Negroes: Images of Race in American Culture* (Cambridge: Harvard University Press, 2004), 8.

4. W. J. T. Mitchell, *Picture Theory* (Chicago: University of Chicago Press, 1994), 89–90.

5. Judith Butler, "Performative Acts and Gender Constitution: An Essay in Phenomenology and Feminist Theory," in *Performing Feminisms: Feminist Critical Theory and Theatre*, ed. Sue-Ellen Case (Baltimore: Johns Hopkins University Press, 1990), 278.

6. "'A Career Is One Thing—Home Another' Writes Young Benedict to Martha Henderson," *Pittsburgh Courier*, April 21, 1928, B1.

7. Andrew Buni, *Robert L. Vann of the Pittsburgh Courier: Politics and Black Journalism* (Pittsburgh: University of Pittsburgh Press, 1974), 145; "'No, No, I'll Not Desert Footlights,' Says Chorine," *Pittsburgh Courier*, November 6, 1926, A1.

8. Buni, 223.

9. "'Courier Best' Says Mencken," *Pittsburgh Courier*, December 20, 1930, A1.

10. By comparison, the circulation of the Chicago *Defender*, which was 200,000 in 1925, declined to 100,000 by 1933 and 73,000 in 1935. By 1937, the *Courier* was ranked as the leading black weekly in the country with a circulation that could regularly claim 149,000; only 20,000 of its readers were from Pittsburgh. In October of 1928, Floyd Calvin claimed that the *Courier* had a circulation of 100,000.

11. Buni, 134, 223. George S. Schuyler, *Black and Conservative* (New Rochelle, NY: Arlington House Publishers, 1966), 165. Likely based on the success of such tabloids as New York's *Daily News*, which first appeared in 1919, the "Illustrated Feature Section" appeared in a number of larger African American newspapers.

12. Floyd J. Calvin, "Has 'IT,'" *Pittsburgh Courier*, October 6, 1928, editorial page, A8.

13. See Schuyler's autobiography, *Black and Conservative*, 166–67.

14. Even though Vann was uncomfortable with the lewd content of much of the "Illustrated Feature Section," he didn't break off ties with Ziff until 1934.

15. Rita Felski, *The Gender of Modernity* (Cambridge: Harvard University Press, 1995), 62.

16. Ibid., 79.

17. Cherene Sherrard-Johnson, *Portraits of the New Negro Woman: Visual and Literary Culture in the Harlem Renaissance* (New Brunswick, NJ: Rutgers University Press, 2007), 13.

18. In *Edith Wharton's Brave New Politics* (Madison: University of Wisconsin Press, 1994), Dale Bauer defines "cultural dialogics" as "the varying intensity of a writer's engagement with material history as revealed through the layers of cultural references with which a writer deepens her work" (4).

19. Patrick Collier, *Modernism on Fleet Street* (Burlington, VT: Ashgate, 2006), 33.

20. Ibid., 35.

21. The images from the *Pittsburgh Courier* are reproduced here from microfilm. To my knowledge, the *Pittsburgh Courier* only exists in microfilm for these years.

22. Quoted. in James F. Wilson, "Bulldykes, Pansies, and Chocolate Babies: Performance, Race, and Sexuality in the Harlem Renaissance," PhD diss., City University of New York, 2000, 1.

23. Floyd J. Calvin, "What of Nudity on the Stage? Are Producers Confusing Art and Vulgarity?" *Pittsburgh Courier*, November 6, 1926, B1.

24. "Glorifying the Brownskin Girl," *Pittsburgh Courier*, December 12, 1925, 9.

25. Eva Jessye, "Chorus Girl Has Helped Glorify Modern Woman," *Pittsburgh Courier*, August 25, 1928, B1.

26. See Martha H. Patterson, *Beyond the Gibson Girl: Reimagining the American New Woman, 1894–1915* (Champaign: University of Illinois Press, 2005).

27. "The Girl of Today," *Pittsburgh Courier,* April 17, 1926, editorial page, 16.

28. Kevin J. Mumford, *Interzones: Black/White Sex Districts in Chicago and New York in the Early Twentieth Century* (New York: Columbia University Press, 1997), xviii.

29. Installment 1, Samuel I. Brooks, "Chocolate Baby: A Story of Ambition, Deception, and Success," *Pittsburgh Courier,* November 3, 1928, "Illustrated Feature Section," 1–2.

30. Ibid., 2.

31. Installment 2, Samuel I. Brooks, "Chocolate Baby," November 10, 1928, "Illustrated Feature Section," 7.

32. Installment 3, Samuel I. Brooks, "Chocolate Baby," November 17, 1928.

33. Installment 4, Samuel I. Brooks, "Chocolate Baby," November 24, 1928, "Illustrated Feature Section," 3, 4.

34. "Where, Oh, Where Are the Nice, Nice Girls?" *Pittsburgh Courier,* February 8, 1930, "Illustrated Feature Section," 1.

35. Mumford, 30.

36. See Tony-Al Gilmore, *Bad Nigger! The National Impact of Jack Johnson* (Port Washington, NY: Kennikat Press, 1975), 118, 153.

37. Mumford, 8.

38. In fact, an advertisement for the fourth installment of "Chocolate Baby" appeared directly above the article "Jack Johnson Subpoenaed for Fraud Jury." *Pittsburgh Courier,* November 24, 1928, 4.

39. *Pittsburgh Courier,* February 28, 1925, 20.

40. Floyd L. Calvin, "Intermixing of Races in Harlem Everyday Occurrence," *Pittsburgh Courier.* April 14, 1928, 1.

41. Jayna Brown, *Babylon Girls: Black Women Performers and the Shaping of the Modern* (Durham: Duke University Press, 2008), 219.

11

Bad Girls: The New Woman in Weimar Film Stills

VANESSA ROCCO

What is the attraction and allure of film stills and why do we never tire of gazing at them? They seduce, through staged and incomplete yearnings, unfulfilled longings, and sometimes direct addresses that leave the narrative open-ended to the viewer. They also avail themselves to multilayered personal references, even to a viewer who has not seen the relevant film. Yet, as public artifacts that are distributed through press kits, theaters, and various print media, they also invite "reflection on popular culture as such."[1] In his recent essay "A Typology of the Publicity Still," Thomas Van Parys commenced with an analysis of a scene from François Truffaut's *Day for Night* (La nuit américaine, 1973) that illustrates the irresistible "attraction and allure" of film stills.[2] The protagonist, a director played by Truffaut himself, has a recurring dream in which he recalls stealing stills from a local movie theater's outdoor display case as a boy, a sublimated expression of his lifelong passion for the cinema. Van Parys rightly pointed out that stills are a largely ignored body of photography precisely due to their existence as a subconscious part of the culture industry; few people seem consciously aware of how these film "extensions" actually work themselves on our imaginations and desires.[3]

In this essay I focus on 1920s German cinema and examine how this intensely seductive phenomenon of film stills contributed to the creation of one of the Weimar era's most debated constructs, that of the New Woman. In doing so, I investigate how the stills of three women of Weimar cinema—particularly Louise Brooks but also Brigitte Helm and Marlene Dietrich—were circulated and received through mass media outlets, including box office programs, posters, lobby cards, and magazines, the reach and influence of which had proliferated in interwar Germany and beyond. Although the films of this period have been well parsed in histori-

cal and more recent critical literature, I argue that the visual influence of those films during their own time and through to the present day has also been based on the film stills that are lodged in the cultural subconscious either as complements to the films or as substitutes for the films themselves. The goal is to bring forth an alternative view as to why films are so internationally and culturally influential, in this case vis-à-vis gender relations and sexual mobility. I should make it clear at this point that the film stills discussed in this essay were taken by anonymous still photographers on the set. With one exception from Fritz Lang's *Spione* (Spies), they are *not* frame enlargements taken directly from the celluloid.[4] I will thus analyze film stills—so often seen and yet not really seen for what they are—as a body of photography in their own right.

Cinematic representations of sexually empowered women and gender destabilization should be contextualized against the backdrop of the sociocultural turmoil of Weimar Germany to make sense of the power of the growing "street awareness"—as I will call it—of the New Woman. Weimar was born in the wake of the First World War and supplanted a defeated monarchy. The democratic Weimar Republic was marked by a period of rapid-fire industrialization, urbanization, and demographic change—including shifting gender relations—throughout the country, which had only just been unified in 1871. For the first two years of the republic's existence, the left-leaning Social Democrats formed an alliance with the communists, a radical shift for a population accustomed to an authoritarian, monarchical system. These accelerated transformations and social convulsions threatened to shred the already fragile social fabric of this modernizing republic, but they also led to radical experimentation and sudden, unexpected freedoms. Within this context, it is not surprising that the New Woman of Weimar was the subject of vigorous debate and linked to broader issues of modernity.[5] Women were granted the vote in 1918 and began to enter the workforce in greater numbers. This influx into the working world resulted in part from the disproportionate ratio of women to men caused by an enormous number of wartime casualties. A social paranoia arose connecting the increase in working women to the declining birthrate.[6]

Anxiety about the changing social roles of women in the 1920s and the impact on the definition of their sexuality extended into the scientific realm. In 1927, for example, the mainstream medical journal *Zeitschrift für Sexualwissenschaft* published the following cautionary note about "intersexuality" or gender confusion.

Emancipated women, suffragettes, female academics, woman politicians, lead-
ers of the women's movement, woman artists, woman drivers . . . are not infre-
quently intersexual. A great enthusiasm for completely unfeminine professions
must always in and of itself *alert* one to intersexuality.[7]

Juxtapositions in women's magazines of the time are often telling of such
societal tensions. Running right next to a controversial medical article about
the dreaded intersexuality of liberated Weimar women, called "Verstand-
ene Frau," in *Die Dame* (January 1927) was a publicity photograph taken
by E. O. Hoppe of film star Anna May Wong, a highly internationalized
symbol of the New Woman as an Asian Hollywood starlet but in this case
depicted as seemingly placid instead of aggressively modern in a virginal
white-trained dress covered with flowers, her hair decorated rather than
the usual severe black bob.

Though dating back to the mid- to late nineteenth century, the New
Woman as a visual trope of sexual liberation and socioeconomic mobil-
ity coalesced in the postsuffragist 1920s and 1930s as mass media outlets
proliferated internationally and provided the means for disseminating
seductive and free-spirited "types" like the flapper and the aviatrix to a
hungry consumer audience, a growing share of which were women. Media
worked together in the creation of these types; magazines fueled the image
machine of international film capitals such as Berlin and Hollywood, and
film stills, as well as posed studio shots, were an essential part of this pub-
licity apparatus.[8] In their films of the late 1920s and early 1930s, Brooks,
Helm, and Dietrich personified, along with others, the mobility of the Wei-
mar New Woman.

A useful starting point for an analysis of how the many facets of the
New Woman were realized in Weimar film stills is the iconic black-and-
white image of Brooks, one of the most magnetic screen presences in the
history of cinema. An American émigré to Germany, Brooks's severe black
bob, perfectly painted lips, and high-fashion clothes embodied the flapper
incarnation of the New Woman. The international diffusion of Brooks's
iconic image exemplified the transatlantic exchange of the New Woman
as a visual, mass media trope of the 1920s. In particular I will analyze stills
from Brooks's famed film collaboration with German director G. W. Pabst,
Pandora's Box (Die Büchse der Pandora, 1929), based on the plays of Franz
Wedekind about the free-spirited Lulu. These stills take her through much
of her character arc in the film: from showgirl mistress to wife to scandal-
ous widow. The character of Lulu put Brooks's already extant New Woman

looks to great use, a fact that emerges strikingly in the stills. The lighting of the stills showed off the shiny black of the pageboy haircut so associated with the androgynous New Woman look. The blacks and whites of the stills also served to emphasize the graphic makeup preferred by modern women, as well as the way fashion was used to signify and differentiate between "good" and "bad" girls, with the New Woman types often wearing the darker and naughtier garb.

The first image (fig. 11.1) depicts a moment after the opening scenes of

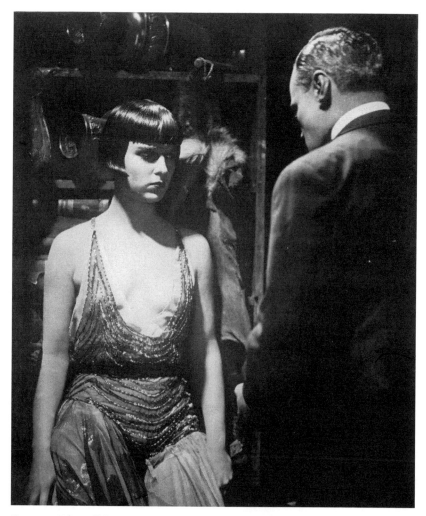

Fig. 11.1. Film still from G.W. Pabst's *Die Büchse der Pandora* (Pandora's Box), 1929, photographer unknown. (Courtesy of Kino International.)

Pandora's Box when Brooks as Lulu has been introduced to us as the hard-drinking, flirtatious mistress of the publishing magnate Dr. Ludwig Schön. We are now backstage at the show where she dances. Lulu is immersed in a moment of vengeful and jealous rage as Schön has brought his wealthy and refined fiancée to the show. On his visit to her dressing room, she instigates a seduction that she knows will be witnessed by the fiancée. Her chorus girl costume appears in the still as glinting with diaphanous layers and sequins and reads, along with the furs hanging in the background, as a grayish, somewhat in-between color, appropriate for her current status as mistress and in contrast to the colors she will later wear as wife and condemned widow.

Once she has succeeded in breaking up the planned marriage, Lulu herself becomes Schön's wife, completing an important step in the attainment of social mobility. A still taken from the wedding banquet sequence achieves so many levels of character development that it is somewhat startling to remind oneself that it is a *still* photograph and not unfolding in time (fig. 11.2). Schön, with his back to the camera, is the viewer's stand-in, and Lulu stares directly at him.[9] She seemingly attempts to seduce us, the view-

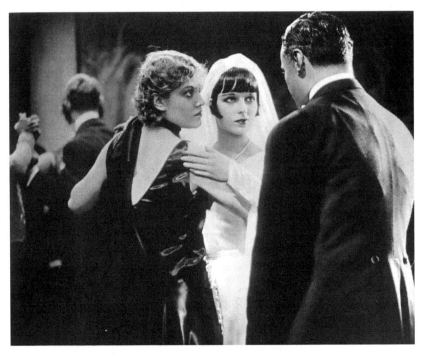

Fig. 11.2. Film still from G. W. Pabst's *Die Büchse der Pandora* (Pandora's Box), 1929, photographer unknown. (Courtesy of Kino International.)

ers, as well as Schön, through her gaze. In this scene, however, he is in no mood to be seduced, as he is confronting Lulu over her licentious dancing with another woman. Played by Alice Roberts and often credited as the first on-screen lesbian, the character of Countess Geschwitz flits in and out of the movie, always coveting Lulu's attention. She is clearly resentful of the husband's intrusion on her moment with Lulu, as her look and body language say unequivocally "go away!"

The still itself is a gorgeously rendered composition, with the glossy blacks of Geschwitz's evening gown complementing Lulu's "shiny black helmet" of hair, which then contrast with the ironically virginal white satin of Brooks's wedding gown.[10] This display of homosexual desire became a particularly popular still to reproduce, both at the time (fig. 11.3) and in subsequent literature attempting to excavate Brooks from obscurity such as James Card's 1956 "Out of Pandora's Box."[11] In figure 11.3, we see how the still was utilized in the lavishly illustrated box office program under the imprint of the *Illustrierte Film-Kurier*, one of the most popular producers of such programs from 1919–44, sold at cinemas throughout Germany and Austria.[12] In this page's composition, the wedding-scene photograph anchored a swirl of masculine images from *Pandora's Box*, including Lulu's vaguely defined father/pimp figure, Schigolch, as well as Brooks in male garb with her hair completely slicked back under a man's cap.

Both here and with her pageboy hairdo showing, Brooks personified the fashionable *garçonne* type of New Woman, a French term for the masculinized flapper spin-off that was a particularly polarizing subject of the Weimar gender debate.[13] The *garçonne* was also described in Germany as a *Bubikopf*, the equivalent term for the pageboy, and she wore loose-tailored dresses or other, more explicitly masculine attire. This "look" was thought to be related to such masculine social behaviors as sexual promiscuity, drinking liquor, and smoking cigarettes. Brooks was actually nicknamed *Bubikopf* by at least two of the German film journals, *Der Film* and *Sudfilm Journal*, which announced Pabst's selection of her as Lulu in 1928. To see how "troublesome" *garçonnes* were considered, one need only see the published discussion in a 1927 article in the mainstream Berlin newspaper *8-Uhr Abendblatt* about three distinctive types of women, the *Gretchen*, the *girl*, and the *garçonne*:

> The *Garçonne* type cannot be grasped by language. . . . [Her combination] of fifty to fifty [percent] sexual and intellectual potency often gives rise to conflict. . . . [T]he most significant one in this group: the business- and life-artist. Unit-

Fig. 11.3. "Die Büchse der Pandora," *Illustrierte Film-Kurier* 11 (1929). (Courtesy of Ira M. Resnick Collection.)

ing a sporting, comradely male entrepreneurial sense with heroic, feminine devotion, this *synthesis*—if successful—often makes her so superior to the man she loves that she becomes troublesome.[14]

What seems to be a celebratory description of the *garçonne* and her abil-

ity to achieve a balance between elements of sexuality and entrepreneur-
ship, of femininity and masculinity, ends with a kind of warning to be on
the lookout for such a disturbing "synthesis." The picture magazines of the
time—which had exploded in popularity—were rife with critiques of gen-
der confusion spurred by the new manifestations of female assertiveness.
This was typified by articles such as "Masculine Masquerade" in *Die Dame*
(1926) and "Now That's Enough! Against the Masculinization of Woman" in
Berliner Illustrirte Zeitung (1925).[15]

Indeed, the best known still from *Pandora's Box* presents Lulu as a
more threatening figure (fig. 11.4). She is the one now wearing black, as she
has become the embodiment of scandal, accused of murdering Schön on
their wedding night as he erupted in jealousy over both Geschwitz's lesbian
overtures and Lulu's suspiciously close relationship with Schön's grown son
Alwa. Although the film set is apparent, this reads as a more contrived
publicity still rather than one taken directly from the film's action, as she
confronts us, the viewers, directly; it also has the overtly sexual come-on
that takes place in a direct gaze at the viewer as she lifts her mourning veil
and seems determined to ensnare us in it.

This still of the scandalous Lulu continues to be used on posters at rep-
ertory screenings (such as one at the Film Forum in New York in 2006) and
serves as the cover of the recent definitive Criterion Collection release of
the DVD (2006). Given that Brooks herself was such an idiosyncratic star
product—that she really *was* a bad girl—perhaps it is this blurring between
actor and life that partly accounts for the continued appeal of this particu-
lar still. After all, she abandoned life as a Hollywood starlet after a contract
squabble with Paramount and exported herself to Germany to star in *Pan-
dora's Box* and then Pabst's *Diary of a Lost Girl* (Tagebuch einer Verloren,
1929). Once she was back in New York, she staunchly refused to do retakes
on her last Hollywood film, *The Canary Murder Case* (Malcolm St. Clair,
1929), making it difficult and expensive for Paramount to turn it into a
talkie and effectively blackballing herself.[16] After returning to Hollywood
in the 1930s, Brooks was handed subpar roles and then no roles at all. This
situation was no doubt partly of her own making, but the idealization of
the New Woman had shifted dramatically in the United States away from
the hard-living, urbanized flapper in favor of the clean-scrubbed athletic
type epitomized by Amelia Earhart.[17] She wound up back on the dance
circuit and then even in a stint as a little shop "girl" in her forties before
James Card—the founding film curator of the George Eastman House—
and other film scholars saved her from obscurity.

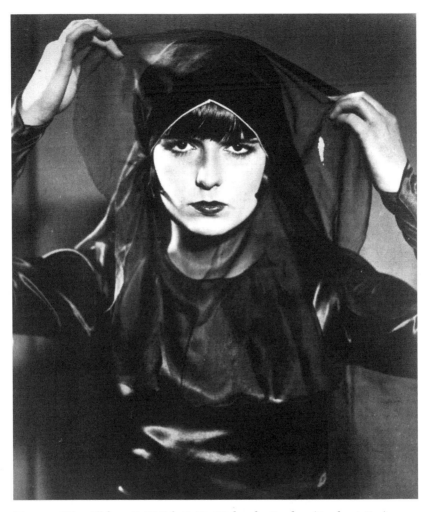

Fig. 11.4. Film still from G. W. Pabst's *Die Büchse der Pandora* (Pandora's Box), 1929, photographer unknown. (Courtesy of Kino International.)

Bad girls were particularly threatening in the context of the Weimar Republic, and a measure of paranoia about the dizzying level of sexual and social female mobility portrayed by Brooks seeps into other films and stills from the period. It must be remembered that those stills allowed the content of films to spill out into a kind of public street awareness, one, albeit ephemeral, with more stasis than the films and one also available to those who had not seen the films. This public transaction took place through the use of stills on posters, on lobby cards, and in magazines with larger

circulations than the box office program discussed earlier. As an example, the pivotal moment of Fritz Lang's masterpiece of modernity, *Metropolis* (1927), is the transformation of a socialist-leaning female activist, played by Brigitte Helm, into a sinister robot, forged in a scientific lab, who attempts to sow discontent among previously united workers. Stills from Maria Makela's essay in this volume demonstrate the evolution from wide-eyed, innocent Maria to robot transformation and subsequently to the Maria who vamps it up with her shoulders swaggering and her come-hither stare.

Large-scale *Metropolis* posters of the robot transformation were even more ominous than their source film stills, with the body of the robot taking up the entire frame. Proof of how such threatening imagery might have been plastered on the streets of Berlin exists in another Lang film, *Spies* (Spione, 1928), which includes street scenes backdropped by large-scale "one sheet" posters of the robot transformation.[18] These included two different versions: one of the robot in profile, still looking quasi-feminine with lipstick visible (fig. 11.5); and another, more famous and threatening full frontal of the completely transformed robot.

Fig. 11.5. Frame enlargement from Fritz Lang's *Spione* (Spies), 1928. (Courtesy of Kino International.)

Josef von Sternberg's *The Blue Angel* (1930), the film that made Marlene Dietrich a star, was another source for assertive stills of the Weimar New Woman. The film in fact centers on a male protagonist, a teacher of young boys played by Emil Jannings, who loses bourgeois respectability and is humiliated by his lust for the aloof but manipulative cabaret singer Lola Lola (Dietrich). One of the best-known stills of Dietrich in *Blue Angel* shows her not only as sexually outré and gender-bending in her manly top hat and cuffs but in control of the scene (fig. 11.6). Her gorgeous legs are encased in the dark stockings and garter belts that often signify prostitution, but she is in the midst of performing cabaret, so the passive beer wenches behind her have the effect of looking more the part of brothel dwellers than she. The still photographs made during this cabaret scene became one of the main sources of publicity images for *Blue Angel* for its German and American release (both in 1930, as the film was shot simultaneously).[19] These were used for street posters but were also displayed prominently on cards in the lobbies of movie houses (fig. 11.7), again contributing to the street awareness of a more sexually liberated woman. Stills

Fig. 11.6. Film still from Josef von Sternberg's *Blue Angel*, 1930, photographer unknown. (Courtesy of Kino International.)

in shop windows also contributed to the spillover, as Card demonstrated in his 1956 article by reproducing a 1929 shop window in Paris jam-packed with at least ten publicity stills of Brooks.[20]

The final outlets for the stills that I want to examine were the most abundant in the interwar period: mass market magazines. The crucial connection needs to be made here between the illustrated press and cinema because they were both subversive modes of address to the New Woman, particularly in imaging gender oscillation. Film stills were a key meeting point of the two, a dialectic that has not been thoroughly addressed. Stills from the films—often devoid of the overfeminization that existed in even New Womanesque cinema, indeed often the opposite, as in the case of the montage in figure 11.3—were some of the most effective weapons in creating these possibilities of oscillation and destabilized representation. They could do so, and did, through their variegated publication. Patrice Petro, in her groundbreaking work on building and theorizing a female spectator, *Joyless Streets: Women and Melodramatic Representation in Weimar Germany* (1989), made the crucial connection between the

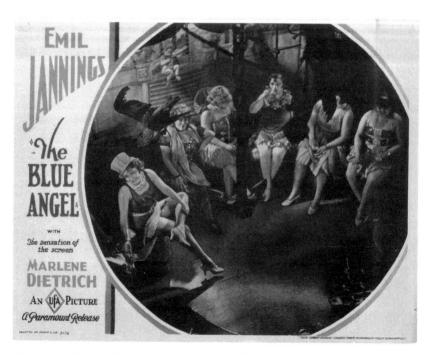

Fig. 11.7. Lobby card for Josef von Sternberg's *Blue Angel*, 1930. (Courtesy of Ira M. Resnick Collection.)

illustrated press and the cinema and did so through the lens of the New Woman:

> Not surprisingly, illustrated magazines and films in Weimar returned to remarkably similar issues when addressing female audiences—concerning sexuality, gender identification, and heterosexual relations. In bourgeois cinema and press, these issues were bound to economics and consumerism—to the need to address women's experiences and bind them to pleasurable forms of consumption.[21]

However, I would like to add to Petro's brilliant analysis as to how film stills were used for these purposes. Even in her closest correlation of films and magazines—Brooks as Lulu relaxing with a copy of *Die Dame,* taking time for a pleasure read despite being on the lam—Petro did not analyze the image in and of itself but rather as a film referent (the reproductions in her book appear to be frame enlargements). It is a scene in the film that is both shocking and humorous, as Lulu has just escaped from the trial where she is accused of killing her husband, yet she looks completely relaxed as she flips through pages of *Bubikopf* fashions. The film itself establishes *her* point of view as a female spectator by showing the viewer these pages. But stunning stills also exist of this scene that emphasize her complete absorption in her own pleasure and no one else's, an absorption that is clearly conveyed in the stills even if one has not seen the film and the jarring break in the narrative.[22] Indeed, many levels of intertextuality exist within this single still since *Die Dame* was known as a publication that reproduced film and publicity stills.

In addition to the box office program reproduced in figure 11.3, the circulation of stills naturally took place most often through other types of movie magazines. It is fascinating to chart the international reach of the image of someone like Brooks in these magazines and to see how consistently she was portrayed from country to country, showing the resonance of the *Bubikopf* image of the New Woman at this time and how it achieved its international iconic status. In addition to movie fame in the United States and then Germany, within a one-year period (mid-1929 through mid-1930) she graced the front and back covers of movie magazines in European countries ranging from Sweden to Portugal, Italy, and France.[23] The cover shots were most often highly feminized publicity stills from her French film *Prix de Beauté* (Augusto Genia, 1930) or her popular Hollywood film *The Canary Murder Case,* but inside were often found more gender-bending

stills from her other films. In the June 1930 issue of *Le Film*, for example, she was the "étoile du jour" (star of the day), and the photos included film stills from *Beggars of Life* (William Wellman, 1928), in which she spent most of the movie cross-dressed as a male hobo, as well as from *Pandora's Box*, titled *Loulou* in French.

General audience magazines also made wide use of publicity and film stills. The illustrated weekly *Eve* was the French woman's equivalent of *Die Dame* (its motto was "le plus vivant—le plus élégant—le moins cher" [the most lively, the most elegant, the least expensive]). A June 1930 issue featured an extreme close-up still of Brooks and actor Georges Charlia in profile from *Prix de Beauté*, solidifying her bobbed New Woman look for an audience extending far beyond that of the cinephile. Inside this issue were various stories related to the New Woman's concerns, including a double-page spread entitled "Les Charmantes Baigneuses" (Charming Bathers), which featured *Bubikopf* looks for all ages, including tiny girls, as well as a smaller feature on an aviatrix named Amy Johnson who posed next to her plane.[24] Such fluid juxtapositions from page to page in interwar illustrated magazines of fashion, beauty, and adventure made a clear case to women that they should feel free to experiment with ambiguous fashions and to extend their activities far into domains previously occupied by men. These addresses to the female reader encompassed both personal and public mobility.

Until very recently there have been occasional, but not sustained, attempts to explore film stills as synthesizers of crucial information about Weimar cinema and indeed cinema in general. For my purposes here, the most relevant was the project undertaken by Cinémathèque Française's founding director Henri Langlois, which had the effect of resurrecting Brooks's and other women's careers after they had fallen into obscurity. From June to September 1955, Langlois mounted an exhibition at the Musée National d'Art Moderne, "60 Ans de Cinéma" (Sixty Years of Cinema), which included various cinematic artifacts and stills, as well as an extensive screening program that sampled widely from Weimar cinema, including showings of *Diary of a Lost Girl* and *Metropolis*. According to Card's firsthand accounts, the "vast and bravely unorthodox exhibition . . . featured gigantic enlargements of rare movie stills towering, ominously, one above the other."[25] In Card's view the two most dominating were of Brooks as Lulu and Maria Falconetti from *The Passion of Jeanne d'Arc* (Carl Dreyer, 1927), although he did not specify which still images they were. Langlois made a now-famous statement at the time justifying his

choice: "[T]here is no Garbo! There is no Dietrich! There is only Louise Brooks!"[26] Langlois also made a somewhat unsettling statement about her in the catalog: "[S]he has the naturalness that only primitives retain before the lens."[27] Despite the unfortunate wording, this reception might help explain Brooks's and other New Women's visceral and almost unnerving appeal on screen at the time: they possessed an unusual sense of freedom on camera, a freedom that allowed conveyance of an omnisexuality that was quite subversive. Langlois went on to praise Brooks further in the show's catalog, calling her the most perfect incarnation of *photogénie*, a French noun version of *photogenic*, so her appeal, in Langlois's mind, clearly carried through to still images as well screen projections.[28]

In conclusion, let us revisit Truffaut's director: what is the *private* attraction and allure of film stills and why do we never tire of them? They serve as general fetish objects, as readily available fantasies of sexual mobility and freedom that can either precede or extend the pleasures provided by a film experience. However, as *public* artifacts they also invite reflection on popular culture and how street awareness functions. The New Woman of Weimar provides a particularly fertile case study for the private and public functions of these artifacts. Women were privately and pleasurably consuming sexually bold and ambiguous cinematic and magazine images as never before, including these interstitial stills existing in the space between film and print. Yet the omnipresence of film stills in public print culture also guaranteed their place, albeit an unacknowledged one, in a contentious and internationalized debate among women and men about the *Bubikopf*.

Notes

This text is marginally based on an essay that originally appeared in the brochure "Louise Brooks and the 'New Woman' in Weimar Cinema," which accompanied an exhibition of the same name at the International Center of Photography, New York, in 2007 (the eleventh exhibition in the series "New Histories of Photography," drawn from the collections of George Eastman House).

1. Thomas Van Parys, "A Typology of the Publicity Still: Film for Photograph," *History of Photography* 32 (spring 2008): 91–92.

2. Ibid., 85. Film stills as fetish objects reappear throughout *Day for Night* even apart from the dream sequences. The opening dedication is to "the Gish sisters," handwritten by Truffaut over a film still of them in heavily contrived poses; the director Ferrand admires a collection of stills of his star, played by Jacqueline Bisset, as he anxiously awaits her arrival on set; and, in probably the most self-reflexive of these moments, Ferrand opens an arriving book order and tosses each excitedly on his desk so the viewer can clearly see that each is a biography of a director (Buñuel, Bresson, Rossellini, and so on), most with an accompanying film or production still on

the cover. The stills photographer on the set of the "movie within the movie" is also omnipresent.

3. There have been sporadic attempts to explore film stills as a legitimate body of photography for study. Thanks to Michel Frizot, I became aware that in 1985 the Cinémathèque Française mounted an exhibition of stills from *Metropolis* by Horst von Harbou, albeit stills known as *tournage*, which show the production crew at work. The catalog contains an essay by Alain Bergala that posits these production stills as having the potential to challenge and transform myths of cinema that have accrued for ninety years by erasing the perceived line between fantasy and production. Film stills have also been the subject of *Film Stills: Emotions Made in Hollywood*, ed. Annemarie Hürlimann and Alois Martin Müller (Zurich: The Museum für Gestaltung, 1993) and a recent book by David Campany and Christoph Schifferli entitled *Paper Dreams: The Lost Art of Hollywood Still Photography* (Göttingen: Steidl 2006), which, like Van Parys's work, refers to them as a body of photography largely ignored and overlooked. This is heartening, as there is a need to expand greatly on this body of research on stills, considering the ubiquity of these artifacts, the widespread dissemination of them, and the fact that the frequent anonymity of the photographers has limited the scholarship. The resurgence of interest in vernacular photography and other previously marginalized aspects of the medium is helping to rectify this.

4. Van Parys refers to images taken from the "film strip itself" as "photograms" (87). Explication on this differentiation between frame enlargements and still photographs in scholarly literature is exceedingly rare. For an enlightening blurb about film still photographers, see the general interest book by James Sanders, *Scenes from the City: Filmmaking in New York* (New York: Rizzoli, 2006), 240. A filmmaker himself, Sanders discusses the fact that frame enlargements from actual 35 mm footage are not considered worthy source material for the stills or large "one-sheet" posters crucial for a film's publicity apparatus, hence the need for a photographer on the set.

5. The New Woman was, as described by Maud Lavin, "an uneasy alliance of women with modernity in twenties Germany." Maud Lavin, *Cut with the Kitchen Knife: The Weimar Photomontages of Hannah Höch* (New Haven: Yale University Press, 1989), 4.

6. Detlev J. K. Peukert provides statistics on the declining birthrate and discusses the public fears it generated in *The Weimar Republic: The Crisis of Classical Modernity* (New York: Hill and Wang, 1993), 7–9.

7. Otto Herschan, "Die weibliche Intersexualität," *Zeitschrift für Sexualwissenschaft* 14 (1927–28): 410, quoted in Lynne Frame, "Gretchen, Girl, Garçonne? Weimar Science and Popular Culture in Search of the Ideal New Woman," in *Women in the Metropolis: Gender and Modernity in Weimar Culture*, ed. Katharina von Ankum (Berkeley: University of California Press, 1997), 20.

8. Barry Paris, *Louise Brooks: A Biography* (New York: Alfred A. Knopf, 1989), 203.

9. This is an important alternative to what Van Parys proposes as the simple dichotomy between the actor gazing directly at us or not: he posits that when the former is

the case it usually contains a sexual tinge. But what about when the actor is looking directly at another actor who is clearly in *our* position? As Van Parys has pointed out, in more contrived, direct-gaze stills there is often a more "palpable tension" between the "real-life person, the actor, the star, and the character" (Van Parys, 89). On this tension, see also Richard Dyer, *Stars* (London: British Film Institute, 1982), 69–70.

10. It is interesting to speculate whether Brooks's magnetic presence in stills is related to Pabst's reported love for the "single scene." See Andor Kraszna-Krausz, "G. W. Pabst's 'Lulu,'" *Close Up*, April 1929, 28. Brooks anecdotally christened her own hairdo "shiny black helmet" in her *Lulu in Hollywood* (Minneapolis: University of Minnesota Press, 2000), 94.

11. James Card, "Out of Pandora's Box," *Image*, September 1956, 152.

12. The still backstage at Lulu's show appears with Schön cropped out in this same *Pandora's Box* box office program.

13. See Frame, 12–40.

14. Ibid., 12, emphasis added.

15. Both are illustrated in Patrice Petro, *Joyless Streets: Women and Melodramatic Representation in Weimar Germany* (Princeton: Princeton University Press, 1989), 112–13. By the early 1930s, several dozen illustrated weeklies were being published in Germany's urban centers, and the most popular, *Berliner Illustrirte Zeitung*, had a circulation of over 1.5 million.

16. Her reputation as a troublemaker was inextricably linked to her persona, to the point where Roland Jacquard's book of essays about her was titled *Louise Brooks: Portrait of an Anti-Star* (New York: Zoetrope, 1986).

17. See Kristen Lubben's essay on Amelia Earhart in this volume.

18. I am indebted to Josh Siegel of the Museum of Modern Art Film Department and Werner Sudendorf of the Deutsche Kimenathek, Berlin, for confirming for me that large-scale movie posters were indeed a popular form of Weimar street culture by this time. Sudendorf sent me the three stills from Lang's film *Spies*, which included a street scene with two versions of the *Metropolis* movie poster plastered everywhere.

19. Important to note about the available posters of *Blue Angel* is one in the collection of the Deutsche Kimenathek, Berlin, which was produced by Ufa and could be ordered by various foreign distributors. It showed Dietrich and Jannings in wedding garb, Dietrich looking up, supplicant and adoring, at her husband, a fleeting moment in the film quickly overtaken by his submission to her whims and needs.

20. Card, 152.

21. Petro, 90.

22. For a reproduction of this image, see the back cover of my brochure for the exhibition "Louise Brooks and the "New Woman" in Weimar Cinema," New York, International Center of Photography, 2007.

23. I thank Ira Resnick for sharing his collection of archival film magazines, with their varied depictions of Brooks, including *Film Journalen*, published in Sweden (April 7, 1929), *Cinegrafia*, published in Portugal (February 6, 1930), and *Al Cinema*, published in Italy (June 9, 1929).

24. *Eve,* June 8, 1930, unpaginated.

25. Card, 148.

26. This is noted anecdotally in Paris, 440; and Card, 148.

27. "[E]lle a le naturel que seuls les primitives gardent devant l'objectif." Henri Langlois, *60 ans de cinéma* (Paris: Musée d'Art Moderne, 1955). The booklet is unpaginated; these quotes are taken from a section entitled "Chefs d'oeuvre du cinéma muet (1895–1930)," which recounts the schedule for the screening portion of the show. *Le Journal d'Une Fille Perdue* (Diary of a Lost Girl) was scheduled for August 6 at 21:00 hours.

28. Ibid.

12

Girl, Trampka, or Žába?
The Czechoslovak New Woman

KARLA HUEBNER

During the 1920s, a Czech man meeting an up-to-date young woman at one of the big winter balls might find himself trying to assess and categorize her. Was she a girl who liked jazz and cocktails? A *trampka* intent on camping and hiking? A cute *žába* (frog)? Was she a Prague flapper? A *garsonka* (*garçonne*)? A *komunistka* (communist)? He might conclude that the young woman was any one of these, more than one of these, or even that she was none of the above. His judgment in the matter would be informed partly by the young woman herself but also by his reading and images from films and the popular press. He would be considering her haircut, the style of her ball gown, and her knowledge of the latest dances but also her opinions on such matters as Victor Margueritte's novel *La Garçonne*, free love, and dual-income families.

Czechoslovakia in the 1920s was a brand new, vibrant country. It had not suffered extreme losses during the First World War, and its cultural identity was still forming. Its First Republic, later idealized as a golden age, lasted from 1918 to 1938 and was a parliamentary democracy with strong political ties to France, Great Britain, and the United States. In this new state, which had high levels of literacy and a strong industrial base, women had achieved higher education, broader employment opportunities, and the vote without the bitter opposition often seen elsewhere. Yet the New Woman's Czechoslovak incarnation has not yet been the subject of scholarly investigation, especially as regards her representation in visual imagery.

How, then, was the Czechoslovak New Woman constructed in the press and visual imagery? What forms did she take? By exploring representation and discussion of the Czechoslovak New Woman in First Republic journalism, advertising, and photography, this essay will uncover some of the ways in which New Women were imagined, pictured, and thought to

perform a version of modernity that was both international and specifically Czechoslovak. This Czechoslovak New Woman or "Girl," though akin to New Women elsewhere, had a decidedly different cultural valence than her French and German counterparts, who were often seen as a serious threat to masculine culture and nationhood.[1]

The First Republic was multiethnic, but Czechs formed its dominant cultural group and to a large extent saw Czech culture as contrasting with German culture. While Czechs did in fact share many aspects of their culture with the Germans, their much-vaunted differences were often genuine.[2] For example, interwar Czechs did not usually see American culture as a threat, and while the so-called Girl was to some extent considered an American phenomenon, she was not seen as solely American nor was the Czech image of America created primarily through its women, as has been argued was true for the Germans.[3] Admittedly, First Republic Czechoslovakia's regions ranged from prosperous Bohemia to "starving" Ruthenia, so it was among the urban Czechs of Bohemia and Moravia that New Womanhood was most evident during the 1920s. While Czechs and Slovaks were politically united as Czechoslovak, in practice the two groups, though close geographically and linguistically, usually considered themselves to be distinct. Both Czech and Slovak periodicals showed Slovaks as primarily rural, whether as quaintly folkloric characters in *kroj* (regional garb) or as impoverished, exhausted farm laborers. Czech women, however, were almost never shown in *kroj* except in theatrical productions of nineteenth-century nationalist plays and operas. Overwhelmingly, Czech women of the First Republic were represented in both the media and the fine arts as being modern, well-dressed, and confident. Modern, urban Slovak women, meanwhile, were fewer in number and less visible in the media, so my comments will mainly address the specifically Czech New Woman with the understanding that educated urban Slovaks were similar and Czech periodicals were often read by Slovaks.

Intriguingly, however, while at first glance Czech illustrated periodicals present a gold mine of images of New Womanhood, close examination suggests that the *Czech* and *Czechoslovak* New Woman appeared in the press primarily in the form of sketches, cartoons, and paintings and only to a lesser degree in photographs. Photography, though constituting a significant percentage of the visuals in most of these magazines, was often of foreign origin or subject matter. Given that interwar Czechoslovakia is now celebrated for its modernist photography, this is surprising. Why, when the New Woman was of obvious visual interest, was the photographic

New Woman in popular journalism usually of foreign or nonspecific origin? Portrait photography of prominent Czech women—which was frequently reproduced in the press—shows that artists were not inventing the short hair, short dresses, and other visual signs of 1920s New Womanhood. With this problem in mind, in this essay I first briefly review the Czech woman's situation in the early twentieth century and then focus primarily on four popular Czech periodicals featuring prominent New Woman imagery—the women's magazines *Eva* and *Moderní dívka,* the men's magazine *Gentleman,* and the general-interest magazine *Světozor.*

The interwar Czech New Woman, who had no fixed appellation, was more than a product of mere international fashion; she came into being partly as a result of the earlier, explicitly named Nová žena (New Woman) of fin-de-siècle feminism. Scholars agree that Czech resistance to feminism was significantly weaker than was typical elsewhere, and by 1920 Czech feminists had achieved many of their early goals. Preindependence Czech political parties, for instance, had mostly endorsed women's suffrage as a reasonable goal. Particular support had come from intellectual and future president Tomáš Garrigue Masaryk, who, in a feminist gesture, took his wife's name.[4] Charlotte Garrigue Masaryková herself had translated John Stuart Mill's influential *The Subjection of Women* into Czech in 1890. Masaryk's Progressive Party had cooperated with Czech suffrage activists, and during most of the period 1905–15 his journal *Naše doba* (Our Era) had carried a monthly column on women's issues.[5] Thus, it was not surprising when Masaryk's Washington Declaration of October 18, 1918, which proclaimed the independence of Czechoslovakia, announced that women would enjoy the same political, social, and cultural rights as men. The new constitution followed up on this promise, stating that privileges of race, gender, and profession would not be recognized. Masaryk's support of feminism continued throughout his presidency, which lasted nearly the whole of the First Republic.

Indeed, during the 1920s some Western feminists considered Czechoslovakia a "paradise of the modern woman," an assessment that was proudly pointed out to westward-looking Czech readers.[6] Divorce was eased in 1919, and Czech women began to vote in the same year.[7] Access to higher education for women, which had been increasing for decades, improved considerably in the 1920s. During this period, Czech women not only became artists, writers, composers, and office workers but also pilots, motorcyclists, and race car drivers, a development that the mainstream women's magazine *Eva* highlighted with one-page photo essays of women from around

the world in unusual fields of endeavor and by providing a page on women and work in each issue. Czech women who pursued unusual careers were often well known and greatly admired; in the early 1920s, the modernist composer Bohuslav Martinů put a picture of Eliška Junková ("Queen of the Steering Wheel" and the only woman ever to win a Grand Prix race) on his wall, and she inspired another composer, the bandleader Jaroslav Ježek, to write the hit tune "Bugatti Step."[8] Meanwhile, new laws abolished the requirement that women employed in the civil service be unmarried and acknowledged their right to the same salaries as men. However, as Melissa Feinberg has shown, while interwar Czechs generally believed that women had a right to intellectual and political equality, in practice women's rights remained subsidiary to the rights of family and nation and did not take precedence over essentialized concepts of womanhood; a woman was female first, a citizen second. Feinberg notes that most Czechs believed in separate versions of citizenship that envisioned men and women as biologically intended to fulfill different roles within the family. This larger group included women who in many respects supported and worked for women's rights. Thus, there existed both feminists in something like the present-day sense, who advocated complete equality in all spheres, and those who worked to better women's position as wives and mothers. This difference in philosophy became more noticeable once legal experts began the labor of revising inherited Austrian legal codes to align them with the egalitarian promises of the constitution and when the economic downturn of the 1930s prompted widespread opposition to double-income families.[9]

Furthermore, throughout the interwar period most Czech feminists continued to tie feminism to nationalism and to emphasize sexual purity, a stance that made explicit feminism unappealing to the younger generation, which was less nationalistic and less concerned with monogamy. Emphasis on purity and temperance clashed with Jazz Age interest in Freud, sexual pleasure, and social drinking.[10] This generational distinction would become very noticeable in mainstream Czech visual culture, where images—largely photographs—of the older generation tended to show these women as dignified and respectable, very much comparable to their male counterparts, while younger women were represented in more diverse, though usually affectionate, ways and in a wider range of media. In any case, evidence is strong that widespread Czechoslovak and especially Czech acceptance of women's access to higher education and the vote meant that this New Woman did not provoke the same degree of anxiety in her compatriots as was the case in many other contexts.

This New Woman, of course, was no more monolithic in her conception than she was anywhere else. She could encompass elements generally regarded as positive, elements admired by some and feared by others, and elements of dubious desirability. Some of these were international and others more local. The notorious French novel *La Garçonne,* for example, appeared in Czech translation (*Garsonka*) in 1923.[11] Reactions varied, but it was clearly not the hot potato it had been in France.[12] The leftist *Studentská revue* (Student Review) noted the novel's critique of French capitalist society.[13] Meanwhile, the editor of the nationalist weekly *Fronta* (Front), which favored the older generation of feminists, regarded *Garsonka* as "through and through" pornography and was at best skeptical of the postwar New Woman and her seeming frivolity.[14]

The perceived frivolity of the 1920s New Woman had little to do with feminism per se; indeed, showgirls also partook of aspects of New Womanhood and were often seen as part of her identity. Showgirls fascinated the Czechs, who bemoaned the relative tameness of their homegrown revues, and, judging by the coverage in popular magazines, Czech women as well as men took a keen interest in the latest revues. Still, the showgirl was not really a model for most middle-class young women; while they might enjoy watching Josephine Baker, the Dolly Sisters, or Joe Jenčík's Girls, and might be fascinated by the image of actress Anny Ondráková in saucy cabaret attire holding a saxophone in the popular film *Saxophon-Susi* (fig. 12.1), it was widely believed that Prague showgirls earned so little that they had to supplement their income. As Jaromír Novák (a pseudonym of the young writer Jan Klepetář) claimed, "The majority of [revue] 'girls' also prostitute themselves."[15] The showgirl, then, might fascinate, but she represented a very distinct species of New Woman. She was photographed only in her role as performer, separated from other possible aspects of her life whether those might be domestic or prostitutional.

Ondráková, who by 1928 had already appeared in more than thirty Czech and German films, was particularly known for her comic roles, in which she often played some version of the New Woman. *Gentleman*'s write-up for the German-made *Saxophon-Susi,* in which she played the starring role, emphasized that this was the first international film in which the director, technical director, and stars were all Czech. Although the two stills published in the magazine both played up the character of Susi as a scantily clad performer holding a remarkably phallic saxophone, *Gentleman*'s text focused on the national significance of the production and ignored the film's plot. Certainly, while Ondráková's roles varied considerably over the

Fig. 12.1. Publicity still of Anny Ondráková in *Saxofon-Susi* (Saxophone Susie), directed by Karel Lamač, Fortuna-Film, published in *Gentleman* 5, no. 1 (March 1928).

years, her youth and energy made her a natural for roles involving modern-day girls. A memorable scene in her second Czech talkie, *Kantor Ideál* (The Ideal Schoolmaster, 1932), contrasts a lone student in prim clothing and long braids with the rest of the class, a gang of lively, naughty, short-haired girls led by the ebullient Ondráková. Film audiences were clearly expected to take the side of the modern majority and to regard the earnest classmate as tedious, backward, and even, as Zdeněk Rossmann's now-famous poster of endangered braids suggested, uncivilized or uncultivated (fig. 12.2). *How should a cultivated woman dress,* indeed?

Eva (founded December 1928), hardly a radical feminist periodical,

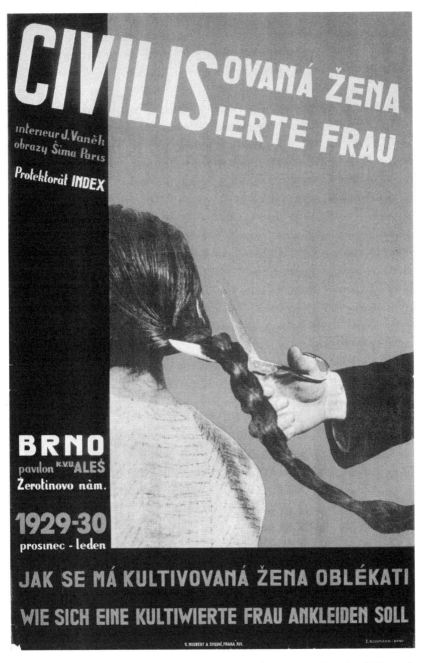

Fig. 12.2. Zdeněk Rossmann, *Civilisovaná žena/Civilisierte Frau* (Civilized Woman), 1929–30, color offset, 91 x 60 cm. (Collection of Museum of Decorative Arts in Prague.)

consistently presented strong images of short-haired, active young women and doubtless counted among its readers many young women who aspired to some degree of New Womanhood. The New Woman as promoted by *Eva*'s staff and advertisers was up-to-date in that she was stylish and physically active and probably held a job, but she also found small children adorable and never drank to excess. Somewhat like the publications of the German Ullstein house, *Eva* presented the modern woman as a rational, thrifty, well-dressed working woman but also one who loved the latest fashions. *Eva*'s mix of photography (often of American women, French fashions, or exotic peoples but also of Czech women writers and performers) and lively, often colorful illustration created a look that was both modern and sophisticated.

In fact, although to today's eye *Eva* appears to focus on very traditional themes, with its ongoing coverage of such typical women's magazine topics as children, textile crafts, domestic arts, Hollywood stars, and especially fashion, the magazine gave strong support to basic feminist goals. Overall, *Eva* was much more feminist and socially conscious than the earlier, apparently less successful *Moderní dívka* (Modern Girl, founded in October 1924), which had stressed preparing young women for love and marriage. Like *Eva, Moderní dívka* relied heavily on illustration, especially for fashion imagery, but often made use of photography to show off new hats and hairstyles. Often, however, it is impossible to tell whether images in *Moderní dívka* are heavily retouched photographs or paintings, a visual choice that fit perfectly with the magazine's curious mixture of the slightly old-fashioned and the cautiously up-to-date. Still, *Moderní dívka* rapidly "modernized" its outlook, adding film stills and putting Ada Brandstetterová—director of the mid-1920s production and distribution company Svetofilm (World Film)—on its May 1926 cover (fig. 12.3). Brandstetterová's photo, which superficially resembled the magazine's usual cover images of anonymous fashionable young women, was apparently intended to relate to stills from Svetofilm's new costume drama release, *Josef Kajetán Tyl,* shown in the same issue. Attentive readers would have been reminded not only that Czechoslovakia had its own fledgling film industry but that women were able to take significant positions behind as well as in front of the camera.

Meanwhile, although *Eva*'s own heavy coverage of fashion earned it a critique from *Fronta*'s editor, who suggested that the Melantrich publishing house was using it to promote snobbery and teach Czechoslovak women how to mix cocktails, only explicitly feminist magazines—which were relatively numerous but less apt to picture the young New Woman—

Ročník II. Číslo 5.-6.

MODERNÍ DÍVKA

Dvojčíslo Pí. Ady Brandstetterová, ředitelka Svetofilmu, Praha Cena 4 Kč

Fig. 12.3. Mrs. Ady Brandstetterová, director of Svetofilm, Prague, on the cover of *Moderní dívka* 2, nos. 5–6 (May 1926).

were likely to focus more intently on women's work, education, and political lives than on combinations of fashion, domesticity, and pleasure.[16]

Visions of the Czech New Woman were not, of course, limited to women's magazines. As we have seen, the anglophile men's magazine *Gentleman* (founded ca. 1923) also periodically contemplated the young urban woman. *Gentleman*, which focused on what might be considered male dandyism, grew more and more similar to the *New Yorker* in its layout and subject matter, and, although it never actively sought a female audience, its editors appear to have carefully calculated how to court a readership of both gay and straight men. Young women, thus, were an ongoing, though by no means dominant, topic of discussion and were studied in a lively but polite manner in *Gentleman*, especially via ads for social dance venues and in sketches by such artists as A. V. Hrska. While *Gentleman* included numerous sketches of fashionable young women, the magazine did not normally print photographs of them. *Gentleman*'s use of photography was relatively limited and emphasized famous men (actors, artists, boxers, and musicians), works of art, interior design, steeplechase and skiing, and stills from Hollywood films. Its writers, however, liked to discuss the varieties of young Czech female. In 1927, Jan Wenig suggested that, although the "Prague flapper" might seem to be "Made in France, England, USA," inside she was neither a flapper, a *gosse* (urchin), nor a *žába* (literally "frog," idiomatically "chick"). Rather, he suggested, Central Europeans decanted their own special quality.[17] By 1929, *Gentleman* felt obliged to ponder two separate varieties of Czechoslovak New Woman. The first, the international "girl," was a slender, modishly dressed person, described as "meaning, to some primitive people," a showgirl but being in fact a synthesis of the prewar *panenka* (doll) and the *děvče s mikádem* (girl with bobbed hair) that followed the *panenka*. The second variety, the specifically Czech *trampka*, was a female member of the popular "Tramp" movement of the 1920s and early 1930s, in which young Czechs lived in tents and on houseboats pretending to be cowboys and hoboes. The *trampka* was a new type who was known for her tan, wool socks, and fondness for woods, water, and hiking. The author thought the *trampka*'s short hair was the only thing she had in common with the "girl," who preferred urban amusements.[18] *Gentleman* did not bother to illustrate the *trampka*—she was not part of the magazine's cultured, anglophile world—and instead used stills of Anny Ondráková in the arms of a top-hatted man and at the wheel of an expensive car (from the film *Anny, pozor—policajt* or "Look Out, Anny—Police"). Sketches of slim modern "girls" abounded, however.

The *trampka*, despite her wool socks, was nonetheless part of the modern Czech ideal, common to other industrialized countries, of the slim, tan, athletic, short-haired woman. She was often illustrated, both favorably (especially in *Eva*, which made her a cover girl in 1929) and satirically (with her similarly satirized male companions), in the popular press, but she was not professionally photographed.

By the 1920s, young Czech women, *trampky* or not, pursued numerous physical leisure-time activities, many of which *were* photographed. Like the Germans, Czechs have taken a great interest in sport and physical activity since at least the nineteenth century. The Czech Sokol (Falcon) movement, founded in 1862, combined gymnastics and rhythmic movement with nationalism, and the women's branch of Sokol had become extremely popular by the 1920s.[19] Modern dance was also becoming popular among physically active women, and *Eva* often printed photos of modern dancers and articles by the Laban-trained dancer Milča Mayerová. Indeed, some of the most famous Czech modernist photos are those Mayerová commissioned of her comic dance *Abeceda* (Alphabet, 1926), in which the slender, muscular dancer embodies the forms of the letters of the alphabet (fig. 12.4). In this collaboration among Mayerová, the poet Vítězslav Nezval, and the theorist and typographer Karel Teige, the ambitious young performer sought to promote her work in a lasting, thoroughly avant-garde manner. As Matthew S. Witkovsky has pointed out, however, modernist "expressive dance" (*Ausdruckstanz* or *výrazový tanec*) had controversial "overtones of emancipation, ambition, and sexual allure" for modern women. Modern dance in Czechoslovakia was high art for a small number of practitioners such as Mayerová but physical fitness for most of their students.[20]

The *Abeceda* photos, with their carefully posed imagery of the lithe and fit young dancer, are to some extent comparable to František Drtikol's studio nudes of the same period, which also featured slender short-haired women in poses inspired by modern dance. Both Mayerová and Drtikol emphasized the abstract possibilities of the athletic female body in relation to graphically strong geometric shapes. Mayerová's photo book, however, presented a dancer with a specific, accessible, identity—one who had commissioned her own photos in a personal self-promotional effort—while Drtikol's nudes remained anonymous models.

Cycling, ball games, and tennis were also enjoyed by young middle-class women, as were swimming, hiking, and camping. Even women's fencing was celebrated, as in a dynamic studio shot featured in *Eva* (fig. 12.5). *Eva* devoted its eleventh issue to women's sports and exercise. The

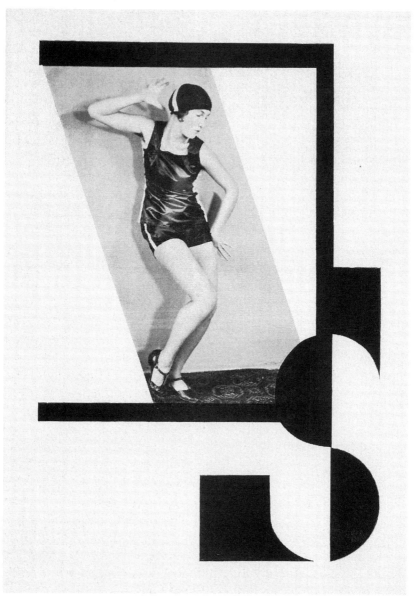

Fig. 12.4. Milča Mayerová as the letter S in the book *Abeceda* (Alphabet), design by Karel Teige, photographs by Karel Paspa (Prague: J. Otto, 1926). (Collection of Museum of Decorative Arts in Prague.)

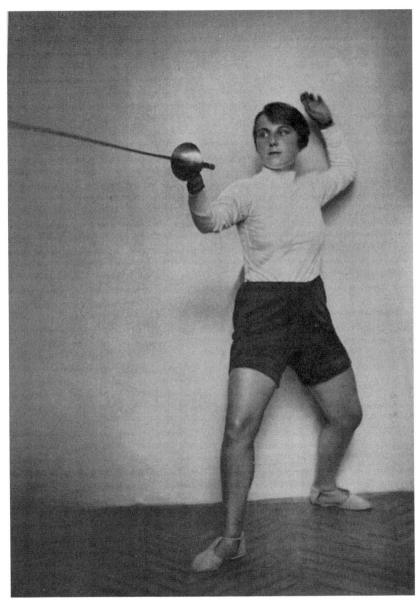

Fig. 12.5. Mrs. Lída Stocková, student of Professor H. Slípka, at her fencing lesson, photo from *Eva* 1, no. 20 (October 1, 1929).

magazine chose its photos internationally, to be sure, indicating that some sports covered were not yet widespread in Czechoslovakia.[21] But even the Catholic women's press showed interest in women's sports.[22] Still, sport and physical culture were not always seen as having much in common. Sport was regarded as focused on success and fame, whereas physical culture was seen as offering strength, health, self-knowledge, and spiritual benefits.[23] *Moderní dívka* initially preferred gentle movement to highly vigorous sports and recommended Sokol exercise as the best option, but within a few months it was claiming that movement and physical exercise were the best protection against so-called women's illnesses.[24] Exercise and physical fitness, however, still attracted suspicion. The writer Fringilla, for example, deplored the young woman who "plays tennis for two hours in the morning and swims for two hours in the afternoon in order to keep slim and healthy" while "her children drown in filth." Fringilla, who also wrote for the feminist magazine *Ženský obzor* (Women's Horizon), appeared to fear that modern Czech women would end up like the bisexually promiscuous, drug-taking German dancer Anita Berber, who was well known to Prague readers and theatergoers.[25] Some of *Fronta's* readers, indeed, were so moved by Fringilla's essay that they wrote in to decry, as one put it, "today's literature, visual and dramatic art, films, [and] dance halls" as hazardous to women in their demoralizing desire for sexual sensation."[26]

Czech women were quite visible in urban public spaces. While early-twentieth-century Prague cafés have sometimes been described as male venues, and indeed they certainly hosted male-only and predominantly male groups of artists and writers, women also frequented them by the 1920s. The women who went to cafés were not limited to the prostitutes who frequented some of these establishments. Although the status of the café women in paintings by fin-de-siècle Czech artists is unclear, journalism and cartoons of the 1920s, particularly in *Gentleman* and the humor magazine *Trn* (Thorn), but also paintings and sculpture, show that ordinary young women often frequented cafés.[27] Although women in cafés rarely appeared in Czech photographs, these visuals show us that they were considered a modern, interesting phenomenon. As women increasingly worked alongside men, they also amused themselves in many of the same places.

This visibility of women, particularly young women, in diverse public venues is obvious in the pages of the venerable general-interest photo-magazine *Světozor* (Worldview). As a participant in the new rage for pho-

tojournalism, *Světozor* sought to bring the world to its readers whether that meant photos of German carnival maskers, Russian ballet dancers, California redwoods, or leopard cubs. Nonetheless, the image of Czech New Woman appeared all over the magazine. Whether on the cover in Dr. Desiderius's sketch of a New Woman standing insouciantly reading a newspaper while presumably waiting for a tram to take her to work or in ads where she tells incredulous older and head-scarved women that her beautiful laundry smells so good because she buys Hellada's Šotka soap, the New Woman is everywhere. *Světozor*'s advertisers, while conservative in their emphasis on beauty, elegance, and maternity over themes of education and employment, nonetheless regularly used colorful imagery of swimming, tennis playing, and women as confident drivers of automobiles. Modern women also, suggested a series of Frigidaire ads, valued efficient home appliances and wanted practical gifts like refrigerators (fig. 12.6).

Thus, the Czech New Woman simultaneously represented modernity, internationalism, mass culture, and to some extent sexual freedom. As the journalist Milena Jesenská felt obliged to point out, those who complained that modern women lacked any trace of femininity were the same people who griped that the modern era was bad, modern dance was ugly, and modern art was laughable. Rather, the hardworking modern woman was doing just fine and did not necessarily forfeit her femininity, but by working and involving herself fully in modern life she became a deeper person.[28] Women had not, of course, achieved full equality. Issues related to women's rights and roles remained significant throughout the First Republic as the government struggled to reform its inherited body of law to conform to its new constitution. While female suffrage seemed a natural part of throwing off Austrian domination and achieving democracy, some legislators saw altered gender roles within the family as a threat to the Czech nation.[29] The right of women to work (unlike that of men) continued to be seen as tied to their financial and marital situations. And, while women's right to civil service employment had been affirmed in 1918, in practice the government did not support equality for its female employees. The ultimate failure of the civil service to uphold women's right to work shows that the government, despite Masaryk's personal feminism, was no more able to see women as ungendered citizens than was the private sector.[30] The situation worsened during the Depression, when married women in government employ became public scapegoats.[31] When push came to shove during the economic slump, the average citizen's allegiance to ideals of democracy

Fig. 12.6. "For a Christmas gift: The best refrigerator. Every modern woman longs to have a Frigidaire at home," advertisement for Frigidaire refrigerators in *Světozor* 29 (1928–29).

and equality gave way to deeply held beliefs about gender roles; a married woman with an office or factory job could only be taking bread out of the mouths of unemployed men.[32]

Overall, however, the First Republic was a positive time for Czechoslovak women, with one of the best women's rights records in Europe.[33]

Gains in equality were recognized even though both sexes noted the need for further progress.[34] Not just President Masaryk but his successor, Edvard Beneš, had feminist spouses and advocated feminist goals. Indeed, although feminism declined in the 1930s due to economic and external pressures, it is not strange that the First Republic has been regarded as the "halcyon" of Czechoslovak feminism both for its hopes and opportunities and for its achievements.[35]

Visual imagery of women, then, changed somewhat in the 1930s as a consequence of the economic downturn and increasing social conservatism. Popular journalism, magazine illustration, and advertising in the 1920s had emphasized going out and having a good time, although in both decades women's magazines tried to balance the goals of pleasure and responsibility. In both decades, images of older women represented either solid, often feminist respectability or rural backwardness, while images of young women stressed attractiveness, modernity, and usually competence.

How, then, did these Czech depictions of women, and especially of the New Woman, differ from those found in other countries? While Czech artists produced some cartoons about gender ambiguity and the sexes trading gender roles, these seem to have been relatively scarce. The preponderance of First Republic imagery showing Czech women as modern, well dressed, competent, and often sexy suggests that Czechs not only valued modernity strongly but expressed it in part through the image of the intelligent, attractive, competent, working New Woman, a woman who was educated, voted, and enjoyed sex.

What, then, of the relative shortage of Czech photos of the New Woman in popular periodicals? The specifically Czech New Woman appeared in the press primarily in the form of sketches, cartoons, and paintings, but the overall visual discourse was one in which Czech readers of popular illustrated magazines and Czech moviegoers were presented with countless images of modern women who usually appeared Czech even if they were really French fashion models or American college students. The explanation appears to lie at least in part with Czech internationalism. Though proud of homegrown stars such as Anny Ondráková and Eliška Junková, not to mention of domestic products such as Czech-made women's hats, Czechs were eager to see what the rest of the world had to offer. Czech photography of this period was strongly oriented toward architecture and consumer goods, documenting unsafe conditions and social problems, and abstract and surrealist imagery. It was much less focused on fashion and daily life, areas that illustrators handled with considerable success. None-

theless, the visual imagery in popular magazines, films, and other sources shows us some of the ways in which women were imagined, pictured, and ultimately expected to perform a version of modernity that was both international and specifically Czechoslovak.

Notes

All translations are my own unless otherwise stated. My thanks to Todd Huebner and Kevin Johnson for their advice on Czech law and film, respectively. Research for this article was funded by Fulbright-Hays Doctoral Dissertation Research Abroad and Foreign Language and Area Studies. I would like to thank the staff at the Prague Fulbright office and the Památník národního písemnictví, Uměleckoprůmyslové museum v Praze, and Národní knihovna for their help, as well as numerous friends and colleagues in Prague, Pittsburgh, and elsewhere. Many thanks are also due to Elizabeth Otto for being such an encouraging and good-humored editor.

1. One of the only scholars to mention the Czech New Woman describes her as "educated, independent and confident, . . . as much the product of American and European feminist traditions as of new scientific hygiene and eugenic discourses . . . this New Woman was also determinedly and manifestly Czech." Teresa J. Balkenende, "Protecting the National Inheritance: Nation-State Formation and the Transformation of Birth Culture in the Czech Lands, 1880–1938," PhD diss., University of Washington, 2004, 135.

2. Discussion of Czech/Czechoslovak identity and its formation and expression is extensive. See Ladislav Holy, *The Little Czech and the Great Czech Nation* (Cambridge: Cambridge University Press, 1996); Derek Sayer, *The Coasts of Bohemia: A Czech History* (Princeton: Princeton University Press, 1998); and Jeremy King, *Budweisers into Czechs and Germans: A Local History of Bohemian Politics, 1848–1948* (Princeton: Princeton University Press, 2002).

3. Manuela Andrea Thurner, "Girlkulture and Kulturfeminismus: Gender and Americanism in Weimar Germany, 1918–1933" (PhD diss., Yale University, 1999), 20. Interest in American culture was significant among Czechs but should be considered alongside related highly visible enthusiasms for French, British, and Soviet culture.

4. See Marie Neudorfl, "Masaryk and the Women's Question," in *Thinker and Politician*, vol. 1 of *T. G. Masaryk (1850–1937)*, ed. Stanley B. Winters (New York: St. Martin's, 1990), 258–82.

5. Katherine David, "Czech Feminists and Nationalism in the Late Hapsburg Monarchy: 'The First in Austria,'" *Journal of Women's History* 3, no. 2 (fall 1991): 30–31; Richard J. Evans, *The Feminists: Women's Emancipation Movements in Europe, America, and Australasia, 1840–1920* (London and New York: Croom Helm and Barnes and Noble Books, 1977), 19.

6. *Europe Centrale*, August 24, 1929, quoted in XXX [pseud.], "Le Féminisme en Tchécoslovaquie," *Revue Française de Prague* 8, no. 46 (December 1929): 410.

7. Czechoslovakia, *Sbírka zákonů a nařízení státu československého* 1919, p. 77. Thanks to Todd Huebner for bringing this to my attention.

8. Erik Anthony Entwistle, "Martinů in Paris: A Synthesis of Music Styles and Symbols," PhD diss., University of California, Santa Barbara, 2002, 9; Michael Beckerman, "The Dark Blue Exile of Jaroslav Ježek," *Music and Politics* 2, no. 2 (summer 2008), http://www.music.ucsb.edu/projects/musicandpolitics/archive/2008-2/becker man.html.

9. See Melissa Feinberg, *Elusive Equality: Gender, Citizenship, and the Limits of Democracy in Czechoslovakia, 1918–1950* (Pittsburgh: University of Pittsburgh Press, 2006).

10. See, for example, Věra Babáková, "Masaryk a mravní základ ženského hnutí," in *Masaryk a ženy* (Prague: Ženská národní rada, 1930), 260–63; and the contributions to this volume.

11. "Expositions and Collections: La Garçonne," *Koninklijke Bibliotheek—National Library of the Netherlands,* http://www.kb.nl/bc/koopman/1919-1925/c17-en.html, accessed May 25, 2006; Mary Louise Roberts, *Civilization without Sexes: Reconstructing Gender in Postwar France, 1917–1927* (Chicago: University of Chicago Press, 1994), 46–48. The novel's problematic ending, in which the heroine finds happiness in conventional marriage and childbearing, did not dilute its shock value for the French. The somewhat later New Woman novels of Vicki Baum were also translated into Czech.

12. See, for example, Míla Grimmichová, "Boj muže proti nové ženě," *Nová svoboda* 3, no. 49 (December 9, 1926): 629.

13. Aja, "Poznámky: Plkrytectví," *Studentská Revue* 3, no. 2 (February 1924): 48.

14. Karel Horký, "Stíny kultury," *Fronta* 6, no. 26 (December 7, 1933): 411.

15. Jaromír Novák [Jan Klepetář], *Prostitutky, jak žijí, milují a umírají: Dokumenty lidské bolesti a bídy* (Prague: Rudolf Rehman, 1927), 24.

16. Karel Horký, "'Eva,'" *Fronta* 4, no. 4 (December 25, 1930): 56–58. Horký's criticism was partly political, as he referred to Melantrich's National Socialist political allegiance in the pages of his "independent" but sympathetic to the Agrarian Party *Fronta.* Both parties were relatively centrist and were part of the ruling coalition.

17. Jan Wenig, "Prague Flapper," *Gentleman* 4, no. 9 (1927): 199.

18. En., "Girl a trampka: Dva nové typy dívek," *Gentleman* 5, no. 6 (October 1928): 128–29. See also Svatava Pírková-Jakobson, "Prague and the Purple Sage," *Harvard Slavic Studies* 3 (1957): 272.

19. See Claire Nolte, *The Sokol in the Czech Lands to 1914: Training for the Nation* (New York: Palgrave Macmillan, 2002). Czech interest in women's sports appears to have been far greater than French. Regarding sport and its lack of acceptance among Frenchwomen of the 1920s, see James F. McMillan, *Housewife or Harlot: The Place of Women in French Society, 1870–1940* (New York: St. Martin's Press, 1981), 170–71.

20. *Abeceda* has been translated and reprinted as Vítězslav Nezval, *Alphabet,* edited by Jindřich Toman and Matthew S. Witkovsky (Ann Arbor: Michigan Slavic Publica-

tions, 2001). See also Matthew S. Witkovsky, "Staging Language: Milča Mayerová and the Czech Book *Alphabet*," *Art Bulletin* 86, no. 1 (March 2004): 114–35.

21. Eva Uchalová et al., *Czech Fashion, 1918–1939: Elegance of the Czechoslovak First Republic*, ed. Andreas Beckmann, trans. Štěpan Suchochleb (Prague: Olympia Publishing House in cooperation with the Museum of Decorative Arts [UPM], 1996), 14. See also Běla Fridländrová, "10 let Českého plaveckého klubu," *Eva* 1, no. 7 (February 15, 1929): 10; and H. Slípka, "Žena a šermířský sport," *Eva* 1, no. 9 (March 15, 1929): 12. Women's fencing was celebrated in the feminist press as early as 1905 in *Vesna* 1. Golf, lacrosse, and cross-country were also featured in *Eva*. See H. S., "Golf mezi našimí ženami?" *Eva* 2, no. 13 (May 1, 1930): 18. The article "Hry koženým míčem," *Eva* 2, no. 12 (April 15, 1930): 24, encouraged women to take up volleyball and basketball. In the mid-1930s, see also the Plzeň periodical *Žena a její reforma*.

22. See, for example "Výhledy: Ženské sporty u nás," *Orlice* (Olomouc) 2, no. 1 (January 1923): 3–4. This periodical appears to have been a sports supplement to the Catholic women teachers' *Ženský časopis Eva*.

23. Lili, "Sport nebo tělesná kultura?" *Ženské noviny: List žen sociálně demokratických* 14, no. 25 (June 23, 1932): 1.

24. "Moderní dívka a sport," *Moderní dívka* 1, no. 1 (October 1924): 24; "Tělesná kultura—půvab ženství," *Moderní dívka* 1, no. 7 (April 1925): 14.

25. Fringilla [pseud.], "My a naše báby," *Fronta* 1, no. 12 (August 11, 1927): 186–87.

26. J. M., "Z Fronty čtenářů: A ještě něco k 'My a naše báby,'" *Fronta* 1, no. 15 (September 8, 1927): 236.

27. Jaroslav Jan Paulík, "Den v kavárně," *Gentleman* 4, no. 6 (July 1927): 124–125.

28. Milena Jesenská, "Dáma a moderní žena," in *Cesta k jednoduchosti* (F. Topíč: Prague, 1926), 23–24. Jesenská herself—best known to English speakers for her friendship with Kafka—was decidedly a New Woman, and her uninhibited personal life often went beyond the bounds of the socially acceptable. In her writing, however, she maintained a fairly mainstream persona. She is among the First Republic journalists whose work is still read today.

29. Feinberg, *Elusive Equality*, 35–36.

30. See ibid., 99–128. The government's desire to decrease pensions, especially for married women, was frequently discussed, particularly in leftist women's periodicals.

31. Feinberg, *Elusive Equality*, 125. Attempts to limit women's employment were well under way by the end of 1930.

32. Melissa Feinberg, "The Rights Problem: Gender and Democracy in the Czech Lands, 1918–1945," PhD diss., Chicago: University of Chicago, 2000, 210–11.

33. Karen Johnson Freeze, "Medical Education for Women in Austria: A Study in the Politics of the Czech Women's Movement in the 1890s," in *Women, State, and Party in Eastern Europe*, ed. Sharon L. Wolchik and Alfred G. Meyer (Durham: Duke University Press, 1985), 51.

34. See, for instance, Bohuslav Koutník, "Nerovná rovnost," *Čin* 5, no. 10 (Septem-

ber 14, 1933): 231–32, which hailed feminist successes but focused on the remaining "shadows" of lower pay and women's lack of political clout.

35. Bruce M. Garver, "Women in the First Czechoslovak Republic," in *Women, State, and Party in Eastern Europe,* ed. Sharon L. Wolchik and Alfred G. Meyer (Durham: Duke University Press, 1985), 66, 74–80.

13

Girls and Goods: *Amerikanismus* and the *Tiller-Effect*

LISA JAYE YOUNG

The mass ornament is the aesthetic reflex of the rationality to which the prevailing economic system aspires.[1]

Reality can only be grasped by examining its extremes.[2]

In 1923 the Hungarian artist and Bauhaus teacher László Moholy-Nagy referenced the subject of the Tiller Girls in one of his many socially charged and sexually loaded collages entitled *Rutschbahn* (Slide) (fig. 13.1). The Tiller Girls were a much-emulated British precision dance troupe (think Rockettes) of regimented fantasy "flappers," perceived for decades to be American in origin and manner. *Slide* combines pen and ink with airbrushed elements and halftone and photogravure reproductions. It depicts a repeated and receding image of the dancers situated on a curved chute, a tall structure much like a toboggan run or industrial conveyor belt. The dancers create a chain-link of connected bodies moving along an assembly line. The legs and shoes form an ornamental pattern. Leg after leg and mary-jane after mary-jane are lined up in rhythmic formation as far up the conveyor belt as the eye can see. The dancers recede beyond the upper-left corner of the composition's frame, implying their infinite plenitude, not one girl but many acting as one.

Moholy-Nagy's inclusion of photographs together with photogravure and hand-drawn figures of the dancers renders this as an even more abstract composition than the serialized formation already creates. The heads and bodies, photographic in the front of the lineup, devolve toward the upper left into tiny circles and lines with black dots for shoes. With the exception of the figure closest to the picture plane, each dancer's head appears to sit right in the center of a pair of legs, rendering the image sexually suggestive,

Fig. 13.1. László
Moholy-Nagy, *Slide,*
1923. (© 2009 Artists
Rights Society [ARS],
New York, and VG
Bild-Kunst, Bonn.)

although its cartoonlike depiction would indicate otherwise. The slide itself
is suspended on a pen and ink structure of crisscrossed pylons, like the iron
piers of an electrical power plant. It delivers for Moholy-Nagy a fantastical,
industrial-strength supply of playful, abstract, female automatons choreo-
graphed into obedience, girls as goods, plentiful as far as the eye can see.

In this essay I will consider the Tiller Girls and their image of plenitude
as a wider visual "effect," what I am calling the *Tiller-Effect.* This may be
defined as a rhythmic seriality born of the Tiller Girl genre that is emulated
by advertising and other vernacular imagery. As a visual effect, promul-
gated by the notion of a "Girl" type and popularized by the sexual and
consumer desire for plenitude during a time of great paucity, its impact
is both insidious and complex. The Tiller Girls' serial format was not only
reproduced in magazines and onstage, but it was also used as a template for
advertising toothbrushes, hosiery, cigarettes, and white collars, captivating
Weimar culture and playfully masking its response to the crisis of capitalist
modernity.

I will focus on the *Tiller-Effect* as a preoccupation with girls and goods

in proliferation (and girls *as* goods), its perceived American qualities, its photographic ubiquity, and its role as spectacular diversion from the crisis of Americanization.[3] Created significantly in the year 1923, Moholy-Nagy's *Slide* parallels American economic policy in relation to Germany. It also points to the interwar writings of Siegfried Kracauer, his discussion of the Tiller phenomenon, and his typology of the "Girl" as associated with American modes of rationalization, conformity, and consumption and his understanding of a new reality grasped by examining the Tiller Girls as a cultural extreme.[4] I will argue that the Girl typology and the serialized *Tiller-Effect* are inextricable from one another and that they underline an understanding of New Womanhood and its transnational definition as complicated by an emerging photographic history of capital.

Moholy-Nagy's relatively simple composition of linked bodies and lined-up piers points to the complexity and ubiquity of the Tiller Girls as a cultural symbol during the 1920s. A version of the Girls headlined every venue and could be found in every magazine or newspaper. In fact, their cultural pervasiveness points to their complexity, not only as dancers but as diversions. The Girls, onstage and off, circulate as "American" goods, suggesting the technological rationalization that the United States began aggressively importing to Germany in 1923 after the implementation of the Dawes Plan.[5]

The years 1922–24 saw hyperbolic economic changes resulting in an increased valuation of durable goods. By September 1923 the German government's order for "passive resistance" by workers in the industrial Ruhr region to the occupying French and Belgian troops had finally ceased and production could resume. The *Rentenmark* (security mark) was implemented, and the Dawes Plan brought with it an influx of American loans and technology, the result of which placed a small group of American businessmen squarely onto the boards of a number of German companies. Thus by 1923 relative stabilization began to take shape in Germany, with periods of instability continuing to occur throughout the decade. As the reliability of paper currency oscillated, greater visual attention was placed on durable goods or consumer products, a desire for concreteness, which manifested itself stylistically in painting and photography as *Neue Sachlichkeit*, or New Objectivity, the valuing literally and visibly of "the thing itself."[6] Whether girls or goods, the desire to have *enough* and the fear of want were abounding in the national psychology. The mid-1920s heralded the era of the product, the new American-style primacy of consumer goods in daily life, politics, and theory.

In relation to this American intervention, the Tiller Girls' wrongly perceived Americanness grew to be something of a myth. As such they were an example of *Amerikanismus,* an anxiety about and obsession with all things American that manifested itself visually.[7] And, although recent authors such as Gunter Berghaus, James Donald, and Peter Jelavich mentioned that the Tiller Girls were not actually American but were originally girl workers plucked directly by John Tiller of Manchester from his own factory, most writers until the 1990s referred to the Tiller phenomenon only in passing and regularly mischaracterized them as not only American dancers but an American invention.[8] Jelavich suggested that they were thought to be American because of one dancer who was hired from America. Donald addresses the myth as an assumption that "if it's modern it must be American." He mentions that the Tiller Girls were hired once to perform on Broadway and were "renamed the Empire Girls for the occasion," which "added to the confusion about the Girls' nationality."[9] I would add that the confusion lies with many dancers rather than one, a perception of Girls in proliferation, an unlimited supply or boundlessness *perceived* to be an American quality. It is a perception that was blown to mythical proportions as an increased American economic and cultural impact gained hold by the mid-1920s.

This mythological "American" status propelled the Tillers further into the Weimar spotlight. On this wave of popularity, the dancers and their knockoffs traveled the country (and the world) as unwitting, indirect ambassadors for American-style rationalization. They were so present in entertainment and magazine culture by the mid-1920s that they became the subject of numerous cartoons. In the March 1925 issue of *Berliner Illustrirte Zeitung,* the cartoonist Paul Zimmel depicted a drunken man seeing not "double" but "multiple" (fig. 13.2). While watching a single female dancer perform, the drunk thinks he is seeing instead a Tiller-style troupe of tens of Girls. The caption reads, "A Drunk (at the stepping of a single dancer): 'Aha, the famous dancing girl troupe!'"

The Tillers' links to the American, Fordist model are evident in a second cartoon by the same illustrator from 1926, which depicted the dancers rolling off of an assembly line and into a wagon that will circulate them like goods to destinations around the world. It reads, "Ford takes over the production of Tiller Girls, Daily Production: 15,000." The association between the Tiller-style performances as a Fordist-Taylorist principle of serialization had become fairly commonplace, one understood by even the most average reader. Their form demonstrated everything that America stood

Fig. 13.2. Paul Zimmel, "A Drunk (at the stepping of a single dancer): 'Aha, the famous dancing girl troupe!'" March 1925, *Berliner Illustrirte Zeitung*, 347. (Courtesy of Staatsbibliothek, Berlin.)

for in the eyes of the world. Their playful movements, impeccably synchronized, were so well known that Renate Berger referred to the Tiller-style dance display as "the hallmark of the 1920s."[10] For a handful of critics, Kracauer leading the way, the Tiller Girls and their knockoffs hinted at detrimental cultural change in Germany, a movement toward a less spiritual and a more matter-of-fact civilization. Yet for the average viewer/reader at the time they were wonderfully distracting, endlessly fascinating, American in nature, and therefore progressive. The Girls and their movements signaled great abundance through organized rationalization and even the possibility of glamour and class elevation for the average office worker.

A handful of examples help to illustrate the popularity of the Tiller troupes in photo-based media. Single photographs as personal interest images, promotional shots, and entire articles about the Girl troupes and their on- and offstage lifestyles can be found in almost every issue of every illustrated popular magazine during the 1920s. The Jackson Girls performed at the Scala Theater in Berlin and were widely photographed for the magazines. Sasha Stone, whose work bridged *Neue Sachlichkeit* and photojournalistic subject matter, depicted the dancers with particular effectiveness.[11] Photographing for *Uhu* magazine in 1929, Stone docu-

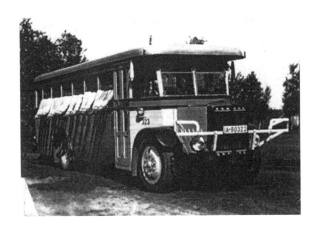

Fig. 13.3. Sasha Stone, "The Girls on the Bus," *Uhu* (1929), n.p. (Courtesy of Staats- bibliothek, Berlin.)

mented the Girls on vacation, dining, relaxing, and playfully dangling their legs from the tour bus window (fig. 13.3). In Stone's photograph, legs, sepa- rated from bodies and decorated with matching mary-janes, are extended by their long, late afternoon shadows striping the side of the bus. Reflect- ing precision, except when imprecise, Stone's Girls flounce their on- and offstage popularity and point to the Girl as an undifferentiated part, a 24–7, living, breathing consumable.

A thoroughly playful piece in *Uhu* contains a poem by "My" next to a Sasha Stone photograph of the Jackson Girls. The poem "The Girls March" revels in the rhythm and identicalness of the dancers and yet marvels at the fact that the Girls retain some (if mock) individuality. The poem not only highlights the popularity of the Girl-units but also points to a trope that will become thoroughly utilized by the advertising industry. That trope is the promotion of consumer desire as mock individuality within the comfort of homogeneity, a strategy that would come to sell everything from hosiery to tract housing.

Every Leg
Wants to remain an individual leg—
And not only troupes,
And not only dolls,
That is no way to talk,
Because each—
Whether it be
Lissi or Hede—
Quinnie?—Winnie—Jessi—Bessy,

Hilde I und Hilde II.
Blond? Brunette? Intelligent? Dumb?
Each is an individual . . .[12]

Erich Salomon identified this strategy of seriality in an article published in 1927 just eight months after Kracauer's "The Mass Ornament." Salomon identified what he called the Tiller-Girl Principle, stating that the serial Girls had been wholeheartedly transposed into a visual application in the illustrated press (fig. 13.4). He called attention to the newly recognized field of advertising, and he observed the ubiquity of "The Tiller-Girl-Prinzip" as a new format for success in advertising.[13] Misunderstanding and thus perpetuating the Tiller phenomenon as American, he declared that its "spatial rhythm" came to Germany from America: "The Americans first recognized

**DAS
TILLER-
GIRL-
PRINZIP
IN DER
REKLAME**

VON
DR. ERICH SALOMON

this effect of spatial rhythm in the Tiller-Girl dance presentation Type that they created, which would soon spread over the whole world."[14]

The first image in Salomon's article depicts the Tillers themselves, each in a bathing suit and wearing the New Woman's *Bubikopf* or "bobbed hair-style." Their zig-zagged bodies are linked in simultaneous movement like the rods and pistons of a locomotive. Its caption reads: "Tiller Girls as they came to us from America." The next image in Salomon's article doubles this one of the Tillers in order to advertise for *Berliner Illustrirte Zeitung* ("Heute neu!" or "Today New!"). It builds up to the idea that their formation was not only employed for their own ads but to advertise products of all sorts: magazines, cigarettes, soap, white collars, coffee, "famous American toothbrushes," and women's bathing suits designed for the champion swimmer. Salomon's own caption above the swimming suit ad reads, "Here

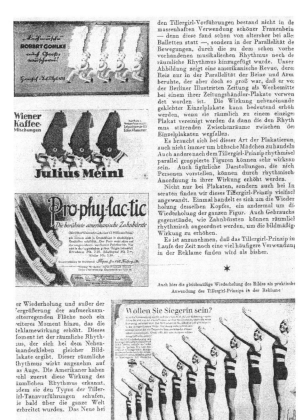

Fig. 13.4. Erich Salomon, "Das Tiller-Girl-Prinzip in der Reklame" (The Tiller-Girl Principle in Advertising), *Die Reklame* 3 (February 1928): 112, 114. (Courtesy of Staatsbibliothek, Berlin.)

too [we see] the regular or simultaneous repetition of an image as practical application of the Tiller Girl-Principle in advertising." Thus the *Tiller-Effect* not only radiated Americanness, but it was able to stimulate sales through association with a spirit of Americanness. It emanated associations with the New Woman, with cleanliness, professionalism, athleticism, good taste, and happiness (the ad for a man's detachable white shirt collar reproduced in this article for Dornbusch reads, "It is a Dornbusch, a Collar that Makes You Happy"). Using the Tiller Girl format as template, the ads employ seriality as a strategy to sell products, to induce desire. The repetitious formation itself seemed to be able to generate these "American" qualities for the consumer.[15]

The most cursory glance at the advertisements of the time reveals Salomon's essay in action: the use of rhythm and repetition in the composition, the fetishization of the quantity and infinity of the objects depicted, a deemphasis of the human, the beautification and abstraction of industrial production, the use of the diagonal in order to imply the availability of infinite goods, an emphasis on the power and mesmerizing effect of the new consumer object, and a celebration of commodity culture and consumer desire, pattern, and surface. We see the *Tiller-Effect* applied to sell almost everything.

One ad for Mystical Compacts ("the powder foundation for the handbag") asks, "Don't we look splendid together" as it depicts six young, doll-like female faces floating together as one. Each face touches the next, blending cheek to cheek as if to present a singular, six-headed body along with the idea that to be a type like every other "Girl type" is desirable all over the world, "Berlin, New York, Paris"(fig. 13.5).[16] *Tiller-Effect* images may be chilling to the modern viewer in that they insinuate a cultural desire for a conformity that seems to know no limits.

The "Girl type" was not only used for sales but can be seen in photovignette pieces addressing the contemporary zeitgeist. In many, the Girl is either twinned or multiplied as in one poem-photograph vignette found in a 1926 issue of *Uhu*. Two look-alike Girls lovingly gaze on a decorative ball-like dancing prop. Profiles in unison, glistening dark bobbed hairstyles caress each face; the caption reads "Sisters . . . though born of different mothers . . ." The accompanying poem points to the idea of the "sister" as a new fashion. The sister is not to be confused with the German *Schwester*. That is, she is one part of two or more Girls who are not blood relatives but rather "mode sisters" or fashion sisters. Again, here, as with the term *Girl*, the English word *sister* is adopted to differentiate this fashion phenom-

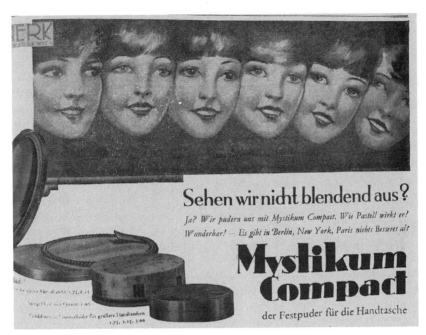

Fig. 13.5. "Don't We Look Splendid Together? Mystical Compact, the powder foundation for the handbag," advertisement for Mystical Compacts, *Berliner Illustrirte Zeitung*, March 1929, n.p. (Courtesy of Staatsbibliothek, Berlin.)

enon as non-German, distinct from the German-language term for familial sister, reinforcing it as an American proclivity.

The writings of Kracauer, perhaps more than any other Weimar critic, ably illuminate the various significances the Tiller Girls held as not only a hallmark of the times but as an *effect,* a contagious aesthetic preference for seriality, sameness, and rhythmic, visual organization. Kracauer was the first, and for a long time the only, writer to recognize the Tiller Girls as a cultural form with great implications for understanding the phenomenon of (American) capitalistic structures. Kracauer's "The Mass Ornament" and his various ruminations written between 1921 and 1933 illuminate the Tiller Girls and their copies as one of his most significant visual tropes of *Amerikanismus.*

While Kracauer only infrequently references the United States by name, America and German perceptions and misperceptions of America are his indexical touchstone. In his writings, America is often the elephant in the room. The United States supplies the girls (magazine icons and cinematic beauties for emulation) and the goods (and the technology and

loans to produce them). Although Kracauer is himself at times an ambivalent filter, America—and images or ideas perceived to have an American origin—largely provide the fuel for his critique.

On June 9 and 10, 1927, *Die Frankfurter Zeitung* ran two installments of "The Mass Ornament" in which the author pinpointed the Tiller Girls as being at the heart of a cultural change in taste. He argued that this represented a proclivity for organized, emptied-of-meaning distraction through sheer numbers, a grand display of accumulation and excess produced by American culture and its factories of distraction. Four years later, in his "Girls und Krise" of 1931, Kracauer would hone this idea in relation to another such Girl group.

> [T]he Girls were artificially manufactured in the USA and exported to Europe by the dozens. Not only were they American products; at the same time they demonstrated the greatness of American production. . . . When they formed an undulating snake, they radiantly illustrated the virtues of the conveyor belt; when they tapped their feet in fast tempo, it sounded like business, business. . . . [O]ne envisioned an uninterrupted chain of autos gliding from the factories into the world, and believed that the blessings of prosperity had no end.[17]

Kracauer's ruminations on the Girls in proliferation were not limited to the Tiller image but extended to a typology he provides by returning to the topic of the Girl in numerous articles. The Girl as a type surfaces in his essays "Photography," "Travel and Dance," "The Mass Ornament," and "The Revolt of the Middle Classes" (the essay that would provide the basis for his later 1931 book *The Salaried Masses*).[18] She even voices her grievances and professes her innermost secrets to Kracauer directly in almost every chapter of *The Salaried Masses*. She is the implied type most susceptible to the whims and fancies of fashion in his essay "Georg Simmel," where he writes, "The fact that women yield to fashion more than men can be explained by the innate lack of objectivity of the female sex and by its dependence on the social environment."[19] As a cousin to the Tiller Girls, she is the main subject of "The Little Shopgirls Go to the Movies," in which Kracauer patronizes female spectators as a social group, portraying them through a fictionalized (and therefore playfully misleading) device as the dupes of society. The little shopgirl spectators will "fall for" every film as it is presented to them according to Kracauer. They have no sovereign stance from which to view the world, let alone the world of moving images. They are only conceivable as part of a chain.

With "The Little Shopgirls Go to the Movies," Kracauer establishes "the Girl" as subject and audience member, the predominant spectatorial contingent of American cinema. She is the "Little Miss Typist" in Berlin, modeling herself after the screen scenarios. His girls "gain unexpected insights into the misery of mankind and the goodness from above." They "grope for their date's hand and think of the coming Sunday." They can't "resist the appeal of the marches and the uniforms" depicted in a war film. They have "silly little hearts," they dream up millionaires based on their girlish magazines, and they "wipe their eyes and quickly powder their noses before the lights go up."[20] In short, Kracauer's "Girl" is to be understood as a multiple and a type: unaware, love struck, gullible, concerned with her appearance, highly emotional, and impressionable.

Kracauer's Girl-type is youngish and chic, a flapper who is an infinitely reproducible product of filmic and photographic culture. She is the "pink-collar worker," the female counterpart to the white-collar, male, salaried office worker. She is extremely significant as both a product of the "American distraction factories" and a German consumer, the target audience for most advertisements and articles in the press. In Kracauer's writings, and in the minds of most (male) critics of Americanization at the time, she is an automatonlike, American creation. She attends the movies, stars in them, performs onstage, devours the illustrated magazines, consumes en masse, and marks the transformation—some thought the decline—of German culture. I would submit that Kracauer's Girl typology, the Girl as worker and consumer, is inseparable from the image and phenomenon of the Tiller Girls and their radiating effect. Kracauer sees the Girl as a type and thus as an implied mass of Girls. This type is composed entirely of the magazine and movie images which "she" also consumes daily. Production and consumption converge in her just as the Tillers exude both ends of this process. The circularity of production and consumption is embedded in their spectacle, which includes, as Kracauer notes, the audience. The Girl, as (re)producer and consumer of product and image, is thus central to any understanding of the visual history and expansion of Western capitalism.

As such the Girl who is part and parcel of the *Neue Frau,* or New Woman, is made possible through photography, which Kracauer sees as a medium for inventorying, a collection or piling up of images signaling modernity and the sped-up pace of consumption. Photography facilitated the Girl as an image, the Tillers and their effect, by way of its ontological condition as a medium for reproduction and as the leading disseminator of *Amerikanismus.* As visual hieroglyphs or "material expressions of

a particular historical condition," Kracauer's photographic tropes, such as the Girl, were often called on as visual reflections of the newly cemented, mass-market economy and the spirit of *Kapitalismus* and indirectly the *Amerikanismus* that accompanied it.[21]

Kracauer's own emphasis implies that the invention of the Girl is part of a larger process that began in the United States and spread to Germany like a contagious virus. His essays in conjunction reveal a tendency to see the Weimar woman as a (diseased) carrier of *Amerikansmus,* a creature most susceptible to the delights and detriments of American-style capitalistic seduction. As one of the main subjects of "The Mass Ornament," the Tiller Girls were situated by Kracauer at the causal moment of a cultural and social chain reaction. The result of this process was a capitalistic emptying out of meaning, a cultural ambivalence driven by profit. It is necessary to quote Kracauer at some length in order to establish not only his definition of the mass ornament and its basis in the American economic model but also how it is forged together with the female body and proliferated through photography. He begins "The Mass Ornament" with the following statement.

> In the domain of body culture, which also covers the illustrated newspapers, tastes have been quietly changing. *The process began with the Tiller Girls. These products of American distraction factories are no longer individual girls, but indissoluble girl clusters whose movements are demonstrations of mathematics.* . . . The tiniest village, which they have not yet reached, learns about them through the weekly newsreels. . . . [T]he ornaments are composed of thousands of bodies, *sexless bodies in bathing suits.*[22]

The key to this quotation is his suggestion of an unnamed "process." What is the process Kracauer intuits? He says that it begins with the Tillers: bodies, American products, photographic illustrations, and worldwide expansion. The amalgamation that he suggests may be what has more recently been referred to as the "soft power" of empire.[23] Kracauer was certainly onto something to say the least. He understood the implicit power of photography, of reproducible imagery, as the key instigator for and promulgator of Western-style capitalism, the process seen but not named.

In defining the mass ornament, Kracauer differentiates it from the mass military demonstrations also gaining visibility, writing that "the mass movements of the girls, by contrast, take place in a vacuum; they are a linear system that no longer has any erotic meaning but at best points to the locus

of the erotic."[24] In these passages, Kracauer again points to something that he does not fully resolve: Why are the girls stripped of their sexuality and why are they not erotic? Do they point to the locus of eroticism without being erotic per se? In other words, are the Girls and their proliferation the point of entry for the visual abstraction of consumer capitalism and as such do they represent the initial fusion of consumerism and prepackaged desire? It is arguable that Kracauer was intuiting this softened, less threatening entrance of American transnational capitalism in one of its earliest phases. That American capital abroad was in step with the entrance of a new female type is no surprise. Woman as newly powerful, newly threatening as political voice and workplace presence, is neutralized, canned, and disseminated worldwide as poster girl for American economic values. In this sense, the Tiller Girl may be in part the *Neue Frau*, whose image was being experienced as a threat with frightening implications for replication and the power to alter both workforce and consumer force. In other words, she was a threat to the patriarchal structures of capital, and this threat needed to be kept as a child, kept in check. But cleaned up, choreographed, organized, and desexualized (or at least with a contained sexuality), she could become an asset for international consumerism, and her expansion as a type could have practical applications, softening the image of Western capitalism as she marched in step with the progressive modes of profit. Molded thus, the Girls and their rippling images could present a controllable, nonthreatening, singular logo for the international dissemination of rationalized production *and* consumption at once, a new paradigm. Moholy-Nagy's *Slide* seems to intuit this conflation as his typically dynamic, diagonal composition yields Girls as freshly produced goods, newly minted and ready to be consumed and to begin consuming.

Kracauer, Salomon, and "My" were not the only writers to observe that this entertainment format was reaching beyond the theaters and into the larger popular imagination. These writers were joined at the time by Paul Landau, Friedrich Heller, Richard Huelsenbeck, Joseph Roth, and Fritz Giese.[25] To most authors the Girls remain an entertainment force reflecting the gender politics of the New Woman, but more than that they are a visual instigator of the politics and effects of Americanization as both perception and reality. In expansion of these observations, the Tiller Girls can be read as part of a larger continuum of the *Amerkanismus* aesthetic: an *effect* of *Amerikanismus* with wider-reaching influence on photographic production and the definition of New Womanhood and its links to American patterns of consumption than previously understood.

Considering the Girls' impact and their constitution as photographic images raises some larger questions concerning the female body as the terrain of contestation for modernism. It also raises questions about the role of photography as the visual promulgator of Western, transnational commercial culture. In a sense, both the female figure as subject (rather than just object) and the body of photography that only more recently has gained visibility as an object had been transparent transmitters all along. The nude, or the prostitute, has served, for instance, as the battleground on which the characterization of modern painting was fought à la Manet in 1863 and then Picasso in 1907. The Girl as a photographic image served in this capacity during the 1920s and 1930s.

The floating and ever-present notion of the Girl in the German press, together with the Tiller Girls' hyperrationalized format and the persistent misperception of their Americanness, suggests an expanded understanding for the New Woman of this era. She is an image-based construct most often diminished as a Girl-type or Girl-unit. As a potential threat, much like burgeoning capitalism itself, she was quickly swept away by National Socialism in Germany and radically altered in the United States by the Second World War and the force of suburbanization.[26] The Tiller Girl as a manifestation of the New Woman was safer to Germany if she could be understood as American, a fascinating product to import rather than a problem for the nation. But even so, her photographic ubiquity and contradictory characteristics render the Girl much less singular than the *singular desire* to visualize (control) her as one with her "sisters." This, then, by tight association, renders the New Woman exceedingly complex, as resistant to a singular, unified identity as the term *woman* itself.

The Tiller Girl as a popularized version of the New Woman was single, traveling, short haired, sexually liberated (or at least perceived to be so onstage as part of her appeal), athletic, and savvy. But her rationalized participation in a lineup choreographed by men, her interchangeability, her vast popularity as a type, her condition of perpetual girlhood, her status as a worker, and her desexualized reality complicate the New Woman's perceived freedom. The details and contradictions of the images complicate the type and contradict the project of typology in general. If the devil is in the details (and the details are in the photographs), the Tiller image suggests the possibility of photography (and any notion of womanhood) as resistant to sweeping cultural pronunciation. As part of the spectacle of cultural excess, of girly repetition and its effect on advertising, the Tillers point to the consumption and control of the New Woman image as bound

to a history of transnational commerce. They suggest the capacity of photographic imagery both to clarify and to deflect the double crisis of burgeoning capitalism and its related expansion of the economic and political power of women. Kracauer suggested that "Reality can only be grasped by examining its extremes." The Tiller Girls and the international preoccupation with them and the fiction of woman as Girl-type is one such extreme pointing to a crisis of Americanization, the boundlessness of which we may be only now beginning to grasp.

Notes

1. Siegfried Kracauer, "The Mass Ornament," in Siegfried Kracauer, *The Mass Ornament: Weimar Essays,* ed., trans., and with an introduction by Thomas Y. Levin (Cambridge and London: Harvard University Press, 1995), 79. Elspeth H. Brown's reflections on my work have been inspired. The tireless support of Geoffrey Batchen has been invaluable, and I am grateful for Rose-Carol Washton Long and Joyce Rheuban for their help with an earlier version of this essay in my dissertation. The translations in this essay are my own.

2. Siegfried Kracauer, "Preface," in Sigfried Kracauer, *The Salaried Masses: Duty and Distraction in Weimar Germany,* trans. Quintin Hoare, introduction by Inka Mulder-Bach (London and New York: Verso, 1998), 25.

3. Sources on the topic of Americanization include Beeke Sell-Tower, *Envisioning America: Prints, Drawings, and Photographs by George Grosz and His Contemporaries, 1915–1933* (Cambridge, MA: The Busch-Reisinger Museum, Harvard University, 1990); Robert W. Rydell and Rob Kroes, *Buffalo Bill in Bologna: The Americanization of the World, 1869–1922* (Chicago and London: University of Chicago Press, 2005); and Mary Nolan, *Visions of Modernity: American Business and the Modernization of Germany* (New York and Oxford: Oxford University Press, 1994).

4. It should be noted that the German word for *girl, Mädchen,* was not used to define this version of the young woman as girl; rather, the Germans wholly adopted the American term *girl* as shorthand for her as a new type.

5. The name Dawes Plan refers to General Charles G. Dawes, an American banker from Chicago who was asked to serve as chairman of an international committee of experts, including Owen D. Young, then chairman of General Electric (and also a director for both German General Electric [AEG] and OSRAM [a lighting company founded in 1906]). The plan was to place Germany back in economic stead as part of the restructuring of Versailles Treaty terms for reparations.

6. For more on the *Neue Sachlichkeit* context and understanding of the term *the thing itself,* see Lisa Jaye Young, "All Consuming: The Tiller-Effect and the Aesthetics of Americanization in Weimar Photography, 1923–1933," PhD diss., Art History, Graduate Center, City University of New York, 2008.

7. Of the numerous sources on *Amerikanismus,* few deal directly with photography. One that remains central is Sell-Tower's *Envisioning America.* Other, more

general sources include Rydell and Kroes's *Buffalo Bill in Bologna;* Nolan's *Visions of Modernity;* and Bittner, Brüning, Fehl, Kegler, eds., *Zukunft aus Amerika: Fordismus in der Zwischenkriegzeit, Siedlung, Stadt, Raum* (Dessau and Aachen: Bauhaus Stiftung, 1995). One of the earliest studies on the issue and its German reception is Adolf Halfeld, *Amerika und der Amerikanismus: Kritische Betrachtungen eines Deutschen und Europäers* (Jena: E. Diedrichs, 1927).

8. Most authors, until recent years, fell under the spell of the Tiller Girls as American. A few recently published articles have stated otherwise. See Gunter Berghaus, "Girlkultur: Feminism, Americanism, and Popular Entertainment in Weimar Germany," *Journal of Design History,* 1, nos. 3–4 (1998): 198–219; and James Donald, "Kracauer and the Dancing Girls," *New Formations* 61 (summer 2007): 49–63. Donald's article helps to dispel this myth and then moves into a discussion of Josephine Baker in relation to Kracauer's comments. See also Peter Jelavich, *Berlin Cabaret: Studies in Cultural History* (Cambridge: Harvard University Press, 1996).

9. Jelavich, 175; Donald, 49.

10. Renate Berger, "Moments Can Change Your Life: Creative Crises in the Lives of Dancers in the 1920s," quoted in Marsha Meskimmon and Shearer West, eds., *Visions of the Neue Frau and the Visual Arts in Weimar Germany* (Aldershot, England, and Brookfield, VT: Scholar Press, 1995), 77.

11. An exhibition of Sasha Stone's photographs depicted his street scenes of Berlin. See "Sasha Stone: Berlin in Pictures," Berlinische Galerie, Berlin, October 28, 2006–March 11, 2007. For an important discussion of Stone, see also Frederic Schwartz, *Blind Spots: Critical Theory and the History of Art in Twentieth-Century Germany* (New Haven: Yale University Press, 2005).

12. "Ein Step von My: Die Girls marschieren," *Uhu* 4, no. 5 (January 1929): n.p.

13. *Die Reklame* (founded in Berlin in 1919) was just one of many new magazines that sprung to life in the 1920s dedicated solely to advertising design issues. *Gebrauchs-Graphik* was another dedicated to advertising and graphic design. It was published from 1924 to 1944 and again starting in 1950.

14. Erich Salomon, "Das Tiller-Girl-Prinzip in der Reklame," *Die Reklame* 3 (February 1928): 112, 114.

15. The burgeoning field of advertising itself was wholly understood to be triumphed by the United States. Ads in German industry magazines at the time offered special trips for German executives to travel to the United States to acquire the most modern methods. The average German illustrated magazine in the 1920s, such as *Berliner Illustrirte Zeitung* or *Uhu,* included articles on the subject of how to achieve a special blend of "American" happiness, often targeting the desire for youth and beauty and plentiful goods and possessions. In addition, the image of a glistening and endlessly supplying assembly line was directly associated with Ford and his American principles of efficiency, his autobiography having sold over two hundred thousand copies in Germany alone after it was published in 1923.

16. For a related discussion of "women as metaphors for rationalization and mass production," see Maud Lavin, *Cut with the Kitchen Knife: The Weimar Photomontages of Hannah Höch* (New Haven and London: Yale University Press, 1993), 140–42.

17. Siegfried Kracauer, "Girls und Krise" (*Frankfurter Zeitung*, May 27, 1931), quoted in Karsten Witte, "Introduction to Siegfried Kracauer's 'The Mass Ornament,'" *New German Critique*, no. 5 (spring 1975): 63–64. See also Patrice Petro, *Joyless Street: Women and Melodramatic Representation in Weimar Germany* (Princeton: Princeton University Press, 1989).

18. Each of these essays may be found in Kracauer, *The Mass Ornament*. See also Kracauer, *The Salaried Masses*.

19. Siegfried Kracauer, "Georg Simmel," in Siegfried Kracauer, *The Mass Ornament: Weimar Essays*, ed., trans., and with an introduction by Thomas Y. Levin (Cambridge and London: Harvard University Press, 1995), 248.

20. Kracauer, "The Little Shopgirls Go to the Movies," in Siegfried Kracauer, *The Mass Ornament: Weimar Essays,* ed., trans., and with an introduction by Thomas Y. Levin (Cambridge and London: Harvard University Press, 1995), 300, 303.

21. Thomas Y. Levin, "Introduction," in Siegfried Kracauer, *The Mass Ornament: Weimar Essays,* ed., trans., and with an introduction by Thomas Y. Levin (Cambridge and London: Harvard University Press, 1995), 20.

22. Kracauer, "The Mass Ornament," 77, emphasis added.

23. For more on "soft power," see Victoria de Grazia, *Irresistible Empire: America's Advance through 20th Century Europe* (Cambridge and London: Belknap Press of Harvard University Press, 2005).

24. Kracauer, "The Mass Ornament," 77.

25. Melissa Ragona, "A Genealogy of Spectacle: Fascism, Consumerism, and the Mimetic Body," PhD diss., State University of New York at Buffalo, 1997.

26. For a discussion of the transformation of the Weimar New Woman in the era of the Third Reich, see Irene Guenther, *Nazi Chic? Fashioning Women in the Third Reich* (Oxford and New York: Berg, 2005).

Girls and Crisis:
The New Woman in the 1930s and Beyond

14

Women, Fashion, and the Spanish Civil War: From the Fashion Parade to the Victory Parade

KATHLEEN M. VERNON

Among the propaganda films produced by the Francoist side during and following the Spanish Civil War, a short, eleven-minute documentary released in late 1939, *Ya viene el cortejo* (Here Comes the Cortege), directed by Carlos Arévalo and produced and narrated by actor and soon to be director Juan de Orduña, stands out for two very different reasons.[1] In the first instance it represents the codification of a visual rhetoric that would provide the central model for subsequent documentary and fictional evocations of the civil war as a sacred crusade to recover and preserve the nation's timeless essence. Rejecting narrative or discursive argument for the poetic accumulation of iconic images of a supposed Spanish essence— medieval heralds and castles, panoramic natural landscapes, tolling bells, national flags and crests—the film culminates in the ritual ceremony of the Victory Parade (Desfile de la Victoria) in a final sequence that anachronistically fuses imagery of the Reconquest against the Moorish invaders with the fascist pageantry of mass public spectacle: tightly choreographed displays of marching troops, modern weaponry, and political symbols (fig. 14.1). Not surprisingly, the protagonists, individual and representative or massed and collective, of this mythmaking projection of Spanish military might and heroic deeds are exclusively male.

Yet a second matter overlooked in analyses of *Ya viene el cortejo* by Spanish film historians is a jarringly feminine interlude that occurs some four minutes into the film and lasts just over two minutes.[2] Set between shots of still more medieval heralds and ringing bells, the sequence is unmotivated and unintegrated thematically and formally into the rest of the film. The opening image shows an ornately carved wooden chest. Hands extend into the onscreen space to extract embroidered fabrics and lace mantillas. Further shots offer women posing in traditional, regional

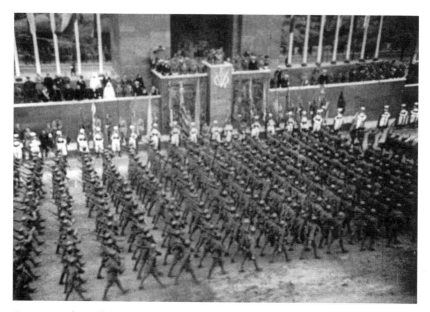

Fig. 14.1. Film still from Carlos Arévalo's *Ya viene el cortejo* (Here Comes the Cortege), 1939. (Filmoteca Española.)

garb juxtaposed against accessories, veils, and clothing animated as they rise, almost unaided, from chests and drawers. The camera work stresses a ritual quality of dresses and dressing while showing the models depicted posing for the camera and before a series of mirrors. Their practiced gestures and knowing smiles acknowledge the presence of other, admiring eyes on them (figs. 14.2 and 14.3). All of these details prompt the question: what are these women doing in the film? The evocation of regional traditions and their sublimation into a unified national essence constituted a central topos of Francoist ideology. And the recovery and preservation of Spanish local cultures, including dress, was a charge taken up following the war by the Falangist women's organization, the Sección Femenina. Still this scene is simply excessive, too long and loving to be easily explained or entirely subsumed into the film. When I consulted a colleague, a Spanish film historian, he pointed to the role of Orduña, a closeted gay man and "women's director" who would come to be known as the Spanish George Cukor. Coincidentally, Cukor's 1939 film classic *The Women*, based on the play by Clare Booth Luce, contains a similarly disruptive fashion show sequence, shot in color in a black-and-white film. However suggestive these hints of a shared cinematic cosmopolitan sensibility, I would argue

Fig. 14.2. Film still from Carlos Arévalo's *Ya viene el cortejo* (Here Comes the Cortege), 1939. (Filmoteca Española.)

Fig. 14.3. Film still from Carlos Arévalo's *Ya viene el cortejo* (Here Comes the Cortege), 1939. (Filmoteca Española.)

that this case has a particularly emblematic value for our understanding of the struggle to incorporate women visually and symbolically into the image of the Francoist "New State."[3]

Victoria de Grazia and Eugenia Paulicelli have found evidence of a similar fusion of female fashion and fascist military spectacle in a staged public event that took place in Mussolini's Italy during the same year.[4] Working from contemporary newspaper reports and an Instituto Luce documentary, respectively, de Grazia and Paulicelli analyze the May 1939 "Great Parade of Female Forces" in Rome that assembled seventy thousand women from diverse social strata, geographic origins, and professions. In the news report reproduced by de Grazia, the identification of the various groups, from rural housewives, women workers, and leisure-time troops to women professionals and artists, is threaded through with detailed references to articles of clothing and accessories: "scarves and shawls; wide skirts . . . jackets and corsets and belts . . . flowered aprons and lace . . . clogs, sandals and kerchiefs . . . azure jumpsuits."[5] The fragmented enumeration concludes with what de Grazia reads as an attempt to tie the heterogeneous collection of women and fashion paraphernalia to the fascist imperial project in its final evocation of the militarized advance of "the Red Cross nurses of the great wars for Africa and Spain, on tanks and ambulances, severe in dress and demeanor, faces to the Duce, then straight ahead, their blue veils lifting off their white headbands."[6] Both de Grazia and Paulicelli are struck by a series of unresolved tensions and contradictions revealed in the scene, whether between the "local time-honored traditions" celebrated by the rural women in folkloric costume and the "modern woman wearing the military uniform,"[7] or more broadly in the clash between the subsuming and sublimation of individual identity into the massed collective and "the pursuit of exclusiveness and individuality typical of the workings of the modern fashion industry."[8]

Thus the film *Ya viene el cortejo* and the Italian Great Parade reflect the difficulty of mobilizing women, or their representations, into a unitary force. The women depicted resist reduction to a singular essence, their heterogeneity on display in the juxtaposition of rural and urban, individual and collective, modernity and timeless traditions. Furthermore, such binary distinctions themselves are blurred as the women incorporate seemingly contradictory traits and identities. In the Arévalo-Orduña film, despite their largely traditional dress, the women models strike a discordant note of modernity in their self-awareness and practiced exhibitionism. In the Italian parade, the variegated figures fail to coalesce into a single body

of marchers, even at the level of visual spectacle, as Paulicelli points out in observing the contrast between the geometric precision of the women in uniform and the "more disorganized and scattered space" figured by the women in regional dress.[9] That disparity is further emphasized in the description of the nurses' warriorlike pose, their purposeful theatricality set against the more random distribution of the "civilian" groups. De Grazia finds in this persistent heterogeneity a measure of women's troublesome resistance to efforts at visual symbolization that ultimately mark them as "too intractable, too volatile a subject for fascist rule."[10]

The issue of women's visibility as social and political actors, their move to the center of the frame, is closely tied in the Spanish and Italian documentaries and media accounts analyzed here to the role of fashion in framing and mediating debates over images and identities. Over the last decade scholars have taught us to see fashion not as frivolous or inconsequential, the antithesis of war seriousness and scarcity, but rather as a source of crucial insights into ways of living, attitudes, and behaviors. As Dominque Veillon argues in her study of fashion in occupied France, the subject provides "an observation point from which to view the political, economic and cultural environment of an historical period."[11] This would seem to be particularly true at moments of political crisis and social and economic stress and when more direct means of public expression are closed to certain population groups. Fashion, as language or system, while susceptible to appropriation as an instrument for imposing conformity and social control, is also available as a vehicle for subverting such goals, whether part of a conscious program or as a result of fashion's very volatility, its function as a bearer of multiple messages. Wendy Parkins alludes to the inherent ambivalence of fashion's social meanings in noting the "multi-accentuality of dress in political contexts . . . [and] the semiotic capacity of practices of dress to either contest or reinforce existing arrangements of power and 'flesh out' the meanings of citizenship."[12]

Clothing styles and the choices they offered women became early recruits in the culture wars that preceded the military conflicts of 1930s and 1940s Europe. Fashion functioned on the one hand as the harbinger of modernity, the rapid turnover of styles and silhouettes linked to the influence of the media, radio, cinema, and advertising, all part of a burgeoning consumer culture that was key in circulating a cosmopolitan, transnational vision of the New Woman. Clothing could and did assume the role of standard-bearer of varying ideological messages. The cult of the healthy body, developed in Fascist Germany and Italy and adopted by the Sec-

ción Femenina in Spain, despite the disapproval of the Catholic Church, promoted streamlined styles of clothing that facilitated movement and quickness.[13] But such styles and attendant lifestyles also generated a backlash that spread across the continent.[14] Helen Graham notes the conservative reaction among women themselves against the threat of social change embodied in the figure of the New Woman, more pronounced in Germany but evident in Spain as well, where middle-class women launched boycotts of "communist" and "Jewish" shopkeepers despite the fact that there were no Jews in Spain.[15] In this context clothing also never lost its link to traditional femininity, its role in situating women as pleasing ornament and domestic decoration. This view of fashion effectively reinforced conventional divisions of labor. Clothing reigned at the core of women's work and women's play, a safe space of distraction and self-cultivation. Little wonder that these tensions played themselves out in the ritual stagings of public patriotic and national spectacle, in the confrontation between traditional costume and modern everyday dress. Official rhetoric to the contrary, the need for special efforts and programs to preserve national and regional indigenous dress offers inadvertent confirmation of the dominance of international styles. Indeed, as Jesusa Vega documents in a study of Spanish regional dress, the battle may already have been lost in Spain by the early twentieth century. For when the organizers of a centenary celebration of Madrid's resistance against the 1808 Napoleonic invasion invited representatives from provincial capitals to attend in regional dress, the response from the Badajoz town hall in Extremadura was categorical: "[A]mong this population there is not one person who wears the typical dress of the old Extremeñans, nor is there a model that can serve to reconstruct said dress with accuracy."[16]

Fashioning the New Woman in Spain

Historians and cultural analysts continue to disagree about whether Francoism effectively endorsed or promoted a vision of the New Woman. As I have noted, the polarized political and social atmosphere under the Spanish Republic in the period before the 1936 outbreak of the Civil War was partially driven by anxieties over the changes associated with modernity, including perceived threats to the family and women's position therein. Yet despite their calls for women to return to the home and traditional roles, the Right moved in the early 1930s to mobilize women, initially through church organizations and later via the founding of the Falangist Sección Femenina

in 1934.[17] This activity would continue, albeit "in an instinctive way and from the perception of their traditional roles," during the war itself.[18] Mary Vincent reports on much more radical activities taken up by women who participated in Falangist street provocations, "girlfriends of Falangists who aided and abetted male violence, concealing guns in the lining of their coats or in the high boots that were coming into fashion," despite official opposition from the party.[19] Nevertheless, she concludes in another article, "There was no 'new fascist woman' to complement the 'new fascist man,'" promoted by founders of the Falange.[20] It is apparent, though, that for all its talk of exalting traditional Spanish womanhood, Francoist propaganda paid a certain contradictory lip service to the appeal of modernity. In her study of the treatment of gender roles in the regime-supported press in the immediate postwar period, Spanish novelist and essayist Carmen Martín Gaite finds vivid examples of the kind of up-is-down, black-is-white logic that opposed "fad-crazy girls, who adore outrageous things and are wild for anything foreign" with the "old yet always new" image of the modest and industrious Spanish woman.[21] She emphasizes the pervasiveness of such campaigns, which were "devoted relentlessly to the task of turning the old fashioned yet ever-new woman into something fresh—that is, selling her as modern."[22]

Following the lead of Martín Gaite, but with a focus trained on the role of fashion coverage in attempts to redefine female identity, I turn to two magazines published by the Falange during the Civil War itself: *Vértice*, the organization's premier graphic and ideological showcase, which began publishing in April 1937; and the women's magazine *Y* (named for Queen Isabela using the archaic spelling of her name), sponsored by the Sección Femenina, whose first issue appeared in February 1938. As monthly publications, both *Vértice* and *Y* combined coverage of the arts—theater and cinema columns and reviews, short stories, and features on photography and the graphic and plastic arts—and leisure activities, including fashion, with tendentious reporting on the progress of the war, admiring articles on Hitler (e.g., coverage of the Führer's birthday celebration in issue 10 of *Vértice* and a spread on Hitler's home in the Bavarian Alps in issue 3 of *Y*), and increasing contributions to the cult of personality building around General Francisco Franco and his immediate family.[23] Directed at a relatively elite and financially well off readership in the Nationalist zone, far from the fighting or the aerial bombardments that targeted Republican-held territory, the two magazines promoted a sense of continuity and normalcy in the conduct of everyday life. Yet their content inevitably betrayed

a certain discomfort or anxiety over the appropriate occupation for women during wartime, on the one hand evincing a determination to maintain women in the frivolous and feminine activities proper to their sex and class standing and on the other seeking to enlist them in suitable acts of devotion to the cause of "nuestra España" (our—that is, Nationalist—Spain). The fashion coverage could not help but reflect this split personality. Emblematic in this regard is an article from the inaugural issue of *Vértice* entitled "Moda: Crónica de abril" (Fashion: Chronicle of April), signed Márgara. In the opening lines the author evokes the Paris spring in which she heard of plans for the new magazine to be published in "liberated" Nationalist territory. Prompted to act, she writes:

> I offered my name, my talent, my knowledge, my enthusiasm, my vision of life, a product of my many years removed from the hermeticism of Spanish life and my formation in a universal setting. I asked, imperiously, with all the force of my conviction, that I be allowed to speak to the women of Spain about something as trivial and as transcendent as Fashion.
>
> I thought about my country at war, I thought about the rarified state of all nations, turbulent and terrified, [which find themselves] at every dawn of every day at the edge of the precipice of war or social destruction. And I thought that Fashion is the symbol of the strong woman, the biblical woman, reserve of Humanity, [who is] pleasant and cordial even in the most adverse moments.[24]

The passage is noteworthy for many reasons. The writer's Parisian and "universal" existence and vision give her the authority to bring the gospel of fashion to an isolated, if not backward, Spain. And fashion is championed in all its contradictory glory as the attribute of strong, "biblical" women who are called to the heroic (but ultimately restricted) task of radiating feminine affability in a war-torn nation. Nevertheless, it is also clear that fashion and fashion journalism gave women like Márgara access to the public sphere—and to worlds beyond "hermetic" Spain—not just as models and specularized objects of the public gaze but as working professionals.

A case in point is the founding editor of *Y*, Marichu de la Mora, director of the Department of Press and Propaganda for the Sección Femenina and sister of the Republican activist, Communist Party member, and director of international press relations for the Republic, Constancia de la Mora.[25] A collaborator in the subsequent Sección Femenina publications *Medina* and *Ventanal* and founder in 1942 of *La moda en España*, de la Mora shaped *Y* into perhaps the most visible representation of the values and concerns

of Nationalist womanhood in all its contradictions. The magazine benefited from its geographic location, headquartered in San Sebastian on the northern Spanish coast not far from the French border and at a significant remove from the military capitals of Francoist Spain in Burgos and Salamanca, which allowed it to acquire "an apparently cosmopolitan touch."[26] *Y* alternated sections charting the history of the Falangist Women's Section and its female leaders with pieces on more domestic topics such as menu planning and child care. In contrast to the more aspirational fashion features in the decidedly upmarket *Vértice,* the April 1938 issue of *Y* offered its readers practical advice in an article titled "Do You Know How to Take Advantage of a No Longer Stylish Dress?"[27] While *Y* sought to guide its audience with respect to contemporary fashions, it also presented a series of pieces on fashion history. Thus in the same April 1938 issue an article explored the timely topic of "Military Influences on Female Fashion."[28] In June 1938 another considered the question of when brides first began to wear white wedding dresses.[29] And in May 1938 the magazine offered an account of government policies in the design and enforcement of sumptuary laws ("El gobierno y las modas"), noting that "the freedom, today, to dress in green or blue, to cut one's hair short or let it grow long, is a very recent conquest."[30] This historical approach offered an implied critique of the essentializing and tautological vision of timeless womanhood espoused by Francoism. Not that such a view was absent from the pages of *Y;* an article by novelist Carmen Icaza in the March 1938 issue proclaimed the proper role of women in the work of reconstructing the nation. Up against alleged "Marxist" demands for women "mechanics, electricians or chemists," the Spain of Icaza "want[ed] its women to serve the nation exclusively as women."[31] In contrast, by recognizing fashion's imbrication in the contingencies of social, economic and political life, the articles cited offered women readers a suggestive if still restricted sense of their stake in history. At the same time, the scholarly approach elevated fashion as a subject worthy of serious attention.

Perhaps in response to these varied and potentially disruptive implications of fashion, there also existed a clear push to instrumentalize its role. As in the film *Ya viene el cortejo,* the magazines give evidence of an insistent if not always intentional linkage of war and fashion. Both *Vértice* and *Y* enlisted fashion, along with so many other charged rhetorical practices during the Civil War, as a way to distinguish and separate Rebel identities, especially though not exclusively female, from those of the Loyalist side. In some cases this meant explicitly claiming a sense of style or fash-

ion as an index of taste and breeding and thus the proprietary attribute of the Nationalist side. An article in the April 1938 issue of *Vértice* evokes the linkage between fashion and the (female) leisure class: "[W]ar has distanced us from the activities that previously filled our days. . . . Hospitals, the making of clothing for our troops, [and] social work now occupy the hours that before we devoted to films, bridge games, and aperitifs. But the change of seasons necessarily brings our thoughts back to clothes for spring."[32] These distinctions became more explicit still in the immediate postwar context as a famous advertisement published in 1939 proclaimed "Reds didn't wear hats" (Los rojos no usaban sombreros).[33] A page-one poem commemorating the Victory Parade in the inaugural issue of another Sección Femenina publication, *Ventanal*, presents a cautionary evocation of "Life as it is or as it might have been: I look out my window and see the troops of the Generalísimo instead of the horror of Stalin's legions." The piece continues, contrasting the fashionably dressed women of Franco's Spain with the "muchachas desaliñadas," slovenly female supporters of the Republic.[34] A particularly tendentious article by playwright Enrique Jardiel Poncela published in the December 1939 issue of *Y* offers a depiction of Christmas in the Republican "Red zone" among a group of what he portrays as grotesquely unfeminine women soldiers, the portrayal highlighted by the photo of a grizzled militiawoman dressed in overalls.[35]

The wartime continuity between fashion and political identity is strikingly on display in the work of artist and illustrator Carlos Sáenz de Tejada. A graduate of the Escuela de Bellas Artes de San Francisco who lived in Paris from 1926 to 1935 and created cover art for *Vogue* and *Harper's Bazaar*, among other well-known fashion magazines, Sáenz de Tejada was also responsible for some of the most recognizable propaganda imagery on the Nationalist side.[36] That double identity is reflected in the first issue of *Vértice*, where his work appears on the cover and in a full-page color fashion illustration inside. The cover depicts a phalanx of billowing flags, the Spanish monarchist standard, the Falangist flag and a red flag bearing a swastika, held aloft by uniformed men with muscular forearms. The fashion image shows three stylish blond women in coordinated black-and-white outfits, black suit and frilly blouse, white blouse and long skirt combination, and long dress with ruffled accents. Two women, both standing, wear hats and gloves, while the third sits before a low table bearing a silver tea service. Despite their very different themes, these two images share certain common tendencies in their depiction of the human body in the elongated and mannered figures that stretch to fill the available space.

Sáenz de Tejada's signature traits become clearer still in two subsequent color illustrations, published in issue 4 of *Vértice*, that portray two groups of male marchers: Requetés, members of the Carlist militia, and Falangists, each in their distinctive uniforms, khaki with red berets in the case of the first and blue shirts with embroidered red Falangist emblems in the case of the second. In reference to these images, Mary Vincent has written of the artist's "highly stylized depictions of masculine strength and beauty . . . reminiscent of El Greco."[37] While the women models are not subject to the same reverent gaze, they are clearly idealized creatures, seemingly abstracted from everyday Spanish reality in their languorous, aristocratic bearing. A two-page color illustration, signed "atc," in the first issue of *Y* brings a further synthesis of fashion and military imagery. There the blond models wearing the feminine version of the Falangist blue shirt project the slender and youthful insouciance and bodily self-awareness of the international New Woman as they pose first in a group of three against a minimalist white background and then among male and female comrades in a more realistic three-dimensional space that suggests a social gathering or even a bar or other public, commercial setting. Vincent has emphasized the role of fashion as key to the essential "theatricality of the Falangist style or spirit," most evident in the provocative proletarian connotation deriving from the adoption of the blue shirt.[38] In contrast to the traditional military uniform with its epaulettes or gold braid, "the [blue] shirts were a new style for a new generation. Blue represented the *mono* or overall, which was the characteristic weekday dress of the Spanish working man."[39] Because of this message, she reports, wearing a blue shirt in public could be, and was, construed as an act of political defiance, and more so for women, who during the Republic could be fined for appearing in blue shirts.[40]

Clearly, the woman in uniform posed an especially suggestive and polyvalent image: on one the hand a means of potentially resolving tensions between the calls to selfless devotion to the cause and traditional notions of individualistic femininity; and, on the other, a means of managing anxieties over the potential blurring of male-female roles as women assumed more visible positions, as we have seen, even on the Right. It is also likely that uniforms for women were the source of still more unease, as Vincent argues, as "self consciously modern" projections of control of the will.[41]

Fashion at the Front Lines, Left and Right

As much as clothing styles surely worked, as we have seen, to divide women

along ideological and socioeconomic lines, the same fashion imagery could also serve to complicate the divisions between us and them. In his memoir, *El niño republicano* (A Republican Boy), writer and journalist Eduardo Haro Tecglen evokes the cosmopolitan and womanly world of his childhood just before the war, recalling, "the lengthy afternoons of the only child . . . amid the machine-gun rhythms of the Singer sewing machine, looking and relooking at Mama's magazines, with [images of illustrators] Penagos, Baldrich, and Sáenz de Tejada [Sainz in the original]."[42] A photograph shot by Robert Capa in Barcelona in 1936 conveys a similar message. With the caption, "A Loyalist Militia Woman," it depicts a woman dressed in the characteristic *mono* worn by both male and female members of the volunteer Republican militia that carried out much of the fighting against the Francoists during the first months of the Civil War (fig. 14.4). At rest on a city bench, her rifle at her side, she peruses the pages of a fashion magazine. Clearly fashion had its place on the Republican side in both the mental and material lives of women and men. And just as the image of the female Falangist *flecha* ("arrow," the name given to blue-shirted women volunteers) or her more committed sister, the Falange-sponsored volunteer nurse in her white uniform, blue cape, and embroidered red crest, was subject to glamorization, the Republican *miliciana* herself could become a fashion icon. A photograph by Capa's companion in Spain, the German-born photographer Gerda Taro, offers an obviously posed portrait of a woman dressed in militia garb. Shot at ground level against a nearly empty horizon, the image shows the woman tensed and seemingly poised for action in a kneeling crouch as her arm extends to the right, gun in hand. Just below and on the extreme left, the viewer notes her feet, clad in somewhat incongruous high-heeled shoes.

It is instructive to consider both the image and the aura attached to the *miliciana* in relation to a cover illustration in the February 1939 issue of the Sección Femenina magazine *Y* (fig. 14.5). Two women in profile occupy the foreground, a blond nurse and a dark-haired *flecha*. They have adopted a warrior's pose, their arms raised in the Fascist salute. In the right rear of the frame, a third woman, wearing an apron with a large Falangist emblem, carries what appears to be a basket of laundry, her face in shadows. Not coincidentally, the first two women evoke the marching nurses in the Italian Great Parade of Female Forces, although here their "severe" dress and demeanor are tempered by the representations of cover-girl beauty. For her part, the *miliciana*, source of the "best-known female iconography of the war," also overshadowed her less visible and alluring sisters (fig. 14.6).[43]

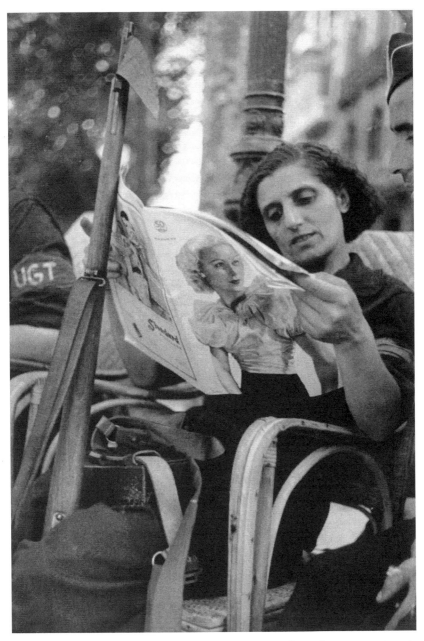

Fig. 14.4. Robert Capa, "Barcelona, August 1936. A Loyalist Militia Woman," 1936. (International Center of Photography and Magnum Photos.)

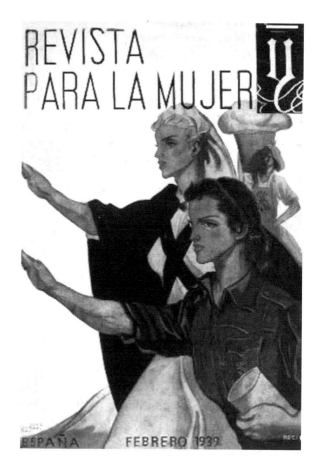

Fig. 14.5. Cover image, *Y* magazine, February 1939. (Collection of the author.)

Denounced and demonized by the Right, the *miliciana* never ceased to provoke strong reactions on both sides of the war. Nevertheless, the image ultimately bore little relation to the reality of women's roles. Just three months into the war, the Republican prime minister was calling for the removal of women soldiers from the front.[44] According to Helen Graham, the "real face of the 'new woman' in Spain" was the female factory or farm worker in the rearguard.[45]

> Most of the photographs of militia women we possess . . . [were] taken in the early days of the conflict and carry the unmistakable stamp of "war as fiesta." They are highly choreographed images, designed to maximize the decorative effects of their female subjects. Like the famous posters of the *milicianas* they are aimed primarily at a male audience . . . as a recruitment device to persuade the male audience to volunteer for military service.[46]

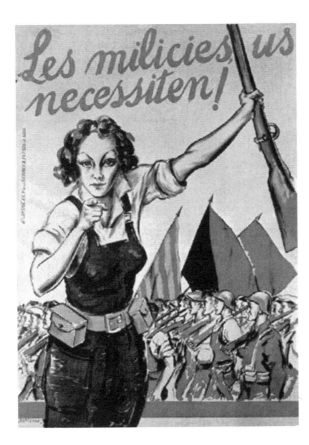

Fig. 14.6. Cristóbal
Arteche, "Les milicies
us necessiten" (The
Militias Need You),
1936. (Collection of
the author.)

This phenomenon notably persists today. The image of the *miliciana* is still
called on to recruit readers and spectators, consumers of a potent conjunc-
tion of war and fashion, in ongoing efforts to make sense of the legacy of
the Spanish Civil War.[47]

These continuities should not lead us to lose sight of the particular role
of fashion and fashion imagery during the war years of the late 1930s in
Spain, however. On both the Left and the Right, clothing styles and choices
were mobilized at the front lines as marking a symbolic fault line between
competing notions of gender identity, serving as a highly visibly yet deeply
embedded index of values, attitudes, and behaviors regarding women and
modernity. The space for debate and dissent generated around the topic
of fashion was soon to close, though, as wartime exceptionalism gave way
to the imposition of ideological orthodoxy under the victorious Franco
regime. In the context of this study, there is perhaps no better evidence
of these changes than those seen in the redistribution of symbolic space in

gender terms represented in the filmed depictions of the annual reenactments of the Victory Parade in the official Spanish newsreel founded in 1943, the Noticiarios y Documentales (NO-DO). In contrast to the setting of the parade in *Ya viene el cortejo*, with its disruptive two-minute, female-centered entr'acte, in the NO-DO women are kept safely consigned to the margins, visualized only in the inevitable cutaway shots of the audience, thus reaffirming women's proper place and role, on the sidelines lending support to the male protagonists.[48]

Notes

1. This essay stems from research conducted under the auspices of a research grant funded by the British Academy, "Film Magazines, Fashion and Photography in 1940s and 1950s Spain." My thanks go to project director Jo Labanyi and fellow researcher Eva Woods for providing a collaborative context for this work. Special thanks also go to Jordana Mendelson for sharing her expertise on Civil War magazines and graphic arts and to Lou Charnon-Deutsch for technical and moral support.

2. See the coverage in Román Gubern, *1936–1939: La guerra de España en la pantalla* (Madrid: Filmoteca Española, 1986), 69–70; and Rafael R. Tranche and Vicente Sánchez Biosca, *NO-DO: El tiempo y la memoria* (Madrid: Catedra and Filmoteca Española, 2001), 296–298.

3. Historian Mike Richards, in "'Terror and Progress': Industrialization, Modernity, and the Making of Francoism," in *Spanish Cultural Studies*, ed. Helen Graham and Jo Labanyi (Oxford: Oxford University Press, 1995), studies the Francoist construction and implementation of a model of the "modern state' inspired by Germany and Italy with the goal of "reordering society in fundamental ways to face the challenges of the future" (176).

4. Victoria de Grazia, "Nationalizing Women," in *The Sex of Things*, ed. Victoria de Grazia with Ellen Furlough (Berkeley: University of California Press, 1996), 337–58; Eugenia Paulicelli, *Fashion under Fascism* (Oxford: Berg, 2004).

5. De Grazia, 352.

6. Ibid.

7. Paulicelli, 20.

8. De Grazia, 352.

9. Paulicelli, 20.

10. De Grazia, 353.

11. Dominique Veillon, *Fashion under the Occupation* (Oxford: Berg, 2002), vii.

12. Wendy Parkins, "Introduction: (Ad)dressing Citizens," in *Fashioning the Body Politic*, ed. Wendy Parkins (Oxford: Berg, 2002), 4.

13. De Grazia, 343; Mary Vincent, "*Camisas nuevas:* Style and Uniformity in the Falange," in *Fashioning the Body Politic*, ed. Wendy Parkins (Oxford: Berg, 2002), 176.

14. De Grazia, 344.

15. Helen Graham, "Women and Social Change," in *Spanish Cultural Studies*, ed. Helen Graham and Jo Labanyi (Oxford: Oxford University Press, 1995), 105–6.

16. Jesusa Vega, "Spain's Image and Regional Dress: From Everyday Object to Museum Piece and Tourist Attraction," in *Visualizing Spanish Modernity*, ed. Susan Larson and Eva Woods (Oxford: Berg, 2005), 214.

17. Graham, "Women and Social Change," 104.

18. Ibid., 110.

19. Vincent, "*Camisas nuevas*," 172.

20. Mary Vincent, "The Martyrs and the Saints: Masculinity and the Construction of the Francoist Crusade," *History Workshop Journal* 47 (spring 1999): 79.

21. Carmen Martín Gaite, *Courtship Customs in Postwar Spain*, trans. Margaret E. W. Jones (Lewisburg, PA: Bucknell University Press, 2004), 28.

22. Ibid., 28.

23. E. Jorge Sánchez, "El cumpleaños de Hitler," *Vértice*, May 1938, n.p.; "La case del Führer en los Alpes Bávaros," *Y*, April 1938, 18–19.

24. Márgara, "Moda: crónica de abril," *Vértice*, April 1937, 86. "Ofreci mi nombre, mis conocimientos, mi entusiasmo, mi visión de la vida, alejada tantos años de la vida hermética española y moldeada en escenarios universales. . . . Solicité con toda la fuerza de mi convicción, imperiosamente, se me dejase hablar a las mujeres de España sobre algo tan trivial y tan trascendente como la Moda. . . . Pensé en mi país en guerra, pensé en el enrarecido ambiente de las naciones, todas, tubulentas y atemorizadas, al borde de precipios sociales o bélicos a cada amanecer de cada nuevo día. Y pensé que la Moda era el símbolo de la mujer fuerte, bíblica, reserva de la Humanidad, placentera y cordial hasta en los momentos más adversos."

25. Immaculada de la Fuente, *La roja y la falangista* (Barcelona: Planeta, 2006), is a fascinating dual biography of the two sisters, aristocratic granddaughters of conservative Spanish prime minister Antonio Maura, whose radically different paths offer insight into the political, social, cultural, and personal forces at stake in the Civil War period.

26. De la Fuente, 228.

27. "¿Sabes cómo aprovechar tu vestido pasado de moda?" *Y*, April 1938, 30.

28. Marqués de Lozoya, "La influncia militar en la moda femenina," *Y*, April 1938, 13.

29. Marqués de Torre Hermosa, "Cuando las novias empezaron a vestirse de blanco," *Y*, June 1938, 7.

30. "El gobierno y las modas," *Y*, May 1938, 17–19.

31. Carmen Icaza, "Quehaceres de María y Marta," *Y*, March 1938, 52.

32. Lidia Blanco, "Orientaciones," *Vértice*, April 1938, n.p.

33. In this regard, see the catalog for the 2007 Bellas Artes exhibition in Madrid, Susana Sueiro, ed., *Posguerra: Publicidad y propaganda (1939–1959)* (Madrid: Ministerio de Cultura, 2007).

34. "Así es . . . así ha podido ser," *Ventanal*, April 1946, 3.

35. The author seems to have taken gladly to this cause of ideological gender war-

fare. In the July–August 1938 issue of *Y*, he provides a color-coded guide to the various inferior subspecies of Spanish women (green, red, lilac, and gray women), whom he contrasts unfavorably with the "mujer azul" (the blue Falangist or Nationalist woman). Enrique Jardiel Poncela, "Mujeres verdes, rojas, lilas, grises, y azules," *Y*, July–August 1938, 36–37.

36. The family of Sáenz de Tejada has strongly contested his reputation as the prime artistic exponent of the Francoist cause. Professor Jordana Mendelson has shared with me her correspondence with Carlos Sáenz de Tejada y Benvenuti, a trained historian and the son of the artist, in which he details the chronology and nature of his father's commissions for the Falange and its organizations. He has also worked to document the alterations made to his father's illustrations and to identify falsely attributed images that continue to circulate.

37. Vincent, "The Martyrs and the Saints," 75.

38. Vincent, "*Camisas nuevas*," 170, 167.

39. Vincent, "*Camisas nuevas*," 169.

40. Vincent, "*Camisas nuevas*," 170.

41. Vincent, "*Camisas nuevas*," 176.

42. Eduardo Haro Tecglen, *El niño republicano* (Madrid: Alfaguara, 1998), 62.

43. Frances Lannon, "Women and Images of Women in the Spanish Civil War," *Transactions of the Royal Historical Society*, sixth ser., 1 (1991): 217.

44. Lannon, 222.

45. Helen Graham, *The Spanish Civil War: A Very Short Introduction* (Oxford: Oxford University Press, 2005), 55.

46. Ibid., 55–56.

47. The covers of two recent Spanish best-selling books that explore the role of women Republican activists during the war and the immediate postwar period, Carlos Fonseca, *Trece rosas rojas* (Madrid: Temas de Hoy, 2007), and Dulce Chacón, *La voz dormida* (Madrid: Santillana, 2002), feature photographs of young, attractive *milicianas* whose frank, open gaze directly addresses the buyer-reader.

48. The DVD that accompanies Tranche and Sánchez Biosca's *NO-DO* reproduces three examples, from 1943, 1961, and 1973, that reveal the unvarying choreography of the ritual.

15

A New American Ideal:
Photography and Amelia Earhart

KRISTEN LUBBEN

Seventy years after her disappearance, Amelia Earhart remains one of the most celebrated women of the twentieth century. Fascination with her brief but influential life has persisted since 1928, when she became the first woman to fly across the Atlantic Ocean. Earhart's distinctive public persona was constructed through a complex blend of genuinely ground-breaking achievements, savvy celebrity marketing, and contemporaneity. Photographs were crucial to promoting her feats and building her image. Photojournalism, particularly in the form of the illustrated press, was on the rise between 1928 and 1937, the height of Earhart's fame, and it is clear that her fame both fed and was sustained by the media. Portraits of celebrities like Earhart leavened the news and sold papers and magazines, and the fame that such coverage afforded Earhart presented opportunities to fund her flying, even in the midst of the Depression. She was a potent symbol of radically shifting cultural and stylistic ideals, and photographs of the iconic aviator—with tousled hair, leather jacket, and silk scarf—were tangible manifestations of that symbol and the means through which it was disseminated (fig. 15.1).

Earhart's disappearance over the Pacific Ocean in 1937 is undeniably part of the story behind the durability of her image today; the trope of the popular hero who dies dramatically at the height of fame is a familiar one, as is the enduring lure of an unsolved mystery. However, her tragic demise does not explain the appeal of her image to her contemporaries or the impact that ubiquitous photographs of the pants-and-tie-wearing aviator had on the shifting image of women in the late 1920s and 1930s.

In her own time, Earhart captivated the public because she represented the physical embodiment of heady new ideals circulating in the culture. Chief among these was the figure of the New Woman, an independent

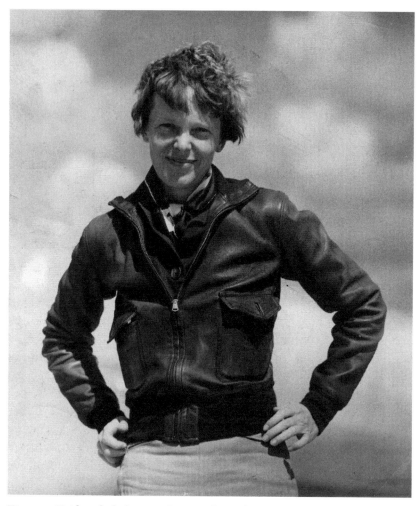

Fig. 15.1. Unidentified photographer, Amelia Earhart in leather jacket, 1936. (International Center of Photography, The LIFE Magazine Collection.)

and convention-defying version of modern womanhood that first emerged in the 1890s and remained a source of both fascination and anxiety as it evolved through the early decades of the twentieth century. The New Woman represented a casting off of the nineteenth-century ideal of "the Angel in the House,"[1] a pure and self-abdicating mother and wife whose world is circumscribed by the private domestic sphere. New images of women moving into public spaces as frivolous "flappers," working women, or political activists were both celebrated and reviled in the popular cul-

ture. Earhart—a career woman who was not subservient to her husband, was an athlete, and was an active participant in the national project of progress and modernity—exemplified a particularly American version of the New Woman, one that offered an alternative to the permissive flapper of the 1920s. She symbolized the thrilling new possibilities for women, certainly through her actions but also in the way that she looked; tall, thin, and androgynous, with short hair and suntanned skin, she personified the changing style in body type and clothing promoted by Hollywood and fashion designers in the 1930s. "Free of fleshly excess," in the words of one critic, her "seemingly weightless" body indicated mobility and a streamlined machine-age aesthetic.[2] Contrasted with the matronly older generation of suffragettes, she offered younger women a new, seemingly more modern feminist model and actively advocated on behalf of women's rights throughout her career.

But above all else, it was her profession that endowed her with its aura of excitement, advancement, and risk. In an era before commercial aviation, the aviator was a heroic symbol of modernism. His female counterpart, the aviatrix, was the ultimate glamorous and daring modern woman, able to employ technology to transcend the limitations of body, gender, and tradition. Earhart was not the first of the celebrated aviatrixes; she stepped into the stylistic template seen in photographs of other female flyers, beginning with Harriet Quimby, Katherine Stinson, and others as early as the teens. But while Earhart's image incorporated existing iconography, it was also essentially authentic. Like her name—almost too good to be true—her leather jacket, short hair, and other key elements of her signature style were not the constructions of a publicist. Rather, these elements were perfected, refined versions of her own (prefame) self-presentation (fig. 15.2). This can be seen in several photographs of Earhart from the years leading up to her 1928 reputation-making flight, including the oft-reproduced photograph from her first pilot's license.[3]

The many photographs taken of Earhart demonstrate that, in the words of one biographer, she had an "unerring instinct for making a physical statement of who and what she was."[4] The complex cultural and stylistic ideals that she embodied are conveyed in even relatively straightforward portraits. However, in their original contexts in newspapers, magazines, and advertisements, the photographs also reveal the ways in which this potent image was threatening and required management or mediation, whether within the photographic image itself or through the framing devices of layout, picture selection, and captioning.

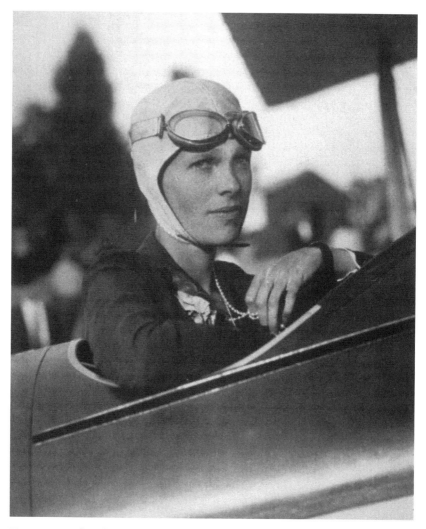

Fig. 15.2. Unidentified photographer, Amelia Earhart in flight helmet and goggles, ca. 1926. (The Schlesinger Library, Radcliffe Institute, Harvard University.)

From the outset, Earhart's image was entangled with the struggle over the representation of American womanhood. She was launched to sudden celebrity in 1928, when she was invited to become the first woman to cross the Atlantic in an airplane. The flight was the brainchild of Amy Guest, an American-born British socialite, who was moved to action in an attempt to prevent Mabel Boll from making the first such Atlantic crossing. Dubbed the "Queen of Diamonds" by the press because of her fondness for deck-

ing herself out in jewels, Boll was deemed an unseemly, publicity-hungry adventuress. Guest, anticipating the international press that such a feat would generate, was determined to bankroll the project with a more "suitable" representative of American womanhood. She enlisted the aid of U.S.-based promoters, including George Palmer Putnam, a publisher who had profitably capitalized on the excitement surrounding Charles Lindbergh's solo Atlantic crossing the year before. Putnam and his colleagues were told to look for "someone nice who will do us proud." After considering a number of high-profile female aviators, they were referred to Earhart. *New York Times* correspondent Hilton H. Railey recalled, "Mrs. Guest had stipulated the person to whom she would yield must be 'representative' of American women. In Amelia Earhart I saw not only their norm but their sublimation."[5] The tall and slender Earhart impressed the search committee with her physical appearance, as well as her modesty, wholesomeness, and genuine interest in flight; she was both attractive and the "right sort of girl." Not incidentally, they were struck by Earhart's similarities to Lindbergh, which Putnam no doubt recognized he could exploit as a promotional angle. Without interviewing any other candidates, they offered the opportunity to Earhart, and she quickly accepted.

While waiting in Boston for the plane to be readied, Putnam arranged for a portrait session with a Paramount photographer. Earhart wore her leather jacket, lace-up boots, and flying helmet for the session, which was themed "Remember Lindbergh." Claiming that the famous resemblance had more to do with his photographic skills than serendipity, the photographer later said, "It wasn't so much that the resemblance was there as that you could make it seem to be there, by camera angles."[6] The photographs were widely circulated with captions that drew attention to the physical similarities between the two flyers, earning Earhart the tag "Lady Lindy," which, to her frustration, stuck throughout her career. However, the similarities between the two are more significant than appearance; their shared qualities explain their usefulness as national icons at a particularly turbulent time. Lindbergh and Earhart were both perceived as modest, temperate midwesterners. As journalism historian Charles Ponce de Leon argues, a subtext of Lindbergh's appeal was a rejection of the "urban and ethnic cultural styles" represented by such popular 1920s figures as Jack Dempsey and Babe Ruth, who were seen as flamboyant and swaggering compared with Lindbergh's reserve. In the midst of these enticements— not to mention the mainstreaming of jazz and other products of African American popular culture—Earhart and Lindbergh were indisputably and

reassuringly American, restrained and plainspoken white Protestants from the center of the country.

Both aviators signaled a break with the aimless frivolity of the decade following the end of the First World War. "By the early 1930s," Ponce de Leon writes, "the jazz age would be reviled as a mindless, wasteful debauch, and spokesmen for the dominant culture would be hard at work trying to kindle public interest in national symbols that bore no trace of the booster spirit of the 1920s. Lindbergh was the first of such symbols."[7] Earhart followed on his heels. In a 1928 article in *Cosmopolitan* magazine entitled "I Want You to Meet a Real American Girl," O. O. McIntyre hailed the coming transformation:

[F]or a number of years youth has stampeded the conventions and gone on a bust. I have myself beheld gradual stages of decadence—from sly gin-guzzling to a calculated harlotry—among those fresh and vibrant young girls reared in a careful luxury. . . . I believe America's proud and convincing answer to it all is Amelia Earhart! . . . Hers is the healthy curiosity of the clean mind and the strong body and a challenging rebuke to those of us who have damned the youth of the land. To few generations have come a Lindbergh and an Amelia Earhart and their coming is a singular and welcome proof of our destiny. A generation producing them has no need to worry about its flappers and cake eaters. . . . Amelia Earhart becomes to all of us one of the significant figures of our time. Not only because she has accomplished what no other woman has accomplished but because she has provided an intellectual, courageous and highly moral reaction from the inflamed tendencies and appetites which have aroused so much alarm. She will become a symbol of new womanhood—a symbol, I predict, that will be emulously patterned after by thousands of young girls in their quest of the Ideal. What a girl![8]

As McIntyre demonstrates, Earhart's appeal, like that of Lindbergh, was bound up with nationalism and the revitalization of the latent American character. The aviators are "a welcome proof of our destiny," and their greatness symbolizes America's prospective superiority over Europe and the rest of the world. McIntyre also reveals the extent to which Earhart was cast as a counter to the media-hyped image of the flapper from the outset of her public career in 1928. Although Earhart's popularity stems from the same fascination with the image of an unfettered modern woman that fueled interest in iconic 1920s characters such as those embodied by the film star Louise Brooks, it is also a rejection of the symbol and narrative of the dissi-

pated flapper.[9] This reaction came from the expected conservative quarters, which were threatened by the liberated and sexualized image of the flapper, but it also came from progressive and feminist critics. The figure of the "Lost Girl" represented by Brooks (unconventional and decidedly modern but invariably tragic) didn't offer women a productive model through which to gain economic independence, political power, or social equality. Earhart proposed an alternate version of modern American womanhood—vigorous and self-sufficient—that was a product of the license of the 1920s but anticipated the more serious and conservative mood of the 1930s.[10]

Prior to the 1928 transatlantic flight, the *New York Times* ran two photographs under the headline "Boston Girl Starts for Atlantic Hop" (fig. 15.3). In one, the fresh-faced "Boston girl" (who was, in fact, a twenty-nine-year-old native Kansan) is seated on a windowsill, hands demurely crossed in her lap, wearing a dress that looks like a child's sailor suit or school uniform. The other is a full-length portrait from the "Lady Lindy" session. The photographs can read as "before and after" shots documenting the moment when Earhart is plucked from obscurity and re-created as a famous aviator. But they also establish what becomes a convention in the layout of photographs of Earhart. Particularly in her early career, she is rarely represented by just one image; most often a picture of the leather-and-pants-clad aviator is paired with one of Earhart in a dress, reminding the viewer that her identity as an aviator is a costume that can be removed at will and that her femininity remains secure.

Although Earhart was already an accomplished flyer, having bought her first plane five years earlier, she did none of the actual flying on the 1928 trip. Nonetheless, she was of far more interest to the press than were her crewmates, Lou Gordon and Wilmer Stultz. She was celebrated on landing in London, and the press eagerly followed her tour of the city. Reinforcing her image as a modest young woman, photographs of her in ill-fitting dresses carried captions explaining that she had to borrow clothes from friends in London because she was so sensible and lacking in vanity that she wore only her flight suit on the trip and did not pack a change of clothes for fear of adding more weight to the plane. (Throughout her career, modesty and seriousness of purpose were used to explain her unfeminine appearance.) Another article notes that in the loaned frocks Earhart "was suddenly and miraculously transformed from a daring celebrated aviatrix to a typical, nice American girl having a celebration abroad with a party of friends from home."[11] Earhart returned to parades and accolades in America. Overnight she had become a media star.

York Times.

THE WEATHER

Rain today and tomorrow; not much change in temperature.
Temperature yesterday—Max, 72; min, 57.
☞ For weather report see Page 42.

928, by The New York Times Company.

RK, MONDAY, JUNE 4, 1928.

TWO CENTS | In Greater | THREE CENTS | FOUR CENTS
New York | Within 200 Miles | Elsewhere in the U. S.

BOSTON GIRL STARTS FOR ATLANTIC HOP, REACHES HALIFAX, MAY GO ON TODAY; AUSTRALIANS FLYING ON TOWARD FIJI

S FACE BATTLE OF 1912

City Finds Split as in Day.

PROBLEM

Minimized —Smith's irbing.

TS TODAY

paratory to Silent on k.

IN.

ork Times.
une 3.—That
Convention
week from
file, interest
Republican
ago conven-
pectation of
ell advance
who are al-
ible here.

carried in
insurgency
that it vir-
through its
Republicans
far sight
of control

ere are out
en though
elt or way-
tract, who
ng out into
and cripple

armers in
he second
re of the
elief bill
proposed
over, and
ate nomi-
ch a dem-
York are
them a
ffect both
of the con-

raised.

the party
me or ex-
ting of the
mittee to
of contests
ts "stop
ering mid-
minations
gic moves
of leaders
eight pos-
r over."
suffered
ia by the
gainst his
an States
ated but

FOUR LEFT KAUAI AT DAWN

Whole Population Out to Wave Godspeed to Crew of Southern Cross.

NEARING 1,400-MILE MARK

Ten Hours Out Fliers Report Motor Trouble 'OK' a Little Later, Then More Spitting.

TWO ISLES IN 3,180 MILES

Hazardous Hop From Hawaii Is Longest Over-Water Flight Ever Attempted.

Plane Is 1,378 Miles Out From Hawaii in 13 Hours

By The Associated Press.

SAN FRANCISCO, June 3.—The Southern Cross has made an average of more than 90 knots since leaving the Barking Sands, on the Isle of Kauai, for Suva, Fiji, this morning, said a message received from the plane by the naval radio station here at 9:20 P. M. (6:50 P. M. Honolulu Time and 1:20 A. M. Monday New York Daylight-Saving Time). The message follows:

"9 P. M. (evidently Honolulu Time)—Have made good 1,226 [nautical miles, about 1,378 land miles], giving an average of over 90 knots. Altitude 2,500 feet now. Lots better up here and much cooler."

[The Southern Cross took off at 5:20 A. M. Honolulu Time. Thus she was about 12 hours and 40 minutes out when this report was sent.]

By VERN HINKLEY.

Wireless to THE NEW YORK TIMES.
HONOLULU, June 3.—The mono-plane Southern Cross, bound from Oakland, Cal., to Melbourne, Australia, hopped off from the Island of Kauai at 5:20 o'clock this morning (11:50 A. M. New York Daylight Saving Time) on the second long leg of its transpacific flight, the objective being Suva, Fiji, 3,180 miles away. If Captain Charles Kingsford-Smith, pilot and commander, and his companions, Captain Charles T. P. Ulm, co-pilot; Captain Harry Lyon,

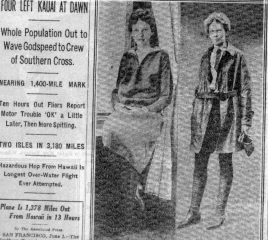

GIRL WHO IS TO BRAVE AN ATLANTIC FLIGHT.
Two Poses of Miss Amelia Earhart of Boston, Who Flew Yesterday on The First Lap of an Air Trip to England.

Times Wide World Photos.

POLAR HUNTER JOINS ITALIA RELIEF SHIP

Man Who Knows Every Mountain in Spitsbergen Islands Goes With the Hobby.

HOLM PLANS FLIGHT SOON

Russian Radio Amateur Reports Nobile S O S Message From Franz Josef Land.

By FREDERIK RAMM.

Wireless to THE NEW YORK TIMES.
OSLO, Norway, June 3.—The Braganza, which left Kings Bay last night with thirteen Italians and Norwegian hunters as leaders of an expe-

FOG FORCES STULTZ TO STAY AT HALIFAX

Friendship Starts Again After Stopping in Harbor There, but Puts Back.

HOP TO TREPASSEY TODAY

Pilot Describes How He Flew Through Hole in the Mist to Perfect Landing.

Special to The New York Times.
HALIFAX, N. S., June 3.—Out of the fog that hung thick along the coast of Nova Scotia, a three-motored Fokker monoplane dropped down to a mooring near the Halifax Naval

WOMAN TO BE CO-PILOT

Miss Earhart, Social Worker and Flier, to Aid Wilmer Stultz.

TAKE OFF AT BOSTON HARBOR

Three-Motored Fokker Plane Friendship, Sold by Byrd, Fitted With Pontoons.

RADIO CAN SEND AND HEAR

Plans, Backed by Mechanical Science Corporation, Kept Silent for Seven Weeks.

Special to The New York Times.
BOSTON, June 3.—At one minute after 6:30 this morning the tri-motored Fokker monoplane Friendship rose from the waters of Boston Harbor and headed eastward into the beams of the rising sun. Her destination is England, after a stop-over for refueling at Trepassey, N. F.

This evening, however, word came back from Halifax that Wilmer Stultz, the pilot, had landed the plane there, after encountering dense fog along the Nova Scotia coast. With predictions for clearing weather around Newfoundland tomorrow, he expects to be able to get away to Trepassey, a matter of five hours' flying, possibly early enough to fuel up and start off on the actual Atlantic flight tomorrow afternoon.

Woman a Co-Pilot.

On board the Friendship is an American girl, eager to be the first of her sex actually to cross the Atlantic by air. She is Amelia Earhart of Boston, amateur aviatrix and professional social worker. Miss Earhart has owned her own plane and is credited with 500 or more "solo" hours in the air. In the present flight Miss Earhart will take her turn at the controls, but the pilot in charge is Stultz, who has a distinguished record as a "big-ship" man, navigator and all-around air expert. His flying mechanic is Louis Edward Gordon of Texas, better known as "Slim."

Secrecy has surrounded the flight's entire preparation, covering some seven weeks, and was successfully maintained until today. This

Capitalizing on that newfound fame was critical to further opportunities for flying. Following the blueprint he had perfected for Lindbergh, who wrote the best-selling *We* after his solo Atlantic crossing, Putnam commissioned Earhart to write a book based on her account of the flight. The book, *20 Hrs. 40 Min.*, played a key role in shaping the personal narrative that laid the groundwork for Earhart's further celebrity. In addition to reinforcing and elaborating the biographical details that appeared in the press, the book was liberally illustrated with photographs. Invoking a comparison to the Hollywood star system, literary scholar Sidonie Smith argues that these photographs are essential framing devices that facilitate the projection of fantasy: "[T]he celebrity figure 'gives a form of embodiment to the mass subject,' fleshing out for the consuming masses imaginary selves and imaginary lives through which they can fantasize future selves. For such an embodiment visibility is essential."[12] In her close reading of the book, Smith also calls attention to its rarely used full title: *20 Hrs. 40 Min.: Our Flight in the Friendship. The American Girl, First Across the Atlantic by Air, Tells Her Story.* Referring to Earhart as an "American Girl" cast her achievement in terms of national progress rather than gender transgression and reinforced her femininity as youthful and innocent rather than sexualized. Additionally, her self-deprecating, antiheroic humor and insistence that she flew for "the fun of it" (the title of her next book) served to domesticate and normalize flight, making her less threatening and promoting the interests of the fledgling commercial aviation industry.

20 Hrs. 40 Min. was just one element of the promotional vehicle set up to take advantage of Earhart's popularity. Putnam also helped arrange speaking engagements, endorsements, and a writing contract with *McCall's* magazine. There were occasional missteps; Earhart's advertisement for Lucky Strike, which used one of the "Lady Lindy" photographs, was considered "unladylike" by *McCall's*, and the magazine canceled her contract. *Cosmopolitan* was untroubled by the endorsement and offered Earhart the position of "aviation editor." Beginning in November 1928, she contributed articles to the magazine on a monthly basis. The first and most striking of these articles includes pictures by *Cosmopolitan* staff photographers combined with well-circulated press images.[13] A double-page spread features images of Earhart as "Lady Lindy," as well as in sports- and eveningwear (fig. 15.4). The effect of so many different costumes on the same figure is rather like a book of paper dolls. In one sense, the notion that women are free to choose from a range of possible selves is liberating. At the same

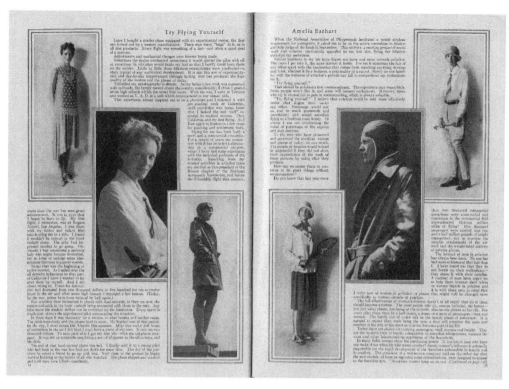

Fig. 15.4. Amelia Earhart, "Try Flying Yourself," *Cosmopolitan*, November 1928. (International Center of Photography, Museum Purchase.)

time, the implication is that Earhart's identity as flyer is just another outfit that can be taken off and replaced with a dress or tennis gear.[14]

Most of the promotional efforts were spearheaded by Putnam, who by this time was acting as her manager. In 1931, he also became her husband. There was much speculation at that time and since about Putnam's role in her career. It is undeniable that his efforts on Earhart's behalf were essential to her celebrity and therefore to her continued ability to fly. His connections at the *New York Times,* Paramount, and other media outlets gave her access that she would not otherwise have had. Publicists and image managers were key to the still relatively new operation of celebrity and human-interest journalism that emerged in the early twentieth century. Putnam's untiring work on her behalf, however self-serving, was instrumental. As the Depression wore on, it became increasingly critical to trade on Earhart's celebrity to fund flights. To those critics who disapproved of

her commercial pursuits, Earhart offered the pointed rejoinder, "I fly better than I wash dishes. I try to make my flying self-supporting. I could not fly otherwise."[15]

The May 1932 issue of *Vanity Fair* featured a typical portrait of Earhart among photographs of a number of similarly posed notable American women flyers in an article entitled "When Ladies Take the Air." A few weeks later Earhart would make a flight that would finally set her apart from that crowded field. After three years spent honing her flying skills and refining her public persona, Earhart quietly began preparations for the first solo flight across the Atlantic by a woman. It would make her the first person (male or female) to accomplish the feat since Lindbergh, further solidifying the connection in the public mind between her and her male counterpart. Earhart launched from Harbor Grace, Newfoundland, on May 20, 1932, the fifth anniversary of Lindbergh's flight. The flight was Earhart's greatest triumph and launched her to amplified levels of renown. It would silence critics who had dismissed her as little more than "a sack of potatoes" on the 1928 flight. She later wrote, "I wanted to justify myself to myself." But, she continued, "there were other reasons—stronger than this . . . simply stated, that women can do most things that men can do."[16]

This self-assurance is apparent in images promoting the flight, in which she is depicted either in a leather flying jumpsuit, as in a series of photographs taken in London, or in simplified, elegant sportswear or eveningwear that emphasizes her slenderness and mobility. As her image is refined, stock poses and thematic tropes recur. A widely reproduced studio portrait by Ben Pinchot shows her in a velvet dress with a pearl necklace draped over her honorary major's flying wings pin. In this image, the signifier of her flying achievements is commingled with those of femininity and class status. A photograph of Earhart before her 1928 flight in an open cockpit and flying helmet, holding a string of pearls between her fingers, was similarly adopted as an expedient image with which to convey the notion of the aviatrix as a daring and technologically adept—but genteel—"lady flyer." The historian Susan Ware writes that the effect of combined male and female signifiers in the photos is "powerful, compelling, yet also destabilizing; especially in the context of 1930s gender roles."[17] This balancing of symbols within the image is not unlike layouts that feature a pair of photographs of Earhart in and out of flying clothes.[18] Other posing conventions are also notable for their frequent occurrence. The image of a machine-savvy woman was still fascinating to the public, so many photographs show Earhart at the controls in her cockpit. Yet other images take this theme a step further and show

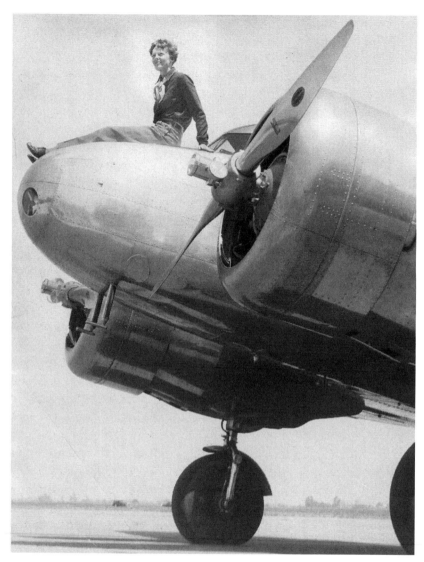

Fig. 15.5. Unidentified photographer, Amelia Earhart on her plane, July 21, 1936. (The New York Times Photo Archives.)

Earhart's body melded in some way with the plane, holding her propeller, with the ring of her radio direction finder playfully held up to frame her face, or astride the plane (fig. 15.5). Images of Earhart with her husband make visual play of their inverted gender roles: she examines maps and machinery while he looks on or she stands on the wing of her plane to bid

him farewell before a flight. These motifs were refined and repeated in photographs that were widely reproduced in the press for nearly a decade, contributing to the vision of what women could do and look like.

By the early 1930s, Earhart's celebrity was secure enough that she could trade on it to advocate for causes she supported. An avowed proponent of women's issues throughout her career, she backed passage of an Equal Rights Amendment, joining a National Woman's Party delegation to the White House in 1932. She was a passionate proselytizer on the subject of careers for women, which she saw as essential for financial independence as well as for changing the perception of women. She encouraged other female aviators and was a founding member of the Ninety-Nines, an association of women flyers.

She also worked on behalf of the aviation industry as it sought to make the transition from the era of daredevil solo flying to safe and profitable commercial travel. In the 1920s and 1930s, the industry was in the process of radical transition. No longer "an exciting but somewhat useless toy," the airplane was becoming a viable means of transportation and air flight a potentially lucrative industry. But the public still associated flying with danger—not incorrectly, since the deaths of many early flyers were covered in the news. The common conception of the "intrepid birdman," the daring and athletic "modern superman" of the first decade of aviation, was anathema to an industry seeking to put the average person in a commercial plane. In the effort to domesticate the skies, women became essential. "Prejudice, paradoxically, begat opportunity" for women, writes the aviation historian Joseph Corn.[19] Earhart and nearly all of the other big-name women flyers at some point in their careers found jobs demonstrating and selling planes, and aviation manufacturers willingly provided planes or other support to women's flying events in the interest of convincing Americans that flying was safe and easy. As one female aviator said, "[I]f women can do it, the public thinks it must be duck soup for men." With the advent of commercial aviation, photographs of aviatrixes like Earhart were used not to signal exceptionalism but to underscore the benign ordinariness of flight; increasingly, the figure of the heroic flyer was to be replaced with that of the (male) career pilot.

In 1937, Earhart announced plans for what she intended to be her last record-breaking flight: a circumnavigation of the globe at the equator. Earhart and her navigator, Fred Noonan, departed from Oakland, California, on May 21 and headed east in their state-of-the-art Lockheed Electra. After more than five weeks of flying, on July 2, 1937, the pair took off for

Howland, a tiny island in the South Pacific. This was to be the final leg of the journey before departing for Hawaii, and Earhart knew that it would be the most treacherous. After over twenty hours of flight, the awaiting U.S. Navy vessel *Itasca* received radio messages indicating that Earhart and Noonan were having trouble locating the island. Hours passed, and the plane failed to appear; attempts to establish radio communication were unsuccessful. Reports of the extensive sea and air search appeared on the front page of every American newspaper for days. But after a decade of constant coverage of her exploits, there were no photographs of Earhart's final and most spectacular episode. The plane was never found, and the definite cause of the disappearance was never resolved by physical evidence.[20] In the absence of photographs of the crash, papers ran a combination of stock portraits of the pair, maps of the planned route, and even drawings of Earhart and Noonan adrift on their plane in shark-infested waters. As the chances for rescue dimmed, newspapers and magazines began to run tributes to Earhart in place of obituaries.

Life magazine published a three-page photostory on the flight; surprisingly, it was the first article on Earhart to run in the picture magazine, which had been founded a year earlier. However, a photo of children playing in the spray of a fire hydrant, not Earhart, made the cover. Entitled "Log of Earhart's 'Last Stunt Flight,'" the layout features an image that was reproduced repeatedly in coverage of the disappearance.[21] Taken when she announced plans for the flight, it shows her response to a reporter who asked how big Howland would look on a map compared to the other places she would visit. Laughing, Earhart holds her fingers apart but an inch to indicate the miniscule size of the island. The image could be read as confirmation of her daredevil nature, implying that she was aware of the risks she faced and was taking up the challenge with spirit and style. Just as easily, the popularity of the image among photo editors—along with a faintly ridiculous photo of Earhart in a rubber escape raft from a previous Hawaiian trip—could betray an undercurrent of disapproval or even derision that is also to be found in textual accounts of the disappearance. The implication in these stories is that her desire to prove herself on behalf of women caused her to get in over her head. In what was supposed to be an editorial tribute to Earhart, *Aviation* magazine let loose a finger-wagging rebuke. Although Earhart

> combined native capacity for quick decision and direct action with feminine charm and personality . . . her greatest weakness was her extreme conscious-

ness that she was a woman. Obvious in all her activities, since she rode as "a sack of ballast" across the Atlantic in the Friendship in 1928, was the constant drive to undertake difficult things just to prove that she (as a woman) could do them. It is not difficult to see that such an urge might sooner or later get her into trouble. . . . At most it [her last flight] would have contributed little or nothing to the knowledge of commercial ocean flying that is now the most important field for the future. The real tragedy of Amelia Earhart is that hers was the psychology of the Age of the Vikings applied at a time when aviation had already passed over into the Age of the Clipper.[22]

Evident in these surprising eulogies for a woman broadly seen as a national hero is the changing attitude toward flight. The era of aviation heroics was over, and record shattering was now seen as an anachronistic "stunt." But just as telling is the censorious attitude toward Earhart's declared feminist purpose and more generally to the sort of new, ambitious woman she represented and championed. This criticism could be seen as an extension of what historian Estelle Freedman terms "the Depression psychology which sought to bring women out of the work force. While legal and political equality were praised, social and cultural emancipation evoked gentle reproaches."[23]

Despite uncharitable displays of *schadenfreude* by a few critics, Earhart's disappearance caused a national outpouring of grief, particularly by her female fans. Still, Earhart's image gradually faded from view as the country headed into the Second World War.[24] It was given new life after the war, when theories began to circulate that the Japanese may have captured Earhart and Noonan and taken them as prisoners of war. In a cycle that perpetuated Earhart's photographic image, articles and books claiming any number of solutions to the puzzle of the lost plane kept photographs of Earhart in circulation, and her appealing and still unmatched image, in turn, contributed to the desire to answer the question of what happened to her.

In addition to the unending stream of disappearance theories, Earhart's image was resuscitated by the women's movement of the 1970s. Recuperated as a feminist icon, Earhart was referenced in Judy Chicago's monument to women's achievements, *The Dinner Party* (1974–79), and her photograph was featured on the cover of a 1976 issue of *Ms.* magazine. Her assertion that "Women must try to do things as men have tried. When they fail, their failure must be but a challenge to others" spoke to a new generation of women, as it had to her own.

More recently, two advertising campaigns serve to illustrate the endur- ing currency of Earhart's photographic image. In 1997, Apple launched its "Think Different" campaign, a series of magazine ads, billboards, and posters with a single black-and-white portrait of an iconic innovator or creative risk taker along with the Apple logo and the tagline "Think Dif- ferent." Along with images of Gandhi, Albert Einstein, and Miles Davis, Apple employed an early portrait of Earhart. It shows her in white flying helmet with goggles perched on her head. Her white shirt and tie are out of focus, so that the suggestion of menswear is present without being fore- grounded, and her expression is both doe-eyed and determined. Earhart's image needs no caption; it is understood that the viewer will recognize her and will associate the Apple brand with daring and adventure, as well as unconventionality, conveyed by the gender-bending signals in the portrait. In a similar campaign by Gap in 1993, the company associated a series of American icons with classic khakis. The photograph of Earhart selected for this campaign shows the aviator (in khakis) next to her plane. Her mastery of the machine that dwarfs her in the photograph telegraphs her confi- dence and modernity, while her boyish, almost childish demeanor disarms and lends her an air of vulnerability.[25] Both ads rest almost solely on the array of associations with Earhart's photographic image, identifiable and potent enough to sell clothes and computers seventy years after her disap- pearance.

Today, Earhart is revered less for what she did than what she stands for. She has become an increasingly abstract symbol—of the thrill and danger of adventure, of the possibilities for women, and of the courage to break with the past and conventional expectations. In this process, her image has become consolidated, and only photographs that convey those ideals can stand in for her. Her iconic photographic image today is much more singular than it was in her own time, when a public very familiar with her narrative could identify and was interested in images of her in a range of activities and guises.

To her contemporaries, Earhart was identifiable in eveningwear at a White House function, a skirt suit giving a lecture on women in aviation, or in a leather flying jacket and pants. Newspapers, magazines, newsreels, and books from her lifetime demonstrate that her image was surprisingly varied for a public figure. Indeed, her continued popularity was probably depen- dent on a carefully calibrated balance of these images. Too masculine and she would have been seen as threatening, too feminine and she would have lost the source of difference that made her image fascinating. Recurring

in thousands of press photographs and studio portraits over the course of a decade—1928 to 1937—in which the image of American women was in transition, the figure of Earhart commanding technology and dressing in a way that signaled physical and social freedom was a potent symbol, particularly for women.

Notes

This text is based on an essay that originally appeared in Kristen Lubben and Erin Barnett, *Amelia Earhart: Image and Icon* (New York and Göttingen: International Center of Photography and Steidl, 2007).

1. This term is from an 1854 poem by the British writer Coventry Patmore. "The Angel in the House" came to symbolize the ideal Victorian wife and mother, also described by the concepts of the "Cult of Domesticity" or the "Cult of True Womanhood." See Carroll Smith-Rosenberg, "The Female World of Love and Ritual: Relations between Women in Nineteenth-Century America," *Signs* 1, no. 1, (autumn 1975): 1–29; and Barbara Welter "The Cult of True Womanhood: 1820–1860," *American Quarterly*, 18, no. 2 (summer 1966): 151–74.

2. Sidonie Smith, "Virtually Modern Amelia: Mobility, Flight, and the Discontents of Identity," in *Virtual Gender: Fantasies of Subjectivity and Embodiment,* edited by Mary Ann O'Farrell and Lynne Vallone (Ann Arbor: University of Michigan Press, 1999), 26.

3. All referenced photographs can be found in Lubben and Barnett.

4. Doris L. Rich, *Amelia Earhart: A Biography* (Washington, DC: Smithsonian Institution Press, 1989), 32, quoted in Susan Ware, *Still Missing: Amelia Earhart and the Search for Modern Feminism* (New York: W. W. Norton, 1993), 145.

5. Quoted in Anne Herrmann, "Amelia Earhart: The Aviatrix as American Dandy," in *Queering the Moderns* (New York: Palgrave, 2000), 21.

6. Quoted in Susan Butler, *East to the Dawn: The Life of Amelia Earhart* (New York: Da Capo Press, 1999), 168.

7. Charles L. Ponce de Leon, "The Man Nobody Knows: Charles Lindbergh and the Culture of Celebrity," *Prospects* 21 (1996): 356.

8. O. O. McIntyre, "I Want You to Meet a Real American Girl," *Cosmopolitan,* November 1928, 21.

9. On Louise Brooks, see Vanessa Rocco's contribution to this volume.

10. Estelle B. Freedman discusses 1930s characterizations of women in the 1920s, which focused on moral and social aspects rather than women's political or economic concerns: "[W]omen in the 1920s began to be presented as flappers, more concerned with clothing and sex than with politics. Women had by choice, the accounts suggested, rejected political emancipation and found sexual freedom. The term feminism nearly disappeared from historical accounts, except in somewhat pejorative references to the Woman's party." Estelle B. Freedman, "The New Woman: Changing Views of Women in the 1920s," *Journal of American History* 61 (September 1974): 379.

11. Herrmann, 27.

12. Smith, 26.

13. All of the *Cosmopolitan* photographs appear to have been lost during the disposal of the Hearst Archive.

14. A 1987 set of "famous American women" paper dolls echoes this idea. Earhart "at a press conference," in skirt and heels, is the doll, whereas the "flying attire"— pants, leather jacket, and oxfords—is the costume one is to put over the doll. (Gertrude Stein's doll does Earhart one better. Alice B. Toklas is part of the "costume" she can wear.)

15. *News-week,* May 18, 1935, 34–35.

16. Amelia Earhart, "Flying the Atlantic," *American Magazine* 114 (August 1932): 17.

17. Ware, 169.

18. It is difficult to ascribe authorship to these conventions. Because archives do not exist that describe in detail the promotional materials that Putnam distributed to the press, we cannot determine the degree of control that he asserted over which photographs were distributed and used and how they were captioned or positioned. The majority of the photographs of Earhart that appeared in print were taken by news photographers at public events, not by studio photographers in the pay or under direction of Earhart or Putnam.

19. Joseph J. Corn, "Making Flying 'Thinkable': Women Pilots and the Selling of Aviation, 1927–1940," *American Quarterly* 31, no. 4 (1979): 560.

20. Most respected scholars believe that Earhart and Noonan missed the tiny island of Howland and ran out of gas somewhere in the region. Attempts to locate the plane continue, and the literature on the disappearance is voluminous.

21. *Life,* July 19, 1937, 21–23. Following the brief tribute to Earhart's "last stunt flight" is a spread labeled "non-stunt flight," about transatlantic survey flights by Pan American and Imperial Airways, "pure commercial flying, the finest of its kind in the world" (24).

22. *Aviation,* August 1937.

23. Freedman, 383.

24. Susan Ware describes Earhart's postdisappearance fade from notoriety and subsequent resurgence in detail in *Still Missing* (224–26).

25. A similar photo from the same period shows Earhart in tie, leather jacket, and pants, hand resting lightly on the wheel of her Vega plane. This image was not, it seems, reproduced widely—if at all—at the time, and it would be an unlikely choice for an advertiser today. Though remarkably similar to the Gap image, the portrait bears a surfeit of masculine signifiers; instead of the softly tied scarf in the Gap photo, she wears a tie. Instead of an unthreatening pose with hands stuffed in pockets, she faces the camera self-assuredly and physically declares her connection with her machine. In contrast, in both the Gap and Apple ads, the insinuation of gender play pushes the envelope of conventionality just enough to create intrigue without going so far as to be destabilizing or off-putting to potential customers.

16

Modern Mulans: Reimagining the Mulan Legend in Chinese Film, 1920s–60s

KRISTINE HARRIS

Before the New Woman, and before the modern female militia immortalized as "The Red Detachment of Women," there was Mulan. In China's tumultuous twentieth century, the legendary woman warrior Hua Mulan was reconfigured as a heroine for the new nation and even a model for the liberated New Woman. Revolutionaries and artists reimagining the nation and gender roles in modern China invoked Mulan in a wide range of media, including fiction, memoirs, spoken drama, and film, along with illustrated children's books, cartoons, and advertising posters; by the end of the century, she would also be found in television serials and in overseas reinterpretations circulating globally.[1] Most of these renditions have been variations on the earliest ballad dating back to the sixth century. The terse, moving poem depicted a young woman of the Northern Dynasties era (ca. 386–581 CE) who offers to perform military service on behalf of her ailing father, dons the uniform of a male soldier, spends more than a decade away at the battlefront, wins recognition with victories that help save the empire, and finally returns home where she sheds her disguise.[2]

This essay explores some of the major filmic incarnations of Mulan that emerged at three critical moments in the history of twentieth-century China: during the Nationalist revolution of the 1920s, through the war with Japan in the 1930s–40s, and into the decades following China's civil war. Retelling the legend in period costume, filmmakers embellished the original narrative to suit their own present-day circumstances, alluding to some of the most intense cultural changes and political conflicts in contemporary China.

The cinematic "modern Mulans" emerged in the interstices of debates over gender, modernity, and the changing relationships among individual, family, and state in early-twentieth-century China. The "New Woman" (*xin*

nüxing) often appeared in newspapers, magazines, films, and songs of the 1920s and 1930s for her aspirations to equality with men in education, employment, and political representation, while "modern girls" (*modeng nülang/modeng guniang*) were figured in Chinese advertising and modern media as glamorous, urban, mobile, and often westernized consumers. For both, self-determination and freedom to choose a marriage partner were often highlighted.[3] The term *modern woman* (*modeng nüxing*) was less common but could bring together various qualities from this spectrum. The modern Mulans, likewise, could be upright and strong, like the New Woman, as they took on responsibilities beyond the home, yet they were also played by stars in the mass medium of film and pictured in popular magazines alongside the array of activities, products, and role models being marketed to modern girls. All the while, the modern Mulans also demonstrate filial care for their parents.

The films developed fresh subplots and characters to reflect a more complex range of motivations and emotions for Mulan, placing much more emphasis on her self-invented identity and the range of her experiences at war away from home. While retaining the classic Mulan themes of self-sacrifice, filial piety, martial skill, and loyal service, the filmmakers introduced new ideas about gender equality, romance, authority, politics, and espionage. Epitomizing the broader cultural negotiations between tradition and modernity in post-imperial China, the new Mulans dramatized the dilemmas faced by teenage girls aspiring to leave their homes to join the revolution or to become independent women in the city.

As a narrative of disguise, in which the central character is a kind of performer, the Mulan tale was especially well suited to interpretations on stage and screen. The element of gender masquerade held special interest for modern dramatists and filmmakers. Peking opera troupes had long used male actors to play all the characters, including Mulan. In fact, the first known filmed interpretation of Mulan was a short opera segment performed by the famed actor Mei Lanfang in 1924.[4] But with the rapid rise of the female movie star as a new social phenomenon in early-twentieth-century China, feature films deployed a range of publicity mechanisms and cinematic devices to reconfigure the legend. Actresses such as Li Dandan (1912–98), Chen Yunshang (1919–), and Ivy Ling Po (aka Ling Bo, 1939–) each transformed the figure of Mulan anew through their star images and screen performances.

The earliest feature films based on the Mulan legend were produced in

Shanghai in 1927–28 and released within months of each other at the height of the military Northern Expedition to subdue China's regional warlords and unify the new republic. The action of the era reverberated throughout the film industry, with Shanghai film companies competing to produce martial arts films and historical dramas based on Chinese popular fiction and legends. The Mulan features emerged in this context, amid roaring debates over gender roles, Confucian patriarchy, and filial piety in China, stimulated by the New Culture Movement of the 1910s–20s and the expanding range of modern media. Of all the films under discussion in this essay, only the 1920s works are no longer extant; however, by consulting contemporary synopses printed in playbills, reviews, news reports, biographies, and production and publicity stills, we can glean valuable information about these films—their production, stars, and narrative emphasis.

The first Mulan feature film to be released was *Hua Mulan Joins the Army* (*Hua Mulan congjun*, 1927), from Tianyi studios, which specialized in action films. Although the director Li Pingqian and cinematographer Wu Weiyun were fairly experienced, the scriptwriter Liu Huogong and the actress playing Mulan, Hu Shan, were both newcomers. Tianyi added several narrative threads that depart from the original ballad. This version showed Mulan facing the dilemma of choosing between family and patriotism. Here, at the outset, Mulan is already betrothed to a young man and their wedding day approaches when war interrupts. Each family receives government orders for military service, so the ceremony is put off until Mulan's fiancé returns. The filial Mulan also joins the army without telling the prospective groom.[5] The Tianyi film also gave substantial attention to Mulan's life on the battlefront, echoing the contemporary consciousness of female participation in China's contemporary revolution against the warlords.[6] These amplifications implicitly engage with cultural debates over love, marriage, family, and nation, showing young women and men deferring their own plans to serve the nation while allowing for some romantic and even comedic moments, as when Mulan encounters her fiancé in the army and he does not recognize her.

All the Mulan films would retain the "homecoming" narrative coda, but each embellished this scene differently. The 1927 Tianyi film emphasized Mulan's filial piety and the shock experienced by her fiancé when she finally reveals her story to him. This modern Mulan was one who could fool even the man to whom she was betrothed while achieving victory for her nation and honor for her family.

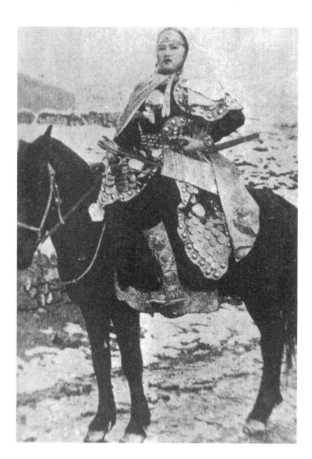

Fig. 16.1. Li Dandan
as Mulan on horse-
back in *Mulan cong-
jun* (Mulan Joins the
Army) (Minxin, 1928).

In 1928, the Minxin company released its own film *Mulan Joins the Army* (*Mulan congjun*), which had been in production two years before Tianyi's began. Unlike the Tianyi film, which was shot in just two weeks, Minxin's rendition benefited from substantial investments, distant location shoots, and accomplished talent. It was produced by Li Minwei, who was inspired to develop this feature after he had filmed the opera actor Mei Lanfang as Mulan some years earlier. Director-scriptwriter Hou Yao and lead actress Li Dandan (fig. 16.1) had worked together on several projects, including the successful costume drama film *Romance of the Western Chamber* (*Xixiang ji*, 1927), which even enjoyed a run in Paris.[7]

Li Dandan had experience transforming classics for the screen, but she had also played contemporary roles, and the studio publicized her as an agile and mobile modern girl.[8] This Mulan film highlighted various elements of that star image such as her swordsmanship and role as a loyal

family member. The film may even have been developed as a vehicle for Li Dandan; her own grandmother was named Mulan, and studio promoters accented Li's martial arts training by recounting a dramatic episode that apparently or apocryphally occurred during a location shoot, in which the actress on horseback pursued thieves and tossed them from a bridge into a river.[9]

Like Tianyi's *Hua Mulan Joins the Army,* Minxin's film devoted substantial attention to her activities on the battlefront and added a marriage scene. Hou Yao's script included a subplot in which Mulan is captured by the Xiongnu invaders. The barbarian chieftain forces his hostage Mulan to marry a girl in the court named Feixia, and Mulan plays along in order to buy time. The added scenario creates a narrative tension in which Mulan's female identity is in danger of being revealed in the intimacy of marriage, a tension that was often built into narratives of disguise across many cultures.[10] In the context of 1920s China, this subplot could have been received variously by audiences, either as a comedy of errors in which the "marriage" to a woman would be viewed as less threatening than one with a barbarian man (given that displays of female closeness, friendship, and sisterhood were often depicted in popular culture while encounters with strange men were considered dangerous threats to chastity) or as a titillating curiosity (since imported medical discourses on "same-sex love" [*tongxing'ai*] and native marriage practices such as concubinage were topics of intense debate in the urban media and academia).[11] Either way, the tension takes on added weight as Mulan also risks the future of her country, but after gathering information through Feixia she escapes to vanquish the barbarians and heroically prevails.

As if to offset the same-sex "marriage" subplot, Hou Yao expanded the ending to include a "proper" marriage for Mulan after she returns home. Her commander comes to call on the Hua family, and after overcoming his astonishment that this charming young woman is Mulan, he asks her father for her hand in marriage. If the normative ending was added to assert a more conventional Mulan, not all audiences found it credible. As one moviegoer commented, the film had not established any relationship or desire between the commander and Mulan, so a marriage between them seemed implausible.[12] This response offers a window into the ever-shifting values of the 1920s New Culture era, when many "new youths" believed that marriage should be based on romantic love rather than traditional betrothals and alliances arranged by parents. Despite this particular criticism of the ending, the Minxin picture opened in Shanghai in the summer of 1928 to

positive reviews and enjoyed critical success as an early effort at filming this important Chinese historical legend with high production values.

A decade later two more Mulan films were made. Once again it was during a period of military conflict, this time the War of Resistance against Japan, and much of coastal China was now under Japanese occupation. In this context, and from the pen of the revolutionary dramatist Ouyang Yuqian (1889–1962), Mulan became the agile defender of the nation in the 1939 film *Mulan Joins the Army* (*Mulan congjun*). This wartime film contained numerous thinly veiled references to China's struggle against outside invaders through the figure of Mulan.[13]

Mulan Joins the Army functioned as a star vehicle for Chan Wan-seung, a rising young Hong Kong actress who had already played in over a dozen Cantonese films, including costume dramas and contemporary films with patriotic and youth themes. In 1938, the Crown Colony was something of a haven from mainland politics and warfare, even viewed as a place of energy and worldly sophistication, so when the actress went to Shanghai that year for her debut in Mandarin films, she was promoted as a cosmopolitan "southern movie queen" wearing Western attire and a garland in her hair.[14] If, as film historian Paul Fonoroff has suggested, Chan Wan-seung was "the only Hong Kong star to successfully crossover into mainland," then the Mulan role was a fascinating way of initiating that crossover.[15] Just as Chan left the "south country" of Hong Kong to move north to Shanghai and be transformed into a Mandarin movie star, now dubbed Chen Yunshang, so the Mulan character she plays is a southerner ("I hail from Fuzhou") heading north and ultimately returning home in success.

The film begins with scenes that highlighted the same star image cultivated by the studio. Mulan appears outdoors, an archer on horseback, pictured from a low angle against the sky. At home, she is an obedient daughter who fulfills expectations of "feminine" virtue and performs women's work such as weaving. In persuading her father to allow her to go to war on his behalf, Mulan emphasizes filial piety and loyalty but also strength and gender equality: "Father taught me martial skills from youth. Staying at home is of no use; it can't compare to serving the army in father's stead." This modern Mulan aspires to action and achievement beyond the home.

In this film version of Mulan, we see a strong emphasis on identity as performance and on the importance of gesture in acting, thanks to scriptwriter Ouyang Yuqian, a famed *dan* (opera actor specializing in female roles) who also had experience writing for silent film. Several scenes in the film evoke Peking opera and silent films, as when Mulan performs a dance-

like series of martial poses before her parents to demonstrate her skill as a warrior (fig. 16.2). The high artifice and gesture here, stylistically aligning the female film star with *dan* opera performers, as well as silent-film stars, underscore the moment of Mulan's visible gender transformation.

Yet crucially this was a sound film—in fact, the first such rendition of Mulan—and it audibly rehearsed Mulan's vocal metamorphosis. Her maneuvers may be impressive, but the young woman's father is not fully convinced, declaring, "You do *look* like a fellow, but your voice . . ." Taken aback, Mulan redoubles her efforts. Late at the night, framed by her bedroom window, Mulan looks out into the darkness and deeply intones patriotic poetry, punctuated by a single word of determination: "Shaaaa!" (Kill!). The transformed *voice* of Mulan articulates—in aestheticized, poetic form—a deadly threat.

Throughout these scenes, the film repeatedly puts *performance itself* on display. In a key addition for this film, the soldier Mulan dons yet another costume and persona when she and a military colleague, Liu Yuandu, are ordered to gather intelligence about their opponents. Mulan urges Liu to dress up as a barbarian hunter and cross enemy lines. Unaware that Mulan

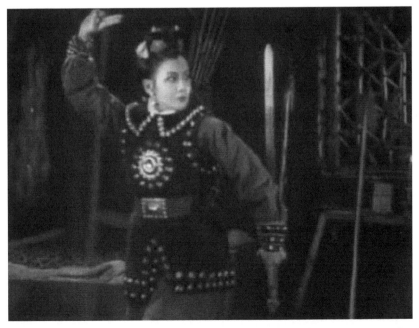

Fig. 16.2. Chen Yunshang as Mulan performing martial arts, opera style, in *Mulan congjun* (Mulan Joins the Army) (Huacheng, 1939).

is in fact a woman, Liu makes his own suggestion: "What about you? You would do well dressed up as a barbarian girl." For the film audience with inside knowledge of the disguises already in play, the conversation might suggest a comedy of errors. But Mulan is serious about her mission. Determined to maintain her credibility as a loyal soldier, she agrees "to pretend to be" a woman for the purposes of espionage in the country's strategic interest.

This new disguise brings Mulan precipitously back to her own gender but now with a different ethnicity. Wearing the bulky fur hats and robes of a "barbarian couple," she and Liu move across the otherworldly desert terrain in a strange masquerade. The scene draws our attention back to the layers of disguise; the southern star Chen Yunshang—as a Shanghai actress—plays the filial daughter Mulan playing a male soldier now playing a barbarian woman. Mulan uses her added layer of costuming to infiltrate the enemy forces, seducing two men with a coy song until they reveal the location of their troops, then promptly doing away with them and stabbing another guard (fig. 16.3). The visceral violence of these moments is even more striking when juxtaposed with the singsong act in "barbarian" costume, boldfacing Mulan's courage and physical strength.

Fig. 16.3. Chen Yunshang as Mulan, in double disguise as a "barbarian" woman, stabbing the enemy in *Mulan congjun* (Mulan Joins the Army) (Huacheng, 1939).

The film does not let us forget the analogy between Mulan's cross-gender disguise and opera acting. While her commander is impressed with the intelligence on the enemy, his traitorous adviser attempts to discredit Mulan by likening the soldier to a *dan*. The adviser's apparent derision of Mulan only proves how effective her disguise really is. Here, through irony, Ouyang's script confronts and defuses the traditional contempt for actors (itinerant performers and *dan* actors were likened to prostitutes, ranking low in imperial China's social hierarchy) and valorizes the act of impersonation as much more than mere entertainment.

The many references to acting within this rendition, as scripted by Ouyang Yuqian, give the film a self-reflexive quality. The figure of Mulan, in her cross-gender disguise, could be seen as a stand-in for actors, writers, and filmmakers in "Orphan Island" Shanghai or for any other contemporary Chinese who might be involved in the underground resistance against the Japanese occupation. Couched in the heroic legend of Mulan, these episodes suggest that assumed identities, and performance itself, are not necessarily just "playing along" with the enemy but can function as subterfuge, serving the national good.

Director Bu Wancang foregrounds the figure of Chen Yunshang in classic Hollywood style, presenting her in isolated shots and close-ups with a soft-focus glow whether she is in female clothing or male military regalia. Chen Yunshang is paired with the matinee idol Mei Xi, as Liu Yuandu, who gets similar treatment: light shimmering on armor, and generous close-ups. Visual cues like these project the image of Mulan and her colleague as an ideal couple despite her costume. Ouyang Yuqian once commented that he added the romantic subplot between Mulan and her fellow soldier Liu Yuandu to raise the audience's spirits in wartime.[16] As in the earlier films, this subplot adds tension to her experience at the battlefront and dramatizes an element of female desire that is not at all present in the original work.

These stylistic touches may undercut the image of Mulan as powerful, capable soldier; yet the film never shies away from that incongruity, even calling attention to it by including characters who see Mulan as an effeminate guy. After Mulan shows "his" martial talent in three years of battle and is promoted to general, they still comment on Mulan's femininity and seem dopily enamored with "him." At these moments, such figures function as metaobservers within the diegesis, sensing and articulating what the film spectator already knows. While this comes perilously close to exposing Mulan's true identity, any such threat is defused through comedy. Once

again star images take over—the taunting soldiers are played by Shanghai's famous film slapstick duo Liu Jiqun and Han Langen—and here, again, the film delights in foregrounding the layers of playacting.

Produced amid an ongoing military conflict, the 1939 *Mulan* is almost entirely concerned with Mulan's life on the battlefront; her homecoming, by contrast, concludes quickly, in just five minutes. Mulan's transformation from soldier back into young woman is accomplished visibly yet efficiently through special effects. Entering her bedroom in her military uniform, Mulan looks in the mirror, and we watch warrior dissolve into maiden. The moment of visual spectacle presents the protagonist in both of her personae at once, simultaneously highlighting the glamorous image of the actress Chen Yunshang. Mulan's mother reports that marriage proposals are pouring in as news of her heroism, piety, and loyalty spreads far and wide.

But this modern Mulan has a mind and voice of her own, indicating to her mother that she has chosen her own partner. Using her masculine voice, she calls out to Liu Yuandu, who is waiting outside with their colleagues. As he calls back in response, Mulan's mother approves, and Mulan sashays out in women's dress, greeting the soldiers. In this moment of revelation, a reverse shot and close-up magnifies Liu Yuandu's shock as he realizes that "General Mulan" was a woman all along. As in the earlier films, marriage ensues. The normative resolution seems designed to suggest that joining in the war effort or working underground using an assumed identity will not threaten society or diminish a woman's eligibility. But in presenting the marriage as Mulan's choice, it suggests that her wartime experiences have only enhanced her prospects and allowed the young woman a vivifying measure of self-determination.

This wartime film had a mixed reception that echoed the complex political divisions in wartime China. In Shanghai, when *Mulan Joins the Army* premiered at the fashionable new Astor Theater at the time of the Lunar New Year in February 1939, it was a box office triumph.[17] With much allegorical power granted to history and legends in China, the film's patriotic message was clear to audiences. Lavish publicity and high production values also helped. The romantic duet between Liu Yuandu and Mulan became a hit record, prompting the Huacheng studio to capitalize on Chen Yunshang's singing voice by casting her in two musicals, even naming one of the films *The Divine Yunshang* (*Yunshang xianzi*) after her. Yet in the interior zones, some were angered by the film's romantic subplot and comedic moments and staged a burning of the film, criticizing the studio

for demeaning the military.[18] Notwithstanding these reactions, the Mulan story had a transcendent quality. Ouyang Yuqian's script was published as a play a month after the film's opening and staged as a spoken drama by propaganda theater troupes traveling through China with the goal of mobilizing the masses and "shaming" men into action.[19] The 1939 mainland Mulan was soon mirrored back in Hong Kong; a Cantonese-dialect production was released later that year, *also* starring Chen Yunshang.

The third wave of Mulan films was produced in a divided China, after the founding of the People's Republic in 1949. With Nationalist Taiwan and colonial Hong Kong separated from the socialist mainland during the Cold War, each locale produced its own new versions inflected with regional music and dialects: a Cantonese musical film of Mulan produced in Hong Kong in 1950–51,[20] a Henan opera version released in mainland China in 1956, and an Amoy-dialect film titled *Mulan Joins the Army* (*Mulan congjun*) made in Taiwan in 1960–61 and starring Malaya-based actress Ding Lan.[21]

But perhaps the most significant postwar Mulan film was the 1964 Mandarin-dialect Huangmei opera rendition *Lady General Hua Mu-lan* (*Hua Mulan*) from Shaw Brothers. This high-profile Hong Kong production succeeded in part because of its continuities with prewar Shanghai cinema. Shaw Brothers, seeking to extend its reach beyond the Cantonese film market in Hong Kong and elsewhere, was making films like *Lady General Hua Mu-lan* in standard Mandarin dialect to serve the expanding commercial film market in Taiwan and abroad. Key members of the cast and crew for *Lady General Hua Mu-lan* were veterans from the "golden age" of Shanghai cinema, giving the film a powerful resonance with a Taiwan moviegoing audience comprised of mainland émigrés. It was directed by "Griffin" Yue Feng, who had started out in 1930s Shanghai making melodramas and then moved to Hong Kong, where he specialized in period epics and opera films with strong female leads. In true Shanghai style, Yue Feng foregrounded the star playing the role of Mulan, Ivy Ling Po. He also cast a former Shanghai star, Chen Yanyan, in the part of Mulan's mother. Chen had lead roles in some of the greatest hits of 1930s Shanghai cinema. Her strong star presence would have resonated for film audiences who still remembered her reputation for playing sweet, romantic, energetic, and defiant modern women who were ultimately conscientious and filial. Casting Chen Yanyan in the 1964 production self-consciously linked the new postwar Hong Kong film world to its glamorous Shanghai predecessor. And Shaw Brothers, as the Hong Kong successor to Shanghai's Tianyi studios,

was in some ways returning to a subject it had first filmed more than thirty-five years earlier.

Yet this version was also informed by new political circumstances, cinematic innovations, and changes in popular culture. The memory of contemporary warfare on the mainland is still powerful in this Hong Kong film. Scenes of crowds fleeing the invaders, leaving behind homes, and roaming as refugees would have struck a chord with contemporary audiences who had fled the mainland for Taiwan and Hong Kong. This Mulan joins the army to protect her family and rescue her homeland from destruction.

The film was performed in the Huangmei (literally, Yellow Plum) opera style in vogue during the 1960s among émigrés from the mainland. The simple, catchy tunes and clear Mandarin ensured that Huangmei operas were accessible and memorable to midcentury audiences accustomed to modern pop songs and musicals, while the form's emphasis on conveying emotion allowed greater self-expression and voice to characters, as when Mulan sings her inner feelings.

As in the earlier Mulan films, the star cast as Mulan was given center stage, but Ling Bo possessed a star image distinct from that of any of her predecessors. She had won acclaim for her first acting role in the Huangmei opera film rendition of the classic romance *The Love Eterne* (*Liang Shanbo yu Zhu Yingtai,* 1962–63), in which she played the lead male role. In that opera, the female protagonist, Zhu Yingtai, disguises herself as a man so she may study at the Confucian academy; there she becomes enamored with a male classmate, Liang Shanbo, who never realizes that Zhu Yingtai is a woman until the very end. Ling Bo's cross-gender performance as the talented male scholar Liang was deemed so successful that fans in Taiwan immediately dubbed her "Brother Liang," and the Golden Horse Film Festival created a special gender-neutral award of "Best Performer" specifically for Ling Bo. In many ways, *Lady General Hua Mu-lan,* depicting Mulan's transformation from young woman into a capable soldier, furnished the perfect vehicle for Shaw Brothers to showcase Ling Bo's gender-crossing star image (fig. 16.4).

Whereas the 1939 film had negotiated between Chen Yunshang's glamorous modern woman star persona and the masculine disguise of Mulan, the 1964 film shifted its focus to Mulan's—and Ling Bo's—virtuosity in crossing gender roles. The opening section of *Lady General Hua Mu-lan* depicts Mulan on the home front moving between activities and spaces conventionally characterized as "masculine" and "feminine" in China. In fact, she seems decidedly more confident outdoors as the skilled hunter

Fig. 16.4. Ivy Ling Po as Mulan in the Huangmei opera film *Hua Mulan* (Lady General Hua Mu-lan) (Shaw Brothers, 1964).

on horseback; indoors she plays the filial daughter weaving cloth, but she frowns, drops the shuttle, and devises a plan for obtaining military gear.

Ling Bo's Mulan manages to convince nearly all the men in this film that she is a man just like them, including when she speaks on behalf of women. When she tries out her disguise as a young soldier and talks with her father about the importance of both men and women fighting for their country, even he does not recognize Mulan. He agrees that there should be "no distinctions between men and women," echoing the gender equality slogans of the May Fourth era, popularized in songs and films such as *The New Woman* (1935). She passes for a man by drinking socially with the group of soldiers,[22] and when they joke and complain about women, Ling Bo as Mulan as soldier retorts by singing the praises of women. Mulan's defense of women takes the soldiers by surprise, and they cannot exactly argue against the high ground of Confucian "good wife, wise mother" ideals. The scene has a tongue-in-cheek irony, of course, for Mulan is asserting all the conventional notions of Confucian gender roles even as she herself is subverting them.

As "convincing" as this Mulan is, her protective mother doubts that the disguise will succeed. Here casting a celebrated actress like Chen Yanyan as Mulan's mother gave new emphasis to this character in the narrative. She twice admonishes Mulan, "No girl can join the army" and seems to see only her daughter's female identity even when Mulan is in disguise. At several junctures, Mulan's disguise comes close to exposure, as when she is injured in battle or drunk at the postwar celebration. The narrative solution in this film, as in several twentieth-century prose versions, was to include an additional character, a male cousin named Hua Ming, who covers for the temporarily helpless Mulan at these awkward moments. Hua Ming serves as a kind of chaperone in the narrative—reassuring conservative audiences who might be concerned about young women going out into the world alone—and even functions as a kind of stand-in for the film spectator, bearing privileged knowledge of Mulan's identity.

This version included a subplot in which Mulan begins to admire a comrade-in-arms, named Li Guang, who returns the great admiration for his fellow soldier. The dramatic irony of Mulan's gender-crossing and her expression of emotion are amplified by the particularities of the Huangmei opera form, as Mulan articulates her own romantic desires in several solos and duets. This Mulan privately struggles to suppress her feelings and maintain her soldier persona without revealing her sentiments to Li Guang until well after war's end.

In this 1964 film, Mulan's troops engage in victorious combat on the battlefield, and her commander proposes rewarding the noble warrior Mulan with his own daughter's hand in marriage. The awkward moment presented another comedy of errors and echoed some earlier film versions, including Minxin's. Here, without revealing her identity or offending the friendly, paternalistic commander, Mulan attempts to decline his offer, citing respect for her own parents' arrangements. By invoking filial piety, Mulan temporarily defuses the situation while keeping open the possibility of a future love match with Li Guang. Since she cannot yet reveal to him that she is really a woman, Mulan sings a cryptic, playful Huangmei duet with Li: "*You* could be my wife, if you were a woman. . . . If you won't change, then I'm more than willing. You will marry me if you change, and I'll marry you if I change. That will be a true affectionate relationship."

The gender-crossing in this and other films starring Ling Bo has been interpreted variously over time and among audiences. Some regard Ling Bo's films as playful, innocent amusements with no other subtext, while others find "queer" elements throughout the films' "double entendres,

euphemisms, and sexual innuendoes."[23] *Lady General Hua Mu-lan* may be all these things at once. Like other twentieth-century filmic versions, it thematized Mulan's gender-crossing as a kind of performance, self-reflexively delighting in the protagonist as actor. The film added more plot details to elaborate on the constant negotiation between varying layers of knowledge about Mulan's "true" identity on the part of characters and audience. Combined with Ling Bo's star image as a male impersonator, the playful tone of this film magnified the audience's consciousness of the layers of gender disguise and (mis)recognition. The Huangmei opera form took the story even further beyond realism. And in keeping with the 1960s Shaw Brothers style, the studio presented the story as a cinematic spectacle in full-color, dazzling "Shawscope."

In the denouement of *Lady General Hua Mu-lan*, Mulan goes home after twelve years at the war front. Whereas the 1939 version presented her transformation via special effects, the 1964 film elides that process and Mulan's return to female identity is simply a fait accompli thanks to Ling Bo's versatile star image. Her return to domesticity and feminine dress might suggest a conservative, "normalizing" resolution to the narrative scenario of gender-crossing, but the Shaw film also made gestures to the contemporary expectations of young women who had gained greater mobility and independence by the 1960s. This modern Mulan retains her skill and status even on the home front, and steadfastly resists arranged marriage alliances. A concluding cycle of songs in the final scene draws attention to Mulan's/Ling Bo's virtuosity, invoking the artifice of opera at the heart of this adaptation. Addressing Li Guang, who has come bearing betrothal gifts on behalf of his commander, the now feminine Mulan playfully mocks Li Guang in a song that compares him to the legendary scholar Liang Shanbo, who never recognized that his classmate Zhu Yingtai was a woman disguised as a man. Contemporary audiences would have gotten the in-joke, recalling that Ling Bo had just played the male role of Liang Shanbo the previous year. Evoking the playfulness of the modern girl along with the resolute determination of the New Woman, this Mulan rejects the commander's gifts and instead exchanges promises and love tokens with her chosen ideal partner at the end of the film. This Shaw Brothers film added new, self-reflexive elements to the Mulan narrative of cross-gender performance by casting a female movie star who was known for male impersonation. The Mulan role confirmed Ling Bo's versatility as a performer, winning her the Best Actress Award at the Eleventh Asian Film Festival in 1964.

<center>∗ ∗ ∗</center>

Each successive Mulan film consolidated and expanded on the versions that preceded it, inflected by ideas and images about the New Woman and the modern girl in twentieth-century China. The films employed dramatic irony in new ways, building on the "narrative of disguise" conventions of earlier and contemporary texts (literary, illustrated, or theatrical), which situated the reader as an informed insider.[24] Mulan's changes in gender identity are presented as powerful and threatening but also permissible in the service of nation building and salvageable through marriage. The filmic Mulan in each case was inflected with the star image of the actress who played her, even as these motion pictures were also integrally linked to the shifting political and social history of China.

The role of Mulan, in turn, transformed the lives and careers of these actresses. Li Dandan gave up movie acting shortly after making the 1928 film, but the action-oriented Mulan role recurrently echoed through the rest of her life as Li crafted distinct new identities. She became the wife of a diplomat, traveled afar to Europe and America, and named her own daughter Mulan; later, as a trained airplane pilot, Li gained a commission from the Nationalists and used her unusual mobility and skills to help support the Chinese war effort against Japan, performing air shows in the aptly named planes *The Spirit of New China* and *Estrella China* (fig. 16.5).[25] Chen Yunshang went on to make dozens of films in Shanghai and Hong Kong, including historical dramas and contemporary musicals. Like her Mulan character, she returned south after much success. For perhaps the most interesting twist of art into life, Ling Bo actually went on to marry the actor who had played Li Guang to her Mulan. She starred in many more Huangmei films as the male lead until 1969, branching out into related roles and other genres on the screen and stage, including martial arts, contemporary subjects, costume dramas, television, and even live tours. Based on her success as Mulan, Ling Bo later played other woman warrior figures, including the famed Song dynasty general Mu Guiying.

Alongside these female stars and their charged personal histories, the Mulan films *as films* deepened and transcended prior renditions. Prose accounts from the imperial period onward had embellished the Mulan legend with plot elements that hinged on anxieties and desires related to sex and gender identity, as Joseph Allen, Louise Edwards, and others have shown.[26] These anxieties were dramatized even more compellingly in the films. The photographic image and recorded voice of the female star embodying Mulan—inevitably magnified and amplified in motion

Fig. 16.5. Li Dandan (Li Xiaqing) with the *Estrella China*, 1940.

pictures—introduced something of a new imperative to establish the cred-
ibility of Mulan's image as a male soldier and to locate drama and comedy
in the constant threat of exposure. In the extant films, we see the "shock
of recognition" close-ups, zooms, and special effects showing the protago-
nist's physical transformation and the reactions she elicits, all presented in
a succession of scintillating, parallel cinematic moments. Yet, while textual
depictions of Mulan appear to shift over time away from the "sartorial" to
the "somatic," as Allen argues—away from descriptions of her clothing and
dress toward a greater concern with the body itself—the Mulan films we

have examined from the 1920s through the 1960s show a continuing concern with *both* the somatic and the sartorial. The Mulan themes of disguise and performance, enacted in the context of mass media representations of modern girls and New Women, activated an acute awareness of roles and playacting when adapted to film.

In twentieth-century print and film accounts, much as in earlier sources, Mulan always returns to her family, transforms back into the female role where she began, and even marries. As noted in our discussions of the homecoming scenes, these endings might be interpreted as conservative returns to convention and as reassertions of clear, rationalized gender identities. Louise Edwards comments that tales about woman warriors in the mid–Qing dynasty (1644–1911) endorsed the virtues of filial piety, loyalty, and patriarchal discourse with "an almost robotic adherence to Confucian morality."[27] Joseph Allen sees the endings as definitive, making Mulan a story of return to domesticity.[28] Poshek Fu notes that in the context of wartime such endings could be reassuring for audiences that might have feared that serving the nation, or even just wearing men's clothing, might dislocate society.[29] Certainly even Hollywood films featuring independent women, especially those produced during wartime, often end with some kind of "'climb-down' on the part of the star," as Richard Dyer notes in his classic book on the subject, *Stars*.[30]

But does an ending fully determine the overall meaning of a film? As Dyer points out, the "climb-down" resolutions of the Hollywood films are, in fact, usually less memorable than the striking independence of the character and the star, which still dominate the core of the film.[31] This is a useful observation. While endings may frame the narrative in a particular manner, other elements of a film can play an equally strong—or stronger— role in its overall meaning. Modern accounts of Mulan, whether in print or on film, generally devoted much more attention to her life on the war front than the early ballad did.[32] Whereas the original sixth-century version described the war front in no more than a third of the ballad, the extant films inverted that balance, vividly dedicating 70 to 80 percent of film time to Mulan's life *away* from home, her initiative, mobility, patriotism, loyalty, talent, skill, quick wit, and equality with men. All these qualities persist into the homecoming conclusions.

The Mulan films from the 1920s to the 1960s played out the legend as a tale about acting and performance with much self-reflexivity and dramatic irony. The magnified photographic moving image and amplified voice of each actress who played Mulan, combined with her modern star image,

lent the films a sensory impact that counterbalanced, if not transcended, the conventionalized homecoming resolution of the narrative. As in many early-twentieth-century Chinese films, traditional values are at once tested and maintained, subverted and fulfilled, exposed and endorsed. Some aspects of these Mulan films may be found in other motion pictures about modern female soldiers (such as *The Red Detachment of Women*, 1960–61), suggesting that women "can have it all"—heroism, a love match, devotion to country and family—provided they dress, speak, and act as men. The male characters in the Mulan films, by contrast, are often presented as unobservant and easily duped. Other aspects of the films lead straight to the glamour of stars such as Maggie Cheung, Brigitte Lin, Gong Li, and Zhang Ziyi, asserting that the actress, too, "can have it all": convincing performances, successful star vehicles, and legendary status.

In the late twentieth century and into the twenty-first, the figure of Mulan continues to reappear on film in various guises through two Disney animations, television serials, and additional feature films. Intense competition among top mainland and Hong Kong actresses for the lead role in a new big-budget, live-action film rendition points to the enduring, magnetic power of the Mulan legend for filmmakers. With the rising mainland star Vicki Zhao Wei—known for her roles in the historical action film *Red Cliff* (*Chibi*, 2008) and the supernatural thriller *Painted Skin* (*Huapi*, 2008)—cast in the lead, another Hua Mulan has now emerged for a new era and a new China.

Filial, self-assertive, feminine, martial: the multiplicity of Mulans, embodied by female film stars Li Dandan, Chen Yunshang, and Ivy Ling Po, lingers in these afterimages.

Notes

A longer version of this essay was presented at the annual meeting of the Association for Asian Studies, Atlanta, in April 2008. For their insightful comments I wish to thank Tze-lan Sang, Louise Edwards, Robert Polito, Jeremy Taylor, and the students in my seminars at the State University of New York at New Paltz and the University of Chicago.

Abbreviations

ZGDYFZS: *Zhongguo dianying fazhanshi* (History of the Development of Chinese Cinema), ed. Cheng Jihua, Li Shaobai, and Xing Zuwen, vol. 1 (Beijing: Zhongguo dianying chubanshe, [1963] 1980).

ZGWSDY: *Zhongguo wusheng dianying* (Chinese Silent Film), ed. Zhongguo dianying ziliaoguan (Beijing: Zhongguo dianying chubanshe, 1996).

ZGWSDYJB: *Zhongguo wusheng dianying juben* (Chinese Silent Film Scenarios), ed. Zheng Peiwei and Liu Guiqing (Beijing: Zhongguo dianying chubanshe, 1996).

ZGYPDD: *Zhongguo yingpian dadian: Gushipian xiqupian, 1905–1930* (Encyclopedia of Chinese Films: Narrative Films and Theatrical Films, 1905–1930), ed. Zhongguo dianying ziliaoguan (Beijing: Zhongguo dianying chubanshe, 1996).

1. See, for instance, Qiu Jin's novella *Stones of the Jingwei Bird* (1905–7) and Xie Bingying's *War Diary* (1928), both excerpted in *Writing Women in Modern China*, ed. Amy Dooling and Kristina Torgeson (New York: Columbia University Press, 1998); and Joan Judge, *The Precious Raft of History: The Past, the West, and the Woman Question in China* (Stanford: Stanford University Press, 2008), chap. 5.

2. This original *yuefu* ballad, "Ode to Mulan," remains the best-known version; for the translation, see Hans Frankel, *The Flowering Plum and the Palace Lady: Interpretations of Chinese Poetry* (New Haven: Yale University Press, 1976).

3. Kristine Harris, "*The New Woman* Incident: Cinema, Scandal, and Spectacle in 1935 Shanghai," in *Transnational Chinese Cinemas: Identity, Nationhood, Gender*, ed. Sheldon Hsiao-peng Lu (Honolulu: University of Hawai'i Press, 1997), 277–302; Louise Edwards, "Policing the Modern Woman in Republican China," *Modern China* 26, no. 2 (2000): 115–47; Sarah Stevens, "Figuring Modernity: The New Woman and the Modern Girl in Republican China," *NWSA Journal* 15, no. 3 (fall 2003): 82–103; Modern Girl Around the World Research Group (Alys Eve Weinbaum, Lynn M. Thomas, Priti Ramamurthy, Uta G. Poiger, Madeleine Yue Dong, and Tani E. Barlow), eds., *The Modern Girl Around the World: Consumption, Modernity, and Globalization* (Durham: Duke University Press, 2008).

4. ZGDYFZS, 104.

5. ZGWSDYJB, 1601–2; ZGYPDD, 119–20.

6. On the role of women in revolution during this period, see Christina Gilmartin, *Engendering the Chinese Revolution: Radical Women, Communist Politics, and Mass Movements in the 1920s* (Berkeley: University of California Press, 1995).

7. See Kristine Harris, "*The Romance of the Western Chamber* and the Classical Subject Film in 1920s Shanghai," in *Cinema and Urban Culture in Shanghai, 1922–1943*, ed. Yingjin Zhang (Stanford: Stanford University Press, 1999), 51–73.

8. *Minxin tekan* July 1, 1926; Yang Cun, *Zhongguo dianying sanshi nian* (Thirty Years of Chinese Cinema) (Hong Kong: Shijie chubanshe, 1954), 47; Patti Gully, *Sisters of Heaven: China's Barnstorming Aviatrixes: Modernity, Feminism, and Popular Imagination in Asia and the West* (San Francisco: Long River Press, 2008), 122–37.

9. Gully, 117–22; 130–31.

10. See Marjorie Garber, *Vested Interests: Cross-Dressing and Cultural Anxiety* (New York: Routledge, 1992).

11. See Frank Dikotter, *Sex, Culture, and Modernity in China* (Honolulu: University of Hawai'i Press, 1995); and Tze-lan Deborah Sang, *The Emerging Lesbian: Female Same-Sex Desire in Modern China* (Chicago: University of Chicago Press, 2003), chaps. 2–3.

12. "Cong *Mulan* shuo dao guzhuang pian" (On Mulan and Costume Dramas), *Minguo ribao Dianying zhoukan*, June 17, 1928, reprinted in ZGWSDY, 1178–79; and ZGYPDD 178–79.

13. See Poshek Fu, "Mapping Shanghai Cinema under Semi-Occupation," in *Between Shanghai and Hong Kong: The Politics of Chinese Cinemas* (Stanford: Stanford University Press, 2003), 1–50, esp. 11–15.

14. Zhang Wei, *Qianchen yingshi: Zhongguo zaoqi dianying de linglei saomiao* (Dust of Bygone Movies: Another Type of Sweep through Early Chinese Cinema) (Shanghai: Shanghai cishu chubanshe, 2004), 157; "Chen Yunshang dihu huaxu" (Tidbits about Chen Yunshang's Arrival in Shanghai), *Mingxing* 7 (January 1, 1939). Also see Fu, 13–14.

15. Paul Fonoroff, *Silver Light: A Pictorial History of Hong Kong Cinema, 1920–1970* (Hong Kong: Joint Publishing, 1997), 38.

16. Ouyang Yuqian, *Dianying banlu chujia ji* (My Film Career) (Beijing: Zhongguo dianying chubanshe, 1962), 36, cited in Chang-tai Hung, *War and Popular Culture: Resistance in Modern China, 1937–1945* (Berkeley: University of California Press, 1994), 73.

17. Fu, 11–15.

18. Ibid., 44.

19. Hung, 72–74, 76–77, 314–15.

20. This version starred Yam Kim-fai and premiered on December 29, 1951. "*Lady General Fa Muk–lan*," in *Hong Kong Filmography*, vol. 3, *1950–1952* (Hong Kong: Hong Kong Film Archive, 2000), 341.

21. "Ding Lan liang xinpian: *Mulan congjun* yu *Qian zuo guai*" (Two New Films by Ding Lan: *Mulan* and *From Riches to Rags*), *Dianying zhoubao* (Singapore) November 5, 1960, 2. My thanks go to Jeremy Taylor for this reference.

22. As Tan See-Kam points out in his interesting discussion of Ling Bo's films, drinking would be a "marker of masculinity." See Tan See-Kam, "Huangmei Opera Films, Shaw Brothers, and Ling Bo: Chaste Love Stories, Genderless Cross-Dressers, and Sexless Gender-Plays?" *Jump Cut: A Review of Contemporary Media* 49 (spring 2007): 3, http://www.ejumpcut.org/archive/jc49.2007/TanSee-Kam/index.html.

23. For the former argument, see Peggy Hsiung-ping Chiao, "The Female Consciousness, the World of Signification, and Safe Extramarital Affairs: A 40thYear Tribute to *The Love Eterne*," trans. Stephen Teo, in *The Shaw Screen: A Preliminary Study*, ed. Wong Ain-ling (Hong Kong: Hong Kong Film Archive, 2003). Also see Rick Lyman, "Watching Movies with Ang Lee: Crouching Memory, Hidden Heart," *New York Times*, September 3, 2001. For the latter argument, see Tan, 1.

24. On the earlier texts as "narratives of disguise," see Joseph R. Allen, "Dressing and Undressing the Chinese Woman Warrior," *positions* 4, no. 2 (fall 1996): 355, 367, 378. On Qing dynasty versions, see Louise Edwards, *Men and Women in Qing China: Gender in the Red Chamber Dream* (Leiden: Brill, 1994), 87–112.

25. Gully, 165, 178.

26. Allen, 353, 355, 363, 367, 371. Allen examines print versions from the imperial

era, as well as illustrated editions from Taiwan published in the mid- to late twentieth century. Also see Edwards, *Men and Women in Qing China,* 87–112. On the same issue in Ling Bo films as viewed by the postwar Taiwan audience, see Tan, 1.

27. Edwards, 97, 102, 112.

28. Allen, 346–47, 368, 373.

29. Fu, 20.

30. Richard Dyer, *Stars* (London: British Film Institute, 1998), 56–57.

31. Ibid., 56–57.

32. Allen, 353.

Contributors

Jan Bardsley (PhD, University of California, Los Angeles, 1989) is Associate Professor of Japanese Humanities and Chair of the Department of Asian Studies at The University of North Carolina–Chapel Hill. Her research explores gender politics in modern Japan. In 2001–2, with University of North Carolina professor Joanne Hershfield, she made the documentary video *Women in Japan: Memories of the Past, Dreams for the Future*. With Laura Miller, she coedited the book *Bad Girls of Japan* (Palgrave, 2005) and *Manners and Mischief: Gender, Power, and Etiquette in Japan* (University of California Press, 2011). Bardsley's book, *The Blue-stockings of Japan: New Women Fiction and Essays from* Seitō, *1911–1916* (Center for Japanese Studies, University of Michigan, 2007), includes translations of work by early Japanese feminists, while her current book project considers how such icons of femininity as the geisha, the princess, and the beauty queen were also viewed as symbols of women's liberation in 1950s Japan.

Matthew Biro is Professor of Modern and Contemporary Art and Chair of the Department of the History of Art at the University of Michigan. Originally trained as a continental philosopher, he came to art history through an interest in aesthetics and visual thinking. He is the author of two books, *Anselm Kiefer and the Philosophy of Martin Heidegger* (Cambridge University Press, 1998) and *The Dada Cyborg: Visions of the New Human in Weimar Berlin* (University of Minnesota Press, 2009), and his articles on modern and contemporary art and philosophy have appeared in *Art History, Yale Journal of Criticism, RES, Art Criticism,* and *New German Critique,* among others. He has published reviews of contemporary art, film, and photography in *Contemporary, Art Papers* and *New Art Examiner.*

Gianna Carotenuto is Visiting Assistant Professor of Art History at California State University, Long Beach. Her recent dissertation on the Indian zenana, "Domesticating the Harem: Reconsidering the Zenana and Repre-

sentations of Elite Women in Colonial Photography of India, 1830–1920,"
was completed in 2009 at the University of California, Los Angeles. Her
teaching and research interests include the art and culture of South Asia,
in particular the period of the nineteenth and early twentieth century, colo-
nial and modern photography, feminism, and postcolonial theory. Curato-
rial projects include "Celestial Gardens and Earthly Paradise: Symbolic
Landscape in Indian Painting" at the Los Angeles County Museum of Art
in 2004. Her forthcoming publications include "Masculinity and Domes-
ticity: Orientalizing Gender in the Nizam of Hyderabad's Zenana" in the
journal *Marg*, and "Remapping the Image of Empire: Lord Curzon's Tours
of 1902 Photographed by Raja Deen Dayal," for *A Photography Reader in
South Asia* (New Delhi: Yoda Press, 2011).

Melody Davis is Assistant Professor and Program Coordinator for Art His-
tory at the Sage College of Albany. Her dissertation, "Doubling the Vision:
Women in Narrative Stereography, the United States, 1870–1910" (Grad-
uate Center, City University of New York), treated the topic of women
as both subjects and patrons of stereoscopic photography. She received a
Henry Luce/ACLS fellowship for her research in the field. Besides pho-
tographic and print media, she studies contemporary art, and her publi-
cations include the book-length study *The Male Nude in Contemporary
Photography* (Temple University Press); articles in *Art Journal, History of
Photography, Part, Paragraph*, and *Millennium Film Journal;* and catalogs
for the Susquehanna Museum of Art. Her poetry has been the recipient of
fellowships from the National Endowment for the Arts and the Pennsylva-
nia Council for the Arts and has been widely published.

Kristine Harris is Associate Professor of History and Director of the
Asian Studies Program at the State University of New York at New Paltz
and recently also was a Visiting Associate Professor in Cinema and Media
Studies at the University of Chicago. Her article on the 1935 Chinese film
The New Woman and actress Ruan Lingyu was published in *Transnational
Chinese Cinemas* (University of Hawaii Press, 1997), and she contributed
an essay on the revolutionary work for stage and screen *The Red Detach-
ment of Women* to a special issue of *Opera Quarterly* (Autumn 2010). Her
other research exploring the social and political facets of film culture in
China from the 1890s to the present has also appeared in *Cinema and
Urban Culture in Shanghai, 1922–1943* (Stanford University Press, 1999),
Dushi wenhua zhong de xiandai zhongguo (Popular Culture of the Mod-

ern Metropolis) (East China Normal University Press, 2007), and *Chinese Films in Focus 2* (Palgrave, 2008).

Karla Huebner is Assistant Professor at Wright State University in Dayton, Ohio. She received her MA from American University in Washington, DC, and her PhD from the University of Pittsburgh. This essay grew from her dissertation research on the Czech artist Toyen (Marie Čermínová), a founding member of the Prague Surrealist Group. Huebner's research interests include Czech modernism, women's history, and the history of gender and sexuality.

Kristen Lubben, Associate Curator at the International Center of Photography, New York, has been a member of the curatorial staff since 1998. She has curated numerous exhibitions, including "Susan Meiselas: In History"; "Gerda Taro"; "Francesc Torres: Dark Is the Room Where We Sleep"; "Amelia Earhart: Image and Icon"; "El Salvador: Work of Thirty Photographers"; and "Dress Codes: The Third ICP Triennial of Photography and Video," with Vince Aletti, Carol Squiers, and Christopher Phillips. Ms. Lubben is the author and editor of numerous publications, including the catalog for the exhibition "In History," which received the Kraszna Krausz Either/Or Award (United Kingdom) for best photography book of 2009 and best historical photography book from Les Recontres d'Arles. She received her BA in art history and women's studies from the University of California, Irvine, and completed graduate studies in the history of art and archaeology at the Institute of Fine Arts, New York University.

Maria Makela is Professor and Chair of the Visual Studies Program at the California College of the Arts. Author of *The Munich Secession: Art and Arts in Turn-of-the-Century Munich* (Princeton University Press, 1990), she cocurated the retrospective "The Photomontages of Hannah Höch" and coauthored the accompanying catalog (Walker Art Center, 1996). She has lectured and published widely on nineteenth- and twentieth-century German art, most recently coediting the anthology *Of "Truths Impossible to Put in Words": Max Beckmann Contextualized* (Peter Lang, 2009), and is currently engaged in a project on visual manifestations of identity in Weimar era Germany.

Linda Nochlin is Lila Acheson Wallace Professor of Modern Art at the Institute of Fine Arts, New York University. She is world renowned for her

groundbreaking work in advancing the cause of women artists, beginning in 1971 with her article "Why Have There Been No Great Women Artists?" Sparking a major development in art history and criticism, this work led to the 1976 exhibition "Women Artists 1550–1950," which Nochlin curated with Anne Sutherland Harris for the Los Angeles County Museum of Art. She has continued to publish and curate widely on the subject of women artists, recently for "Global Feminisms" at the Brooklyn Museum in 2007, as well as on such topics as Courbet, realism, impressionism and postimpressionism. Nochlin is the recipient of countless awards and honors, including the Frank Jewett Mather Prize for Critical Writing (CAA) and a Guggenheim Fellowship. She is also active in the field of contemporary criticism.

Elizabeth Otto is an art historian who focuses on issues of gender, visuality, and media culture in the later nineteenth and twentieth centuries, especially in Germany and France. In addition to coediting *The New Woman International,* Otto is the author of *Tempo, Tempo! The Bauhaus Photomontages of Marianne Brandt* (Berlin: Jovis Verlag and the Bauhaus-Archiv, 2005) and essays on such topics as gender at the Bauhaus, the represented male body in film and photomontage in the Weimar Republic, and Siegfried Kracauer's art historical writings. She has been a fellow of the Alexander von Humboldt Foundation, the American Association of University Women, the German Academic Exchange Service (DAAD), and the Humanities Center at the University of Pittsburgh. Otto received her PhD from the University of Michigan and is Associate Professor in the Department of Visual Studies at the University at Buffalo, the State University of New York.

Martha H. Patterson is Associate Professor of English at McKendree University and the author of *Beyond the Gibson Girl: Reimagining the American New Woman, 1895–1913* (University of Illinois Press, 2005) and *The American New Woman Revisited: A Reader, 1895–1930* (Rutgers University Press, 2008). She is currently examining literature published in African American newspapers for a book-length study of the Harlem Renaissance tentatively entitled "The Harlem Renaissance Weekly." During the 2010–11 academic year Patterson was a Fulbright scholar and lecturer at the University of Agder in Kristiansand, Norway, where she was researching the feminist roots of Henrik Ibsen's New Woman dramas.

Vanessa Rocco, Adjunct Assistant Professor in the History of Art and Design at Pratt Institute, has a PhD in art history from the Graduate Center, City University of New York, where she specialized in Weimar-era photography, film, and exhibition culture. She organized numerous exhibitions and publications as Assistant Curator at the International Center of Photography in New York, including "Expanding Vision: Laszlo Moholy-Nagy's Experiments of the 1920s" (2004), "Modernist Photography from the Daniel Cowin Collection" (2005), and "Louise Brooks and the 'New Woman' in Weimar Cinema" (2007). She served as Curatorial Adviser for the exhibition "Universal Archive: The Condition of the Document and Modern Photographic Utopia," which opened at the Museu d'Art Contemporani de Barcelona in fall 2008, and published an essay in its catalog (*Public Photographic Spaces*) about architectonic photography in Italian fascist exhibitions. Her reviews and articles about photography have also appeared in *History of Photography, SF Camerawork*, and *Afterimage*, among other publications.

Clare I. Rogan is Curator of the Davison Art Center at Wesleyan University. She received her PhD in the history of art and architecture from Brown University. In her dissertation, she examined the construction of the lesbian in German art and visual culture from 1900 to 1933. Her publications include articles on early lithography and the German lesbian magazines of the 1920s. She has curated numerous exhibitions, including "Philip Trager: A Retrospective" (2006) and "Keiji Shinohara: Color Harmony" (2007). At Wesleyan University she teaches courses on the history of photography, the history of prints, and museum studies.

Despina Stratigakos is an architectural historian with an overarching interest in gender and modernity in European cities. She is the author of *A Women's Berlin: Building the Modern City* (University of Minnesota Press, 2008), a history of a forgotten female metropolis and winner of the 2009 German Studies Association DAAD Book Prize and the 2009 Milka Bliznakov Prize. Stratigakos has also published on the public image of women architects, the gender politics of the Werkbund, connections between architectural and sexual discourses in Weimar Germany, and exiled Jewish women architects in the United States. She lectures publicly on issues of diversity in architecture and in 2007 curated an exhibition on Architect Barbie to focus attention on gendered stereotypes within the architectural

profession. Stratigakos received her PhD from Bryn Mawr College and taught at Harvard University and the University of Michigan before joining the Department of Architecture at the State University of New York at Buffalo.

Brett M. Van Hoesen is Assistant Professor of Modern and Contemporary Art History and Faculty Associate in the Gender, Race, and Identity Program at the University of Nevada, Reno. She holds a PhD from the University of Iowa and a Master's degree from the University of Massachusetts, Amherst. Her recent publications include contributions to the *International Encyclopedia of Revolution and Protest* (Wiley-Blackwell, 2009) and the international feminist art journal *n. paradoxa* (July 2010), as well as the essay "Weimar Revisions of Germany's Colonial Past: The Photomontages of Hannah Höch and László Moholy-Nagy" for the edited volume *German Colonialism, Visual Culture, and Modern Memory* (Routledge, 2010). Van Hoesen is currently preparing a book manuscript on the legacy of German colonialism in Weimar era visual culture and the work of artists associated with expressionism, Dada, and the Bauhaus.

Kathleen M. Vernon is Associate Professor of Hispanic Studies and an affiliated faculty member of Women's Studies, Comparative Literary and Cultural Studies, and Latin American and Caribbean Studies at the State University of New York at Stony Brook. Her publications include *The Spanish Civil War and the Visual Arts; Post-Franco, Postmodern: The Films of Pedro Almodóvar;* and numerous essays on modern Spanish and Latin American cinema, culture, and literature. She is currently completing a monograph entitled *The Rhythms of History: Cinema, Music, and Cultural Memory in Modern Spain,* and two multiauthored books, *The Mediation of Everyday Life: An Oral History of Cinema-Going in 1940s and 1950s Spain* and *Film Magazines, Fashion, and Photography in 1940s and 1950s Spain.*

Lisa Jaye Young has been Professor of Art History at the Savannah College of Art and Design since 2007. She earned her PhD in the history of photography at the Graduate Center, City University of New York, in 2008. Between 2000 and 2005 she taught at the State University of New York at Nassau Community College and served as the campus gallery director. Through the 1990s Young worked at the Martin Gropius Museum in

Berlin, curated independent exhibitions, and worked for Deitch Projects in New York. Her work deals with the intersection of art and corporate culture in the photography of the 1920s and 1930s in Germany and the United States. She writes about contemporary art and has contributed to *Art Review* (London), *Tema Celeste, Chicago Art Journal, Performing Arts Journal, Zing, PART,* and *Bonds of Love.*

Index

Page numbers in *italics* indicate illustrations.

Foucault, Michel, 8
Fragonard, Jean-Honoré, 166
Franco, Francisco, 279, 282, 287
Frankfurter Zeitung, 262
Frau im Osten, 62
Freedman, Estelle, 305, 307n10
Freia (model), 136, 146
Freud, Sigmund, ix, 234
Freundin, 140, 145–46
Fringilla, 244
Fronta, 235, 238, 244
Fu, Poshek, 326
Fun of It, 299

Gandhi, Mahatma, 306
Ganeva, Mila, 14
Gap, 306, 308n25
Garb, Tamar, 155
Garbo, Greta, 227
garçonne, 1, 6, 12, 145, 155, 158, 162, 218–19, 231
Garçonne, La. See Margueritte, Victor
Garvey, Marcus, 196, 198
Gentleman, 233, 235, 240, 244
Giese, Fritz, 265
Gilman, Charlotte Perkins, 17n25
Gilman, Sander, 181
Girls' Companion, 42
Glyn, Elinor, 197
Godey's Lady's Magazine, 27, 37n19
Goebbels, Joseph, 189
Goldman, Emma, 50
Gong Li, 327
Gordon, Eugene, 196
Gordon, Lou, 297
Gouges, Olympe de, 5, 15n10
Graham, Helen, 278, 286
Grand, Sarah, 6
Graves, C. H., 29–30
Gray, Gilda, 199
Greco, El, 283
Griffith, George W., 32
Gropius, Walter, 158, 166
Grosz, George, ix–x
Guest, Amy, 294–95
Gurlitt, Wolfgang, 145
Gürster, Eugen, 183

Haas, Willy, 175
Hale, Sarah, 27–28, 37n19
Hara Hideko, *51*–*52*
Harbou, Thea von, 176, 179, 183, 184, 186

Hardt, Hanno, 95
Harlem Renaissance, 13, 194–98, 204
Haro Tecglen, Eduardo, 284
Harper's Bazaar, 282
Hauptmann, Gerhard, 129
Heller, Friedrich, 265
Helm, Brigitte, 12, 213, 215
Herschel, Sir John, 120–22
Hershfield, Joanne, 16n15
Hessling, Katherine, 108
Heyward, DuBose, 196
Higuchi Raiyō, 47
Hiratsuka Raichō, *40*, 45–47, 51
Hitler, Adolf, 189, 279
Höch, Hannah, 12, 97, 104–5, 108, 110–11, 115–32, 164, 170n29; *Das schöne Mädchen, 117; Die Kokette II, 110; Hochfinanz, 120*
Hoppe, E. O., 215
Hori Yasuko, 53
Horký, Karel, 249n16
Hou Yao, 312–13
Hrska, A. V., 240
Hua Mulan Joins the Army, 311, 313
Hübschmann, Gretel, 136
Hübschmann, Kurt, 136
Huelsenbeck, Richard, 265
Huggan, Graham, 100
Hughes, Langston, 196, 201
Humboldt, Alexander von, 101–2
Hurley, Frank, 98–101
Hurston, Zora Neale, 196
Hu Shan, 311
Huyssen, Andreas, 154, 166

Ibsen, Henrik, 44–45, 52
Icaza, Carmen, 281
Ihering, Herbert, 178
Ikuta Chōkō, *40*, 43
Illustrierte Film-Kurier, 218
Illustrierte Frauenzeitung, 64
Iskin, Ruth, 4
Itō Noe, 52, 53
Ivens, Joris, 144
Iwano Kiyo, *48*–*49*

Jackson Girls, 13, 256–58
Jack the Ripper, x
Jardiel Poncela, Enrique, 282, 289n35
Jelavich, Peter, 255
Jermoloff, Marie, 66
Jesenská, Milena, 245, 250n28

41 31 35